SUMI WAKIRO

brilliant corners

はじめに

鷲見和紀郎は1950年岐阜県生まれ、千葉県在住の美術作家。1972年に現代美術の寺子屋Bゼミを修了。ブロンズやワックスなど多様な素材を使いながら、彫刻の始源のような幾何学的形態から有機的な形態まで、幅広い表現をおこなっている。また「垂直性」と「水平性」の問題に一貫して取り組むなど、「彫刻のスタンダード」な課題を継続的に誠実に追求してきている。

今回の展覧会では、これまで数十年間制作してきた彫刻群を、食卓を飾る料理のように空間全体に配し、さまざまな音を奏でる森のような空間を提供してくれるはずだ。他方、新作のワックスでできた巨大な造形物は、まるで料理を調理する特大のオーブンのように、これから生まれてくる「創造物」の予感を与えるにちがいない。ガラスが液体でも個体でもなくアモルファスに存在しているように、鷲見の作品も彫刻（立体）が生まれる前の、柔らかい、優しい、とらわれのない形を、豊かに示してくれるだろう。

池田 修

Introduction

Born in Gifu Prefecture in 1950 and based in Chiba, Wakiro Sumi completed the private contemporary art school, "B-semi" in 1972. Using diverse materials such as bronze and
wax, he developed a comprehensive range of work, from geometric to organic forms, reminiscent of sculptural origins. He consistently engaged with the issues of "verticality" and "horizontality" and diligently pursued "standard sculptural" themes on an ongoing basis.

For this exhibition, several decades of work from his sculptural collection will fill the space like culinary offerings adorning a dining table, providing a forest-like space that resonates in a spectrum of sounds. On the other hand, the new wax sculptures are like industrial ovens for cooking and will surely give a foretaste of the "creations" that will birth from them. Just as glass exists amorphously, neither liquid nor solid, Sumi's works will enrich us with representations of the soft, gentle, unrestrained forms that existed before the birth of sculpture.

Osamu Ikeda

brilliant corners

ブリリアント コーナーズ（輝ける片隅）はジャズピアニスト、セロニアス・モンクのリバーサイドレコードレーベル1956年発売のレコード名でありその1曲目のタイトルでもあります。彼のオリジナル曲で変則的なテンポの繰り返しが続きながらも、ナチュラルに聞こえる不思議な曲です。
このタイトルは2004年、府中市美術館での公開制作「ペインティングスカルプチャー」の作品タイトルにも使わせていただきました。
建築においてコーナーは左右の壁＋床と天井の4つのディメンションで構成されています。インスタレーションにおいても4つの空間要素が集約される魅力的な場所にもかかわらず、文字通り普段は片隅にあってほとんど見過ごされています。
美術史においてもこのコーナーに居た作家たちが居ます。たとえばピエール・ボナール、たとえばメダルド・ロッソ、たとえばモーリス・ルイスなど有名無名に関わらず淡々と実験を繰り返した態度に共感を覚えます。
まがりなりにも50年間制作発表を続けてきた自分の場所が ブリリアントコーナー になることを願い個展のタイトルにしました。

鷲見和紀郎

brilliant corners

Brilliant Corners is the album title and first track of jazz pianist Thelonious Monk's 1956 release on the Riverside Records label. An original by Monk, it is a bizarre track that sounds natural despite its repetitive and irregular tempo. I used this same title for my public artwork in the "Painting Sculpture" exhibition at the Fuchu Art Museum in 2004.
A corner in an architectural space is composed of four dimensions: the left and right walls, the floor, and the ceiling. In installations, despite being a fascinating place where the four spatial elements concentrate, it is usually overlooked because it is literally "in the corner."
Some artists in the history of art have also been in this corner; Pierre Bonnard, Medardo Rosso, and Morris Louis. Regardless of their fame or obscurity, I feel sympathy for their unfazed attitude towards continuous experimentation. I chose this title for my solo exhibition in the hope that my place, where I have created and exhibited for the past 50 years, will become a brilliant corner.

Wakiro Sumi

at Studio SUMI

写真＝鈴木理策

Photo=Risaku Suzuki

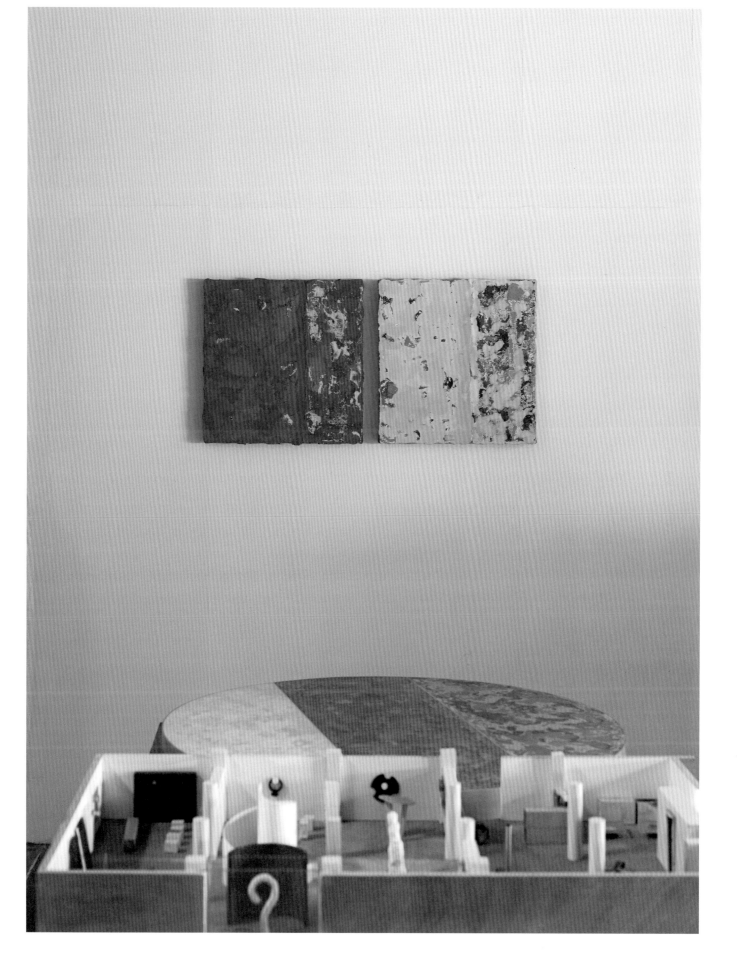

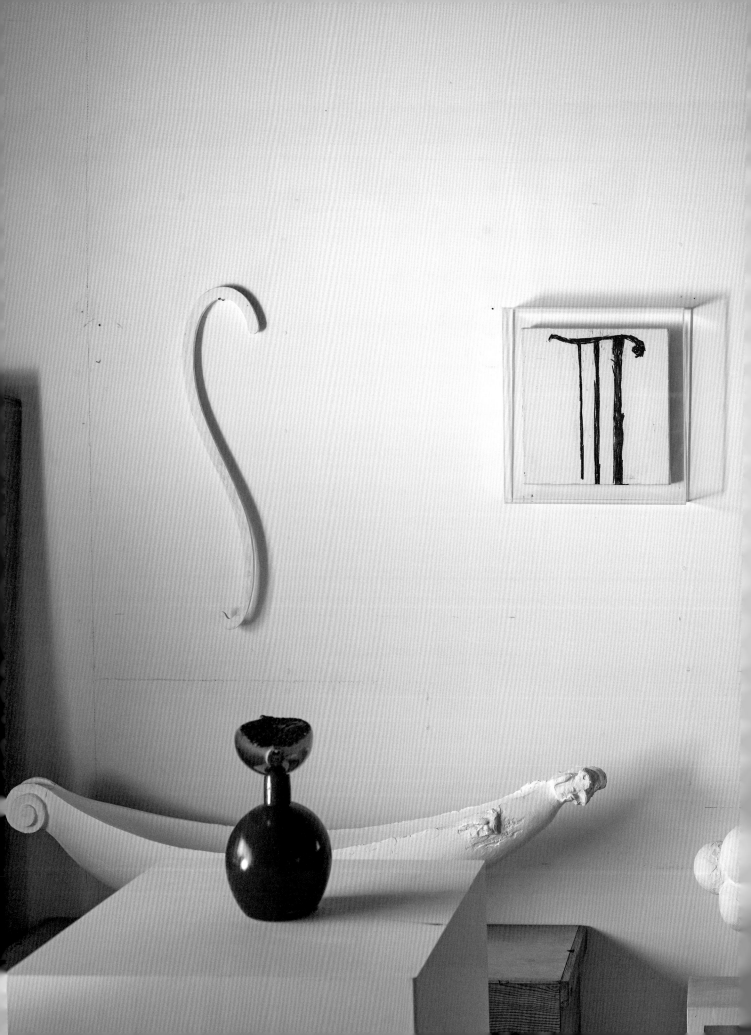

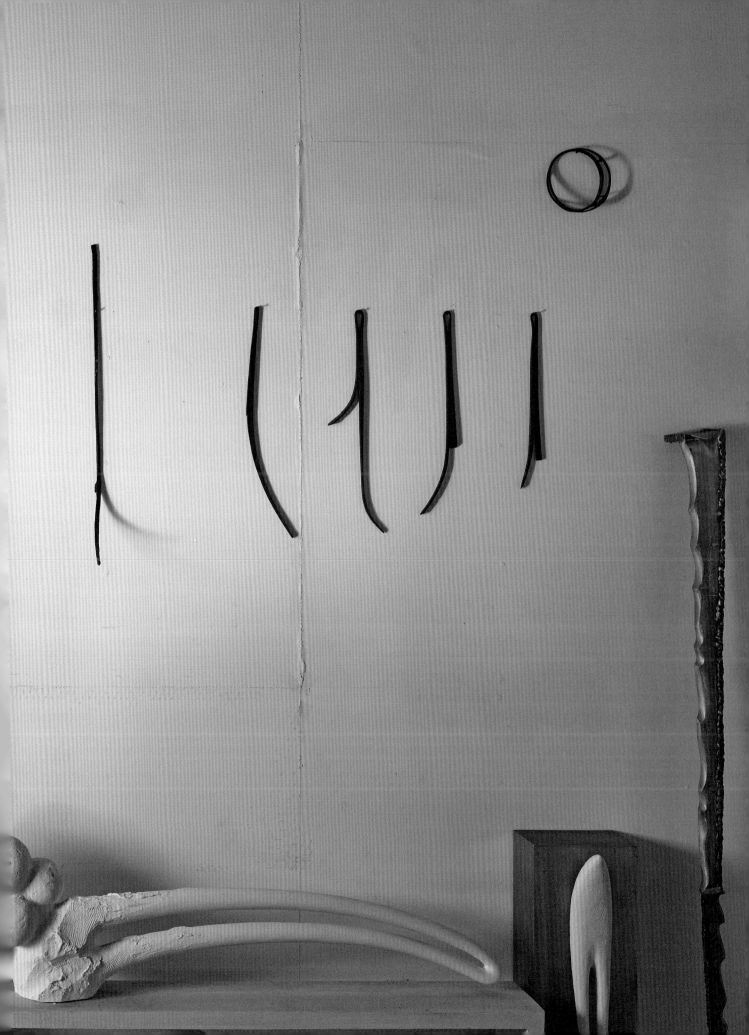

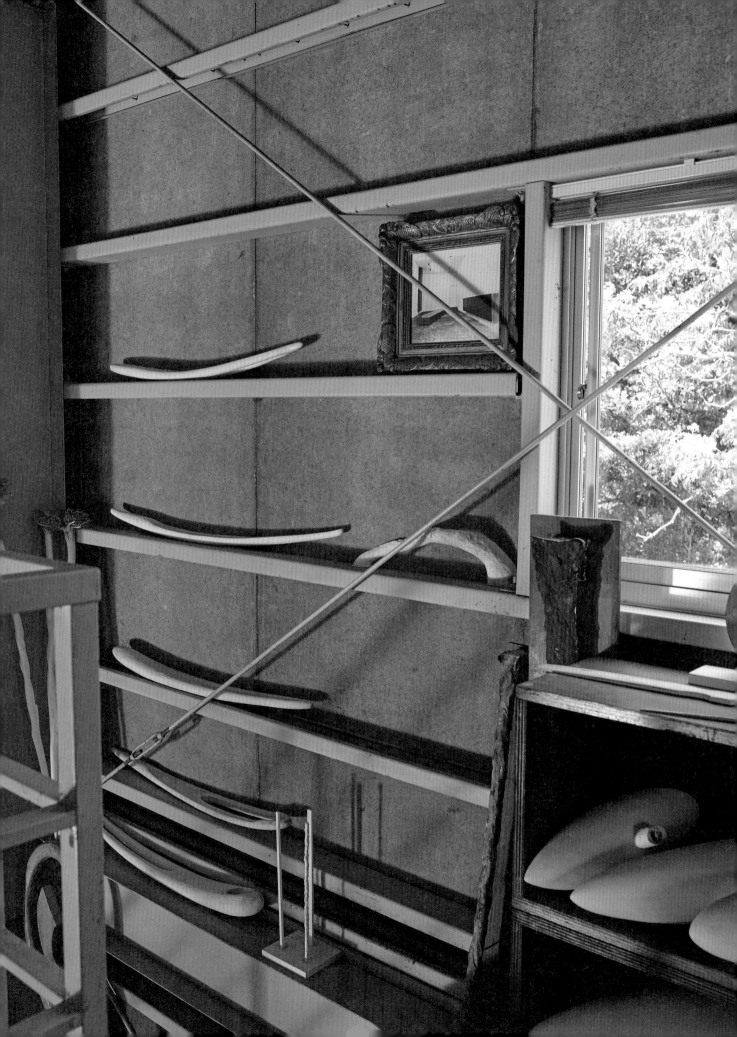

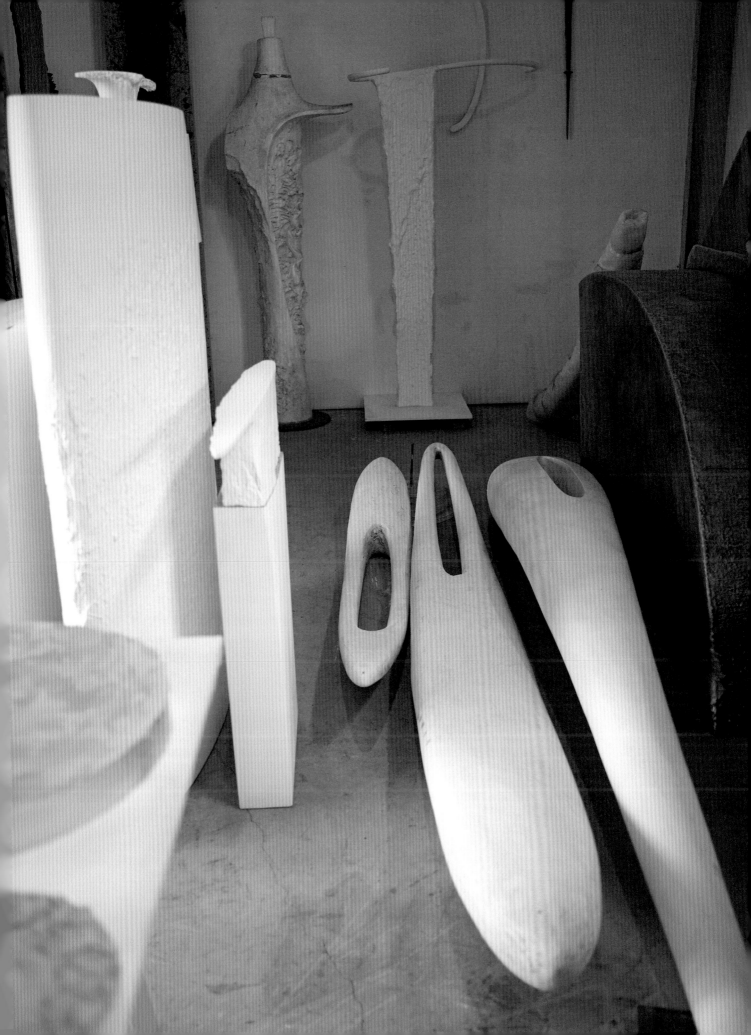

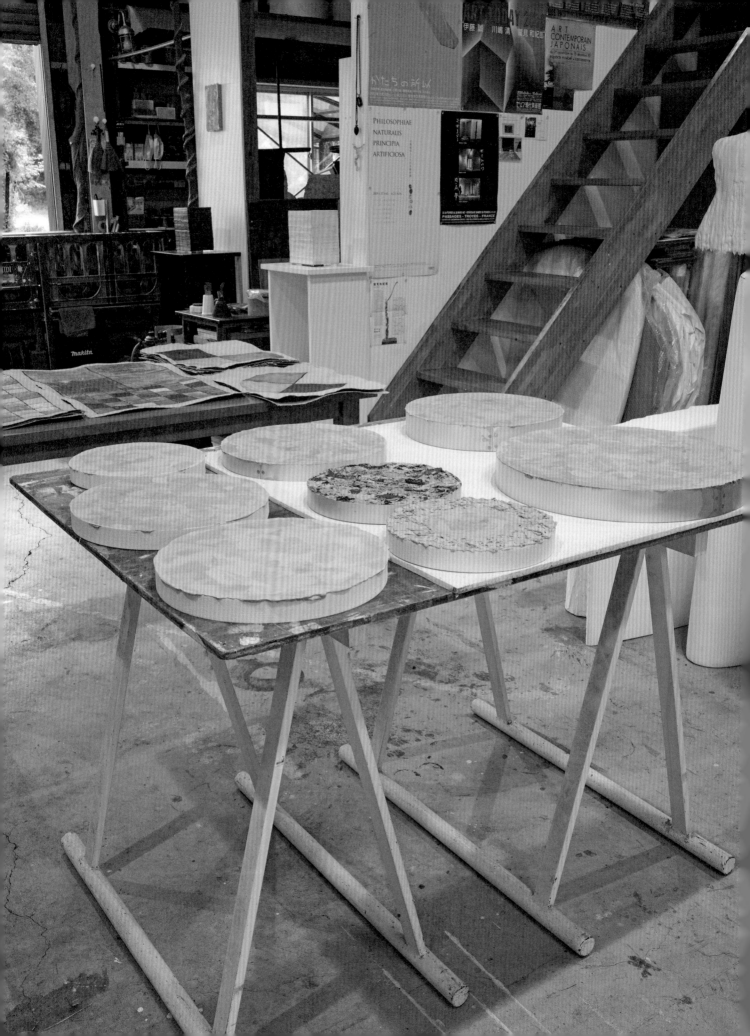

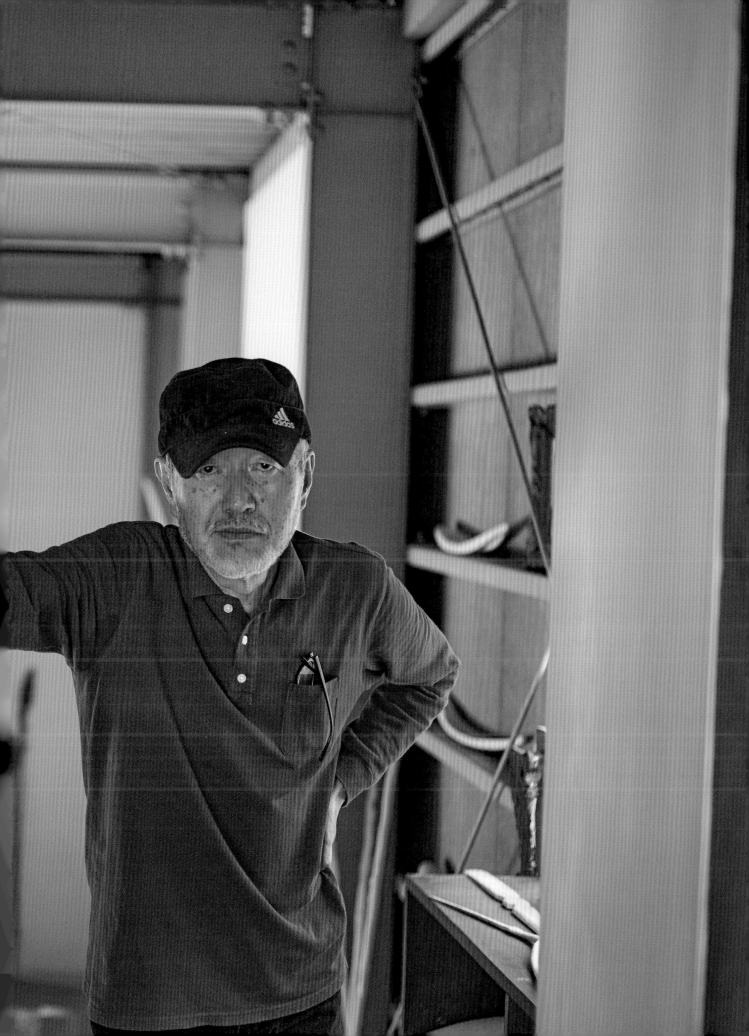

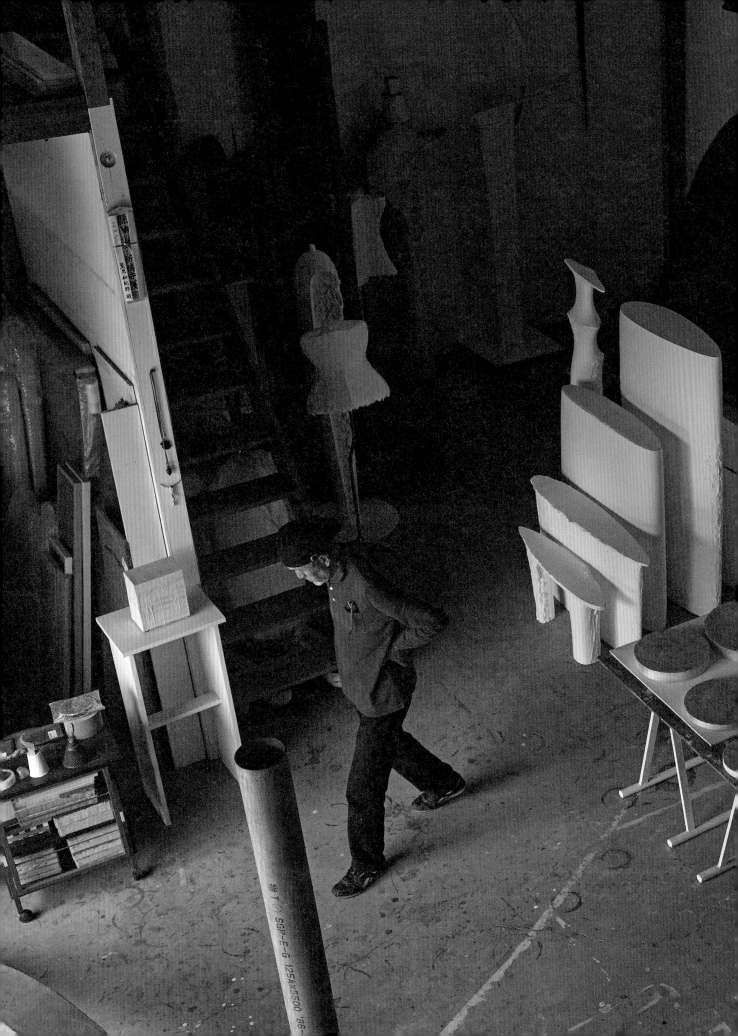

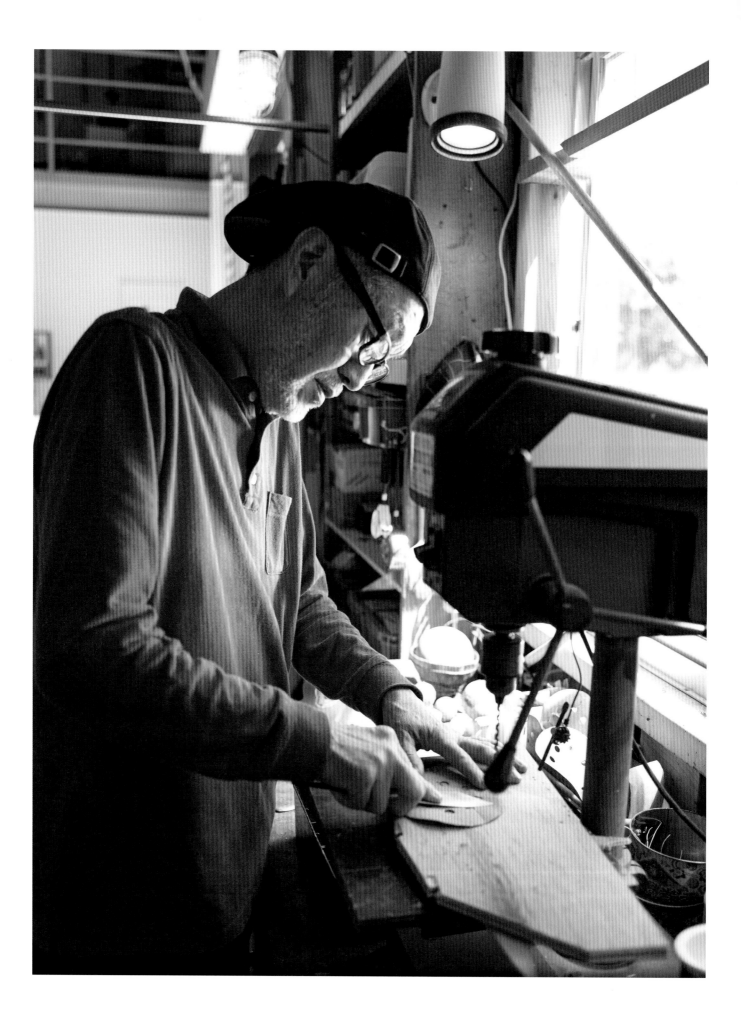

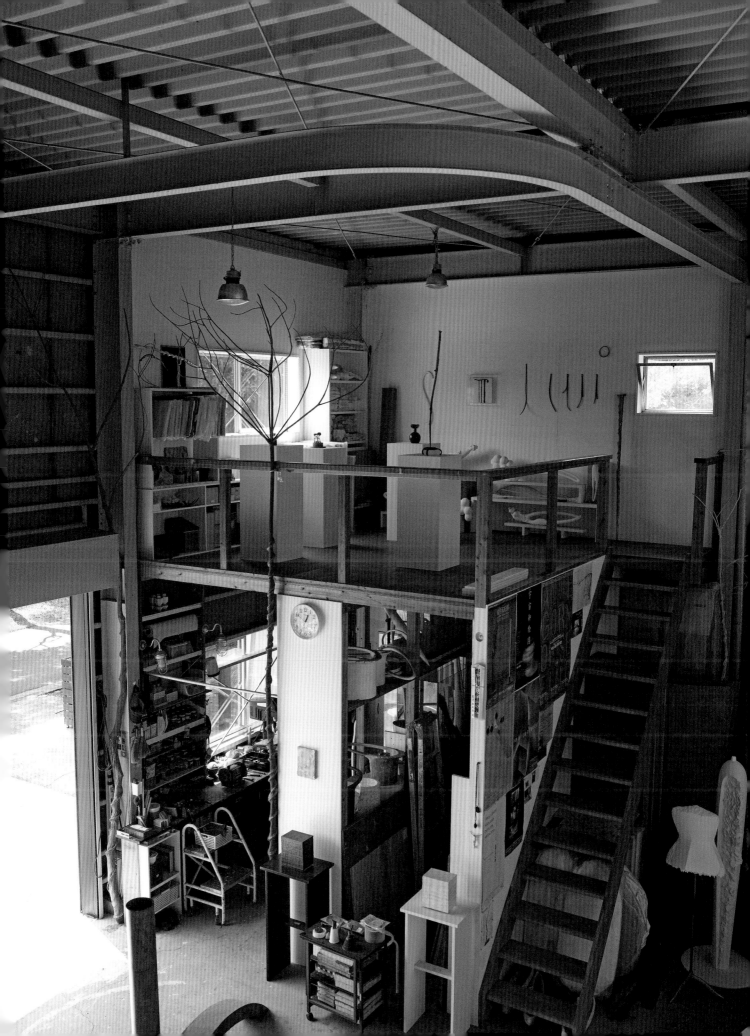

鷲見和紀郎
brilliant corners

CONTENTS

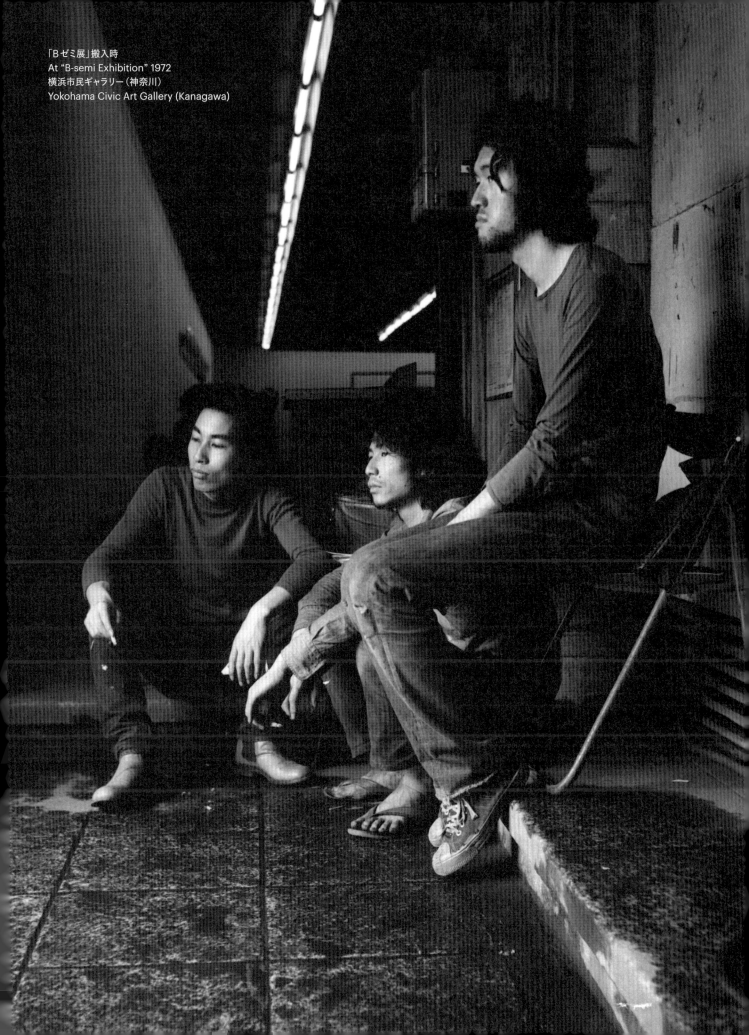

「Bゼミ展」搬入時
At "B-semi Exhibition" 1972
横浜市民ギャラリー（神奈川）
Yokohama Civic Art Gallery (Kanagawa)

ヴェールとリズム──鷲見和紀郎の彫刻について

森 啓輔［千葉市美術館学芸員］

要するに、ポイエーシスの本質的な性格とは、その実践的で意志的な過程の局面においてではなく、むしろその存在において、ヴェールを剝ぎとるという意味での真理［ἀλήθεια］の様態だったのである[1]。

ジョルジョ・アガンベン

1970年代初めから半世紀を超え、間断なく続けられてきた鷲見和紀郎の活動を俯瞰する時、作家が度々口にした「保守的」というその制作態度は、戦後から今日にかけ目まぐるしく変容してきた芸術動向に対する鷲見の揺るぎない信念を、端的に示しているように思われる[2]。たとえば、80年代の国内においては「ポストモダン」の名の下に、「ニュー・ウェーヴ」や「ニュー・イメージ」といった過去の歴史との断絶や忘却を称揚する傾向が、顕著に現われたのであり、少なからず鷲見の実践もまた、メディアや制度の側からそれらへの包摂が幾度となく図られてきたはずだ。しかし、鷲見とは数多に創出された作品と言説の同時代性に対する欺瞞こそを冷静に見据えていた人物であり、それらとの距離の遠さにおいて作品を錬成し、強固なものとしてきた美術家といえるのではないだろうか。そのような思考の独自性には、71年にBゼミに学び、以後は田中信太郎や李禹煥ら当時の専任講師だった作家たちや、三木富雄のアシスタントを務めた活動初期の稀有な経験が大きく影響している。さらに、同専任講師であった藤枝晃雄の抽象表現主義やミニマル・アートといったアメリカの同時代美術に対する刺激に満ちた知見は、76年のニューヨークへの滞在時の作品との対峙を通じ、揺るぎない確信へと変わっていったことだろう。ジャクソン・ポロックやマーク・ロスコ、バーネット・ニューマンら美術史にその名が刻まれ、クレメント・グリーンバーグが「アメリカ型」絵画と呼んだフォーマリズムの動向は、鷲見の作品制作においても、常に遡及が可能な参照点であり続けたことは、疑いの余地がない[3]。つまり、こういって良ければ鷲見の彫刻は、モダニズムの芸術が持つ豊かな鉱脈において、今もなお眩く輝き続けている。

幾何学的な構造体の造形において、鷲見はプライマリー・ストラクチャーとの親和性を感じさせる1970年代の自身の作品を、「消極的な表現」であったと半ば反省的に述懐している[4]。一方で、80年代前半は「積極的な表現の方法、素材、形式」を獲得していく時代とされ、物質の再検討と制作プロセスの拡大、そしてそれに伴う技術の開拓をもたらした[5]。これまで複数の論者が指摘してきたように、この時期の「私はジャクス（ママ）ン・ポロックが絵を描いたように彫刻を作りたい」という表現の志向性は、ブロンズ作品の制作と並行して、ロストワックスというブロンズの鋳造方法の研究を重ね、絵具や金属粉が混ぜられたワックスを刷毛で塗り重ねていく一連の大型作品の制作手法において、実現化されていった[6]。ポロックが、40年代後半に大型化するキャンバスの上で行ったドリッピングやポーリングと、溶けたワックスを重層化させる鷲見の制作手法は、絵画と彫刻、水平と垂直といった複数の境界を失効し、素材の粘性と重力の可視化という作品構造上の同質性を備えている。さらにそれらを、ともに制作者の身体が伴う重層的な時間化／空間化としての行為であると理解するならば、ハンス・ネイムスが50年に映像と写真に収めたポロックのあの躍動的で、あたかも踊るような制作行為が持つ特性は、その後の鷲見の多様な変遷を貫く重要な問題系となりうるだろう。94年に鷲見は、ワックスを型取り、アルミニウムの鋳造後に彩色を施す「ヴェール」シリーズを開始する。それらの作品タイトルのうちの一つには、アメリカで抽象表現主義のアーティストらと同時代に活躍したジャズピアニストのセロニアス・モンクの名が付された。モンクがセッションの最中、不意にピアノから離れ聴衆に披露したダンスという身体の運動への鷲見の関心は、この問題系に連なるものだ[7]。さらに2001年には、「ダンス」という名称が付された作品群が鷲見の新たなシリーズに加わることとなる[8]。

ポロックに接近し、また作品制作上の飛躍を果たした1980年代前半に、鷲見は作品を「手の延長」であると

理解していた[註9]。この思考は、作家が敬愛するデイビッ
ド・スミスの彫刻を分析する際に言及された「作家は手
で考える。特に優れた作家はなにも考えなくとも眼と手
の知性によって作品を産みだしてしまう」という記述に
も、明白に表れている[註10]。それは、まさしく鷲見自
身の眼と手に宿る知性をこそ指し示すものだろう。80
年代以降、鷲見は展覧会の会場でのワックスを用いた
作品制作を試みていく。ここに、先に触れた一回的な
行為の重層性としての手の意義を見出すことも可能だ。
そして、一般的にインスタレーションと呼ばれるこの仮
設的空間化は、構造上の変化を作品にもたらすことと
なる。そもそも鋳造とは、原型として制作された物質が
型取りによって反転し、外部へと写し替わる技法であり、
表面を境に転移が繰り返されるという存在の虚ろさを、
宿命的に備えている。平面でありながら、矩形の画面
の中にイリュージョンとしての奥行きを生じさせる絵画
に対し、「彫刻とは表面である」と言明し、そこに存在論
的な意義を見出した鷲見の思考は、この型取りの方法
論に依拠している[註11]。やがて、その彫刻の表面は厚
みの喪失において、垂直あるいは水平方向に伸長し、
空間を横断していくのであり、そのような自身の彫刻を、
建造物に物理的に接合し、分割する「壁」であり、押し
寄せる「波」であり、さらに隔てられた空間と時間に架け
られる「橋」であると捉えていた[註12]。90年代の展開
において、画期的な作品である「ヴェール」もまた、そ
のような複数的な表面の象徴性の獲得を成立条件とし
ている。

液体から固体へと、重力の影響を受けながら変質して
いくワックスの滴りが、鋳造の技術によって半永久的
にその痕跡を表面に留める「ヴェール」。人体の皮膚、
水や光の皮膜、さらには作品の表面と視る者の網膜と
いうヴェール＝膜の二重性から、鷲見が「世界はヴェー
ルで出来ている」と語ったように、それらは世界の根源
に触れるべく、私たちの眼前に今まさに現出したかのよ
うだ[註13]。ここで興味深いのは、「ヴェール」をはじめと
するその一連の制作行為に、松浦寿夫が「力線」の「産

出」を見定め、通史的にはメディウムの純化のプロセ
スとして理解されてきたフォーマリズムと鷲見との共通
性を、「分離＝接合（dis-jonction）の形式を組織する
実践」であると指摘していることだ[註14]。たしかに、鷲
見の制作に顕著であるのは、構造体が透けるように塗
り重ねられたワックスにしろ、あるいは建造物の内部
から湧出する錯覚をもたらす仮設的な作品にしろ、異
質な要素同士の複雑な結合のプロセスが認められるこ
とにあるだろう。今もなお続く作家のこの志向性は、
彫刻と絵画の綜合という点だけに留まらない。「ヴェー
ル」と、99年の個展で発表された紡錘形の形態を持
つ古生代の原生動物に由来する「フズリナ」シリーズの
結合こそが、あの「ダンス」であったという事実が、何
よりこの結合のプロセスの複雑さを物語っている。鷲
見にとって知性を有する「手」は、ここにおいていっそ
う重要な意味を持つだろう。なぜなら、かつて三木の
傍らで複数の「耳」が同時に生まれる瞬間に居合わせ
たように、鷲見の手もまた複数的な境界を、あたかも
ヴェールによって全てを覆い尽くすように、複雑なその
関係性の止揚でもって作品へと昇華しているからだ。
ここで、あのポロックによる絵画制作の一場面を私た
ちは思い浮かべるべきだろうか。それは、描かれた形
象の意味性すべてを時に無化する「覆われ」の力として、
「オールオーヴァー」と呼ばれた[註15]。

この半世紀にわたる鷲見の芸術への奉仕を「真理」と
形容することを、作家は躊躇いもなく否定することだろ
う。しかし、ジョルジョ・アガンベンが芸術作品の思惟
において、「生 - 産する」という意味を持つギリシャ語の
「ポイエーシス」に触れ、その本質的な性格を「ヴェー
ルを剥ぎとる」という真理の問題へと敷衍した時、鷲見
の「ヴェール」もまた覆い、剥奪する「分離＝接合」の
諸力を潜勢することからこの問題への接続を果たして
いる[註16]。ところで、この芸術作品や風景に対するポ
イエーシスの考察にあたり、アガンベンがヴェール（の
剥ぎとり）へともう一度接近する場面がある。そこで問
われたのが、「リズム」であった[註17]。リズムの本質とは、

第一に芸術作品への「根源的な空間を一致＝調律させる力」だ[註18]。だが、それはまた永遠の流れへの「ひとつの分裂、ひとつの中断」を導入するのであり、「時間における非時間的なものの現存として現われてくる何か」である[註19]。付言するならば、アガンベンはそれを音楽作品から導き出している。しかし、ここでアリストテレスがかつて提起した、「全体がその諸要素の単なる組合せ以上の何かである」という「構造」に対するアガンベンの読解が、芸術作品の経験の根源に触れていることを理解するならば、翻ってそれは鷲見の作品の構造を語りうるものとなるだろう[註20]。なぜなら、ヴェールとリズムとはともに、鷲見の作品に内在する力そのものを指し示すのであり、非時間的な現前として、あるいは制度化された芸術の境界を無効化する全体、つまり「何か」として、それらが眼と手の知性から生み出されてきたからだ。寡黙に、ただひたすら保守的であろうとすること。膨大な時間をかけて、生を投企するその鷲見の制作態度が輝きを与えるのは、「隠れた闇から作品が発する充溢した光へと移行する」ポイエーシスの経験によってのみ可能となる、絶対的な汲み尽くせなさを湛えた表面＝彫刻に他ならない[註21]。

註

[1]　ジョルジョ・アガンベン『中味のない人間』岡田温司・岡部宗吉・多賀健太郎訳、人文書院、2002年、p.102
[2]　たとえば「保守的」、「コンサバティヴ」という表現は、下記の中で語られている。
　　　市川平・鷲見和紀郎・倉林靖・高島直之「［脱領域］をめぐって　現代美術の現在」『武蔵野美術』No.95、1995年、p.16
　　　鷲見和紀郎・難波英夫（聞き手）「鷲見和紀郎は語る」『ART TODAY 2000　3つの回顧から　伊藤誠、川嶋清、鷲見和紀郎』図録、セゾン現代美術館、2000年、p.15
[3]　グリーンバーグにおける「アメリカ型」絵画に関する詳述は、下記を参照のこと。
　　　クレメント・グリーンバーグ「『アメリカ型』絵画」『グリーンバーグ批評選集』藤枝晃雄訳、勁草書房、2005年、pp.111–140
[4]　鷲見和紀郎「（タイトルなし）」『美術手帖』1983年3月号、p.65
[5]　同前、同ページ
[6]　同前、同ページ。また、ジャクソン・ポロックの絵画と自身の彫刻の関係に対する鷲見の言及を引用した主なテキストとして、下記が挙げられる。
　　　本江邦夫「《ヴェール》について」『鷲見和紀郎　THE VEIL』図録、ギャラリーところ、1994年、ページなし
　　　松浦寿夫「もうひとつのヴェール」『さまざまな眼86　鷲見和紀郎展　アラベスク』図録、かわさきIBM市民文化ギャラリー、1997年、ページなし
　　　山梨俊夫「親不孝な彫刻―新作をめぐって」『今日の作家XI　鷲見和紀郎　光の回廊』図録、神奈川県立近代美術館、2007年、pp.4–7
[7]　鷲見和紀郎「（タイトルなし）」『Chiba Art Now '02　かたちの所以』図録、佐倉市立美術館、2002年、p.14
[8]　同前、同ページ。また、鷲見は「ダンス」シリーズについて、モンクのダンスにまつわるローラン・ド・ウィルドの言及からの影響を、彫刻における「重力」と「浮遊」という問題につなげて語っている。また、鷲見も述べている通り、ウィルドはモンクのダンスを

「踊り（danse）」と「比重（densité）」の語呂合わせとして「一種のダンシテ（dansité）」と評している。
　　　同前、同ページ
　　　ローラン・ド・ウィルド『セロニアス・モンク　沈黙のピアニズム』水野雅司訳、音楽之友社、1997年、p.199
[9]　前掲4　『美術手帖』1983年3月号、p.65
[10]　鷲見和紀郎「デイヴィッド・スミスの彫刻　グレート・アメリカン・スカルプター」『美術手帖』1984年2月号、p.134
[11]　彫刻を「表面」と捉える言及について、もっとも早い時期に確認できる主な資料として下記がある。
　　　鷲見和紀郎「（タイトルなし）」『'86岐阜県現況展　戦後生まれの作家たち〈平面部門〉』図録、岐阜県美術館、1986年、p.22
　　　鷲見和紀郎「（タイトルなし）」『美術手帖』1986年6月号、p.25
　　　Wakiro Sumi,"(no title)", Wakiro Sumi Works 1981–1986, ARGO Corporation, 1986, n.pag.
[12]　前掲11　『美術手帖』1986年6月号、p.25
[13]　鷲見和紀郎「回廊にて」『今日の作家XI　鷲見和紀郎　光の回廊』図録、神奈川県立近代美術館、2007年 p.14
[14]　前掲6　『さまざまな眼86　鷲見和紀郎展　アラベスク』図録、ページなし
[15]　下記の論考では、ポロックが1951年以降に描いたブラック・ペインティングについて、具象的な形象が現れて以降も制作を続ける理由として、ポロックの「イメージにヴェールをかけたいんだ」という言葉を引用し、画面の最下層に描かれていた形象に対する検証が行われている。
　　　筧菜奈子「ジャクソン・ポロックのオールオーヴァー絵画の制作過程　ハンス・ネイムス撮影の写真・映像の解析を通して」『美学』第68巻1号（250号）、2017年、p.52
[16]　本江邦夫は、鷲見が言及した「橋」を「ヴェール」を読み解く上での参照項と認識し、「鷲見にとって橋とは、ヴェールのごとく異質のもののなかに介在し、あるものを隠し、あるものを明らかにし、その一方で見る者を、まったく新たな次元へとみちびく存在なのだ」（傍点引用者）と、本稿でも言及する「ヴェール」の「覆われ／剥ぎとり」という両義性を指摘していた。
　　　前掲6　『鷲見和紀郎　THE VEIL』図録、ページなし
[17]　前掲1　『中味のない人間』、pp.148–149
[18]　同前、p.148
[19]　同前、pp.148–149
[20]　同前、p.144。なお、鷲見の作品制作の意義について考察するにあたり、本稿で展開できなかった問題として「もの派」の影響とそれへの応答がある。71年当時のBゼミには、李や関根伸夫らもの派の作家たちが専任講師として在籍しており、鷲見は多くの影響を受けるとともに、その動向との自己差異化を活動初期の時点で意識化していったと推測される。中でも、鷲見のもの派の批判は、石と鉄、石とガラスといった異素材の組み合わせによる関係性の創出を重視した李の理論に向かった。つまり、このことは本稿で言及してきた「分離＝接合」的な力としてのポイエーシスを鷲見が正しく認識し、実践してきたことを証明している。鷲見によるもの派への代表的な言及については、下記を参照のこと。なお、本稿の執筆にあたり、鷲見氏にはこれまでの作品制作に関して貴重なお話を伺う機会を与えていただいた。ここに記して感謝申し上げます。
　　　鷲見和紀郎「アート・オルタナティヴ」『あいだ』35号、美術と美術館のあいだを考える会、1998年、pp.14–16
[21]　前掲1　『中味のない人間』、p.102

森 啓輔：千葉市美術館学芸員。1978年三重県生まれ。武蔵野美術大学大学院造形研究科美術専攻修了。ヴァンジ彫刻庭園美術館学芸員を経て2019年より現職。専門は日本近現代美術、美術批評。高松次郎、もの派を中心とした1960–70年代の美術動向の研究と並行して、絵画、彫刻に関する現代美術作家の展覧会を企画・担当。近年の主な展覧会に、2020年「宮島達男 クロニクル 1995–2020」（千葉市美術館）、2022年「生誕100年 清水九兵衞／六兵衞」（千葉市美術館）など。

Veil and Rhythm: On the Sculptures of Wakiro Sumi

Keisuke Mori [Curator, Chiba City Museum of Art]

> The essential character of poiesis
> was not its aspect as a practical and
> voluntary process but its being a mode of
> truth understood as unveiling, [ἀλήθεια.][1]
> —Giorgio Agamben

Since the beginning of the 1970s, for over half a century, Sumi has continued working without interruption. The artist's often-quoted "conservative" attitude clearly demonstrates his unwavering faith toward his work in the rapidly changing artistic trends from the postwar period to the present.[2] The 80s in Japan, for example, saw an emergence of a marked movement in the name of "postmodernism" to glorify the disconnection from and erasure of its previous history in the form of "New Wave" and "New Image." To no small extent, Sumi's practice could have repeatedly been included in this trend by the media and institutions. However, Sumi calmly observed such deceptions of contemporaneity in the countless works and discourses, distancing himself from these deceits while refining and reinforcing his works. This singularity of thought was greatly influenced by the rare experience he had in the early years of his career as an assistant to Shintaro Tanaka, Lee Ufan, and other artists who were full-time instructors, as well as Tomio Miki, after graduating from the B-semi in 1971. Furthermore, Teruo Fujieda's stimulating knowledge of American contemporary art, such as Abstract Expressionism and Minimal Art, must have transformed into an unshakable conviction through his encounter with the works during his 1976 residency in New York. Undoubtedly, the formalist developments identified as "American-type" paintings by Clement Greenberg included Jackson Pollock, Mark Rothko, and Barnett Newman. These names inscribed in art history have always been a reference point tracing back to Sumi's art practice.[3] In other words, Sumi's sculptures continue to shine brightly in the rich vein of modernist art.

Sumi somehow in regret remembers his 1970s geometric structural model work, with their affinity to Primary Structure, as being "passive expressions." [4] On the other hand, the first half of the 1980s saw the adoption of "active, representational methods, materials, and forms," which led to material reconsideration, expansion of production processes, and correlating technological development.[5] As several critics have pointed out, this was the period of the artist's directive to "wanting to make sculptures in the same way Jackson Pollock painted," along with producing bronze works, he also studied the lost wax method of casting bronzes, and developed a series of large scale works that involved brushing wax mixed with paints and metal powders.[6] Pollock's dripping and pouring technique, carried out in the late 1940s on progressively larger canvases and Sumi's technique of layering melted wax, both nullify the multi-level boundaries of painting and sculpture, horizontality and verticality. There's a common structural homogeneity in visualizing the viscosity and gravity of the materials. Furthermore, if we understand these two approaches as multilayered temporalization/spatialization involving the body of the artist, the characteristics of Pollock's dynamic, almost dance-like production, which Hans Naims captured on film and photography in 1950, may be an important question that runs through Sumi's diverse transitions in the years that followed. In 1994, Sumi embarked on the "Veil" series, in which wax is molded, cast in aluminum, and then applied with color. One of the titles of these works was named after Thelonious Monk, a jazz pianist who was active in the United States at the same time as abstract expressionist artists. Sumi's interest in the physical movements of dance is connected to Monk's unexpected dance during a performance when he abruptly left his piano.[7] And since 2001, a new series entitled "Dance" became part of Sumi's body of work.[8]

As his approach to Pollock drew closer in the early '80s, Sumi made another leap forward, by realizing his work to be "an extension of the hand." [9] This thought transpired upon analyzing David Smith's

sculptures, whom Sumi admired. "Artists think with their hands. An outstanding artist produces works with the intelligence of his eyes and hands without thinking." [10] Smith's statement clearly indicates the wisdom inherent in Sumi's own eyes and hands. From the 1980s onward, Sumi experimented with wax works created on-site. As mentioned earlier, we can now identify the hand's significant role as a multiplier of the singular act of layering. This temporary spatialization, generally referred to as installation will bring about structural changes to his work. Casting is a technique in which a material created as a prototype is inverted through molding and transposed to the exterior, a process predestined to repeat the transition from one surface to the next, thus creating a vacant existence. While paintings are flat and create an illusionary depth within their rectangular surface, Sumi's notion of "sculptures are surfaces" reveals the existential significance underlying his methodology of mold making.[11] Eventually, the sculpture's surface, in losing its thickness, extends vertically or horizontally, traversing space, and characterized as "walls" that physically join and divide structures, "waves" that crash down and surge, and "bridges" further separated between space and time.[12] "The Veil," a groundbreaking work developed in the 1990s, also has this conditional formation in adopting this multi-faceted symbolism.

With gravity's influence, droplets of wax transform from liquid to solid, the casting technique creates "The Veil" by retaining traces of the wax semi-permanently on its surface. The duality of the veil = membranes, such as the skin of the human body, the layers of water and light, and eventually the work's surface and the observer's retina, suggests that *the world is made of veils,*" as Sumi describes, that they appear before our eyes now, as if to touch the root of the world. [13] What is intriguing here is that Hisao Matsuura identifies the "production" of "lines of force" in the series of production acts including "Veil," and points out the commonality between Formalism and Sumi, which has been historically accepted as a medium

purification process, and "a practice of organizing the form of dis-junction."[14] Indeed, what is remarkable about Sumi's work is the complex process of combining disparate elements, whether it is the wax applied to reveal the underlying structure or the ephemeral works that create the illusion of gushing from a building's interior. This ongoing direction is not limited to the synthesis of sculpture and painting. The fact that the combination of "Veil" and "Fusulina," (a series of spindle-shaped protozoa from the Paleozoic era, shown in the 1999 solo exhibition), together leading to form "Dance," demonstrates the complexity of this process. Here, the "hand," possessing intelligence, holds greater significance for Sumi. Just as Sumi was present in the moment when Miki's multiple "ears" birthed simultaneously, his "hand" distilled multiple boundaries into a work of art by sublimating the complex relationships between them as if a veil were covering everything. Should we recall a particular scene from Pollock's paint production? It was called "all over everything" as the power of "covering" sometimes nullifies all semantics of the painted forms.[15]

The artist would have no hesitation in denying his service to art for the past half-century described as "truth." However, when Giorgio Agamben refers to the Greek word "poiesis," meaning *make,*" his deliberations on artistic works elaborate on its essential disposition to the matter of truth as "The stripping of the veil." Sumi's "veil," too, is a latent force of "separation-junction" that covers and strips away, and thus connects to this issue.[16] Incidentally, in examining poiesis regarding artistic works and landscapes, Agamben approaches the veil again (the stripping of the veil). The question posed there was "rhythm."[17] The nature of rhythm is primarily "the force that tunes the fundamental space" to a work of art.[18] But this also introduces "one division, one interruption" to the eternal flow, "something that appears as the presence of the non-temporal in time." [19] To add, Agamben deduces this from musical work. However, if we understand Agamben's interpretation of

"structure," which Aristotle once proposed as *the whole is greater than the sum of its parts*," touches the root of the experience of artistic works, and could, in turn, speak to Sumi's structuring of his works.[20] Both veil and rhythm denote the very force inherent in Sumi's works. They have been manifested out of the intelligence of the eye and the hand, either as non-temporal presences or as a whole, or "something" that nullifies the boundaries of institutionalized art. Taciturnly and devotedly, he maintains a conservative attitude. What shines through Sumi's production approach, where he spends considerable time plotting his life, is nothing but sculpture, a surface filled with absolute impenetrability, made possible only through the experience of poiesis, "the transition from hidden darkness to the fullness of light emanating from the work." [21]

Notes

[1] Giorgio Agamben, *Nakami no nai ningen*, (*L'uomo senza contenuto*) translated by Atsushi Okada, Sokichi Okabe, and Kentaro Taga, Jinbunshoin, 2002, p. 102.

[2] For example, the expressions "conservative" and "conservatism" are discussed in Taira Ichikawa, Wakiro Sumi, Yasushi Kurabayashi, and Naoyuki Takashima, "Datsuryouiki wo Megutte, Gendai Bijutsu no Genzai" *Musashino Bijutsu*, No. 95, 1995, p. 16.
 Wakiro Sumi and Hideo Namba (interviewer), "Wakiro Sumi Speaks," ART TODAY 2000: From Three Retrospectives by Makoto Ito, Kiyoshi Kawashima, and Wakiro Sumi, catalog, Sezon Museum of Modern Art, 2000, p. 15.

[3] For a detailed discussion of "American-type" painting in Greenberg's work, see the following.
 Clement Greenberg,"'American-Type' Painting," *Greenberg's Critical Essays*, translated by Teruo Fujieda, Keiso Shobo, 2005, pp. 111-140.

[4] Wakiro Sumi, "(No title)," *Bijutsu Techo*, March 1983, p. 65.

[5] Ibid.

[6] Ibid. In addition, the following are the primary texts that cite Sumi's reference to the relationship between Jackson Pollock's paintings and his sculpture.
 Kunio Motoe, "On Veils," *Wakiro Sumi THE VEIL*, catalog, Gallery Tokoro, 1994, n.pag.
 Hisao Matsuura, "Another Veil," *Various Eyes 86: Wakiro Sumi Exhibition Arabesque*, catalog, IBM-Kawasaki City Gallery, 1997, n.pag.
 Toshio Yamanashi, "Undutiful Sculptures: On the New Works," *Today's Artists 11: Wakiro Sumi, Corridor of Light*, catalog, The Museum of Modern Art, Kamakura & Hayama, 2007, pp. 4-7.

[7] Wakiro Sumi, "(No title)," *Chiba Art Now '02 Retracing the Paths*, catalog, Sakura City Museum of Art, 2002, p. 14.

[8] Ibid. Sumi also talks about the "Dance" series, connecting the influence of Laurent de Wilde's reference to Monk's dance to the issue of "gravity" and "levitation" in sculpture. As Sumi also states, Wilde describes Monk's dance as a "kind of dansité" as a combination of the words "danse" and "densité."
 Laurent de Wilde, *Thelonious Monk: Pianism of Silence*, translated by Masashi Mizuno, Ongaku no Tomo Sha, 1997, p. 199.

[9] Op. cit. Note 4, *Bijutsu Techo*, March 1983, p. 65.

[10] Wakiro Sumi, "David Smith's Sculpture: The Great American Sculptor," *Bijutsu Techo*, February 1984, p. 134.

[11] The following are the primary sources that provide the earliest confirmation of the reference to sculpture as "surface."
 Wakiro Sumi, "(No title)," *'86 Exhibition of Current Situation in Gifu, Artists Born after World War II* (Plane section), catalog, The Museum of Fine Arts, Gifu, 1986, p. 22.
 Wakiro Sumi, "(no title)," *Bijutsu Techo*, June 1986, p. 25.
 Wakiro Sumi, "(no title)," *Wakiro Sumi Works 1981-1986*, ARGO Corporation, 1986, n.pag.

[12] Op. cit. Note 11, *Bijutsu Techo*, June 1986, p. 25.

[13] Wakiro Sumi, *"In the Corridor," Today's Artists 11: Wakiro Sumi, Corridor of Light*, catalog, The Museum of Modern Art, Kamakura & Hayama, 2007, p. 14.

[14] Op. cit. Note 6, *Various Eyes 86: Wakiro Sumi Exhibition Arabesque*, n.pag.

[15] The following discussion of Pollock's post-1951 black paintings is an examination of the figurative elements at the lowest level of the canvas, citing Pollock's statement, "I want to veil the image," as a reason for continuing to work after the figurative forms appeared the work is an examination of the underlying surface of the painting.
 Nanako Kakei, "The Production Process of Jackson Pollock's Allover Paintings Through the Analysis of Photographs and Video Images Taken by Hans Namuth," *Bigaku*, Vol. 68, No. 1 (250), 2017, p. 52.

[16] Kunio Motoe recognizes the "bridge" mentioned by Sumi as a reference point in reading "Veil" and says, "For Sumi, a bridge, like a veil, intervenes among heterogeneous things, concealing some things and revealing others, while leading the viewer to a completely new dimension," pointing out the ambivalence of the "veil," which is also referred to in this paper, as "covering/stripping off."
 Op. cit. Note 6, *Wakiro Sumi THE VEIL*, catalog, n.pag.

[17] Op. cit. Note 1, *Nakami no nai ningen*, pp. 148-149.

[18] Ibid., p. 148.

[19] Ibid., pp. 148-149.

[20] Ibid., p. 144.
 In discussing the significance of Sumi's work, one issue that could not be developed in this paper is the influence of and response to the "Mono-ha" school. It is assumed that Sumi was influenced by many of them and became conscious of his self-differentiation from their trends in the early stage of his career. Sumi's criticism of the Mono-ha was directed toward Lee's theory, which emphasized the creation of relationships through the combination of different materials, such as stone and iron or stone and glass. In other words, this proves that Sumi correctly recognized and practiced poiesis as the "separation-joining" (disjunction) force referred to in this paper. For a representative reference to Mono-ha by Sumi, see below. In writing this report, we were given the opportunity to speak with Sumi about his work to date, and we would like to thank him for his valuable comments on his work. We would like to express our gratitude to him for this opportunity.
 Wakiro Sumi, "Art Alternative," *Aida*, No. 35, Association for Art and Museums, 1998, pp. 14-16.

[21] Op. cit. Note 1, *Nakami no nai ningen*, p. 102.

Keisuke Mori: Curator, Chiba City Museum of Art . Born 1978 in Mie Prefecture, Japan. MFA, Musashino Art University, Graduate School of Art and Design. After many years as a curator at Vangi Sculpture Garden Museum, he is currently a curator at Chiba City Museum of Art, specializing in Japanese modern and contemporary art and art criticism. In parallel with his research on art trends in the 1960s and '70s, with a particular focus on Jiro Takamatsu and Mono-ha, he organizes exhibitions by contemporary artists concerned with painting and sculpture. Recent exhibitions include: "Tatsuo Miyajima: Chronicle 1995-2020" (2020) and "Kiyomizu Kyubey/Rokubey VII Retrospective" (2022, both at Chiba City Museum of Art).

EARLY WORKS 1970-

No Name Age

日本の現代美術シーンでは戦後のアヴァンギャルドムーブメントがひと段落して70年代に入り、もの派を中心とした新しい造形運動が東京を中心に広まった後の時代です。局所的にみると東京の銀座から神田に至る中央通り沿いに点在したギャラリー街が現場でした。それらのギャラリー巡りの終着点が神田の田村画廊やときわ画廊でしたが、そこでは評論家や編集者に有名作家から学生までもが入り混じってテーブルを囲み、アートだけでなくさまざまな話題で盛りあがっていたのを思い出します。ギャラリーが閉まる時間になると残ったものたちは神田の葡萄舎や新宿のゴールデン街に流れて行ったものでした。その時代を生きた作家たちを No Name Age と名づけてみます。

美大の学生による美共闘やアルテ・ポーベラなどムーブメントの影響は受けつつも、この時代は個々の作家が絵画、彫刻、抽象、インスタレーション、パフォーマンスといったテーマに向きあった時代だったと思います。それぞれの探求は大きな流れや運動に結びつくことはなく、突出した名称も与えられぬまま80年代のニューイメージペインティングやポップ化したアートカルチャーに地滑り的に押し流され忘れられたまま現在に至っています。

No Name Age

Following a subsiding of the Japanese postwar avant-garde movement, the 1970s contemporary art scene saw a new figurative movement centered on the Mono-ha, spreading wide with a focus on Tokyo. It was a very localized gallery scene, scattered along the Chuo-dōri district from Ginza to Kanda. The final stop of these gallery tours were the Tamura Gallery and Tokiwa Gallery in Kanda, where critics, editors, renowned artists, and even students would gather around the table to discuss a wide variety of topics including art. Around closing time, those who stayed behind would drift off to Kanda's Budo-ya or Shinjuku's Golden Gai. Those artists who lived in that era shall be known as the No Name Age.

While influenced by movements such as the Bikyōto and Arte Povera, each artist engaged with contemporary themes through painting, sculpture, abstraction, installation, and performance. These explorations did not link to any significant trend or movement. Without any significant identification, they have swept away in the landslide of the 1980s New Image painting and Pop Art culture and have remained forgotten to this day.

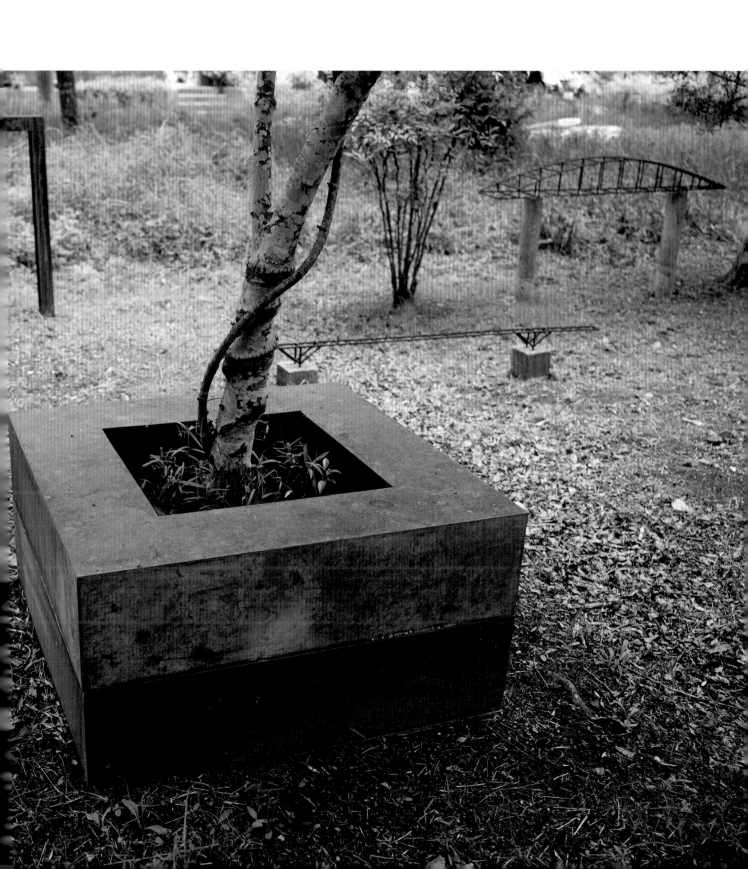

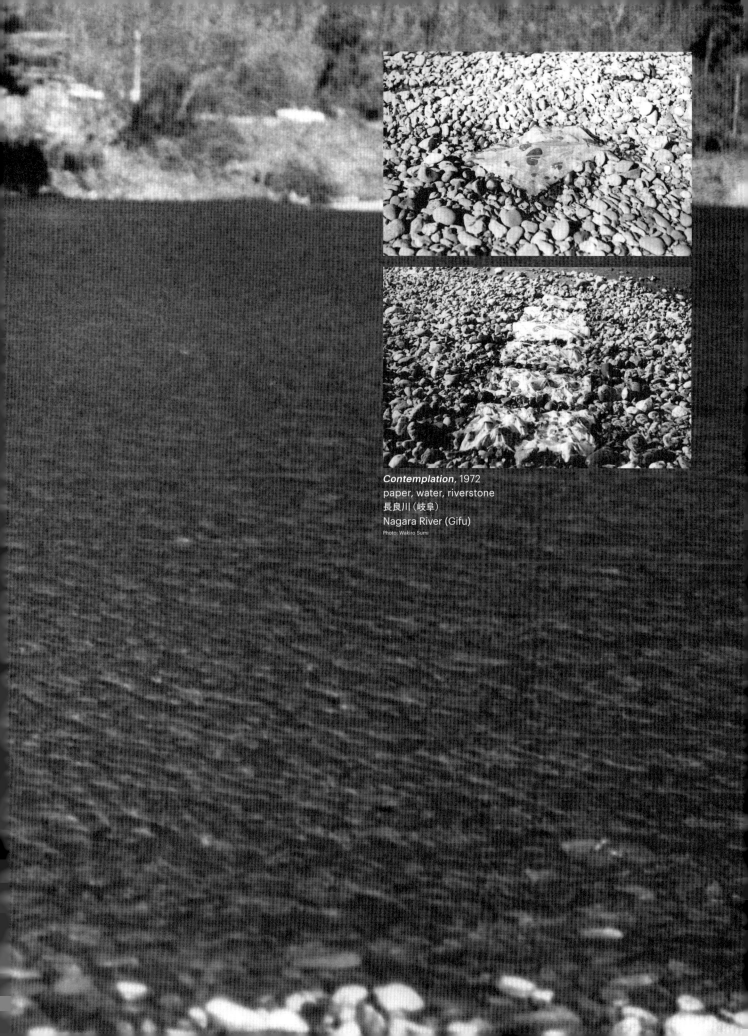

Contemplation, 1972
paper, water, riverstone
長良川 (岐阜)
Nagara River (Gifu)
Photo: Wakiro Sumi

Exhibition Invitation, 1970

タイトル不明、1970年
Title Unknown, 1970
mixed media on wood panel
「パラレル展」河原町ギャラリー（京都）
"Parallel Exhibition" Kawaramachi Gallery (Kyoto)

Early Days

岐阜の美術科のある高校を卒業し、京都、名古屋、東京と拠点を変えつつ1971年横浜のBゼミに入所するまでの時代に出会ったり、影響を受けた人々を思いつくままに挙げてみます。

「アウトサイダー」のコリン・ウイルソン、「大洪水」のル・クレジオ、寺山修司、吉田一穂、ジョン・コルトレーン、チャーリー・ミンガス、アルバート・アイラー、セシル・テイラー、そして山下洋輔、阿部薫、藤圭子、大橋巨泉に笑福亭仁鶴、植草甚一。カール・リヒター、グレン・グールド、武満徹、舞踏の土方巽、笠井叡、ルドルフ・ヌレエフ、ザ・ビートルズ、ビーチ・ボーイズ、ミュージカル「ヘアー」、ジャン＝リュック・ゴダール、ミケランジェロ・アントニオーニ、0次元の岩田信一、シアター36の丹羽政孝、ヨシダミノル…

当時の20歳としてはごく普通のごちゃ混ぜのサブカルチャー体験だったと思います。ただバロック音楽からジャズ、現代音楽までを同時に受け容れた経験は今から見ても特別感がありますが、これは一重に岐阜の高校教師の影響でした。さまざまな同時代の刺激のアッサンブラージュとして自己形成されてきたことが思い起こされます。

Early Days

The following is a partial list of people I have encountered or been influenced by since graduating from an art department in a Gifu high school and moving around from Kyoto, Nagoya, and to Tokyo before joining the B-semi in Yokohama in 1971. Colin Wilson, author of *The Outsider*, Le Clézio, author of *Le Déluge (The Flood)*, Shuji Terayama, Issui Yoshida, John Coltrane, Charlie Mingus, Albert Ayler, Cecil Taylor, Yōsuke Yamashita, Kaoru Abe, Keiko Fuji, Kyosen Ōhashi, Shofukutei Nikaku, Jinichi Uekusa. Karl Richter, Glenn Gould, Tōru Takemitsu, Butoh performer Tatsumi Hijikata, Akira Kasai, Rudolf Nureyev, The Beatles, The Beach Boys, Hair (the musical), Jean-Luc Godard, Michelangelo Antonioni, Shinichi Iwata of Zero Jigen (Zero Dimensions), Masataka Niwa of Theater 36, Minoru Yoshida, For a 20-year-old at the time, it was a typical mishmash of subcultural experiences. However, the experience of simultaneously being exposed to everything from baroque to jazz and contemporary music had a rather exceptional feel even in retrospect, and this was due in no small part to the influence of my high school teacher in Gifu.

ワタシハ 京都市美術館 ノ 中庭 ニ
オイテ、ニンイノ 正方形 ニ 大地 ヲ 二ヶ所
切リトリ、ソレヲ 美術館 二階
寛 号室 ノ 床 ニ 移 シカエマシタ。
　　・・・　　91.3.3.
　　　　　　W. Sumi

京都市美術館 平面図

美術館平面図　美術館平面図
1F　2F

Production scene, 1971
「京都アンデパンダン展」京都市美術館（京都）
"Kyoto Independent Exhibition" Kyoto City
Museum of Art (Kyoto)

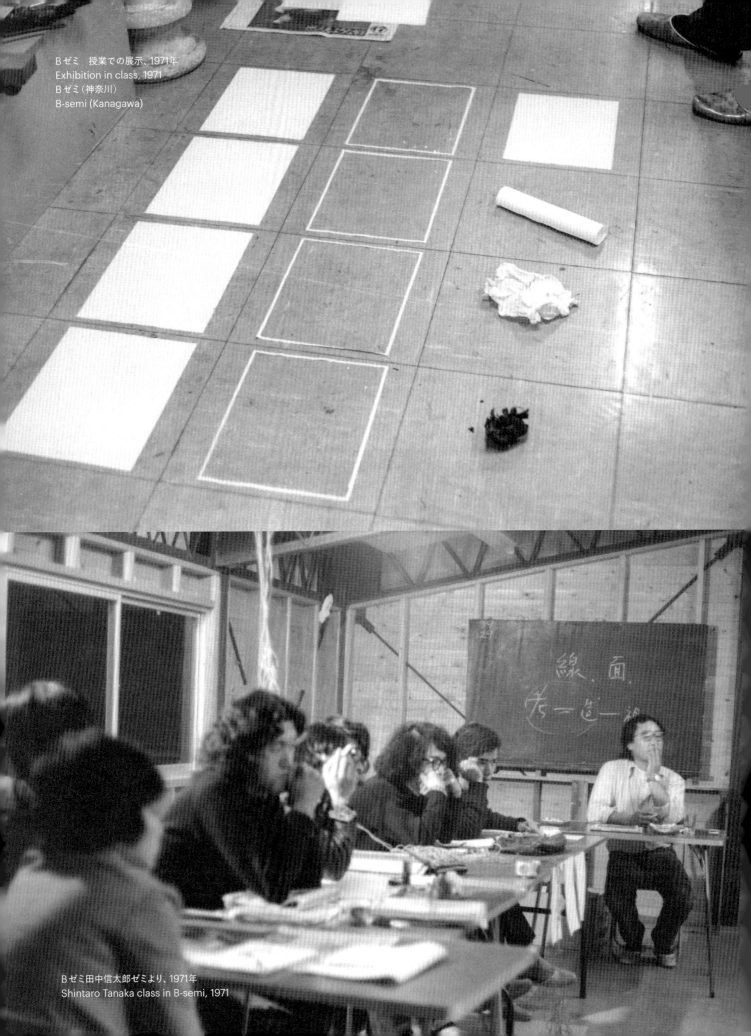

Bゼミ　授業での展示、1971年
Exhibition in class, 1971
Bゼミ（神奈川）
B-semi (Kanagawa)

Bゼミ田中信太郎ゼミより、1971年
Shintaro Tanaka class in B-semi, 1971

Bゼミ

Bゼミは私が20代で美術家として基礎ができあがるときを過ごした場所です。小林昭夫氏が自宅の屋根の上に乗っけてつくった粗末な教場には歳上の講師たち ── 関根伸夫、李禹煥、原口典之、田中信太郎、藤枝晃雄、等々が日替わりで登場してきて新鮮な出会いの連続でした。彼らもまだ若く貧乏で生々しく生きていた時代です。ゼミでの授業よりも日常的な会話や居酒屋での立ち振るまい、そしてそれぞれの作品制作現場でのアシスタント体験から強い影響を受けたと思います。そこでは理論より実践を大切にすること、あるいは実践が理論を連れてくることを実感したのでした。

藤枝さんからは抽象表現主義〜カラーフィールドペインティング〜ミニマルアートへの流れを紹介されてアメリカを中心とした現代アートを再認識することとなり、その後のバーネットニューマン研究会（須賀昭初、中村功、中上清らと）へと導いていただきました。

B-semi

B-semi is the place where I grew up as an artist as I was building my foundation in my twenties. Akio Kobayashi had built a modest seminar room on the roof of his house, where senior instructors such as Nobuo Sekine, Lee Ufan, Noriyuki Haraguchi, Shintaro Tanaka, Teruo Fujieda, and others instructed every day, making way for a series of fresh new encounters. These were the days when they, too, were young, in poverty, and living precariously. I think I was strongly influenced by the everyday conversation, mannerisms at the izakaya, and the assistant experiences at each production site, even more so than in the seminar classes. B-semi is where I realized that practice is valued more than theory, or that practice brings theory.

Fujieda taught us how Abstract Expressionism transitioned to Color Field Painting and Minimal Art, which helped us reacquaint with American contemporary art, and later led us to the Barnett Newman Study Group (with Shōhatsu Suga, Isao Nakamura, Kiyoshi Nakagami, and others).

Production scene, 1972-73
「Bゼミ展」横浜市民ギャラリー（神奈川）
"B-semi Exhibition" Yokohama Civic Art Gallery (Kanagawa)

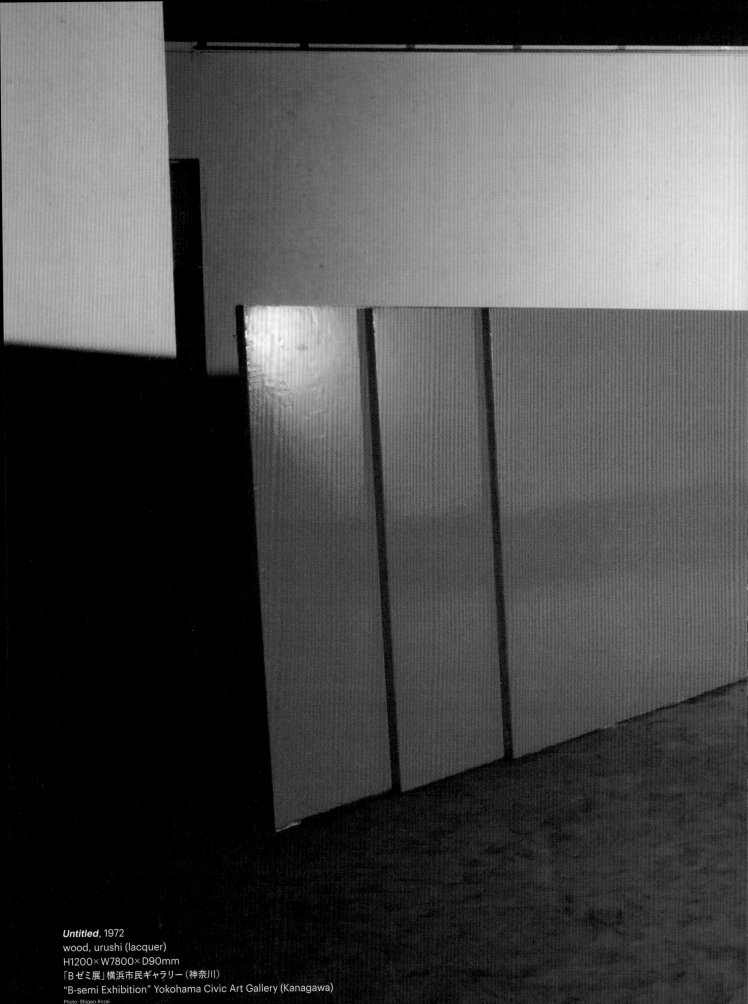

Untitled, 1972
wood, urushi (lacquer)
H1200×W7800×D90mm
「Bゼミ展」横浜市民ギャラリー（神奈川）
"B-semi Exhibition" Yokohama Civic Art Gallery (Kanagawa)
Photo: Shigeo Anzai

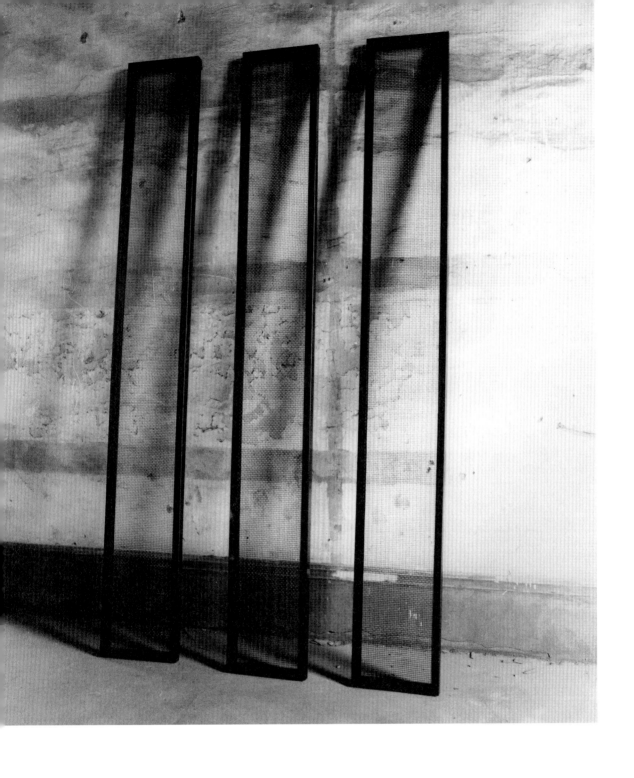

Contemplation, 1972
iron, wire mesh, paint
H2270× W300× D40mm each

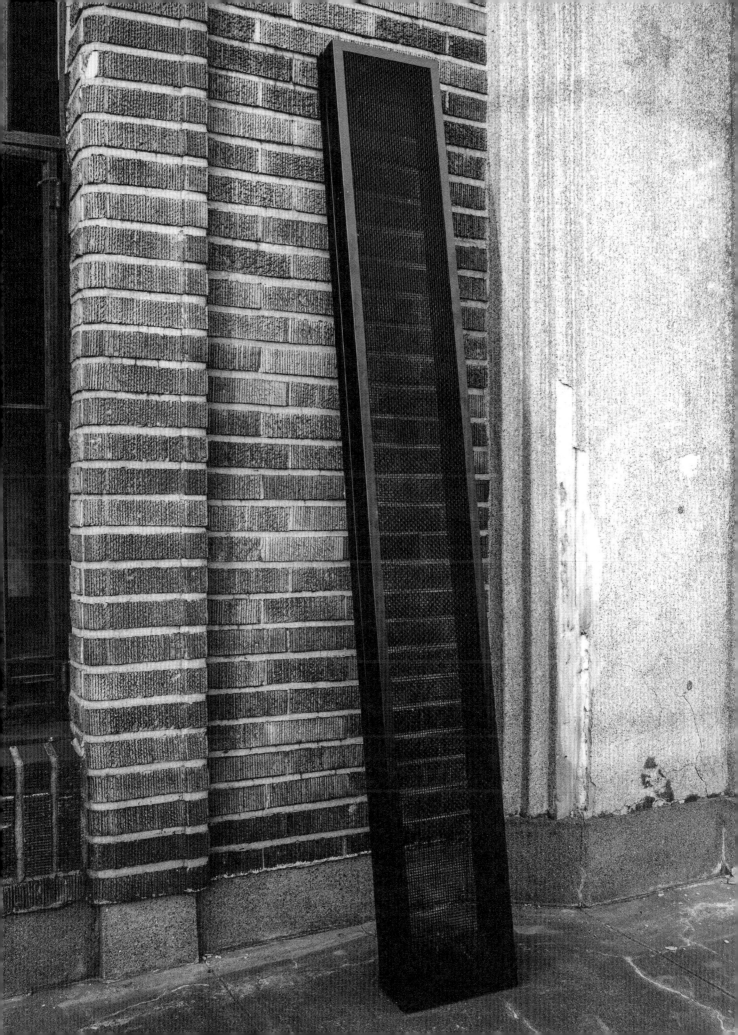

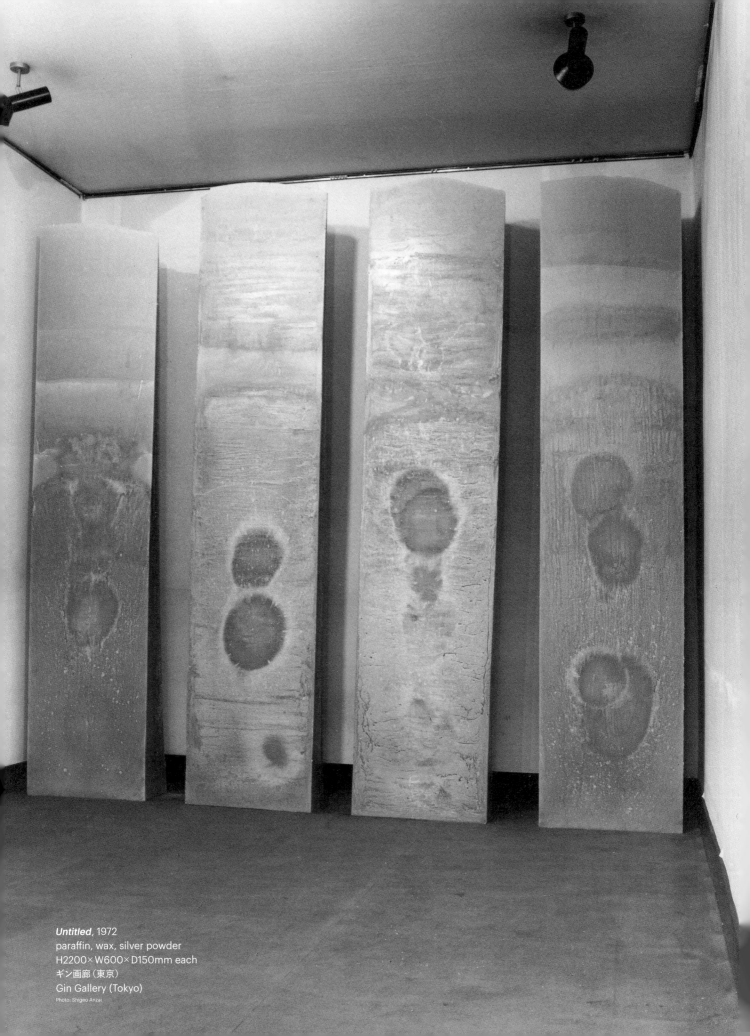

Untitled, 1972
paraffin, wax, silver powder
H2200×W600×D150mm each
ギン画廊（東京）
Gin Gallery (Tokyo)
Photo: Shigeo Anzai

三木富雄

その後、関根伸夫と田中信太郎両氏の紹介で南画廊での個展を控えていた三木富雄のアシスタントをすることになるのですが、ここでも強烈な影響を受けることになりました。みなが言うように三木は天才でした。まともな美術教育など受けたことは無く、先生などもいなかったと思います。今思えば当時の彼は「いかに耳の制作をやめるか」という自問の時期に入っていたと思われますが、僕は毎日スタジオに通って彼の両手の間にある粘土の塊から次々と耳が生まれ出てくるのに立会い、それを石膏取りして鋳物屋に運びアルミの塊となった耳を又磨くといった作業を延々と続けたのでした。哲学も美学も超えたそれはまるでモルグのようなスタジオに鈍く光って横たわっていて、その横で三木はブツブツとダヴィンチの解剖図と会話しているのです。

そんな人間の側にいて流行りのコンセプチュアルアートやニューアートなど目に入るわけがありません。さあ、僕はなにをすればよいのでしょうか。私のギン画廊での初個展を見にきて「スミクン、チャント作ッタラ見ニクルヨ」とだけ言って帰った彼はその数年後に亡くなってしまいました。

Tomio Miki

Both Nobuo Sekine and Shintaro Tanaka introduced me to Tomio Miki, who was preparing for a solo exhibition at Minami Gallery. I subsequently became his assistant, which also had a powerful influence on me.

As everyone claims, Miki was a genius. Yet, I don't think he ever had any formal art education or instructor. Looking back, I believe he was at a period during his career when he questioned how to conclude his ear production. I was at his studio everyday to witness the ears emerging one after another from the lump of clay between his hands. I would then take plaster molds of them and deliver them to the foundry for aluminum casting and then polish all over those ears in a never-ending operation. These works, transcending philosophy and aesthetics, lay there gleaming dully in Miki's morgue-like studio while he muttered and babbled to Da Vinci's anatomical drawings.

With such a person at my side, there was no way I could keep up with current trends in conceptual art or new art. So, what could I do? When he came to see my first solo exhibition at Gin Gallery, he simply said, "Sumi, I'll come see your work when it's finished," and went home. Unfortunately, he passed away a few years after that.

三木富雄個展オープニング、奥さま真弓さんと、南画廊（東京）にて、1972年
With his partner, Mayumi, at the opening of Tomio Miki's solo exhibition, Minami Gallery (Tokyo), 1972
Photo: Shigeo Anzai

Untitled, 1972
wax, aluminum
H150× W4000× D150mm
ギン画廊（東京）
Gin Gallery (Tokyo)
Photo: Shigeo Anzai

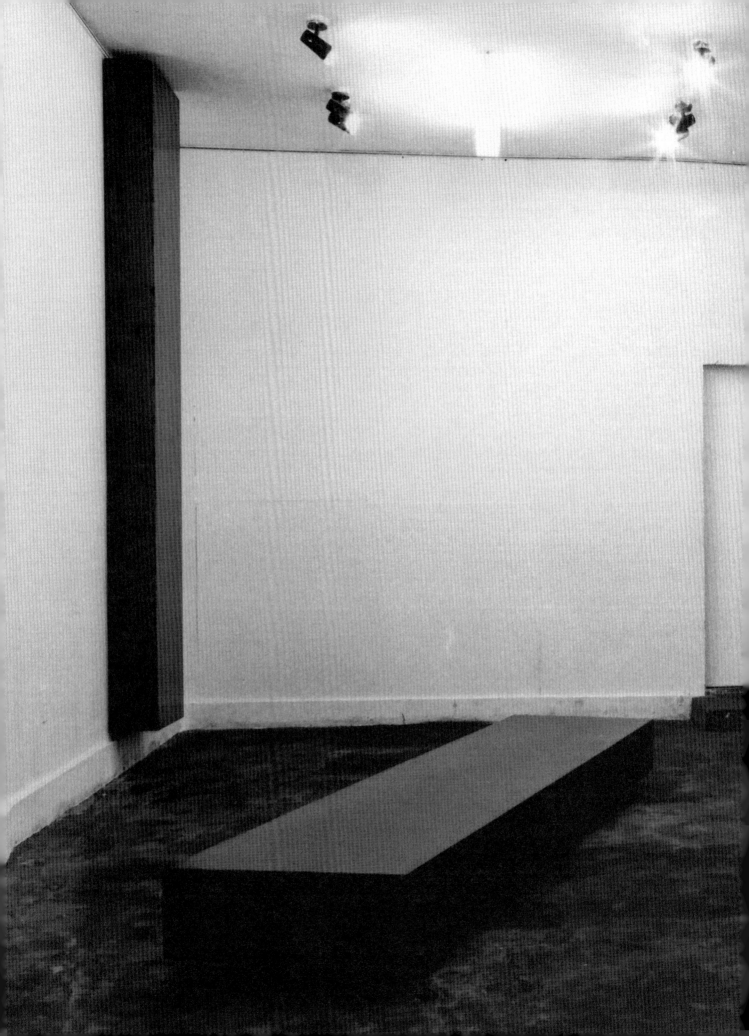

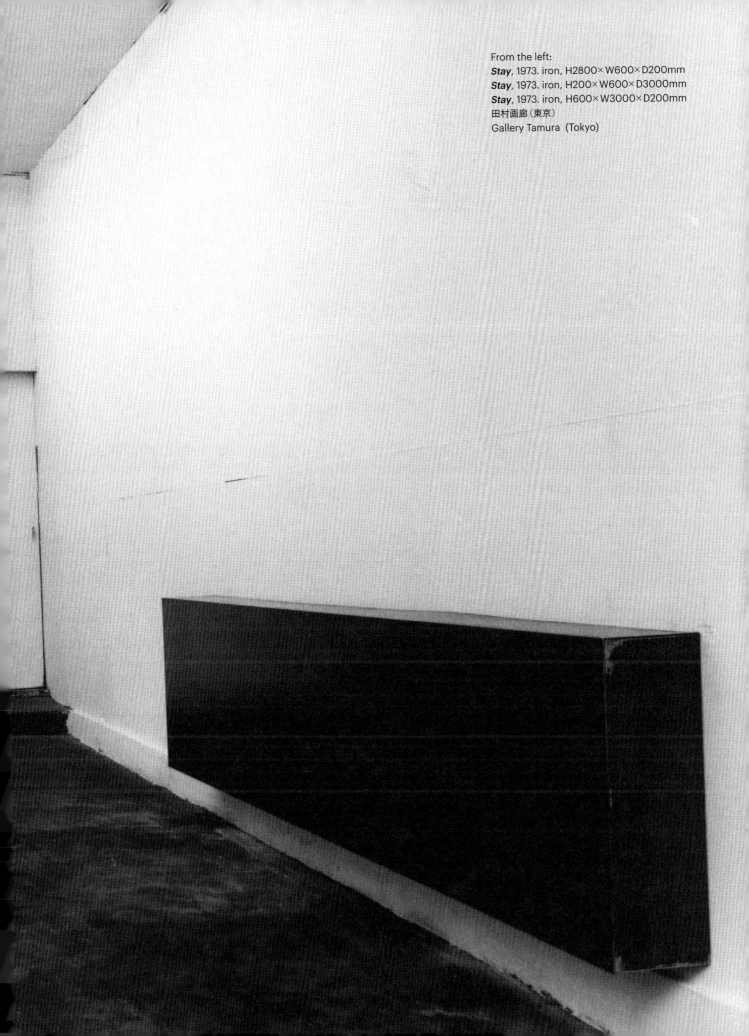

From the left:
Stay, 1973. iron, H2800×W600×D200mm
Stay, 1973. iron, H200×W600×D3000mm
Stay, 1973. iron, H600×W3000×D200mm
田村画廊（東京）
Gallery Tamura（Tokyo）

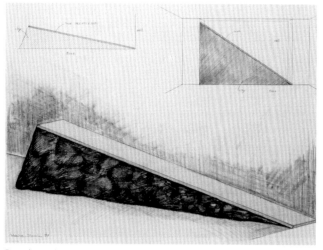

Drawing, 1973-74
colored pencil on paper

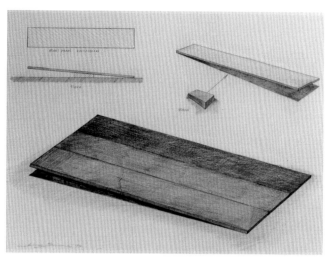

Drawing, 1973-74
colored pencil on paper

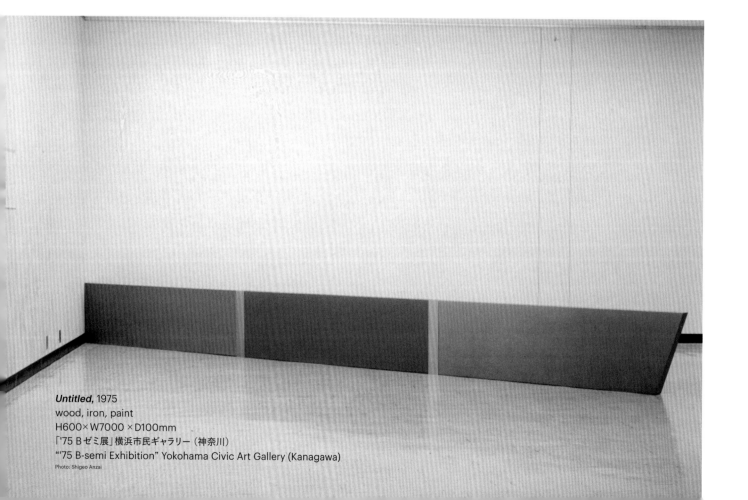

Untitled, 1975
wood, iron, paint
H600×W7000 ×D100mm
「'75 B ゼミ展」横浜市民ギャラリー（神奈川）
"'75 B-semi Exhibition" Yokohama Civic Art Gallery (Kanagawa)
Photo: Shigeo Anzai

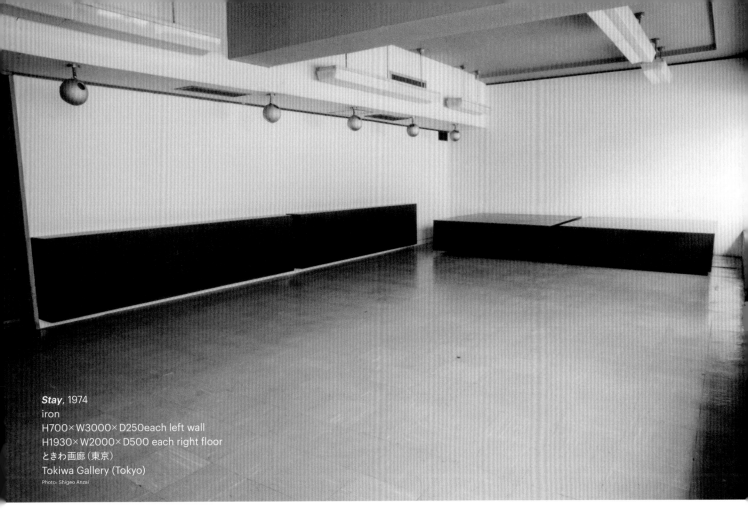

Stay, 1974
iron
H700×W3000×D250each left wall
H1930×W2000×D500 each right floor
ときわ画廊（東京）
Tokiwa Gallery (Tokyo)
Photo: Shigeo Anzai

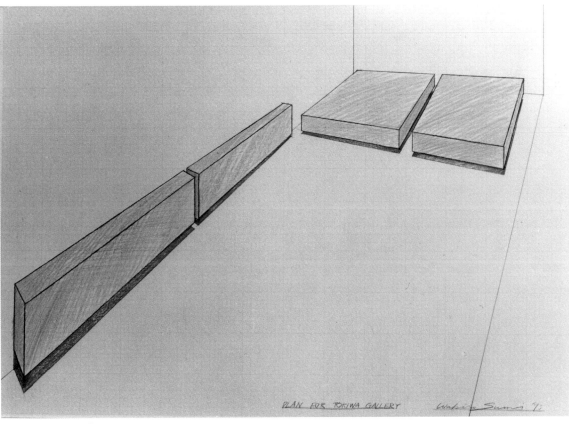

Plan for Tokiwa Gallery, 1973
colored pencil on paper

GALLERY TAMURA

田村画廊

安斎重男と、田村画廊（東京）にて、1973年
With Shigeo Anzai at Gallery Tamura (Tokyo), 1973

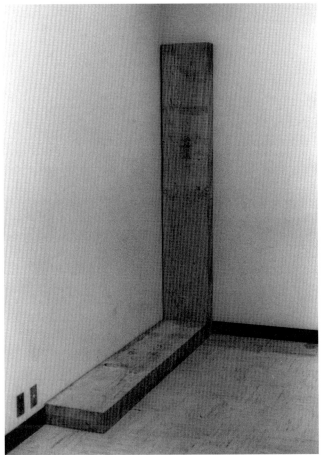

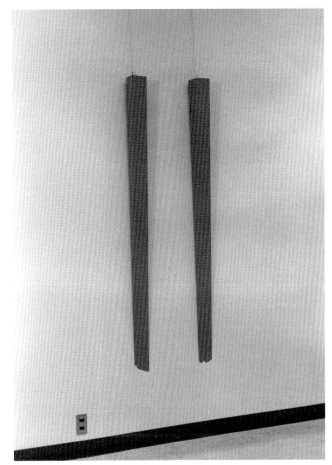

Corner Wood Plan, 1975
wood
H2800×W400×D2550mm

Untitled, 1975
wood, urushi (lacquer)
H1500×W150×D150mm

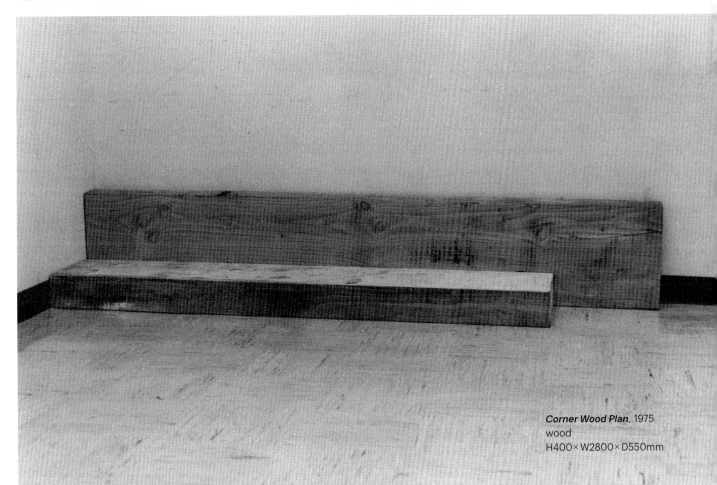

Corner Wood Plan, 1975
wood
H400×W2800×D550mm

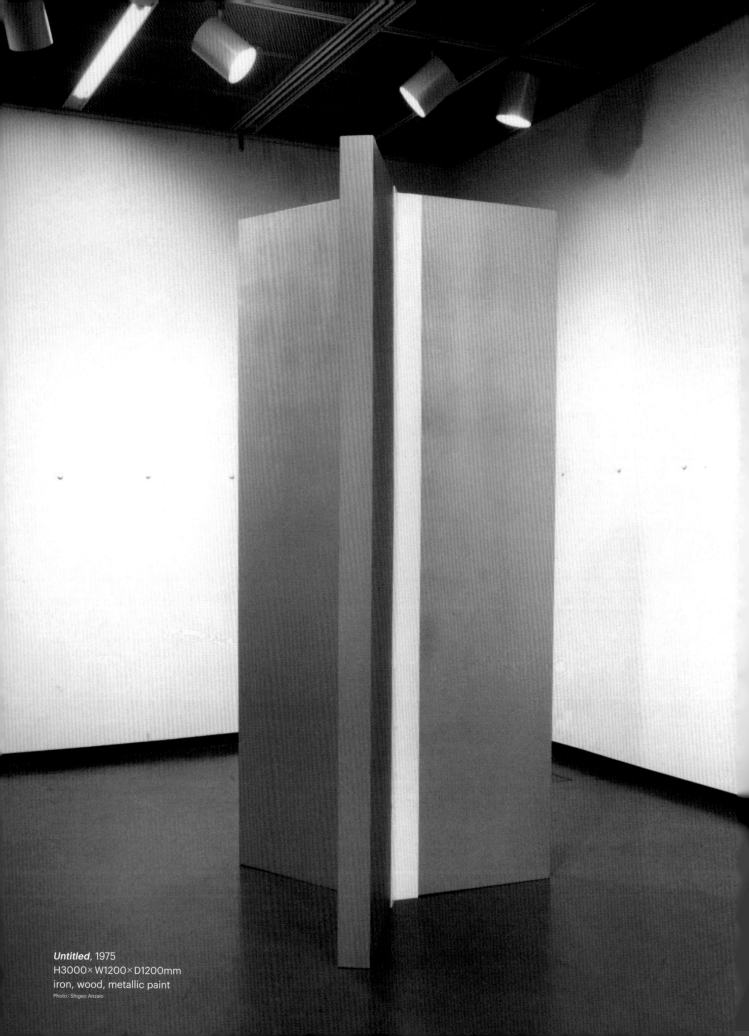

Untitled, 1975
H3000×W1200×D1200mm
iron, wood, metallic paint
Photo : Shigeo Anzaio

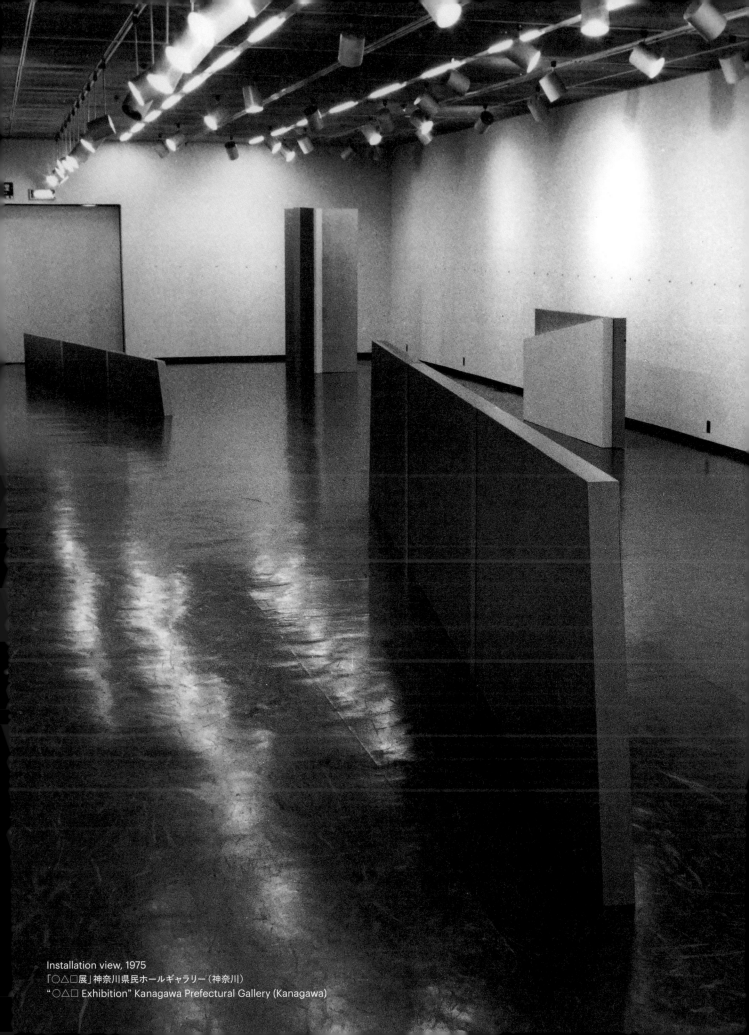

Installation view, 1975
「○△□展」神奈川県民ホールギャラリー（神奈川）
"○△□ Exhibition" Kanagawa Prefectural Gallery (Kanagawa)

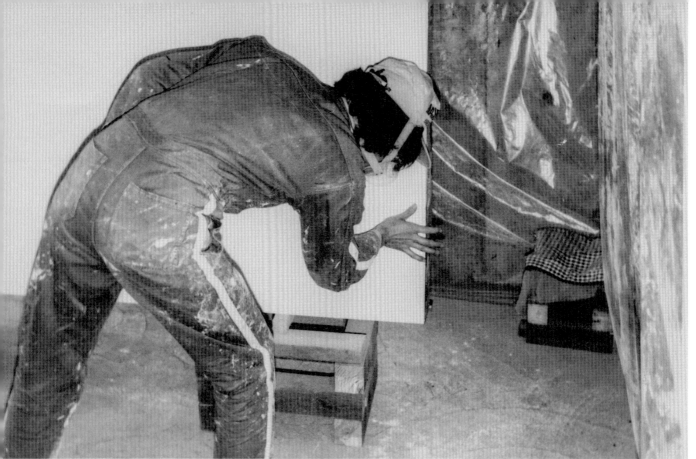

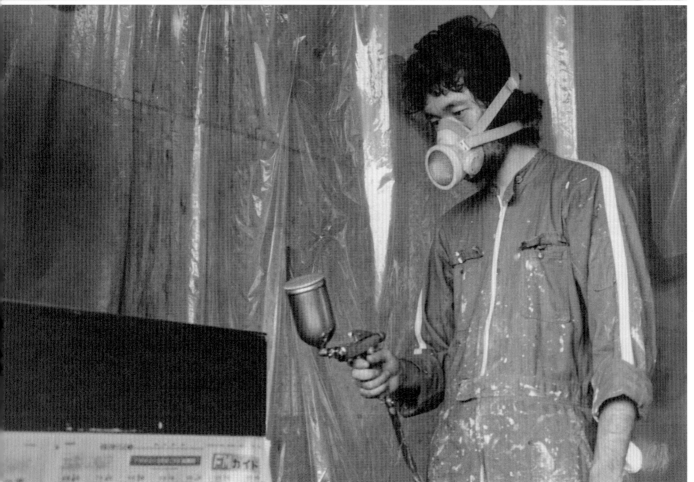

木のパネル作品、塗装制作風景、1975年
Wood panel, paint process, 1975

花園町の Studio SUMI（千葉）にて、1975年
At Studio SUMI in Hanazono-cho (Chiba), 1975

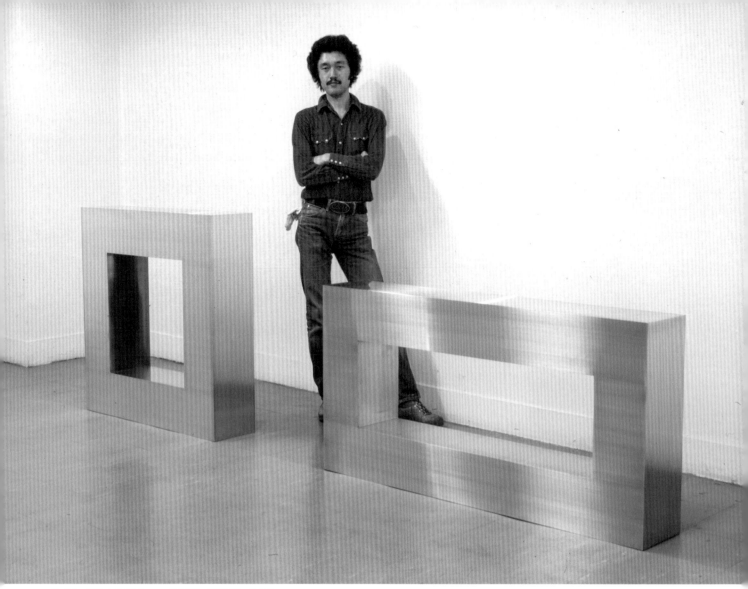

Untitled #B-1, 1977. brass, H1000×W1000×D250mm
Untitled #B-3, 1977. brass, H750×W1500×D250mm
村松画廊（東京）
Muramatsu Gallery (Tokyo)

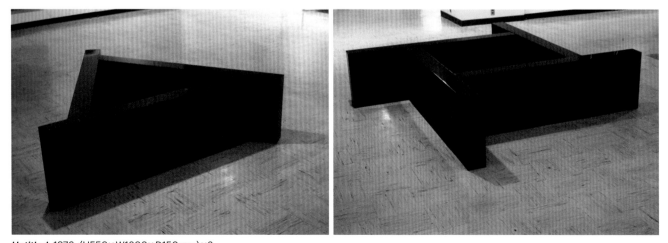

Untitled, 1976. (H550×W1800×D150mm)×3
Untitled, 1976. (H550×W1800×D150mm)×4
「第12回今日の作家展：今日の空間展」横浜市民ギャラリー（神奈川）
"12th Annual Today's Artist Exhibition: Today's Space Exhibition" Yokohama Civic Art Gallery (Kanagawa)

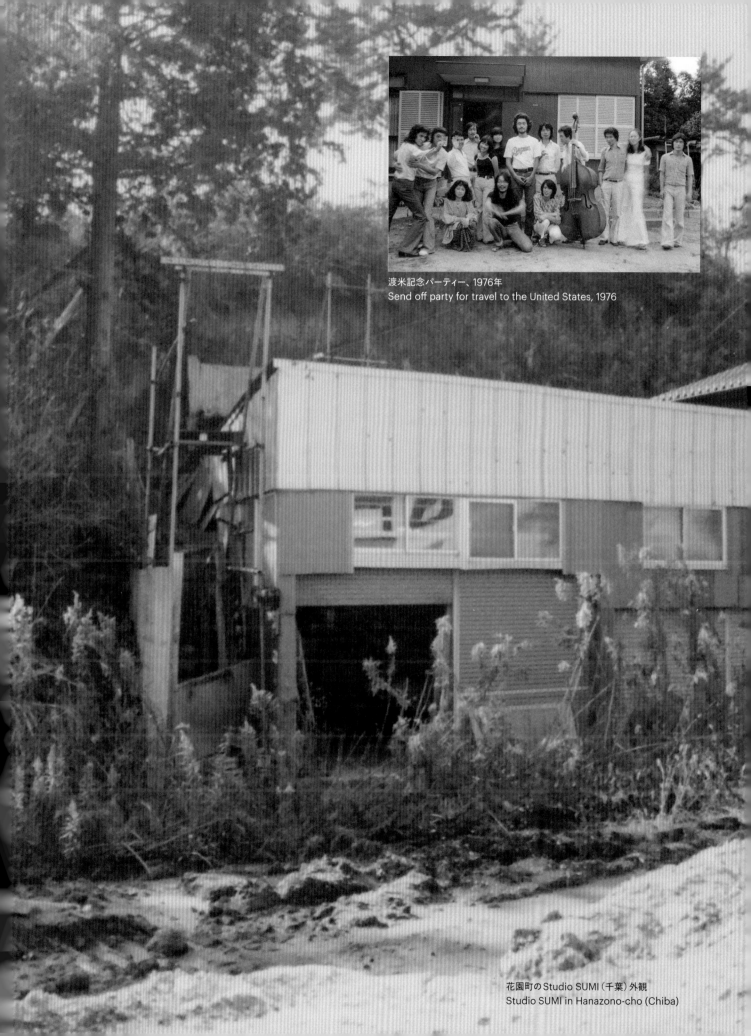

渡米記念パーティー、1976年
Send off party for travel to the United States, 1976

花園町のStudio SUMI（千葉）外観
Studio SUMI in Hanazono-cho (Chiba)

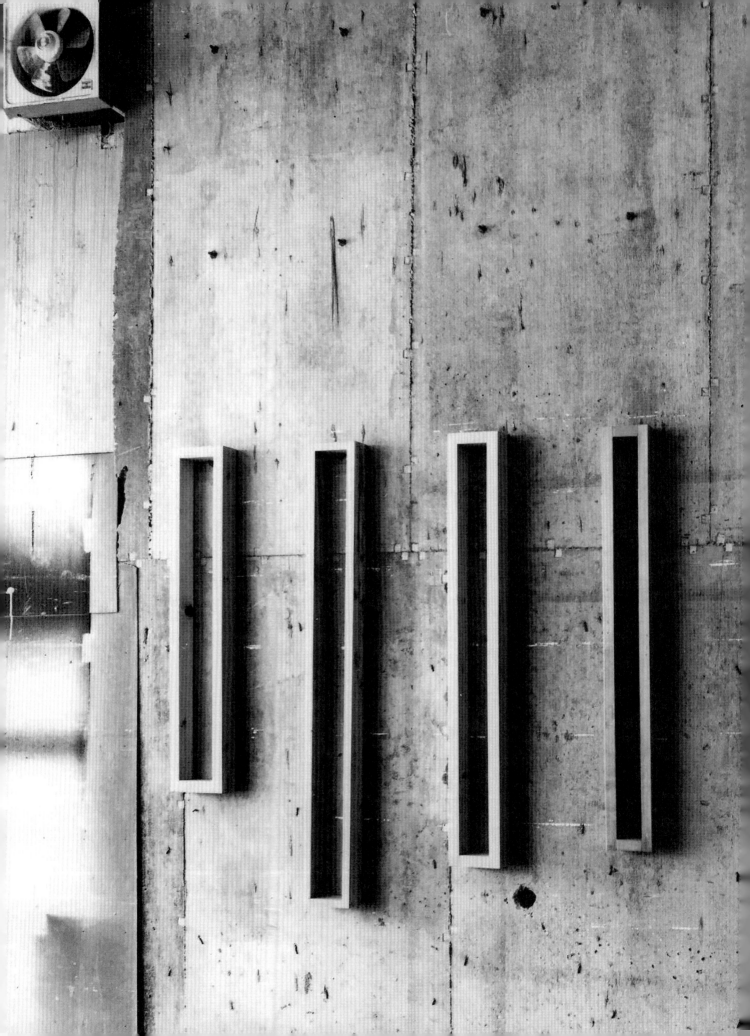

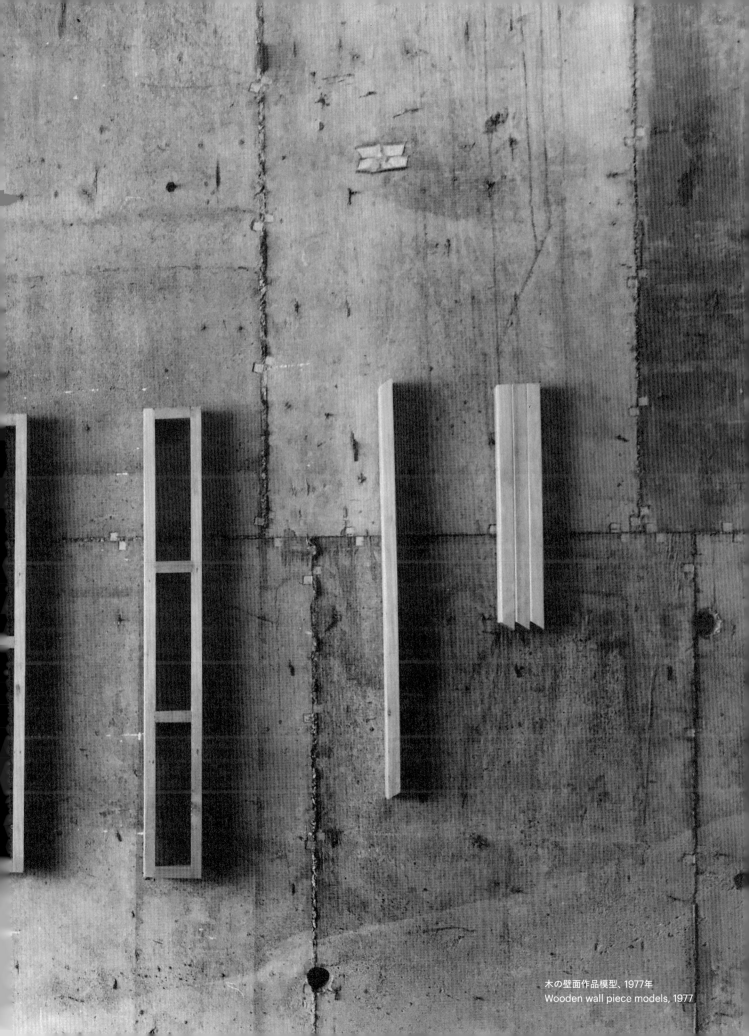

木の壁面作品模型、1977年
Wooden wall piece models, 1977

田中信太郎

田中信太郎さんは一番親密に長くつきあってくれたアーティストの先輩です。

Bゼミ、祖師ケ谷の小屋、ニューヨークのロフト、日立の山のアトリエ、野毛・東神奈川・赤羽・谷中… さまざまな場面が思い出されます。そこではモノの触り方、物の表面の手触りの変化、職人の凄さ、酒の飲み方、世間との距離の取り方等々、彼からすべてを学んだと思います。そんな田中さんの言う「いいね」とはいかに馬鹿げているか、いかに無意味か、いかに無用か、といった一貫した美学があったように思います。つまりいかに美しいかと言う一点に行き着くのではないでしょうか。

晩年彼は多くのアフォリズムを書き留めて残し、他人に送ったり手渡したりしていました。イメージの人 ─ 田中信太郎は作品をつくる前にイメージの世界で細かなディティールまで作品を一度完成させるのです。その後実際の作業で削ぎ落としたり、つけ加えたり、色彩を変化させたりして制作するのですが、その作業が体調不良等で叶わなくなったときにも、アフォリズムだけで視覚的作品と同等に作品が完成していたのではないでしょうか。私の机の壁にはブルーのペンで書かれた手書きの紙片が止められていて、そこにはサインと共にこう書かれています。─ 蛍の造形　風船のテーブル　音だけのためにつくられた音楽 ─

Shintaro Tanaka

Shintaro Tanaka is the senpai artist I most intimately associated with for the longest time. B-semi, a cottage in Soshigaya, a loft in New York, a studio in the Hitachi mountains, Noge, Higashi-Kanagawa, Akabane, Yanaka... I remember so many of those scenes. There, I learned everything from him, including how to handle things, how surfaces of objects transform by touch, the greatness of craftsmanship, methods of alcohol consumption, and how to maintain a distance from the world. In his words, "nice" equated to the ridiculous, meaningless, and useless, of which he held a consistently aesthetic point of view. In short, it all boils down to: how beautiful it is.

During his later years, he wrote down many of his aphorisms and kept them to send or hand out to others. A person of images, Shintaro Tanaka first completed his works down to the smallest detail in his world of images before he produced the actual artwork. He would carry on with the fabrication by shaving off, adding to, and/or changing colors throughout the process. Even when his health prevented him from working this way, his aphorisms alone could pass as complete as his visual work. Above my desk, a piece of paper pinned to the wall, handwritten in blue pen, along with Tanaka's signature, reads. -firefly forms, balloon tables, music created just for sounds-

篠原有司男宅にて（ニューヨーク）、1976年
右から篠原夫婦、鷲見、田中信太郎とその友人
At Ushio Shinohara's house (New York, USA), 1976
From the right, Mrs.and Mr.Shinohara, Sumi, and Shintaro Tanaka and friend of artist

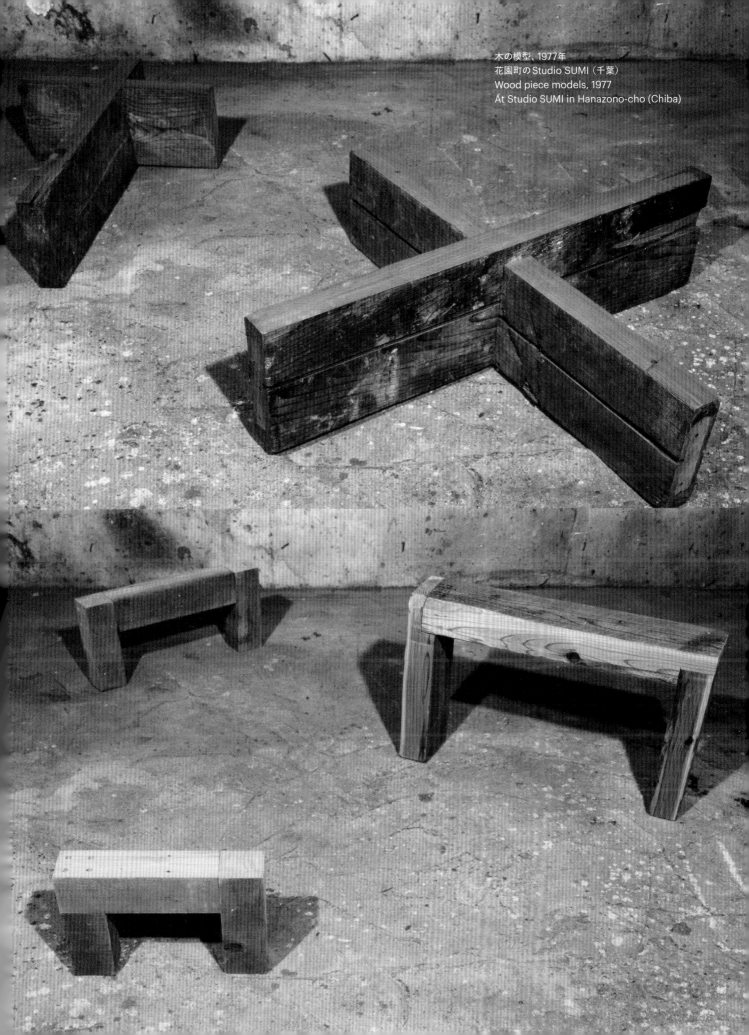

木の模型、1977年
花園町の Studio SUMI（千葉）
Wood piece models, 1977
At Studio SUMI in Hanazono-cho (Chiba)

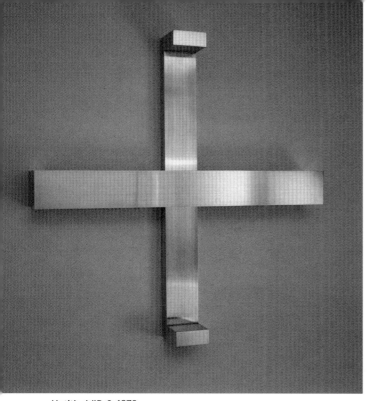

Untitled #D-2, 1978
H1050× W1050× D120mm

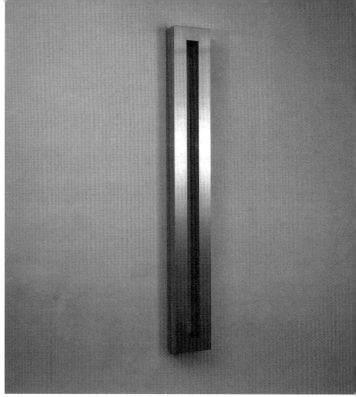

Untitled #C-2, 1978
H1200× W150× D75mm

Bottom: ***Untitled # F-3***, 1979. iron, H250× W1200× D1200mm
Above: ***Untitled # F-4***, 1979. iron, H300× W1800× D900mm

Untitled #E-2, 1978. galvanized iron, H500× W1500× D1500mm

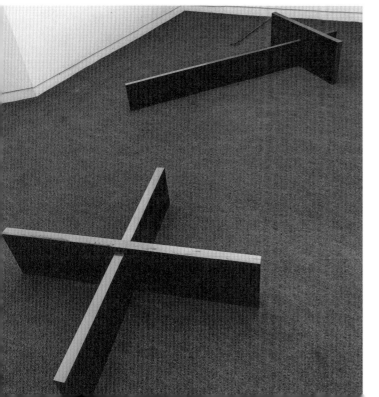

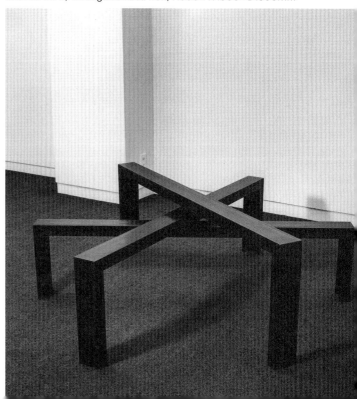

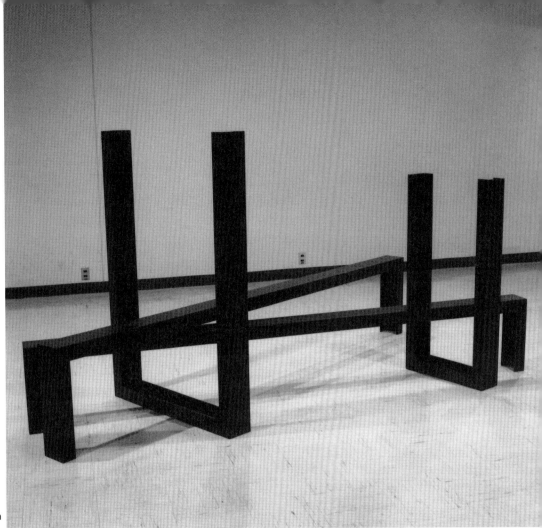

Untitled #E-4, 1979
painted iron
H1400×W3000×D3000mm
Photo: Tadasu Yamamoto

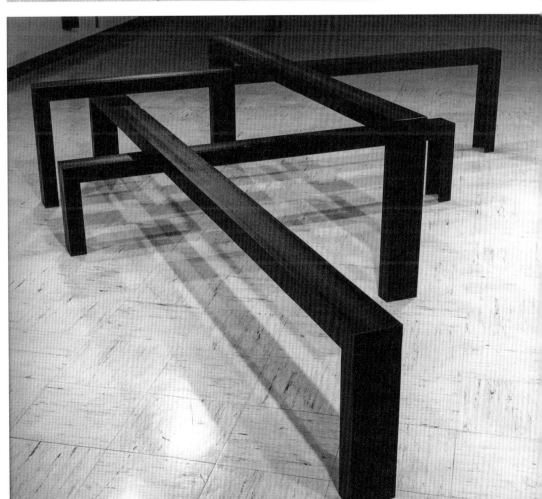

Untitled #E-3, 1979
painted iron
H645×W3000×D2500mm
Photo: Tadasu Yamamoto

BRONZE
WORKS
1980-

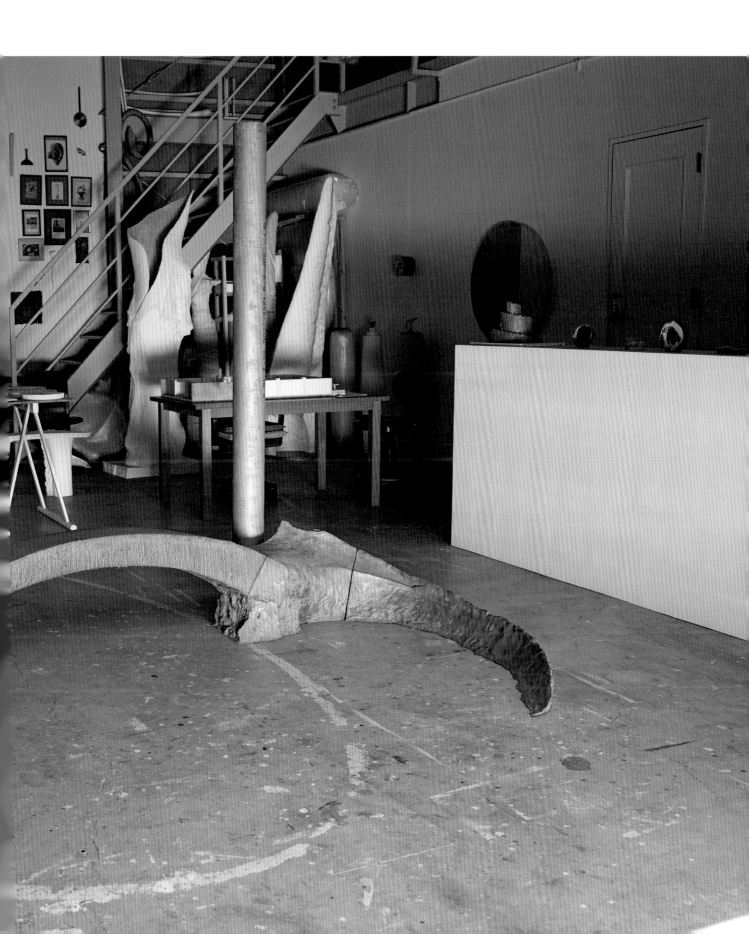

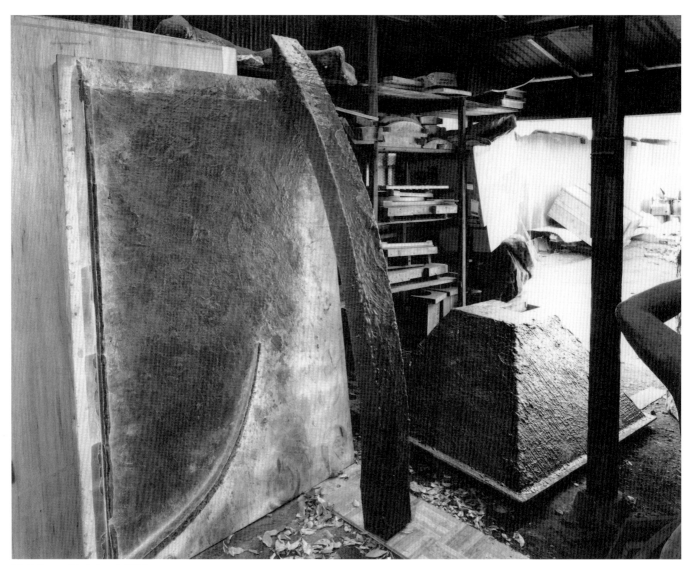

Stolichnaya (Prototype), 1984

Photo:Tadasu Yamamoto

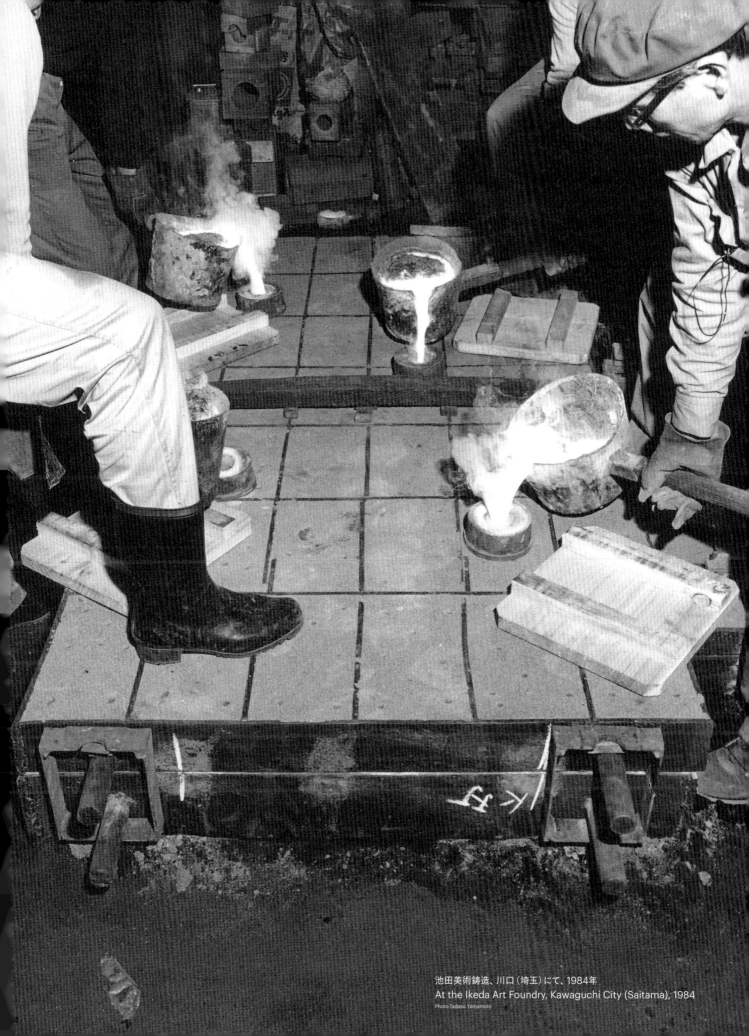

池田美術鋳造、川口（埼玉）にて、1984年
At the Ikeda Art Foundry, Kawaguchi City (Saitama), 1984
Photo:Tadasu Yamamoto

ブロンズワーク・ペインティングスカルプチャー

固体だったパラフィンワックスは熱を加えると瞬く間に透明な液体になります。その状態がペインティングスカルプチャー制作の時間です。気温やパラフィンワックスの融点選定によって差異は有るものの手早い作業が求められます。左手に溶けたパラフィンワックスの容器を持ち、右手に刷毛を持って対象物に塗り重ねていきます。しばらくするとパラフィンワックスは表面から幕を張り固まり始めます。その作業を繰り返していくと、ある厚みを持った半透明の継ぎ目のない幕の重なり — ヴェールが生まれます。当然それは重力に逆らうことなく垂れ落ちながら固まっていくので氷柱のような、あるいは溶けたチーズのような表面を持つこととなり、ある面積を持つとパラフィンワックスの世界からかけ離れた形容しがたい立体物となるのです。

このペインティングスカルプチャーの表面を型に取って肉厚をつくり、そこに金属を流し込むと、いわゆるロストワックス技法によって硬くて重いブロンズやアルミニウムの表面を持つ彫刻世界が生まれます。半透明のパラフィンワックスの造形から鈍く光る表面を持つブロンズやアルミニウム彫刻との落差、その振り幅の大きさに私は魅了されたと言ってもよいでしょう。どこまでも続く表面を持つ空間的インスタレーションと刷毛で塗られた表面を持つ金属彫刻をパラフィンワックスが結びつなげたのでした。

Painting Sculpture and Bronze Work

The solid paraffin wax instantly dissolves into a clear liquid when heated. This condition provides an opportune time to create the Painting Sculpture. While there are variables as climate temperature and the melting point of paraffin wax, the work must be executed promptly. Holding the container of melted paraffin wax with the left hand and the hake-brush with the right hand, the wax is painted in layers onto the object. Eventually, the paraffin wax begins to harden, forming a thin membrane over the surface. In this repetitive process, a seamless, semi-transparent film with a certain thickness - a veil - materializes. Naturally, the wax hardens as it dribbles down without defying gravity, forming a surface that resembles an icicle or melted cheese. And when this surface overspreads an extensive area, the transformation is an ineffable three-dimensional structure that is worlds beyond the realm of paraffin wax. When the surface of this painted sculpture is molded into a thick wall and metal is poured into it, the so-called lost wax technique yields a sculptural environment characterized by hard, heavy bronze and aluminum surfaces. I was mesmerized by the wide variance from the translucent paraffin wax forms to the bronze and aluminum sculptures in their dull, shiny surfaces. The paraffin wax united a spatial installation of infinite surface with a metal sculpture of brush-painted surface.

Work A-1, 1981
bronze
H900× W400× D50mm
Haruki Collection
Photo:Tadasu Yamamoto

Work E-10, 1981
paraffin, wax, oil dye
H30× W900× D900mm
Photo:Tadasu Yamamoto

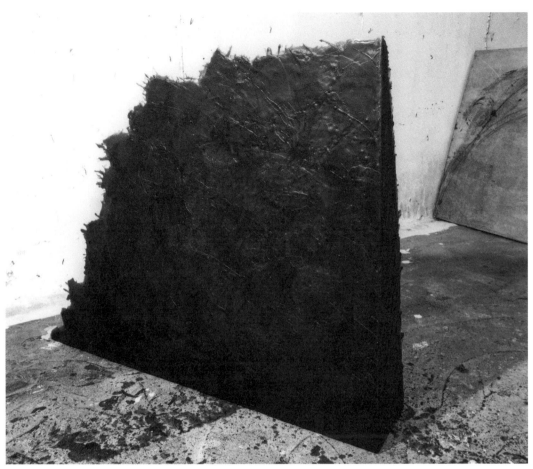

Work I-3 (prototype), 1982
paraffin, wax

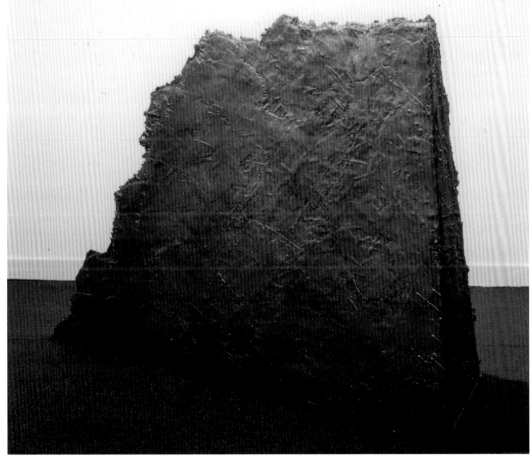

Work I-3, 1982
bronze
H810× W1050× D180mm

Photo: Tadasu Yamamoto

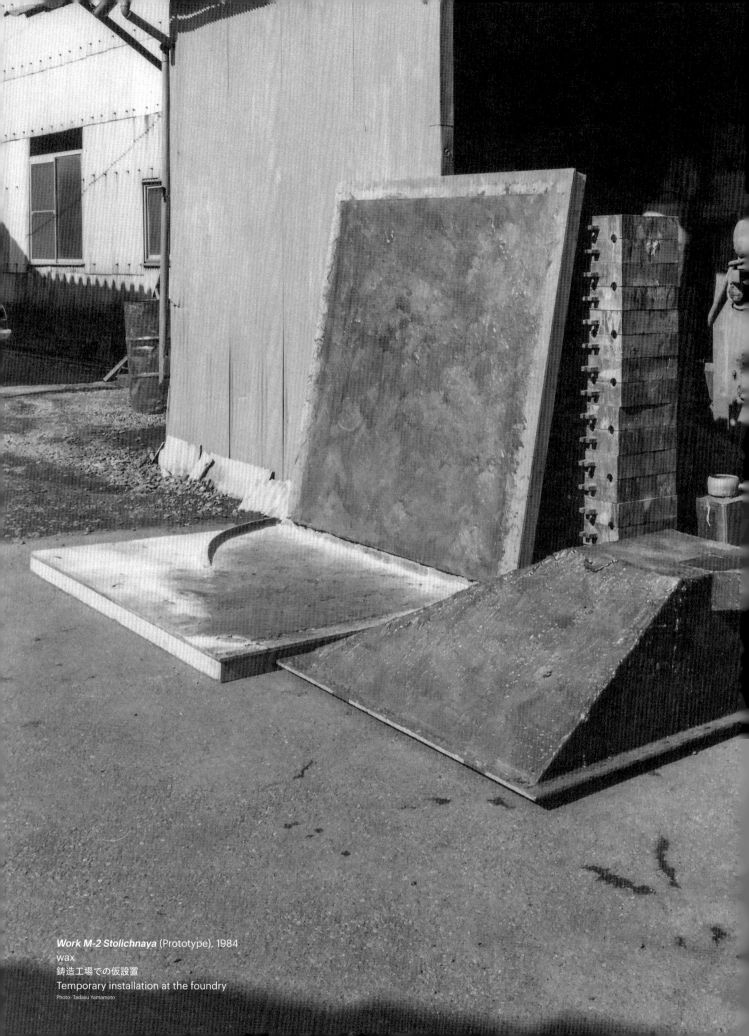

Work M-2 Stolichnaya (Prototype), 1984
wax
鋳造工場での仮設置
Temporary installation at the foundry
Photo: Tadasu Yamamoto

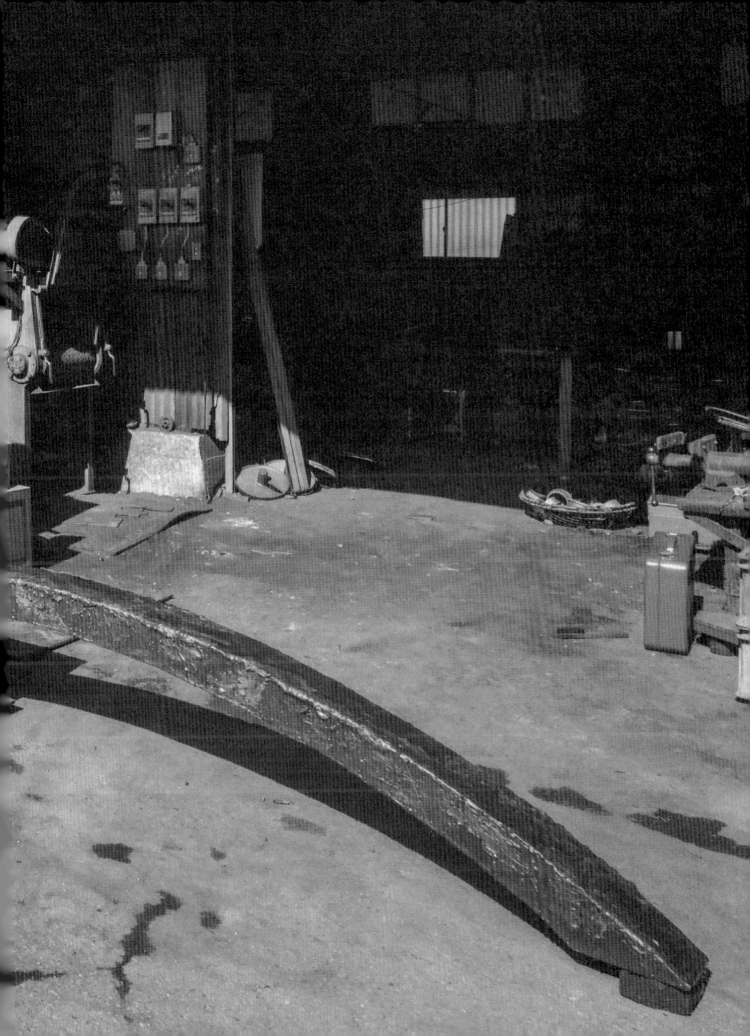

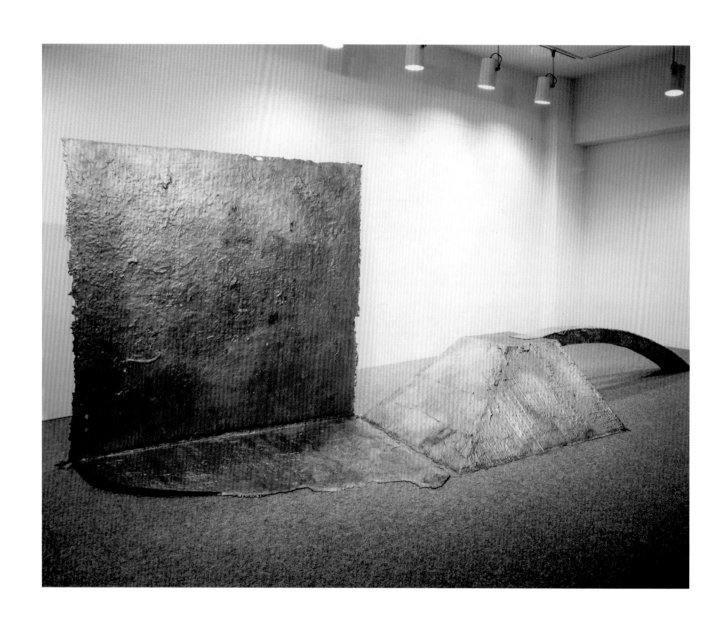

Work M-2 Stolichnaya, 1984
bronze
H1600×W4700×D1100mm
ギャラリー手（東京）
Gallery Te (Tokyo)
Photo:Tadasu Yamamoto

Photo: Junko Kitajima

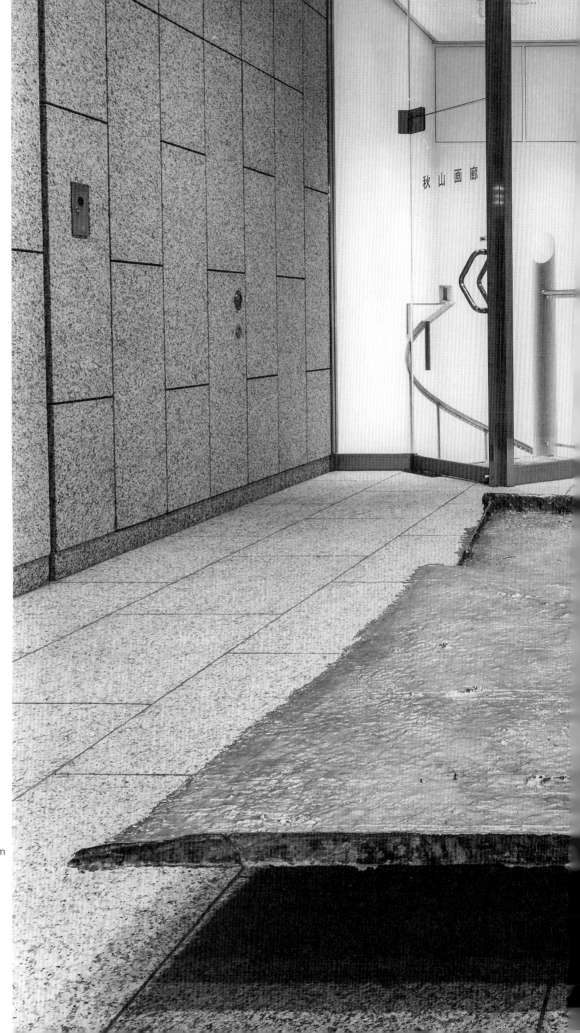

Foreground:
Work M-3 Stolovaya, 1985
bronze
H1800×W3400×D400mm

Front wall:
Work L-5, 1985
bronze
H185×W95×D910mm
秋山画廊（東京）
Akiyama Gallery (Tokyo)
Private Collection
Photo:Tadasu Yamamoto

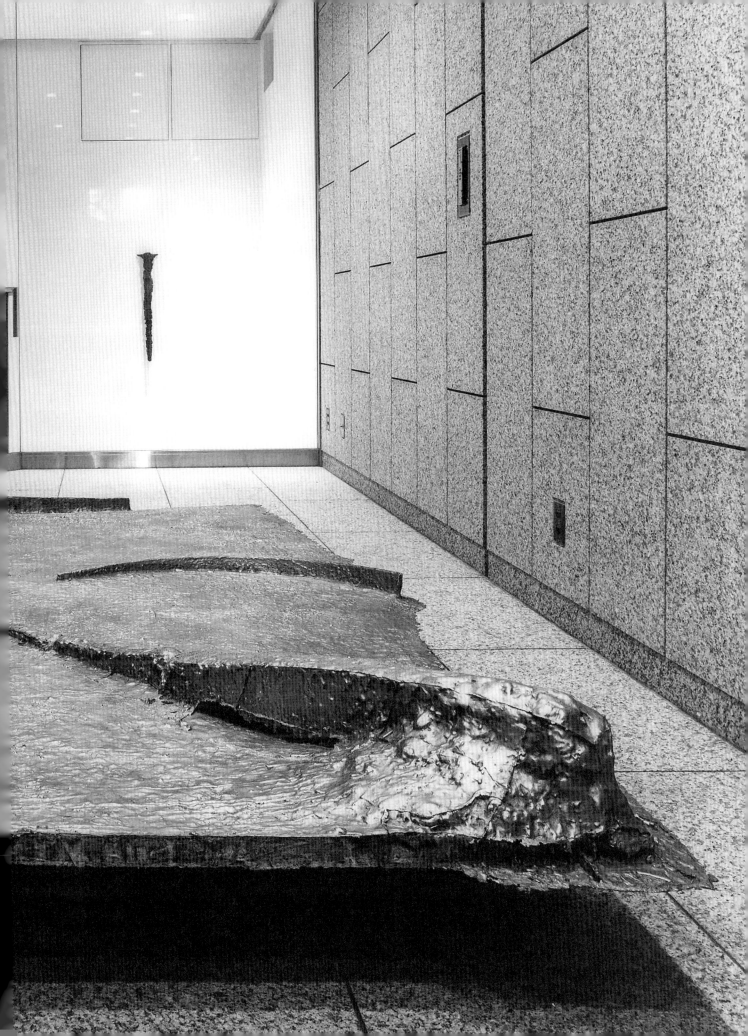

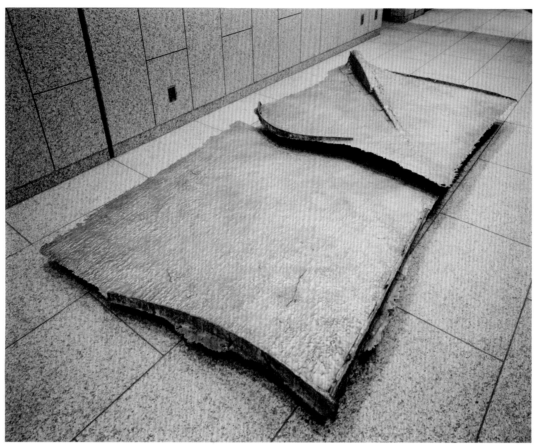

Work M-3 Stolovaya, 1985
bronze
H400×W3400×D1800mm
Haruki Collection

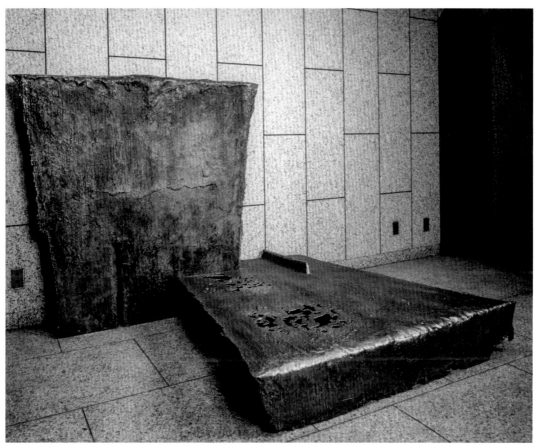

《**Work M-5 対岸**》
Work M-5 Opposite bank, 1986
bronze
H1500×W2800×D1510mm
秋山画廊（東京）
Akiyama Gallery (Tokyo)
Courtesy of the National Museum of Modern Art, Tokyo
Photo:Tadasu Yamamoto

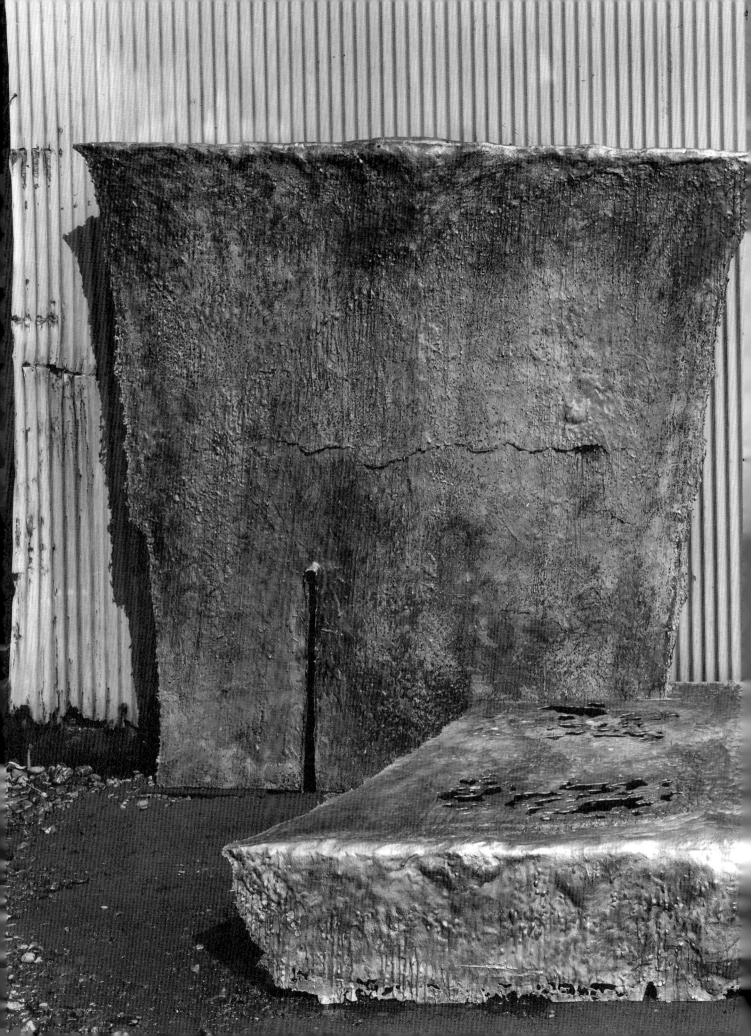

《Work M-5 対岸》
Work M-5 Opposite bank, 1986
bronze
1500×2800×1510mm
鋳造工場での仮設置
Temporary installation at the foundry
Photo:Tadasu Yamamoto

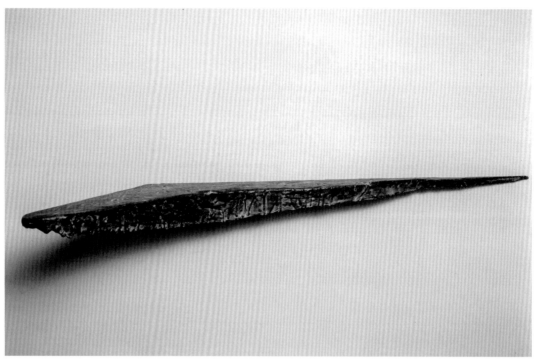

《**Work O-3 水平の夢**》
Work O-3 Horizontal dream, 1986
H840×W40×D80mm
bronze
Haruki Collection

《**Work O-2 垂平の長い孤独**》
Work O-2 Long Horizontal Solitude, 1986
H900×W220×D70mm
bronze
Haruki Collection

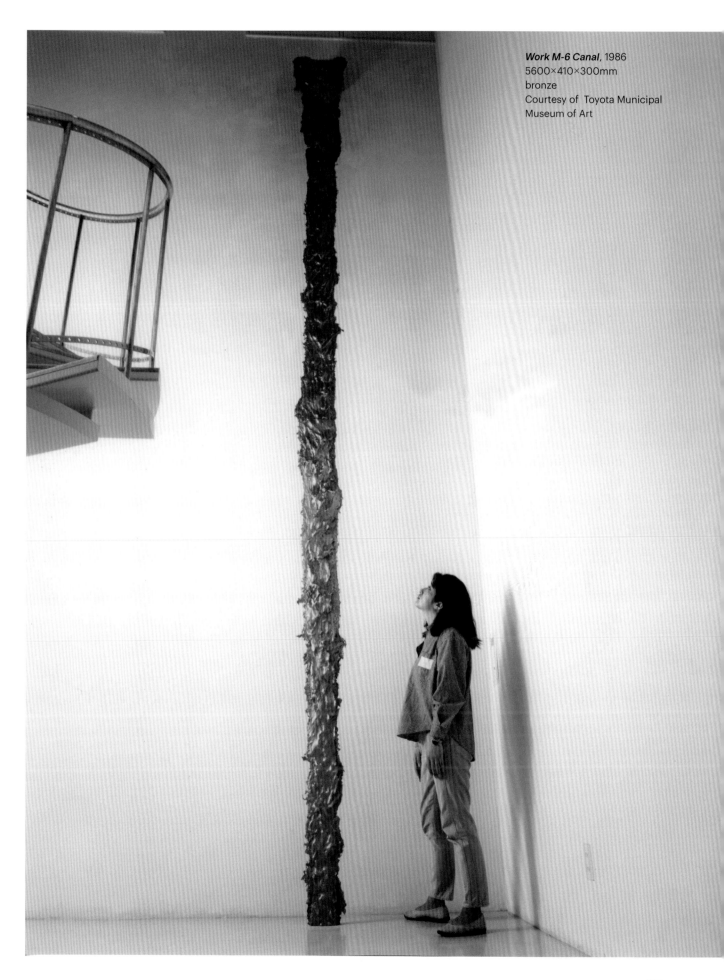

Work M-6 Canal, 1986
5600×410×300mm
bronze
Courtesy of Toyota Municipal
Museum of Art

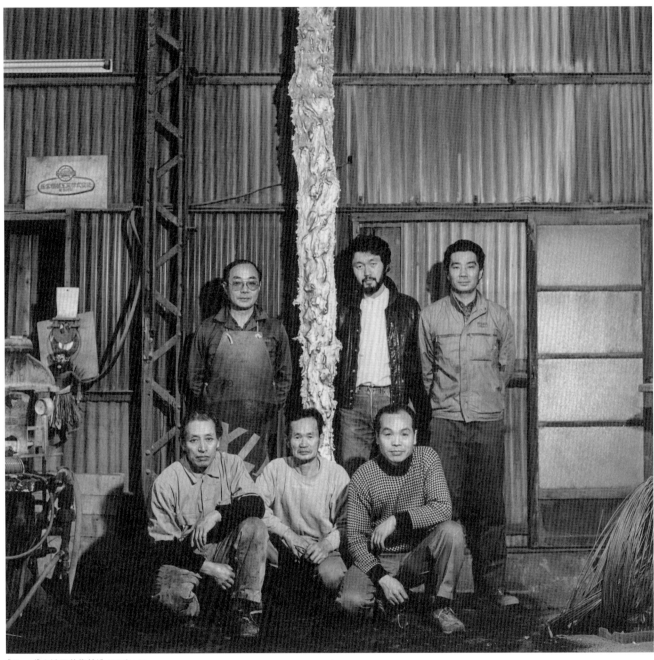

《Canal》と池田美術鋳造のスタッフ
"Canal" and the Ikeda Art Foundry's founders, 1986

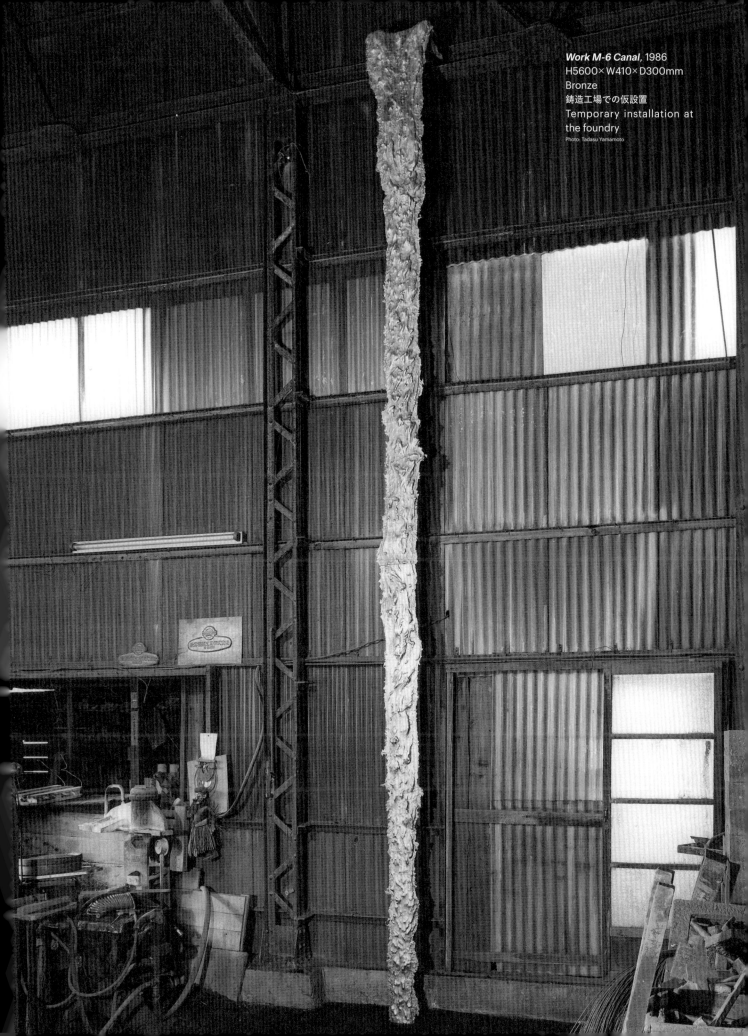

Work M-6 Canal, 1986
H5600×W410×D300mm
Bronze
鋳造工場での仮設置
Temporary installation at
the foundry
Photo: Tadasu Yamamoto

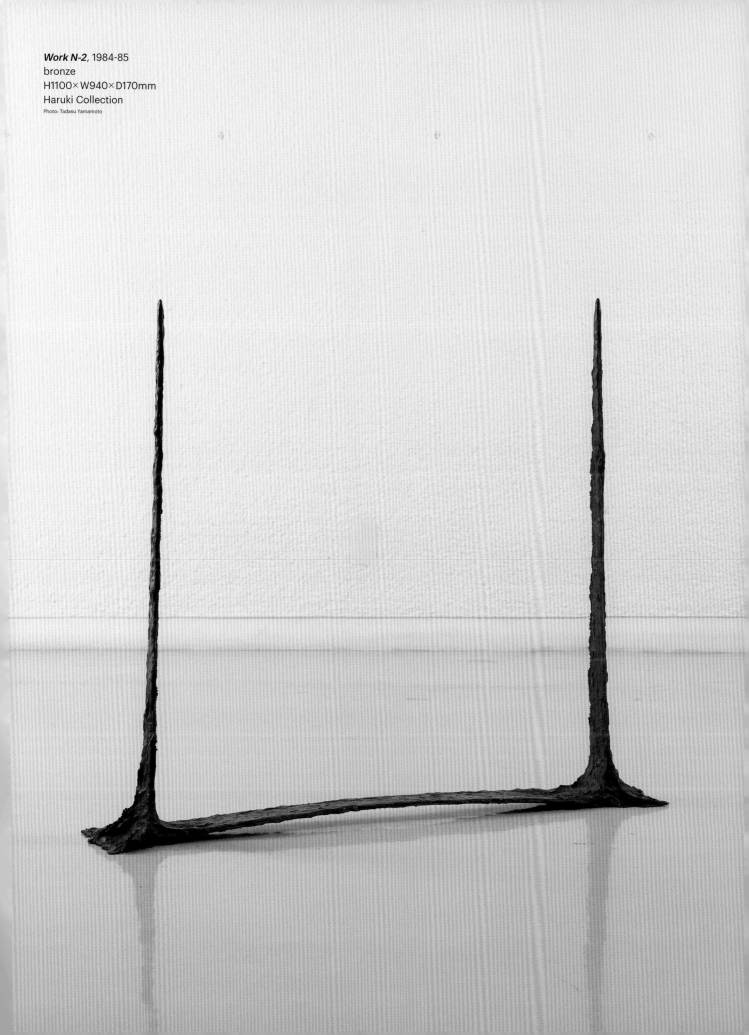

Work N-2, 1984-85
bronze
H1100× W940× D170mm
Haruki Collection
Photo: Tadasu Yamamoto

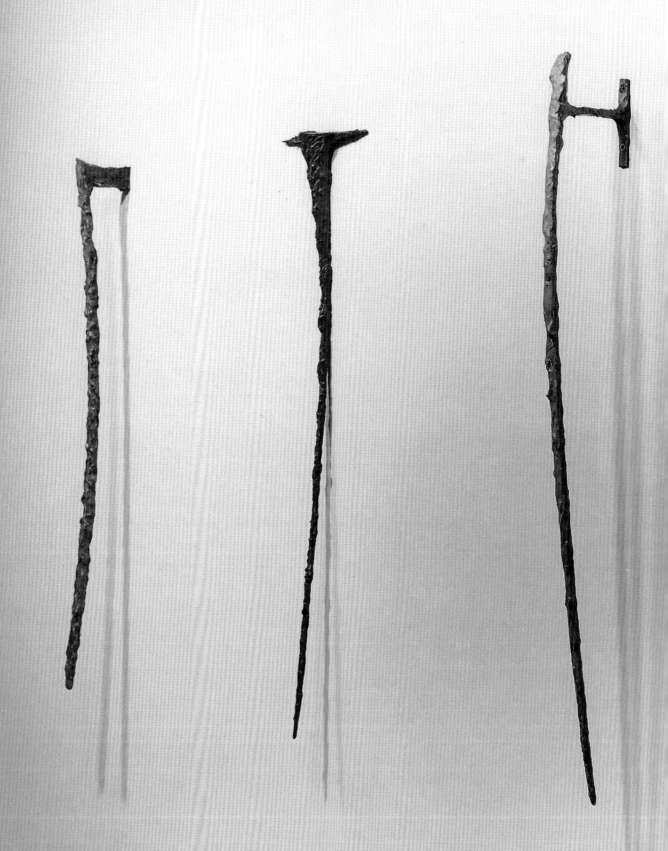

From the left:
Work L-4, 1984. bronze, H910×W35×D130mm, Private Collection
Work L-6, 1984. bronze, H900×W230×D50mm, Private Collection
Work L-7, 1984. bronze, H900×W25×D130mm, Private Collection
Work L-5, 1984. bronze, H910×W185×D95mm, Private Collection
「'85岐阜現況展 戦後生まれの作家達・立体部門」岐阜県美術館（岐阜）
"CURRENT STATE of GIFU '85. Postwar Born Artists. 3D department" Gifu Prefectural Museum of Art (Gifu)

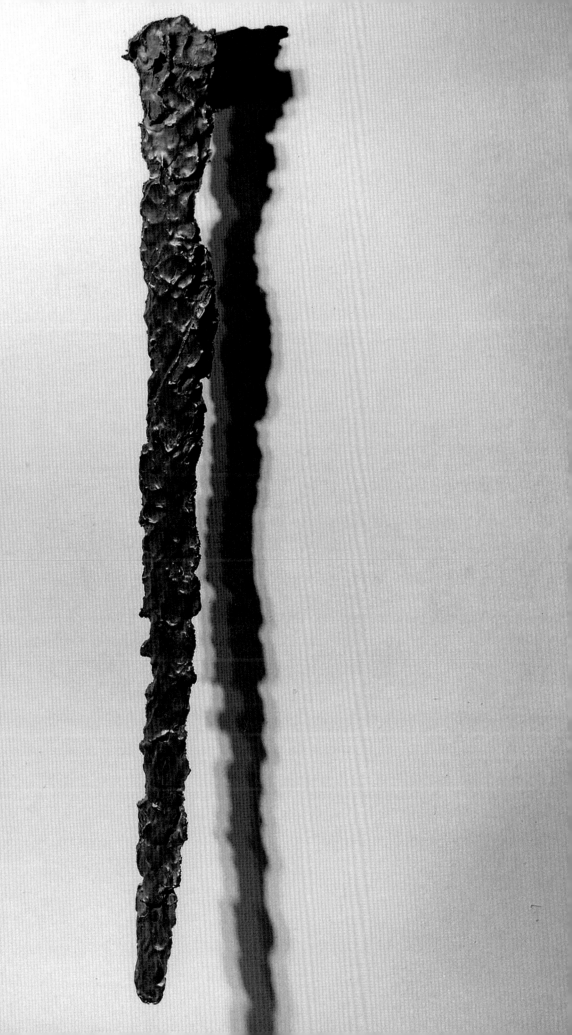

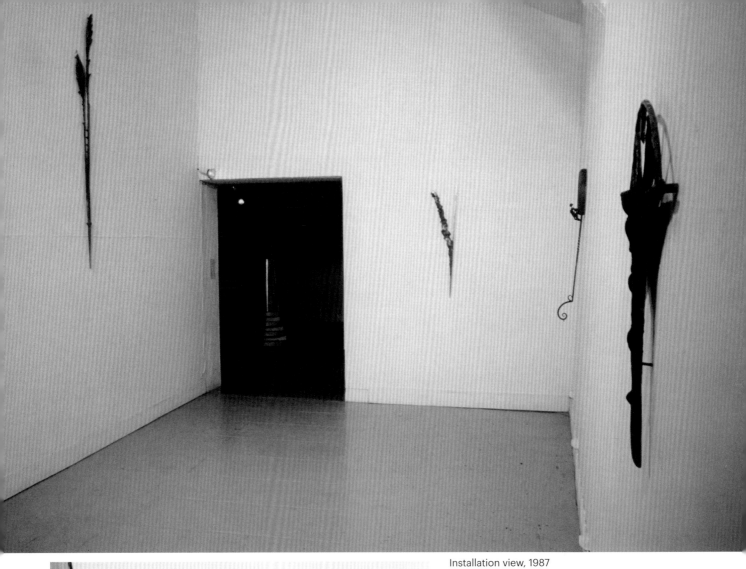

Installation view, 1987
「矢野・池ヶ谷・鷲見」ギャラリー・パッサージュ（トロワ、フランス）
"YANO/IKEGAYA/SUMI" Gallery Passage-Centre d'Art
Contemporain (Troyes, France)

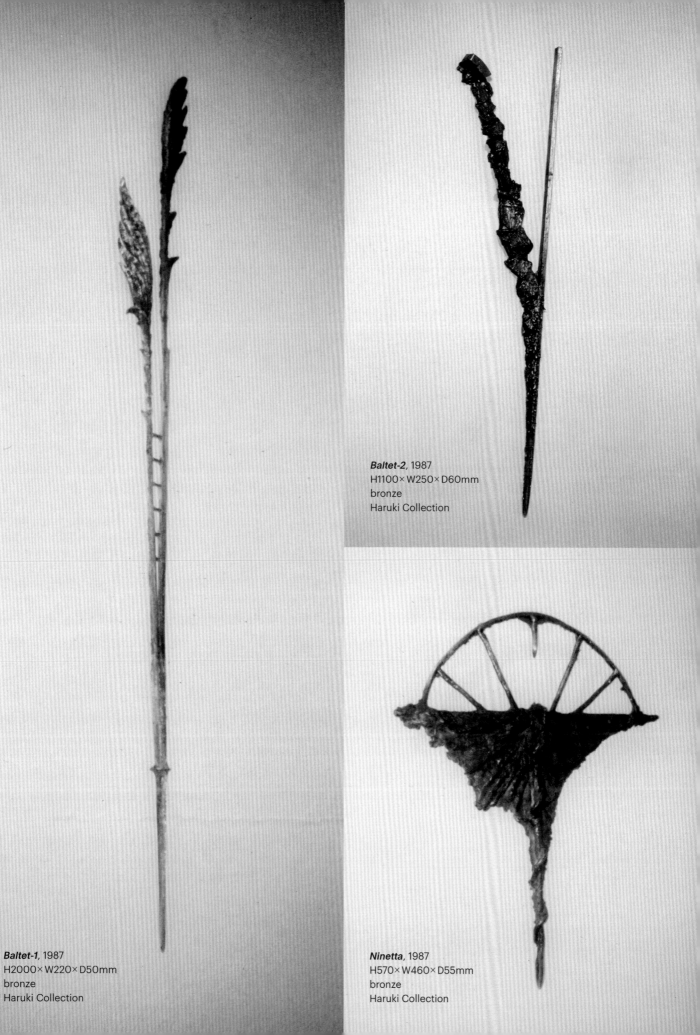

Baltet-2, 1987
H1100×W250×D60mm
bronze
Haruki Collection

Baltet-1, 1987
H2000×W220×D50mm
bronze
Haruki Collection

Ninetta, 1987
H570×W460×D55mm
bronze
Haruki Collection

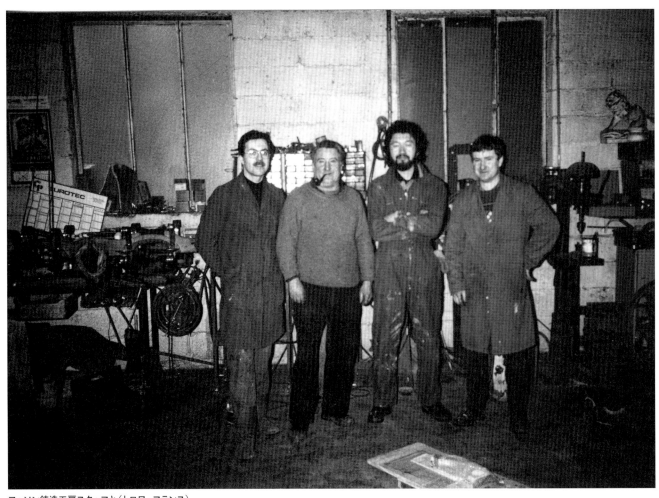

フッソン鋳造工房スタッフと（トロワ、フランス）
With the Fousson Foundry's founders, 1987（Troyes, France）

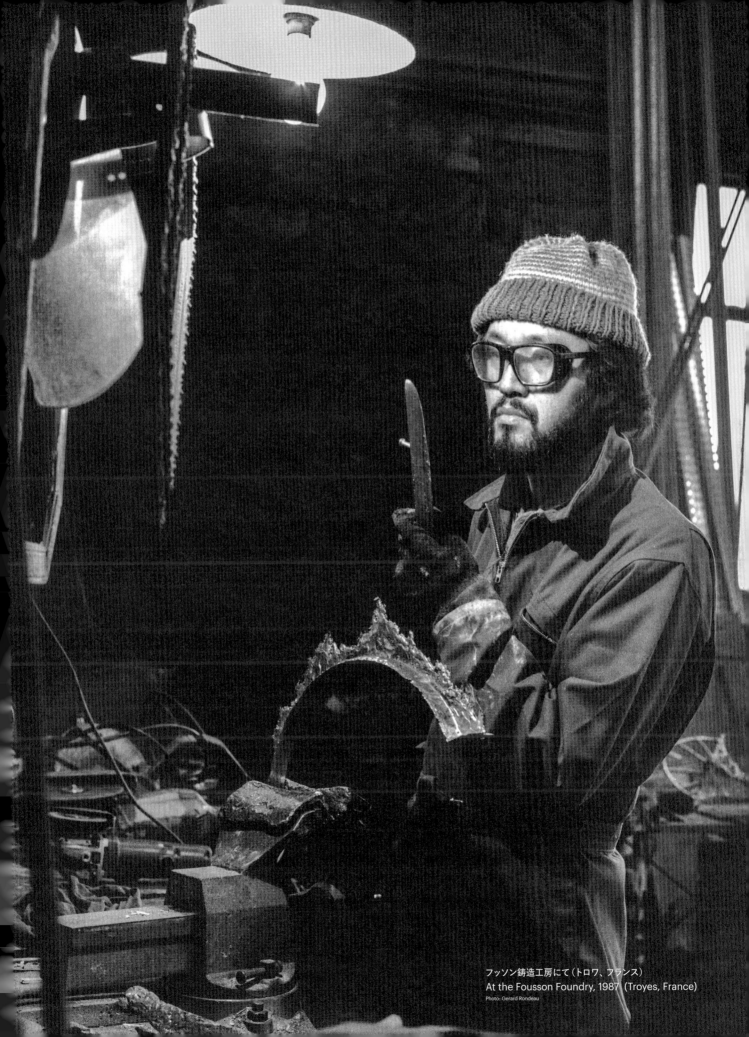

フッソン鋳造工房にて（トロワ、フランス）
At the Fousson Foundry, 1987（Troyes, France）
Photo: Gerard Rondeau

《Prepared Sculpture-3 起き上がる闇》
Prepared Sculpture-3. Wakening Darkness, 1987
bronze, iron
H2000×W2800×D800mm
鋳造工場での仮設置
Temporary installation at the foundry
Photo: Tadasu Yamamoto

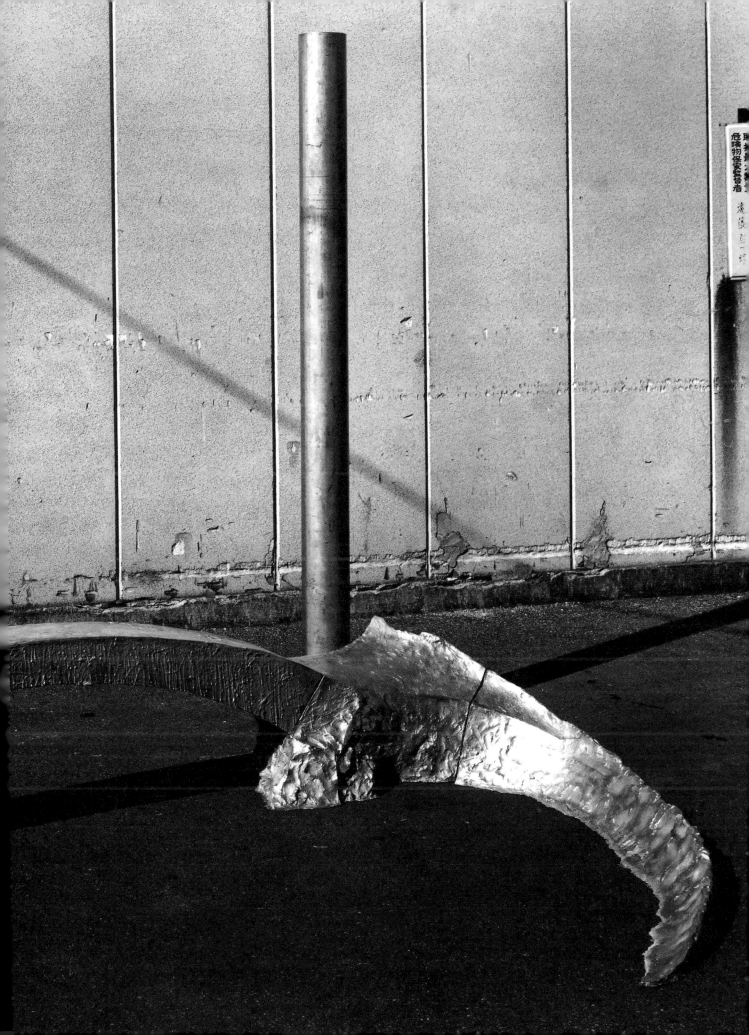

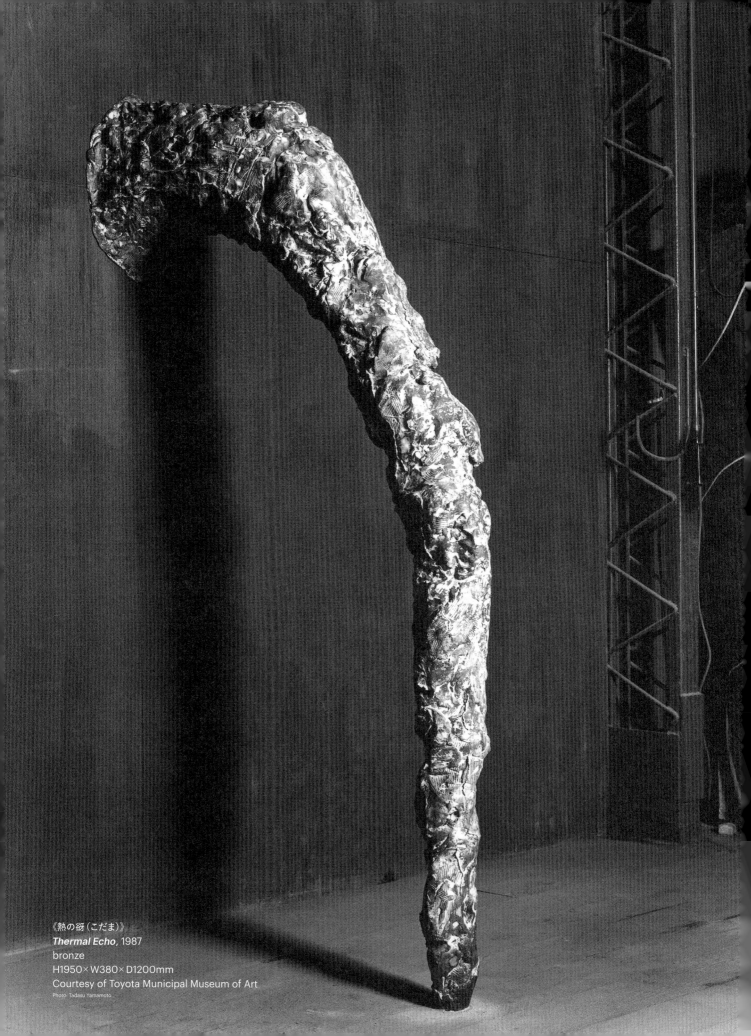

《熱の谺（こだま）》
Thermal Echo, 1987
bronze
H1950×W380×D1200mm
Courtesy of Toyota Municipal Museum of Art
Photo: Tadasu Yamamoto

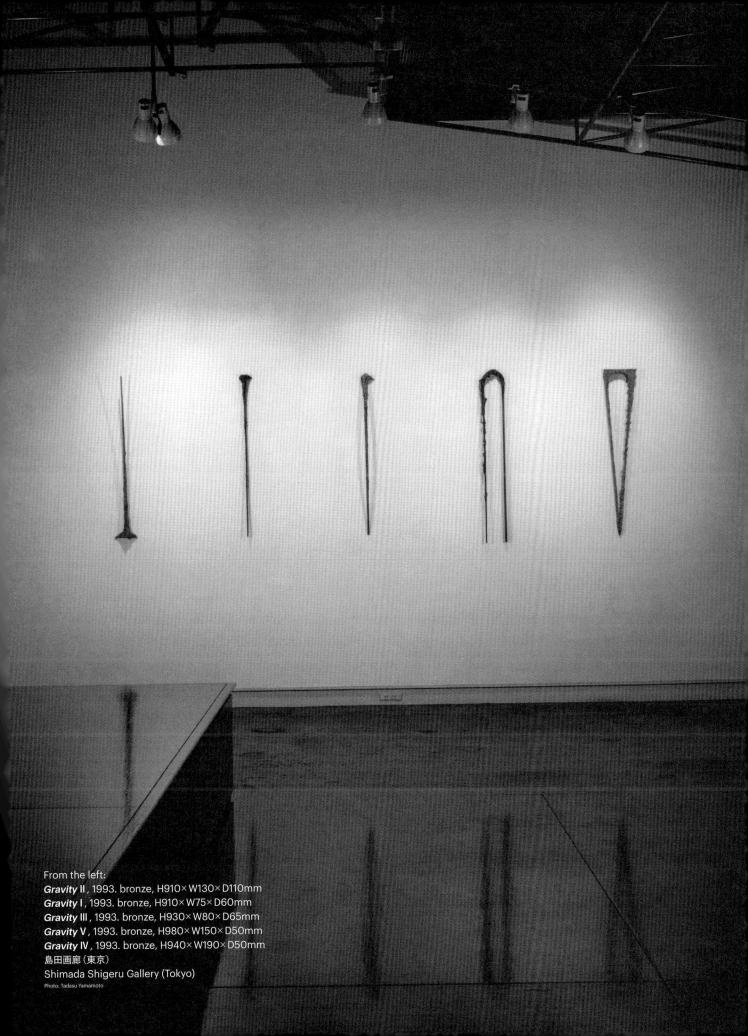

From the left:
Gravity II , 1993. bronze, H910×W130×D110mm
Gravity I , 1993. bronze, H910×W75×D60mm
Gravity III , 1993. bronze, H930×W80×D65mm
Gravity V , 1993. bronze, H980×W150×D50mm
Gravity IV , 1993. bronze, H940×W190×D50mm
島田画廊（東京）
Shimada Shigeru Gallery (Tokyo)
Photo: Tadasu Yamamoto

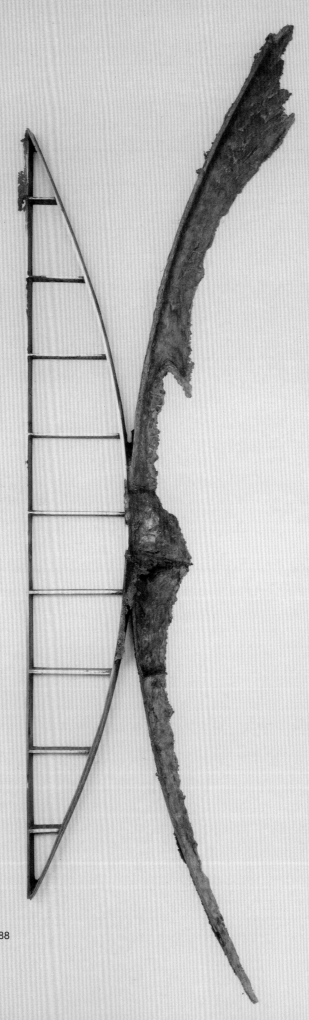

Prepared Sculpture-1. Ornette II, 1988
bronze
H1100× W300× D40mm
Photo: Tadasu Yamamoto

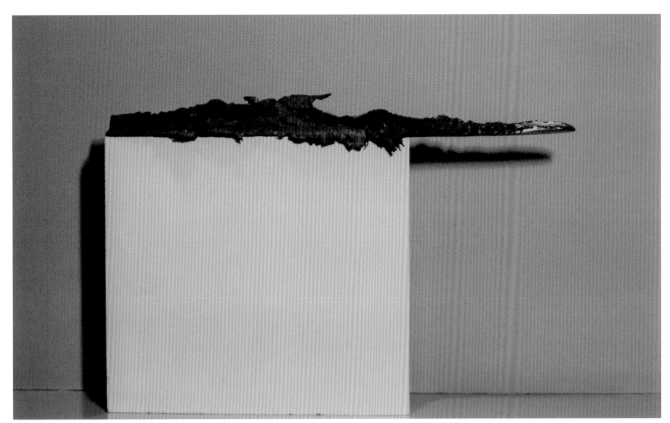

Eastward, 1991
bronze, stone
H3600×W530×D70mm

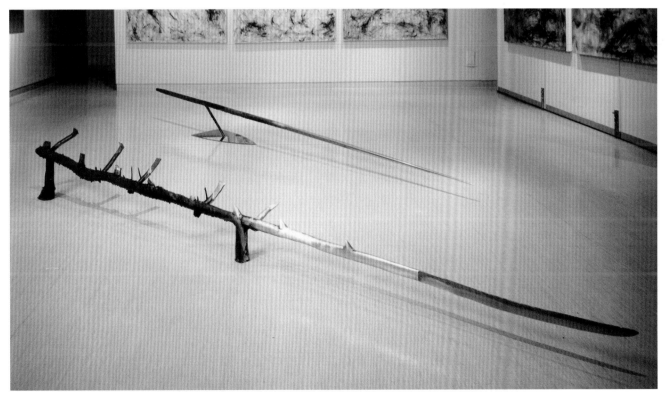

Installation view, 1987
Foreground: *Crochilled-1*, 1987. bronze, wax, H300×W2300×D170mm
Back: *Crochilled-2*, 1987. aluminum, stainless steel, wax, H260×W2500×D200mm
「共相 "Sāmānyalaksana" 展」彩林画廊（神奈川）
"Common phase 'Sāmānyalaksana' Exhibition" Sairin Gallery (Kanagawa)

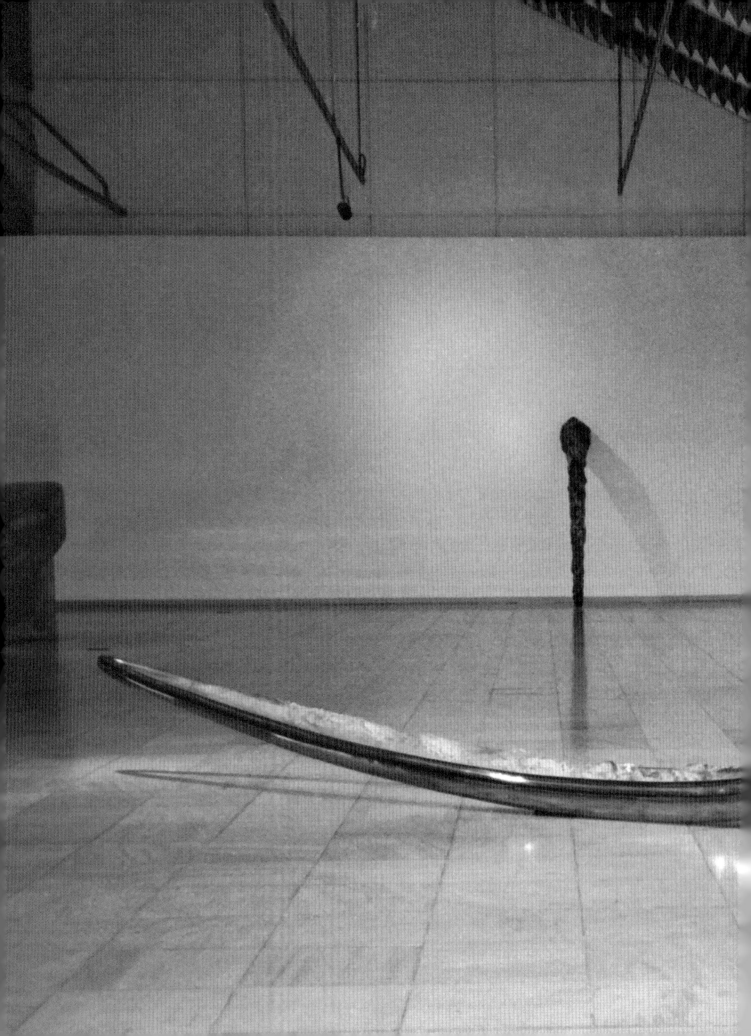

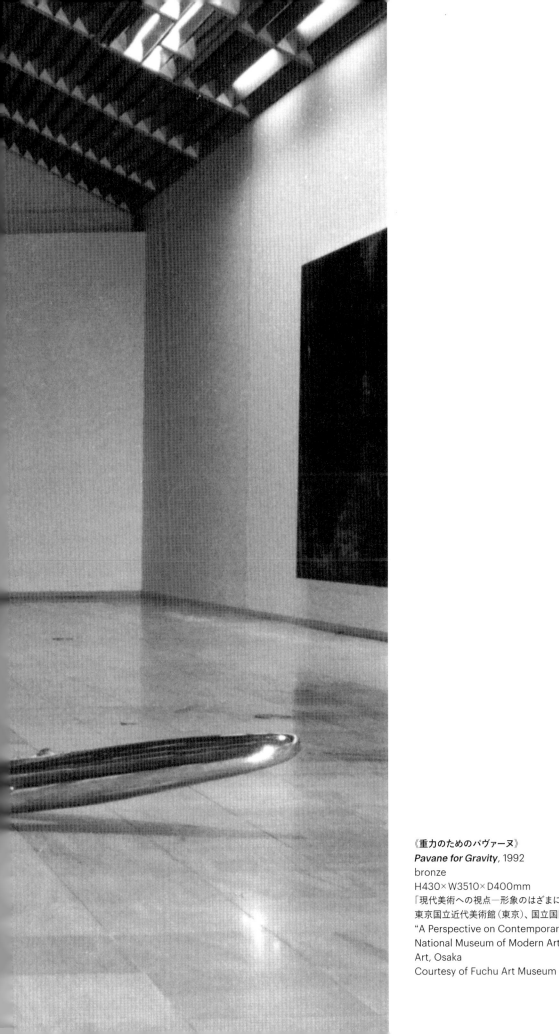

《重力のためのパヴァーヌ》
Pavane for Gravity, 1992
bronze
H430×W3510×D400mm
「現代美術への視点─形象のはざまに」
東京国立近代美術館（東京）、国立国際美術館（大阪）
"A Perspective on Contemporary Art：Among the figures"
National Museum of Modern Art, Tokyo, National Museum of
Art, Osaka
Courtesy of Fuchu Art Museum

WAX INSTALLATIONS 1980-

ワックス インスタレーション

私の70年代の制作は基本的にプライマリーストラクチャー
であり、素材と色彩がポイントとなっていました。それら
の素材は金属であれ、木材であれ、所詮工業規格品であり
サイズや厚み、表面のテクスチャーもあらかじめ与えられ
たモノでしかありませんでした。「自分の手でつくられた
表面とサイズを持つパネルをつくりたい」という単純な願
望が金属の鋳造やワックスワークを始めたきっかけでした。
ワックスの型枠への流し込みから始まり、ハケ塗りでのド
ローイング、そして現場制作によるインスタレーションへ
とスケールアップしていきました。1987年、フランス、マ
ルセイユの古い教会建築のアートセンターでは現場制作
で直接床に巨大な円弧の一部をペイントして自立するよ
うにし、会場の入り口からは作品を跨いで入場するように
しました。これが空間と作品が密接に関係しあう方法を
取った最初のワックスインスタレーションとなりました。
壁と床、建物のコーナー、窓からの光、人の動線、そして
そこに現れるワックスの構造物との関係から生まれるイ
ンスタレーションのアイデアは尽きることがありません。

Wax Installation

Most of my work in the 1970s was basically Primary
Structure, with materials and colors being the main
points of interest. The materials used, metal or wood,
were all industrial grade, predetermined in size,
thickness, and surface texture. A simple desire to
"produce panels with surfaces and sizes made with
my own hands" prompted me to pursue metal casting
and waxwork. It began with the pouring into wax
molds, then to hake-brush drawings, and eventually
sizing up to site-made installations. In 1987, at an art
center housed in an old church building in Marseilles,
France, I painted a section of a massive arc directly on
the floor to make it free-standing so visitors could
step over the piece to enter the venue. This exhibition
presented the first wax installation in which the space
and the object were closely interrelated.
The ideas are endless for installations inspired by
relationships between walls and floors, building
corners, ambient light from windows, the flow of
people, and the wax structures manifested in the
space.

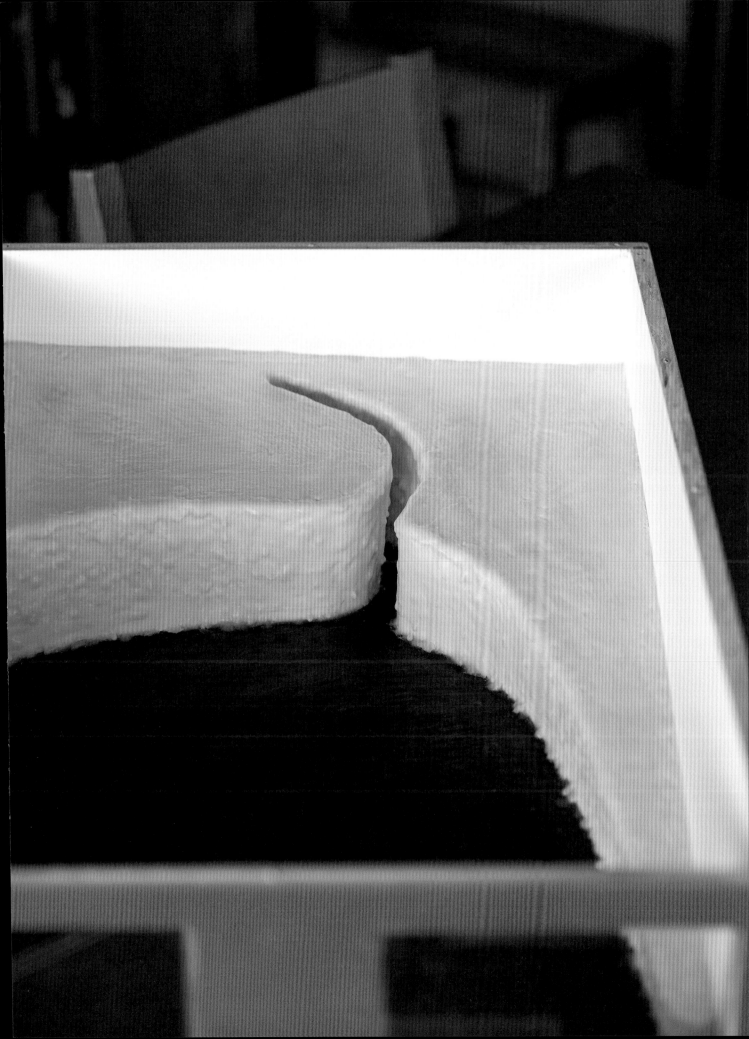

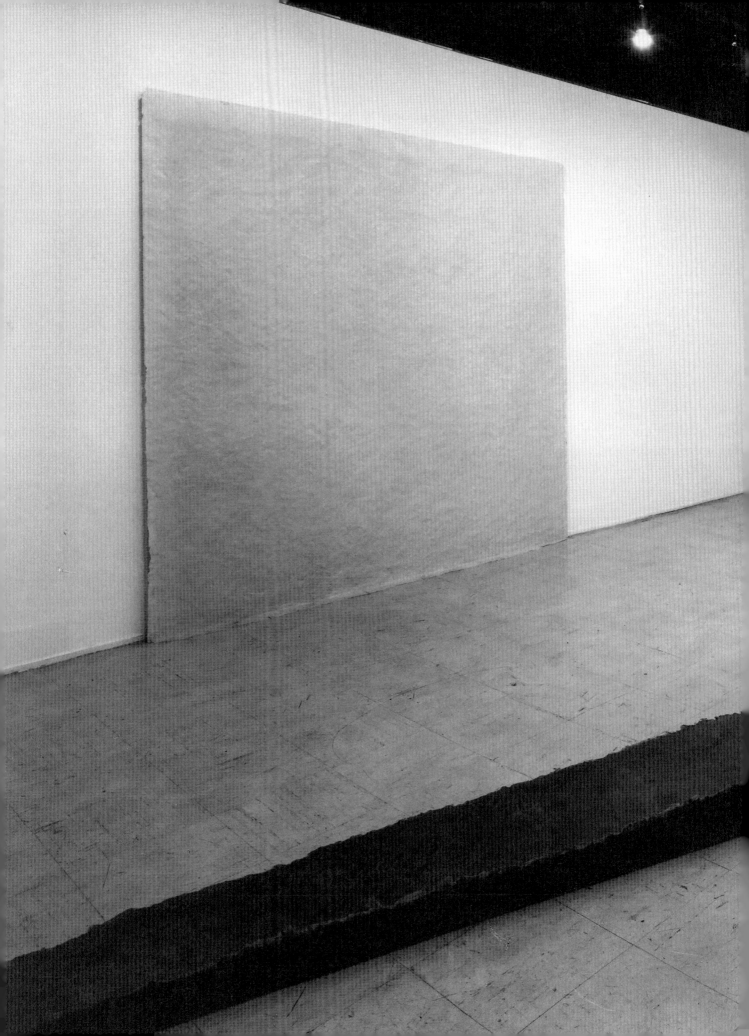

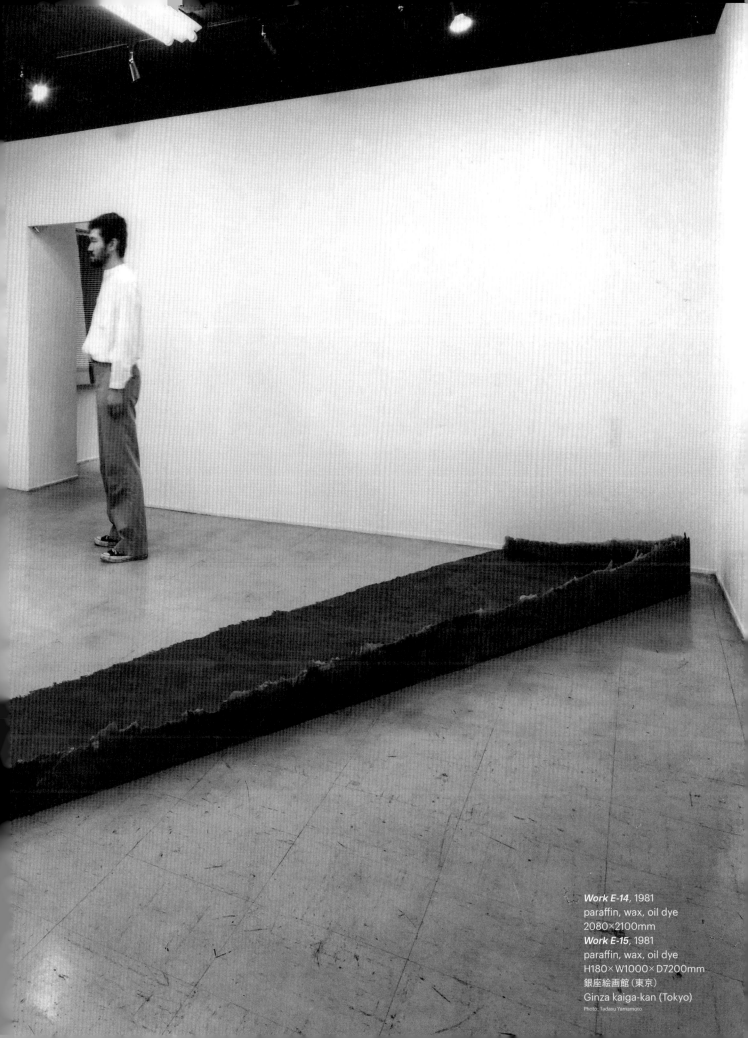

Work E-14, 1981
paraffin, wax, oil dye
2080×2100mm
Work E-15, 1981
paraffin, wax, oil dye
H180× W1000× D7200mm
銀座絵画館（東京）
Ginza kaiga-kan (Tokyo)
Photo: Tadasu Yamamoto

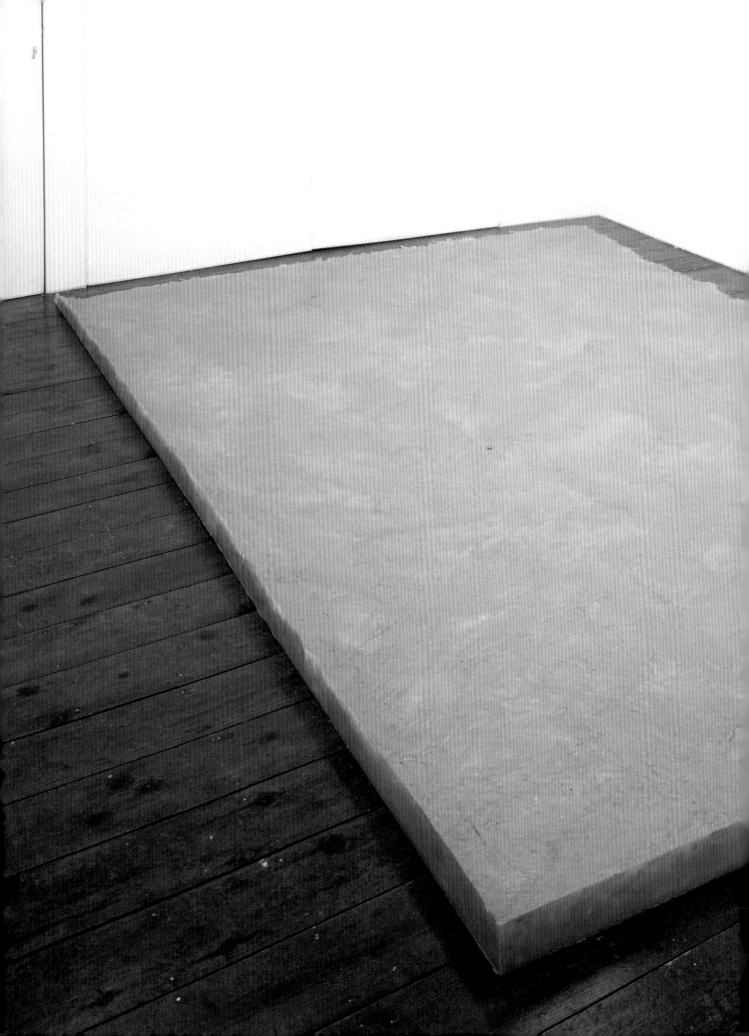

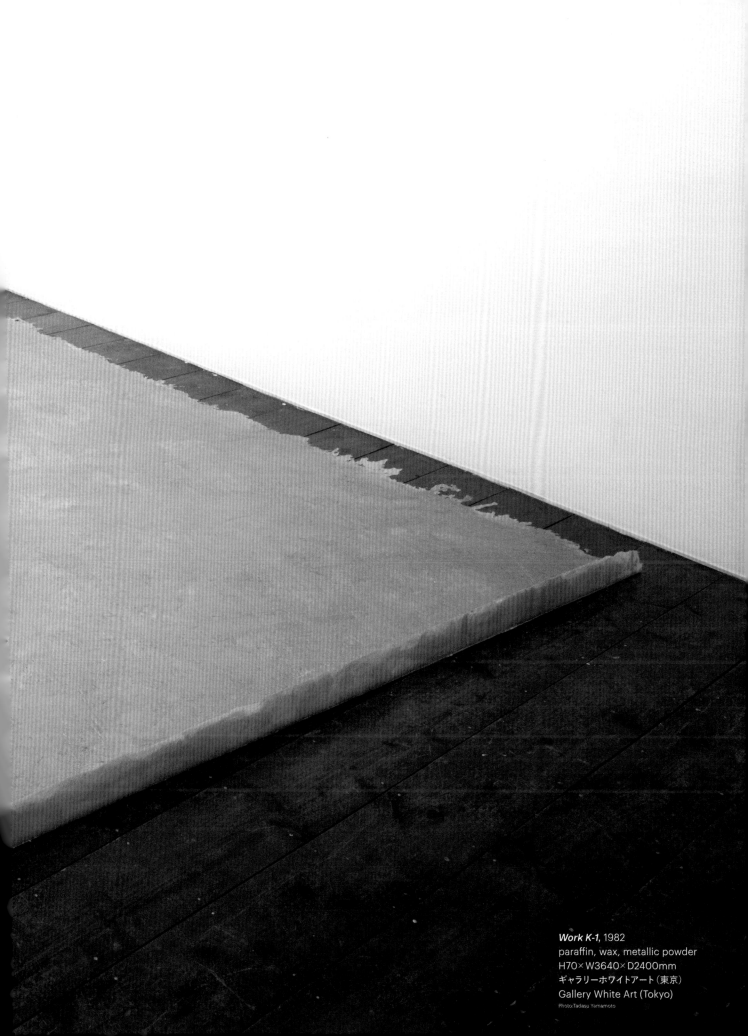

Work K-1, 1982
paraffin, wax, metallic powder
H70×W3640×D2400mm
ギャラリーホワイトアート（東京）
Gallery White Art (Tokyo)
Photo:Tadasu Yamamoto

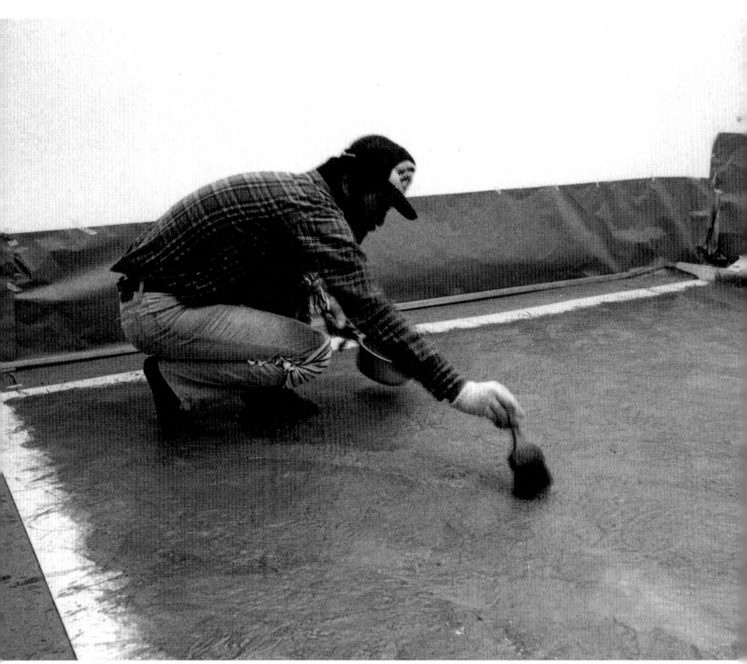

Working process 1982, Gallery White Art (Tokyo)

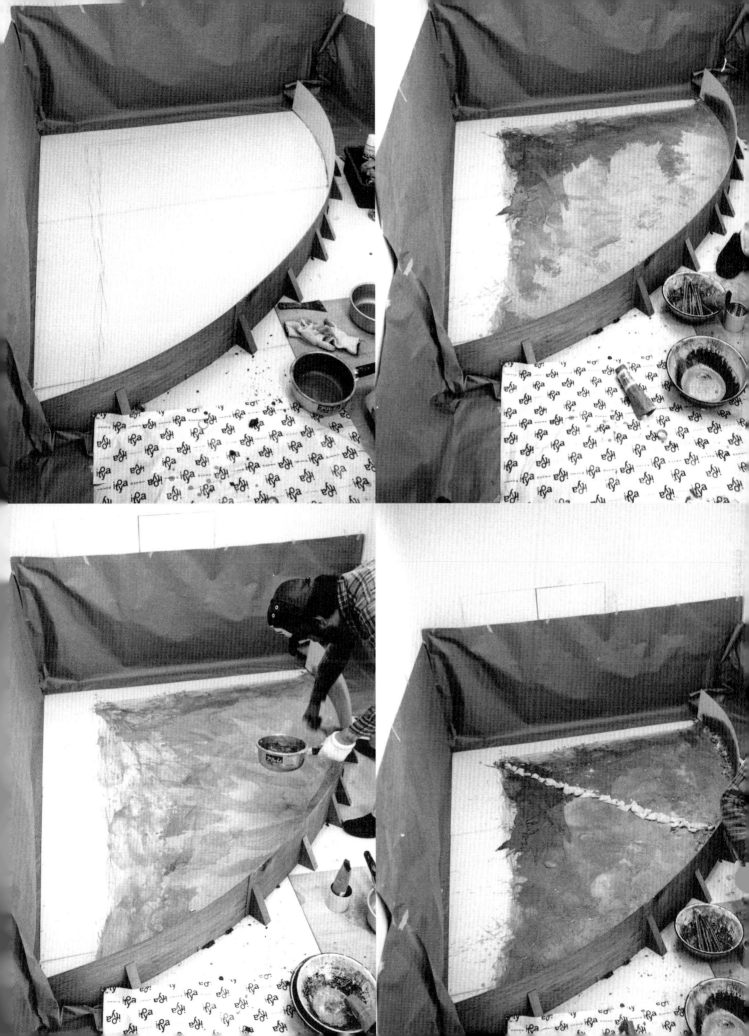

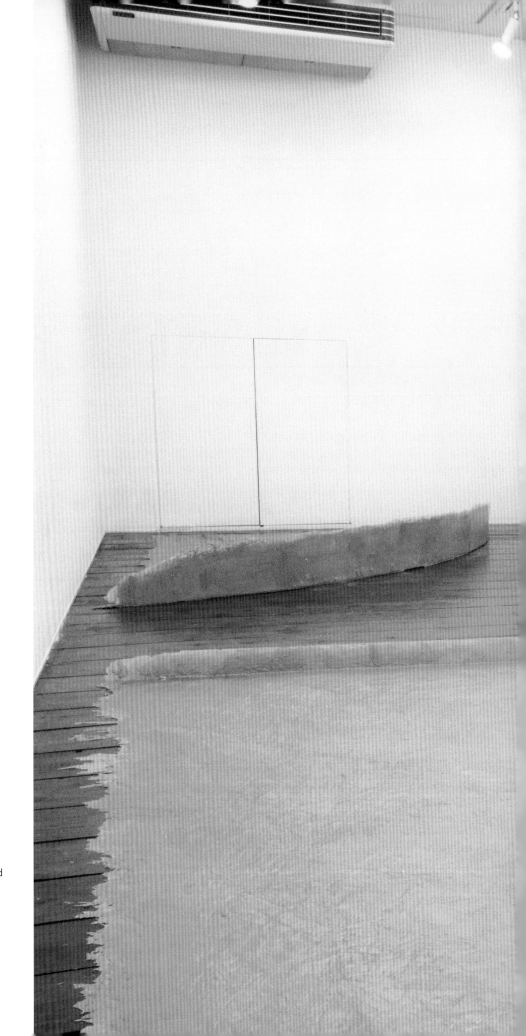

Back:
Work K-2, 1982
paraffin, wax, metallic powder, wood
H200× W1600× D2000mm
Foreground:
Work K-1, 1982
paraffin, wax, metallic powder
H70× W3640× D2400mm
ギャラリーホワイトアート（東京）
Gallery White Art (Tokyo)

108

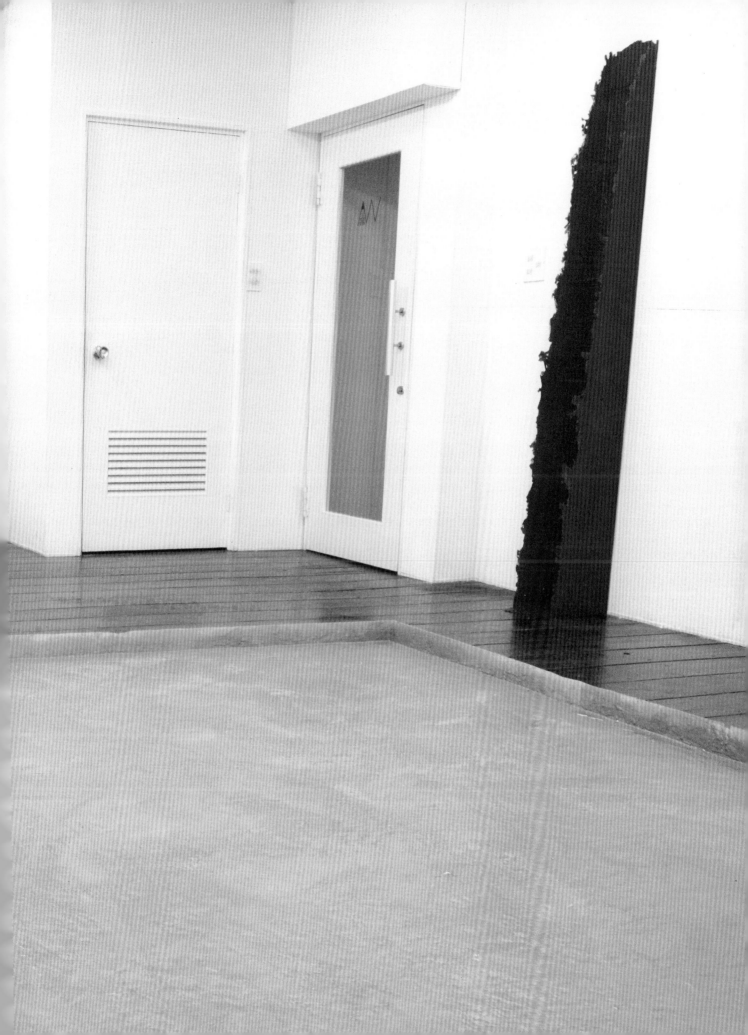

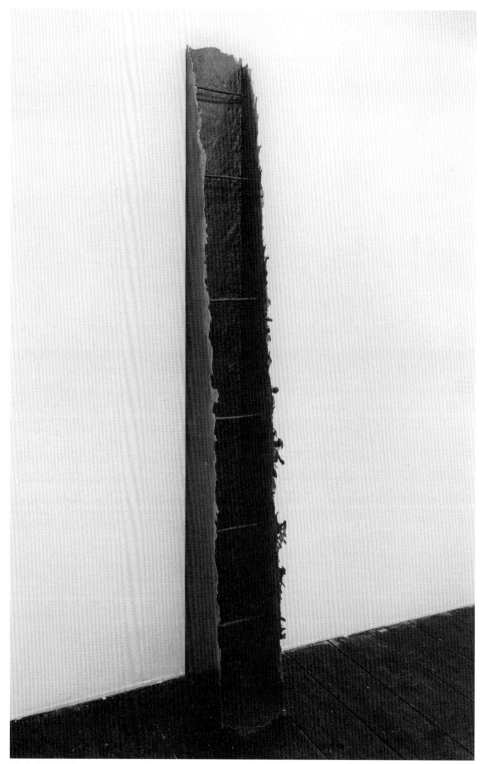

Work H-2, 1982
paraffin, wax, oil dye
H1800×W200×D300mm

Photo: Shigeo Anzai

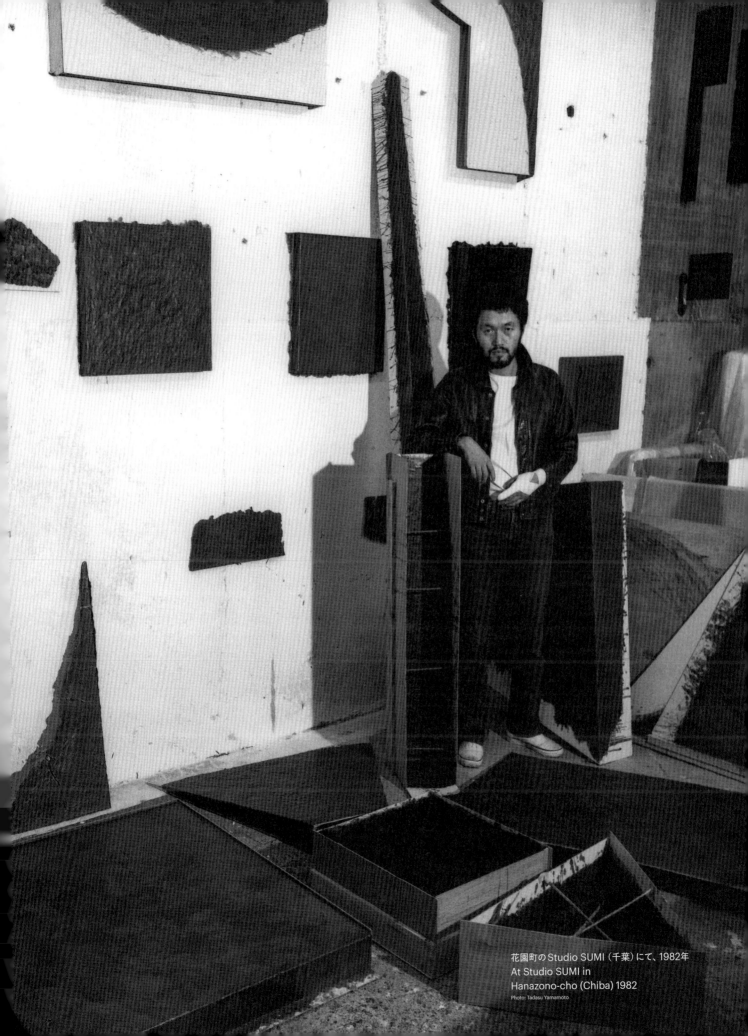

花園町のStudio SUMI（千葉）にて、1982年
At Studio SUMI in
Hanazono-cho (Chiba) 1982
Photo: Tadasu Yamamoto

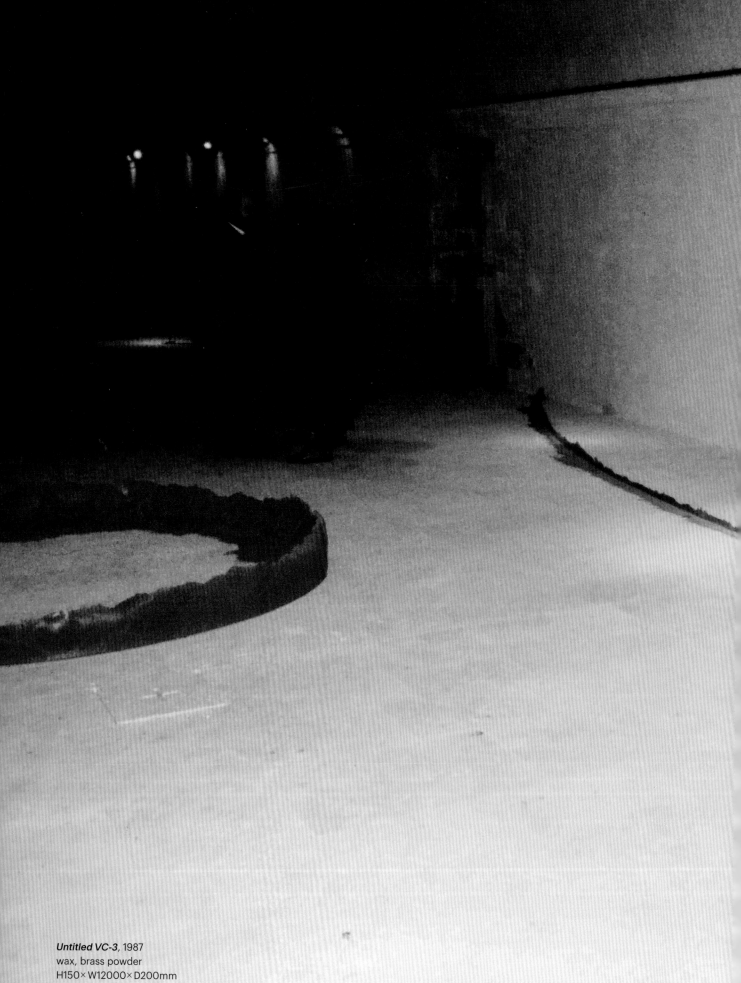

Untitled VC-3, 1987
wax, brass powder
H150×W12000×D200mm
"JAPON ART VIVANT 1987 – Japon Passé - Présent A Marseille" Centre de la Vieille Charite (Marseille, France)

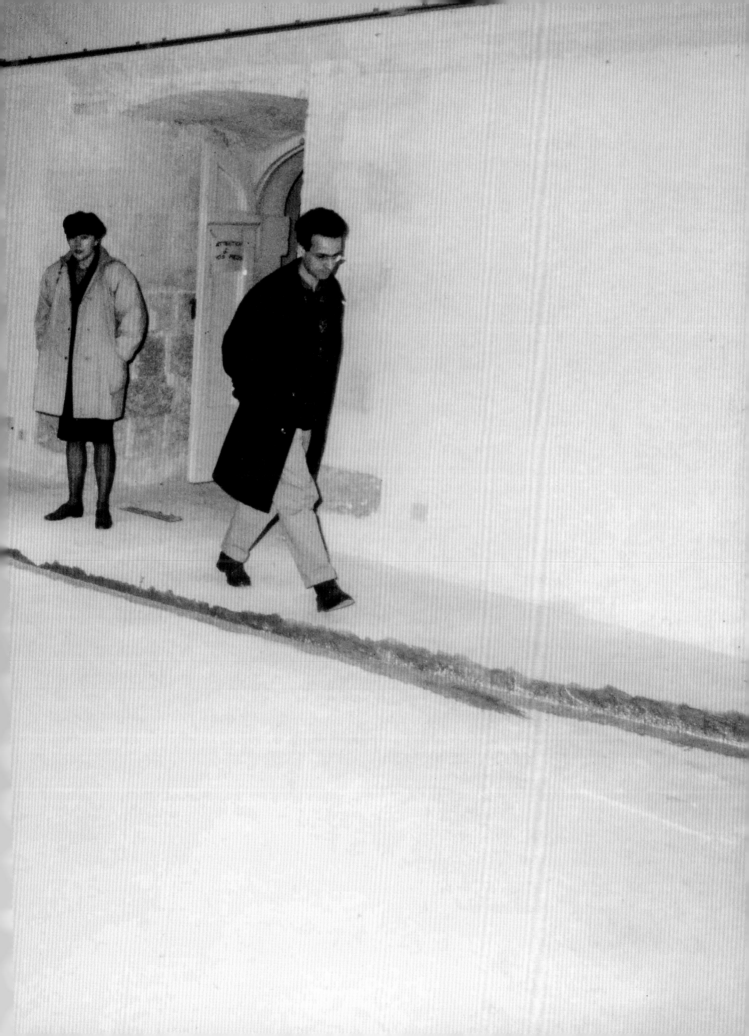

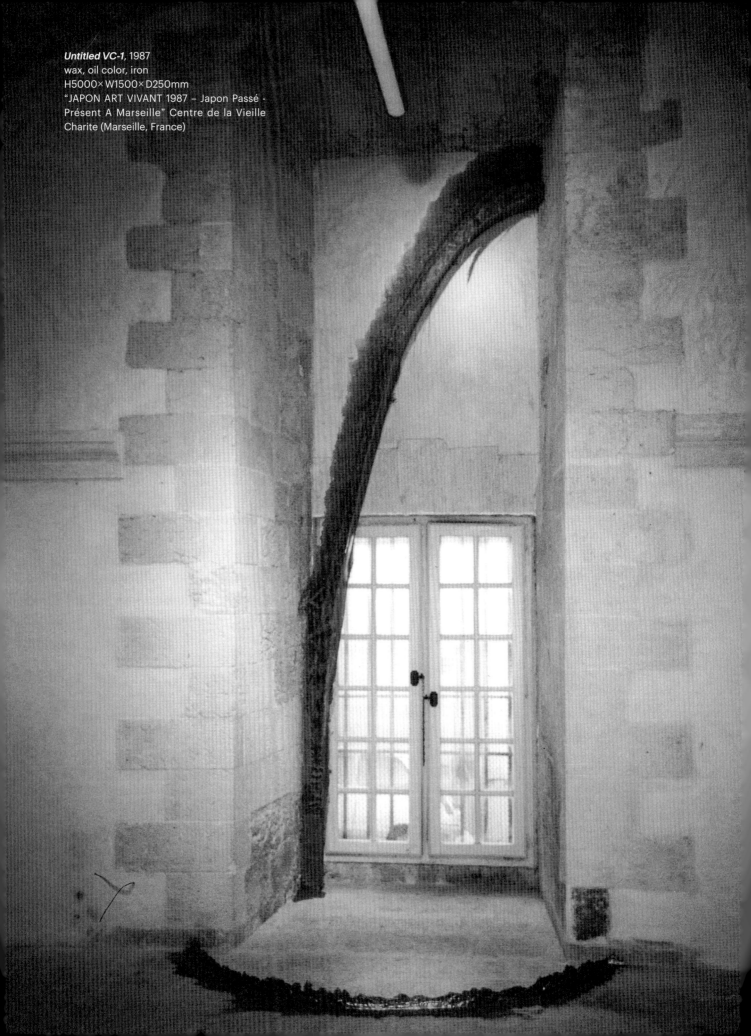

Untitled VC-1, 1987
wax, oil color, iron
H5000×W1500×D250mm
"JAPON ART VIVANT 1987 – Japon Passé -
Présent A Marseille" Centre de la Vieille
Charite (Marseille, France)

ヴィエイユ・シャリテ・センター（マルセイユ、フランス）にて、1982年
At Centre de la Vieille Charite (Marseille, France) 1982

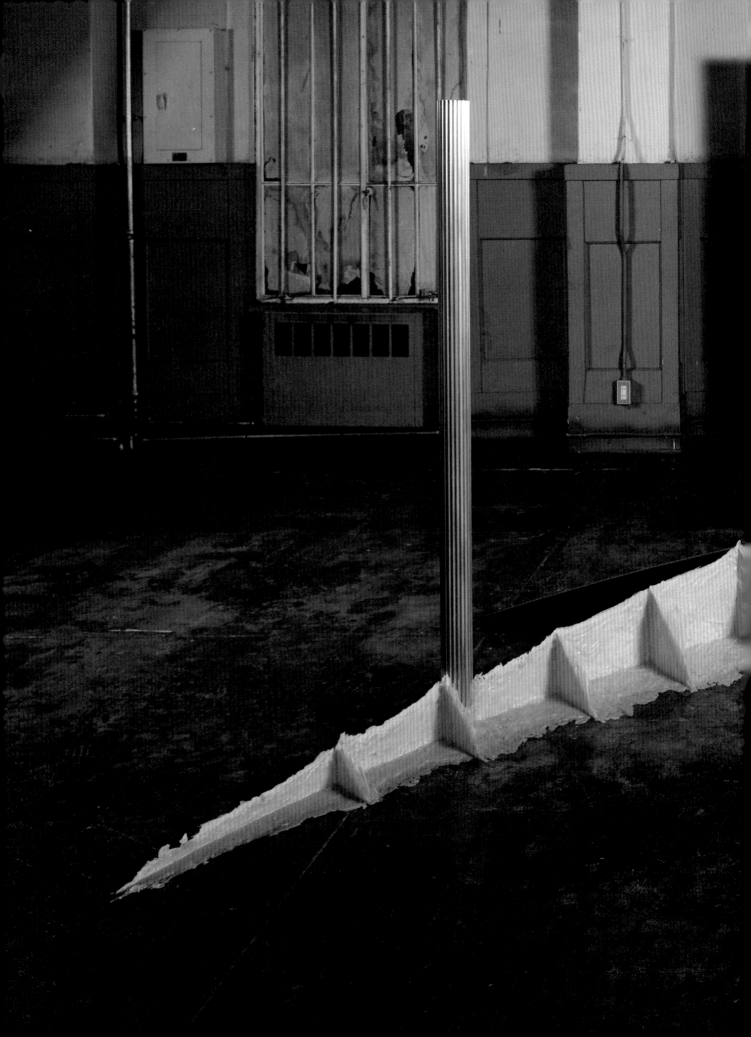

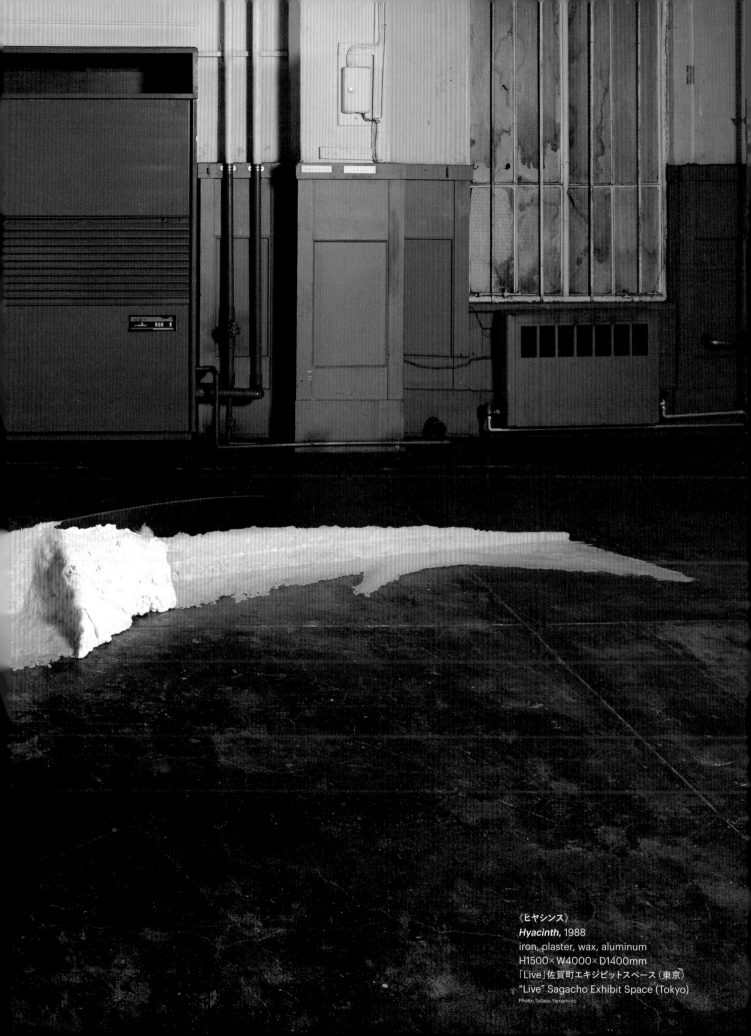

《ヒヤシンス》
Hyacinth, 1988
iron, plaster, wax, aluminum
H1500×W4000×D1400mm
「Live」佐賀町エキジビットスペース（東京）
"Live" Sagacho Exhibit Space (Tokyo)
Photo: Tadasu Yamamoto

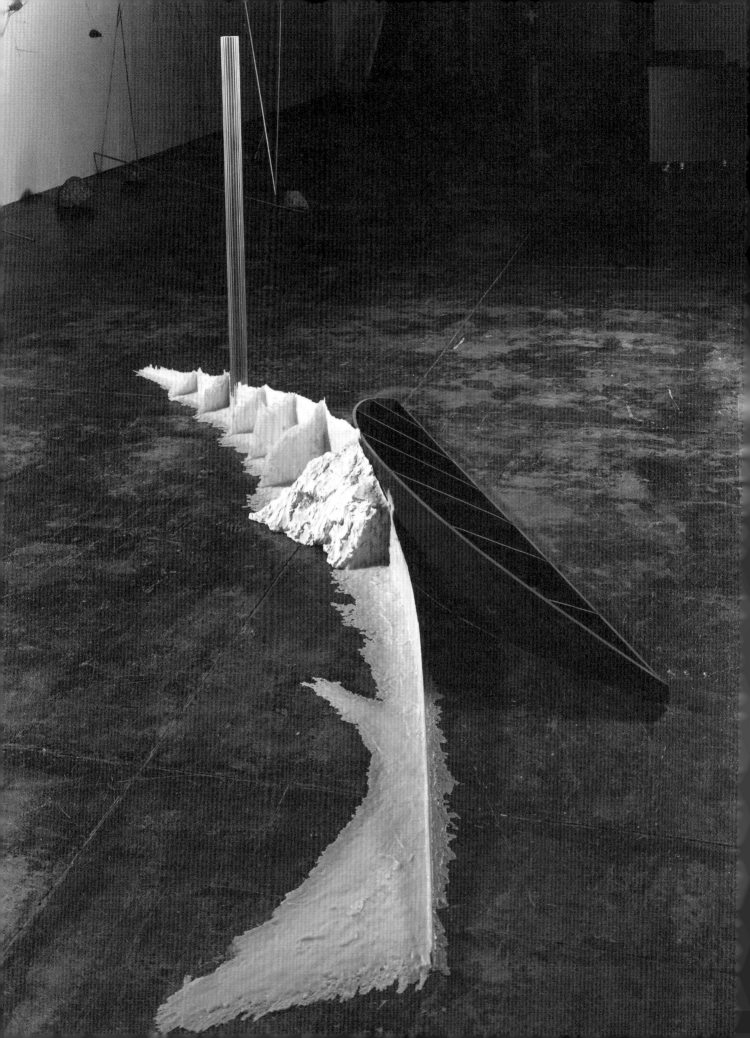

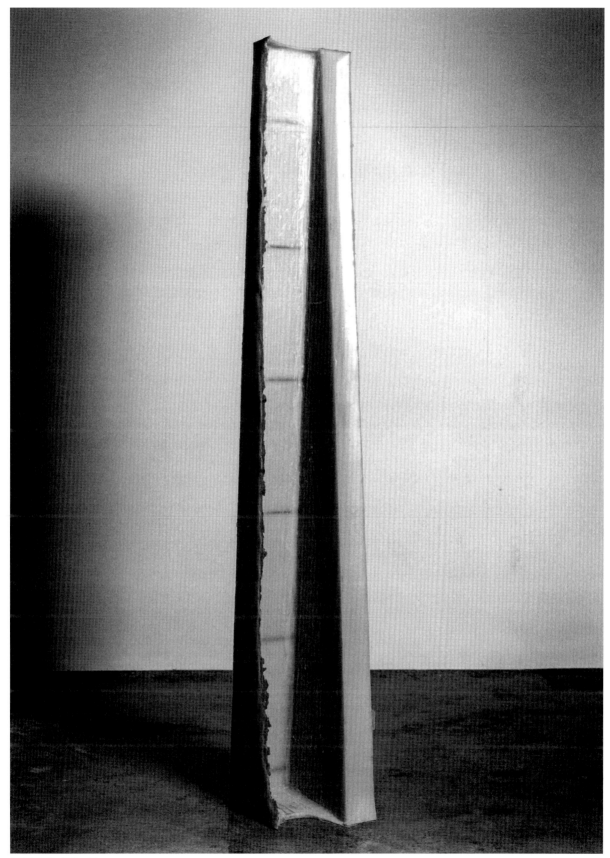

《不可思議の月立てり》
Rising Wonder Moon, 1988
wax, oil, iron
H1780×W200×D250mm
Photo: Tadasu Yamamoto

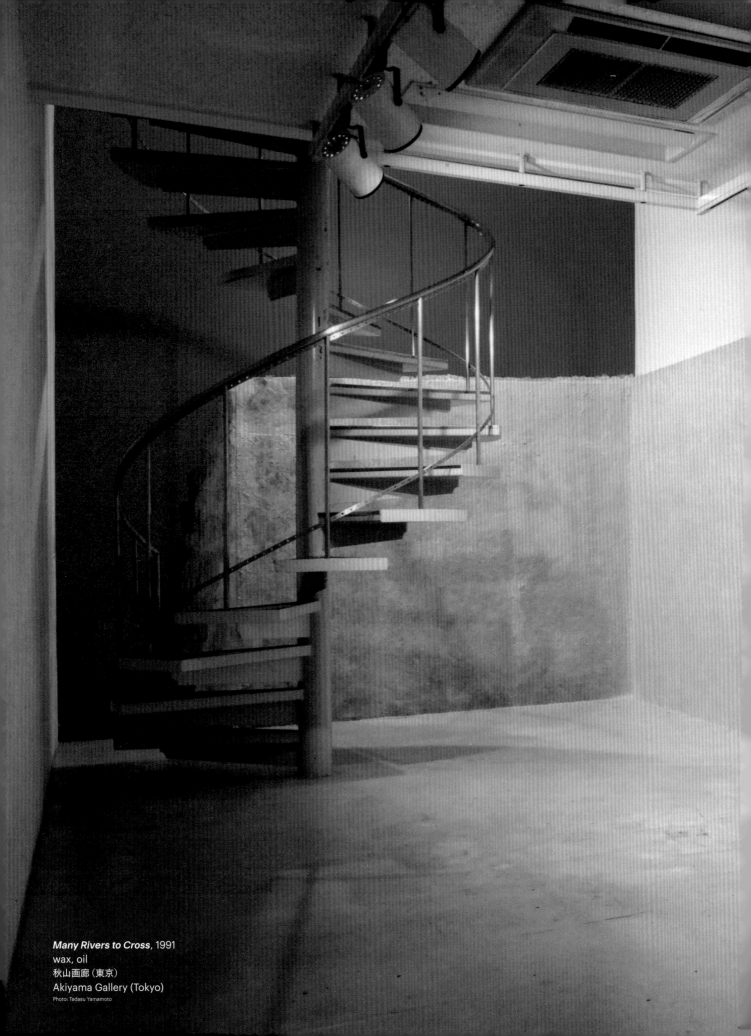

Many Rivers to Cross, 1991
wax, oil
秋山画廊（東京）
Akiyama Gallery (Tokyo)
Photo: Tadasu Yamamoto

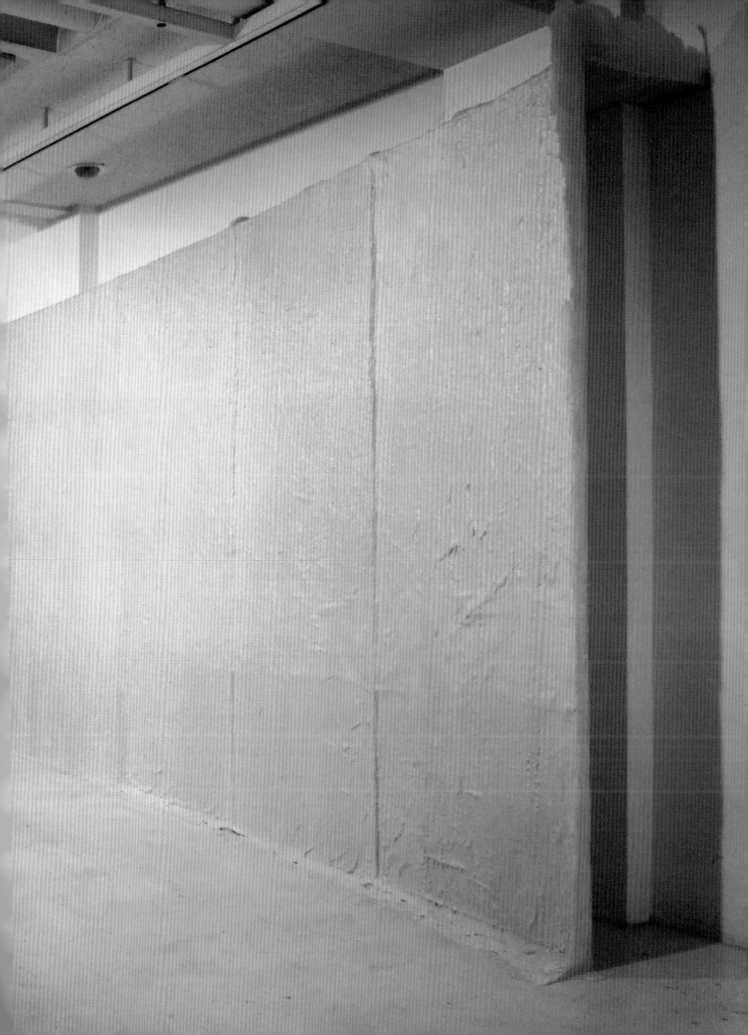

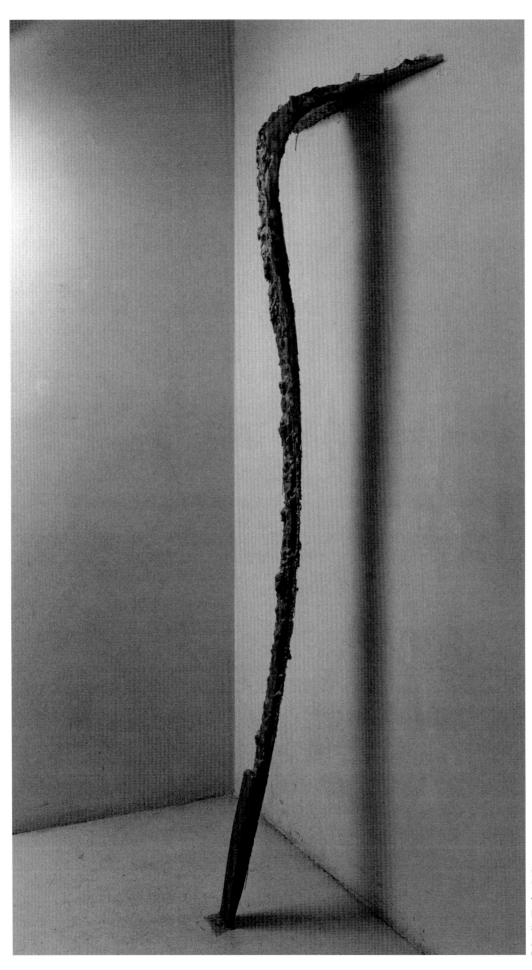

《ミューズの爪先》
Tiptoe of Muse, 1991
wax, oil
H2400×W900×D400 mm
秋山画廊（東京）
Akiyama Gallery (Tokyo)
Photo: Tadasu Yamamoto

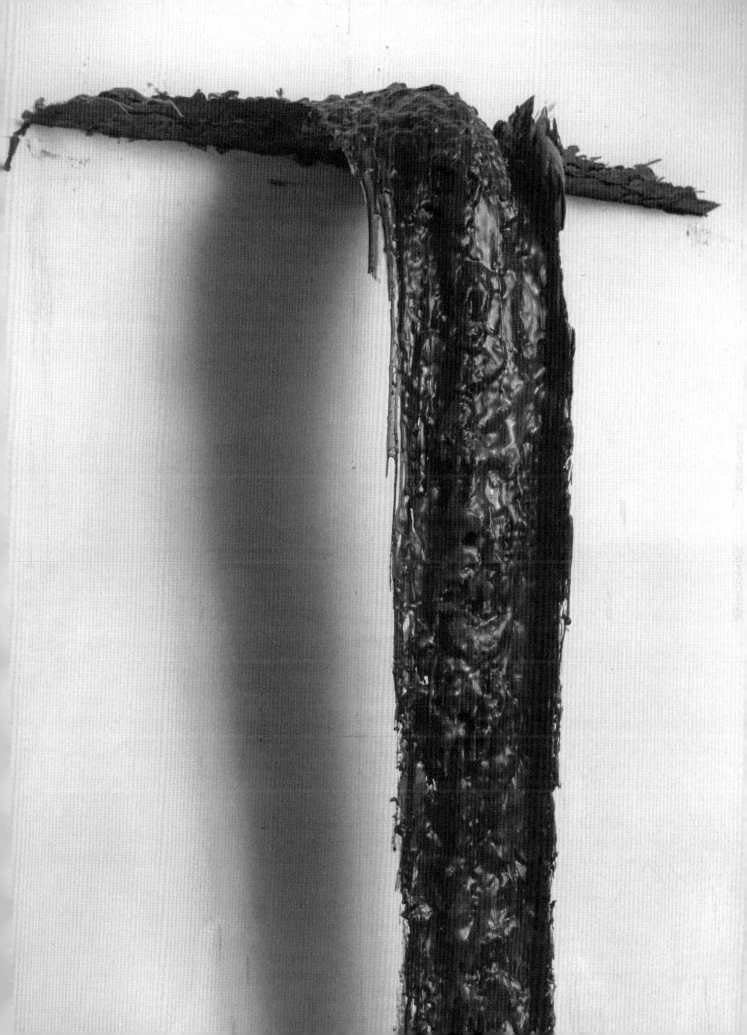

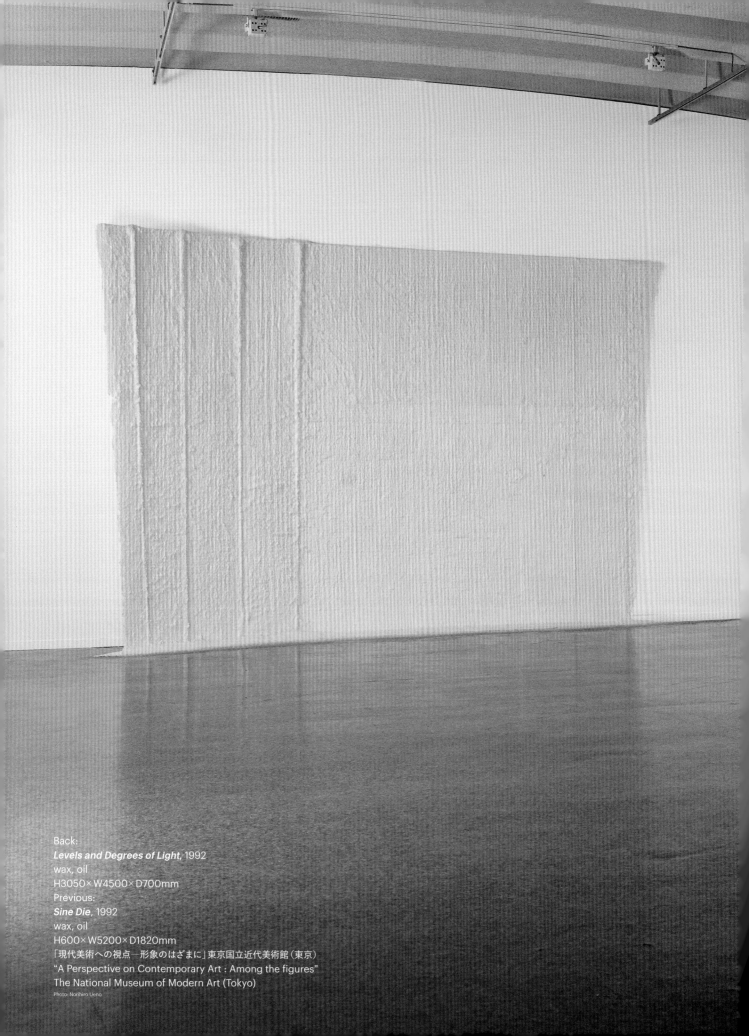

Back:
Levels and Degrees of Light, 1992
wax, oil
H3050×W4500×D700mm
Previous:
Sine Die, 1992
wax, oil
H600×W5200×D1820mm
「現代美術への視点—形象のはざまに」東京国立近代美術館（東京）
"A Perspective on Contemporary Art : Among the figures"
The National Museum of Modern Art (Tokyo)
Photo: Norihiro Ueno

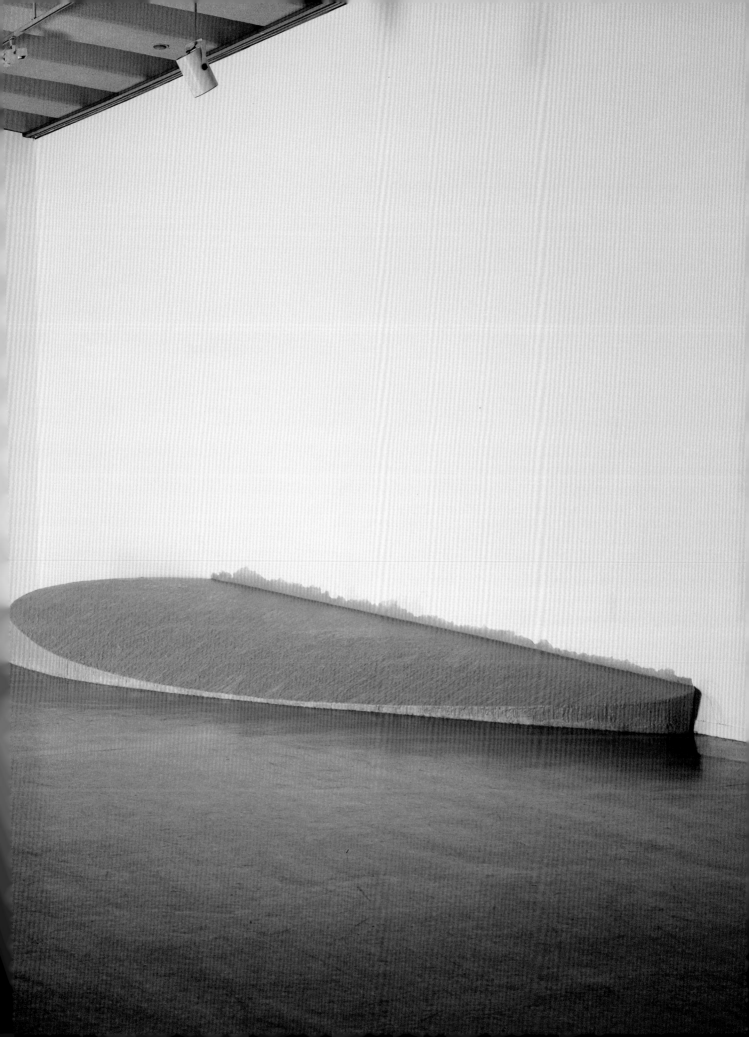

《月の径》
Lunar Passage (Models), 1994
FRP, paraffin, plaster
Studio SUMI in Togane (Chiba)

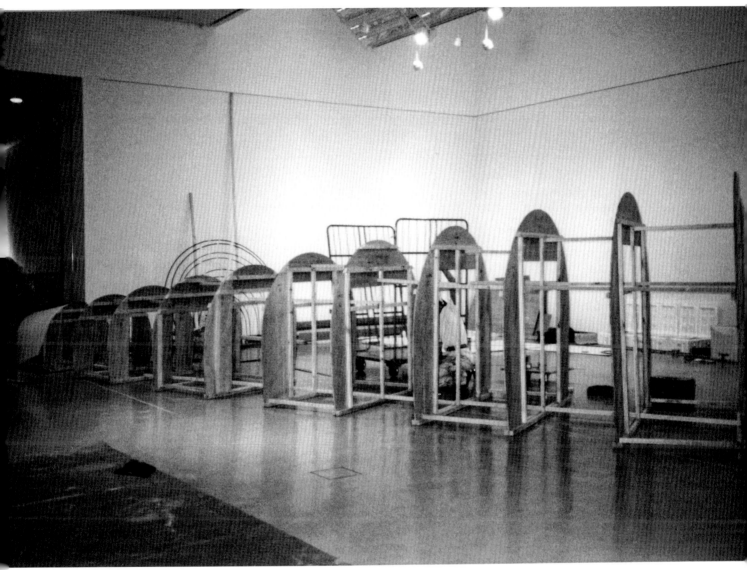

《月の径》
Lunar Passage (Framework), 1994
広島市現代美術館（広島）
Hiroshima City Museum of Contemporary Art (Hiroshima)

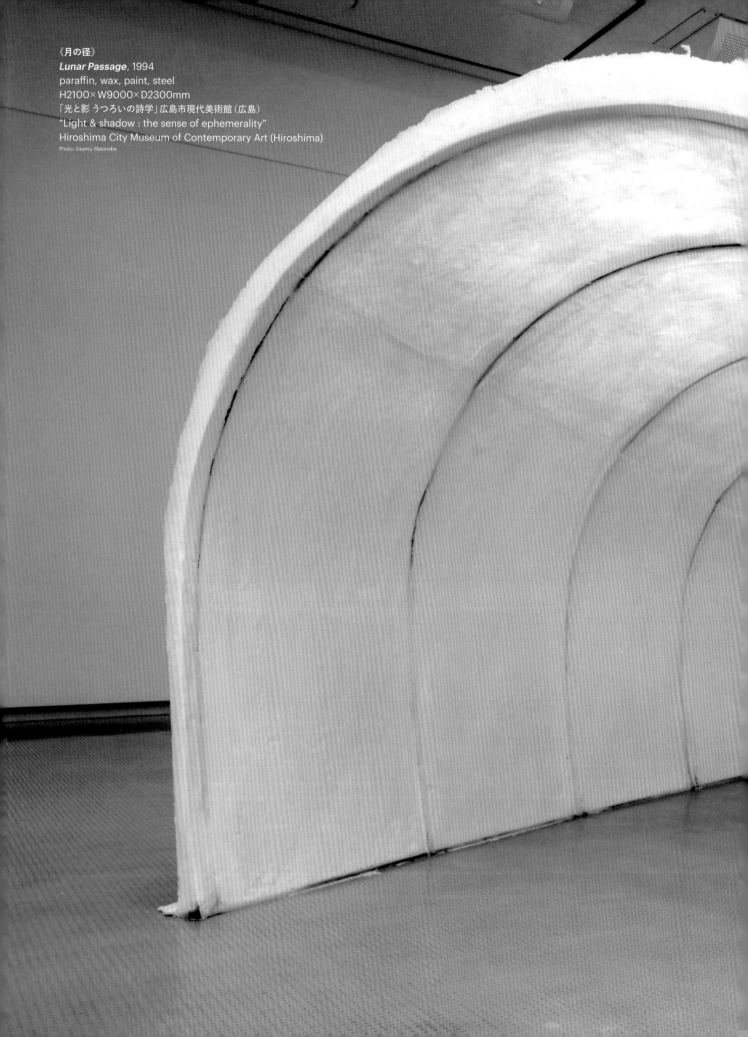

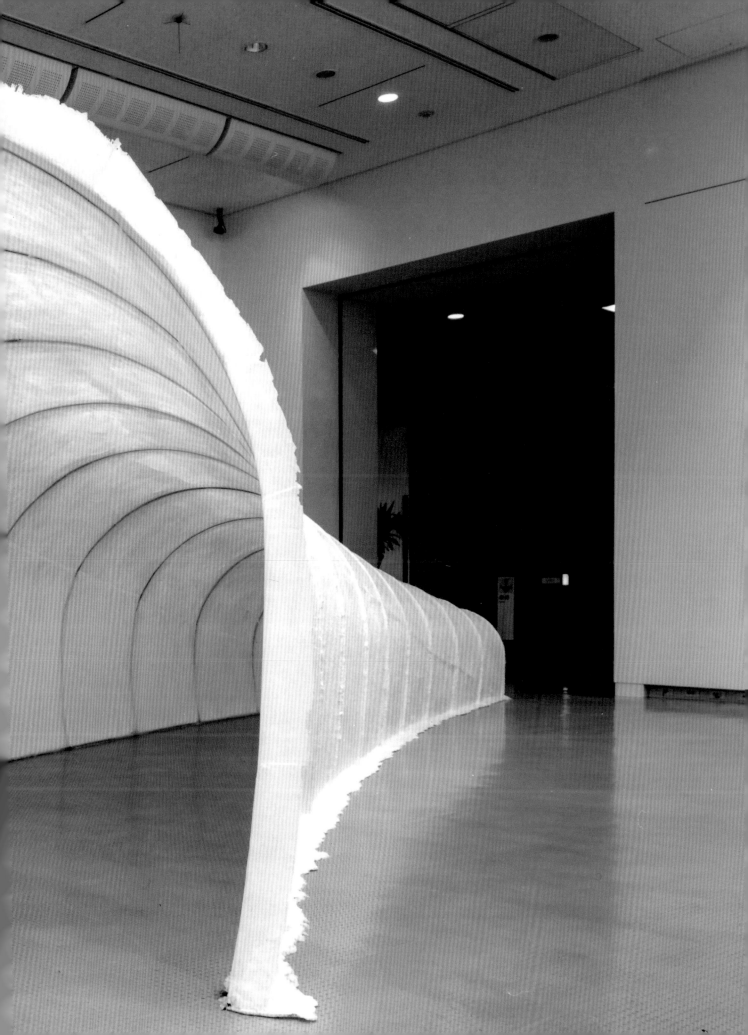

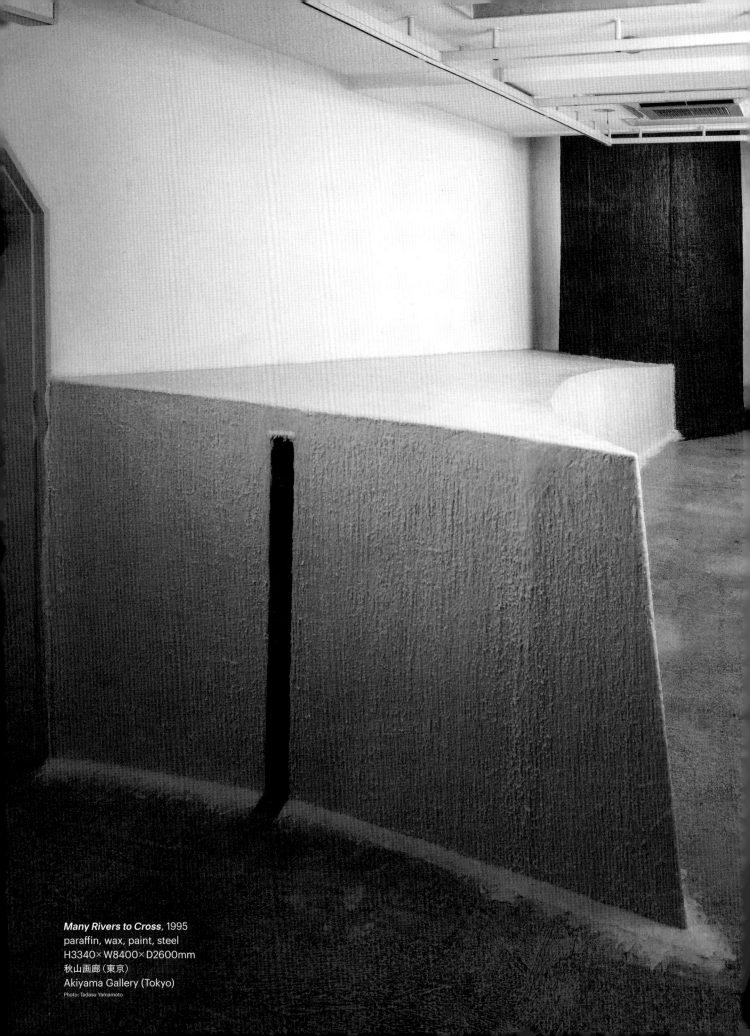

Many Rivers to Cross, 1995
paraffin, wax, paint, steel
H3340×W8400×D2600mm
秋山画廊（東京）
Akiyama Gallery (Tokyo)
Photo: Tadasu Yamamoto

Many Rivers to Cross (Working progress), 1995
秋山画廊（東京）
Akiyama Gallery (Tokyo)

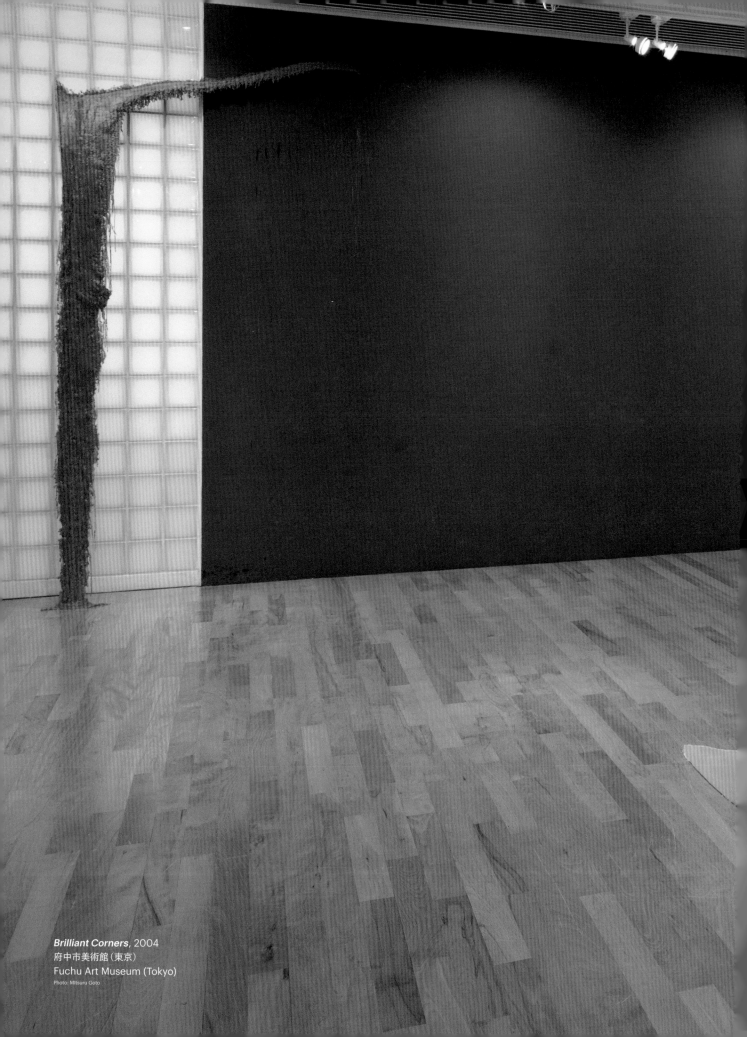

Brilliant Corners, 2004
府中市美術館（東京）
Fuchu Art Museum (Tokyo)
Photo: Mitsuru Goto

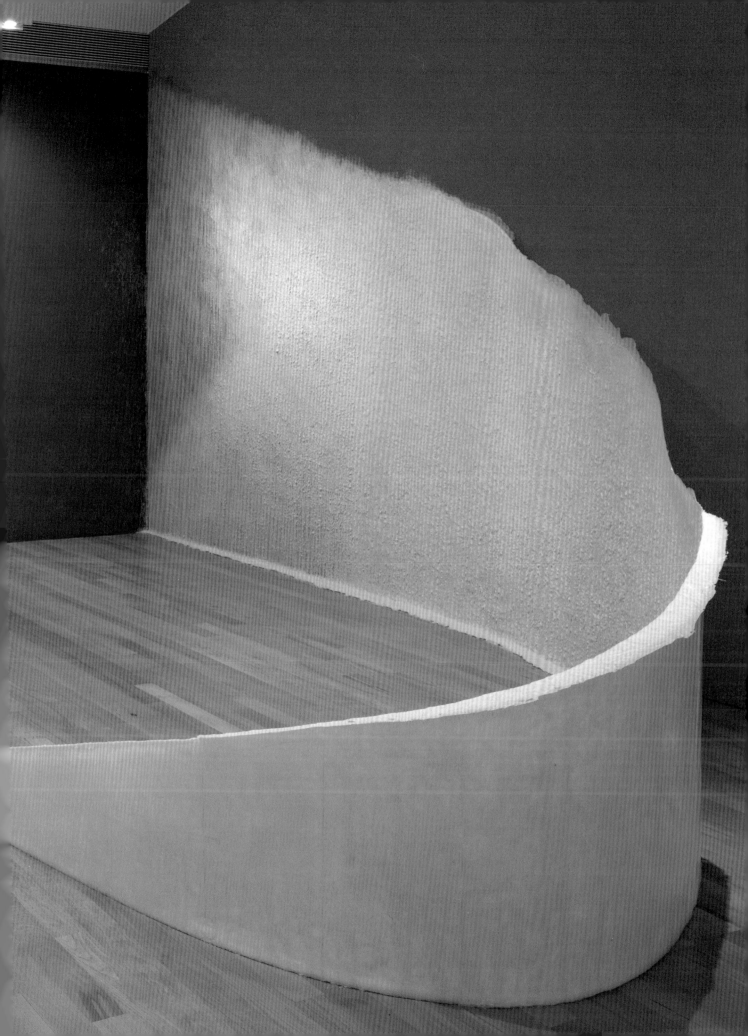

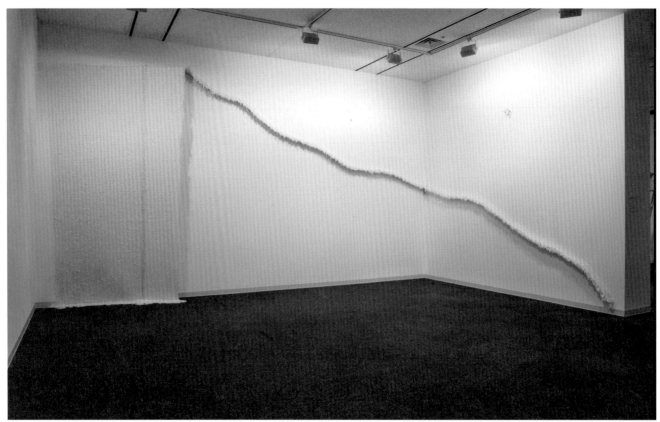

《Coral Cascade 2000（小林昭夫に捧ぐ）》
Coral Cascade 2000 (Dedicated to Akio Kobayashi), 2000
paraffin, wax, paint
H3000×W9000×D100mm
「ART TODAY 2000 Preview」セゾンアートプログラム・ギャラリー（東京）
"ART TODAY 2000 Preview" Saison Art Program Gallery (Tokyo)
Photo: Moriyoshi Sugaya

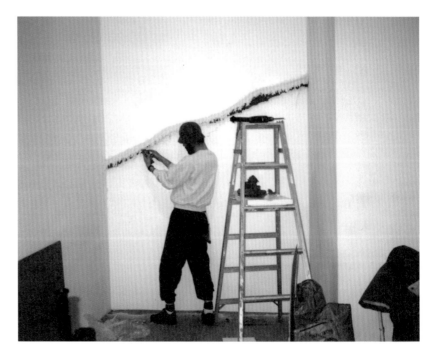

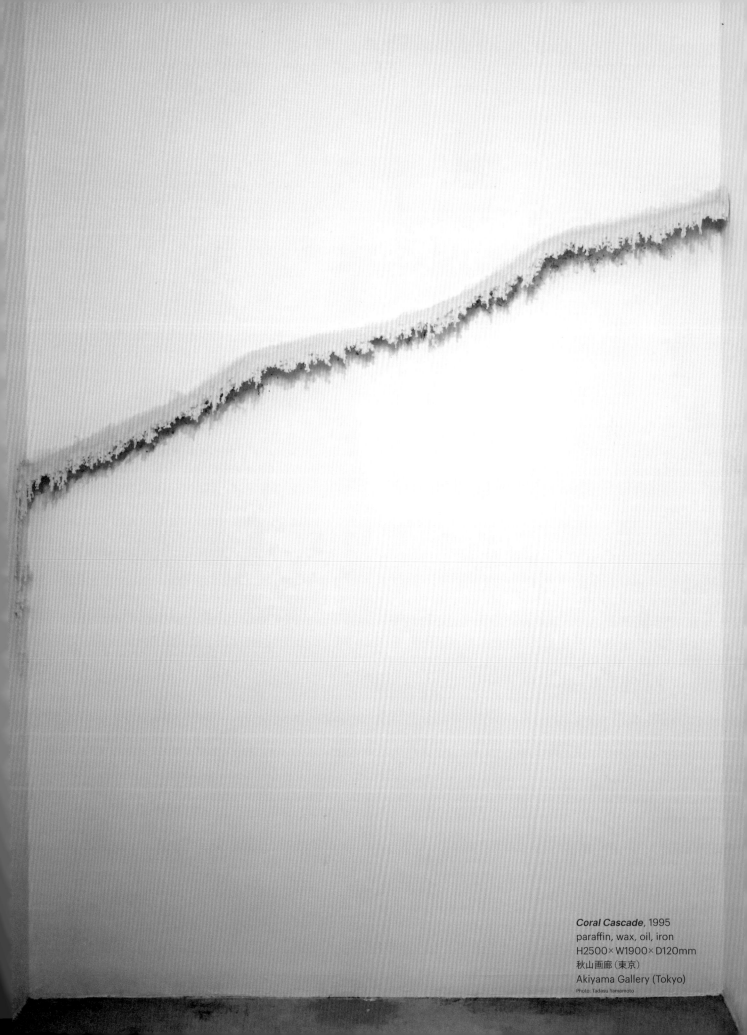

Coral Cascade, 1995
paraffin, wax, oil, iron
H2500×W1900×D120mm
秋山画廊（東京）
Akiyama Gallery (Tokyo)
Photo: Tadasu Yamamoto

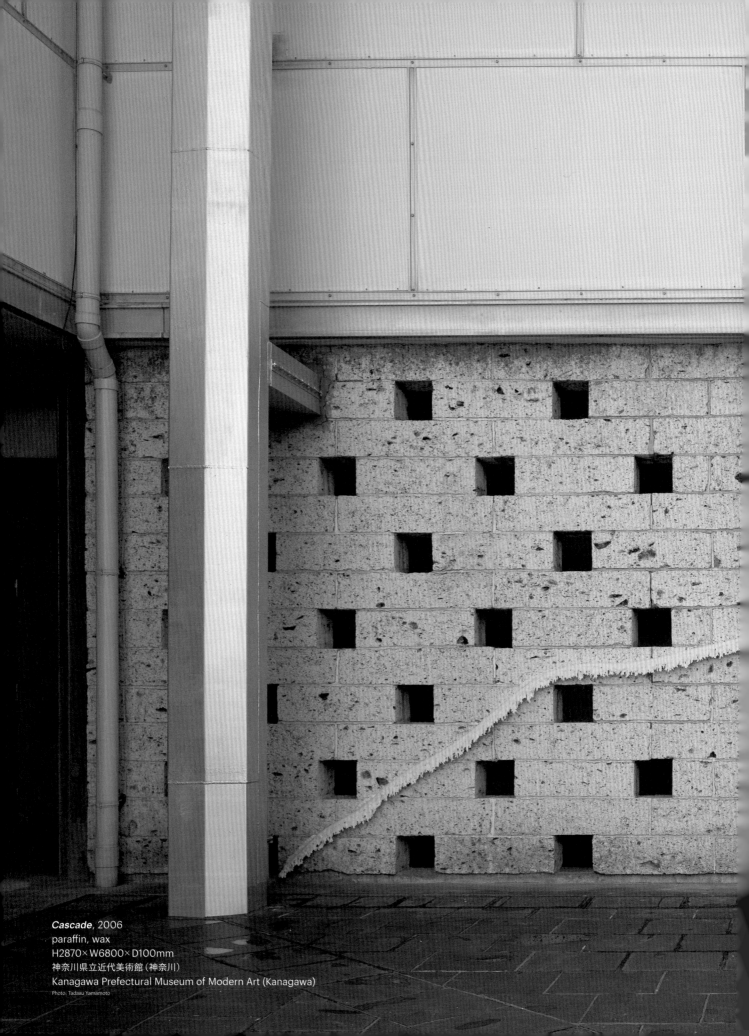

Cascade, 2006
paraffin, wax
H2870×W6800×D100mm
神奈川県立近代美術館（神奈川）
Kanagawa Prefectural Museum of Modern Art (Kanagawa)
Photo: Tadasu Yamamoto

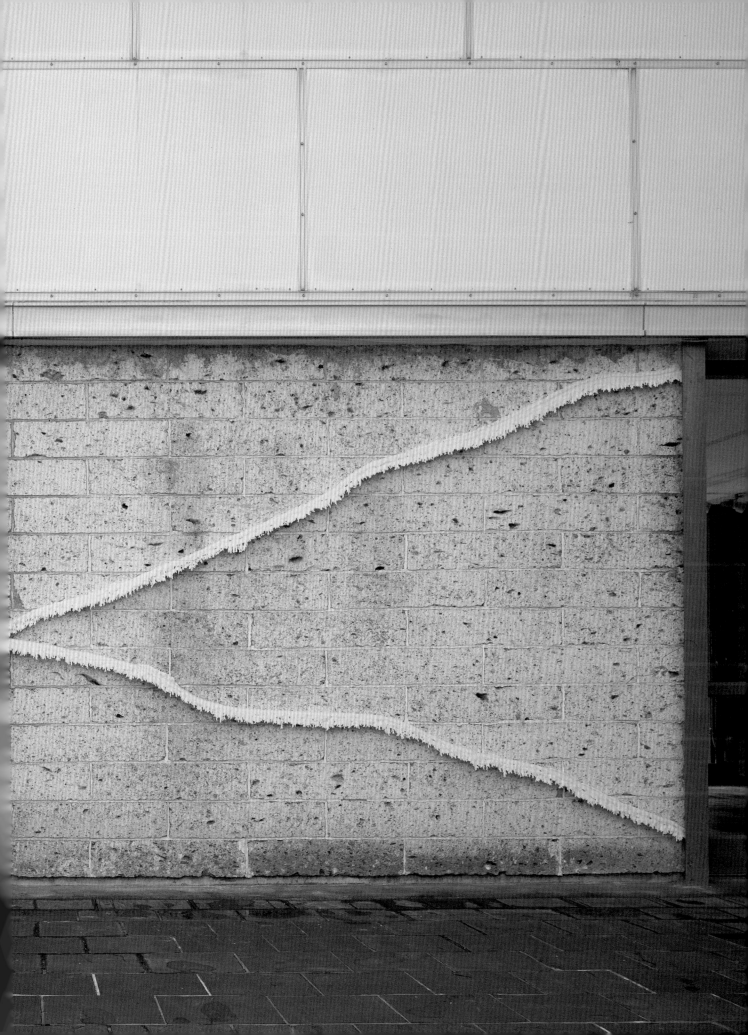

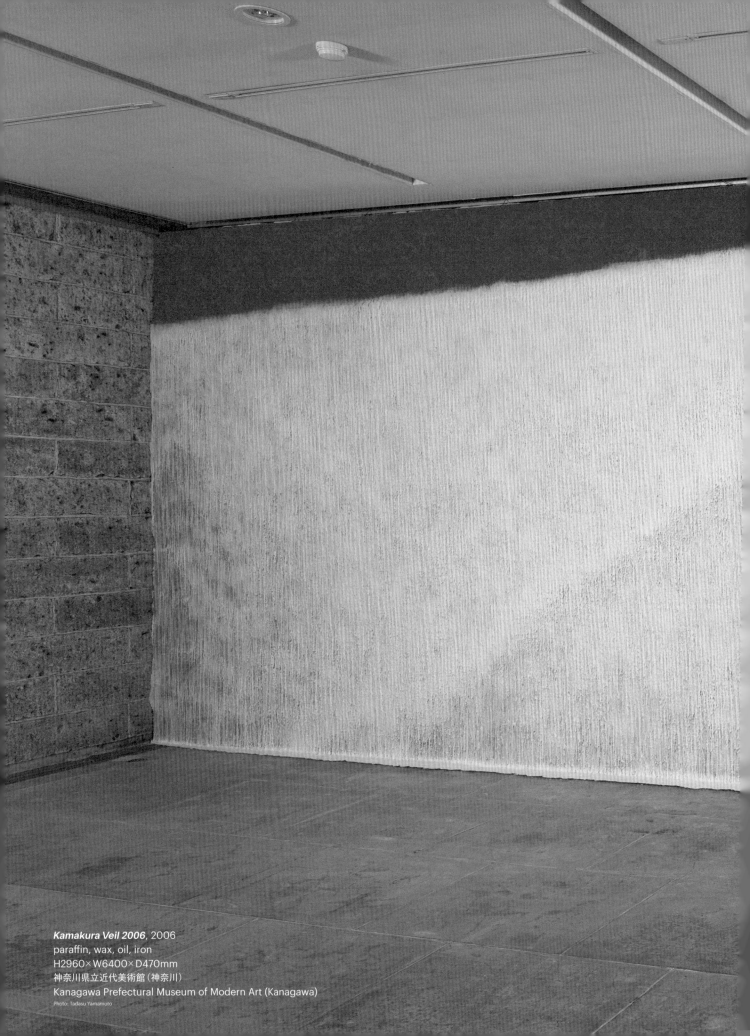

Kamakura Veil 2006, 2006
paraffin, wax, oil, iron
H2960×W6400×D470mm
神奈川県立近代美術館（神奈川）
Kanagawa Prefectural Museum of Modern Art (Kanagawa)
Photo: Tadasu Yamamoto

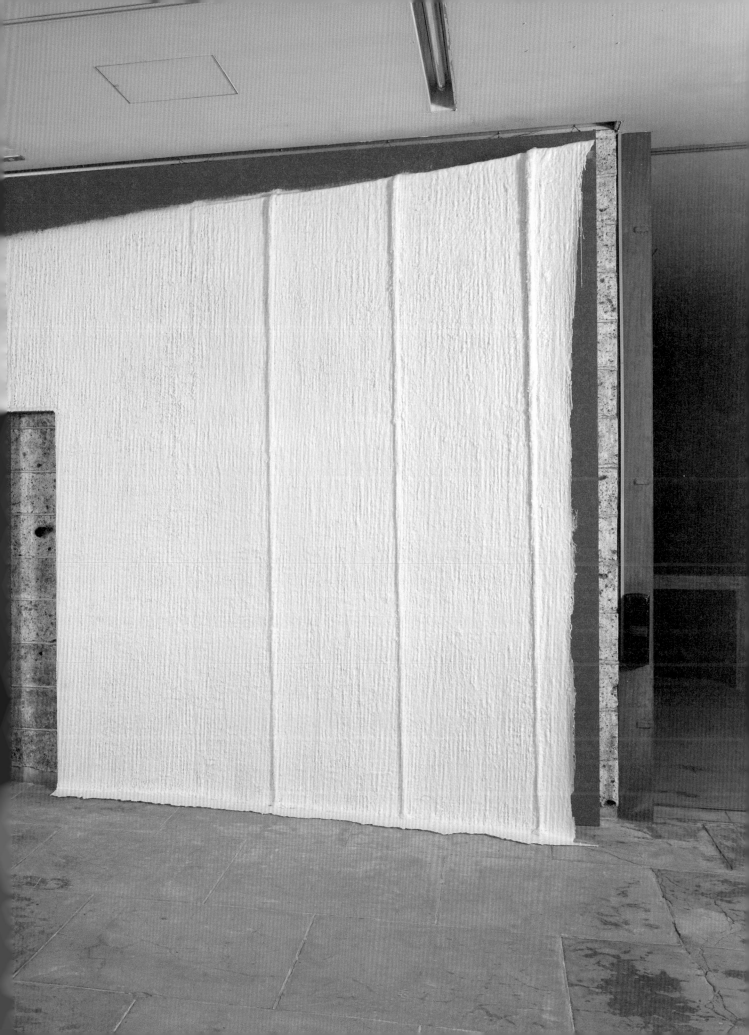

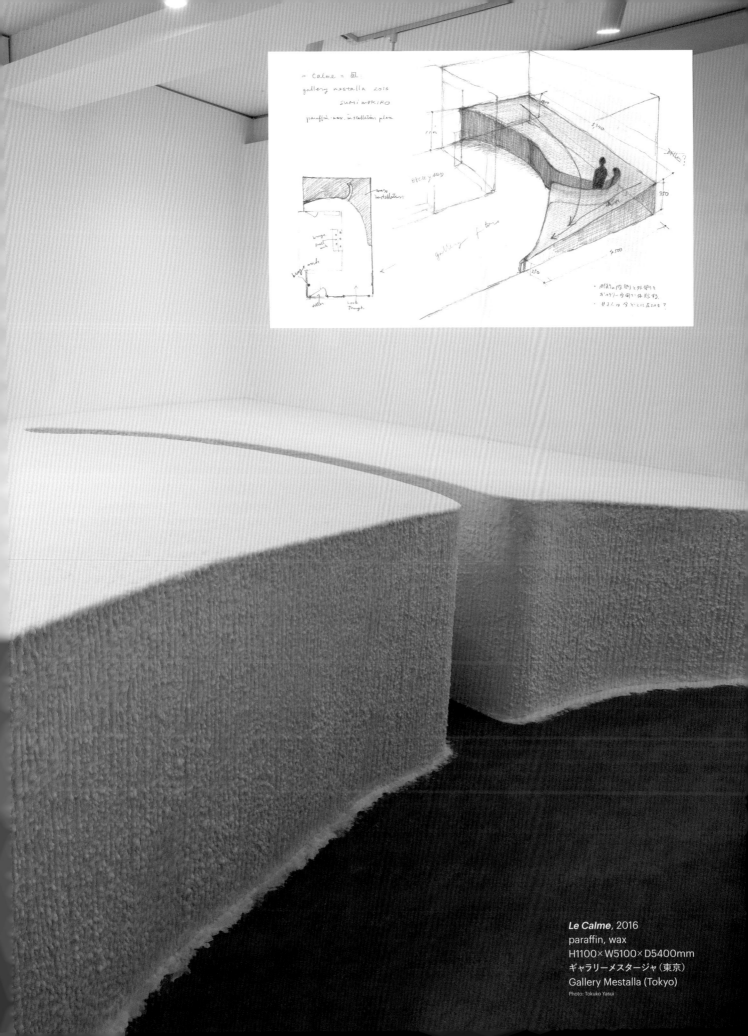

Le Calme, 2016
paraffin, wax
H1100×W5100×D5400mm
ギャラリーメスタージャ（東京）
Gallery Mestalla (Tokyo)
Photo: Tokuko Yasui

VEIL
SERIES

ヴェール（ナイアガラ）

ワックスワークとブロンズキャスティングワークに共通しているのは立ちあがるヴェールの壁のイメージです。これをはっきりと意識したのは1976年にアメリカのナイアガラ大瀑布を訪れた折に、カナダ側に渡って滝壷の裏側を見ることができたときでした。滝の内側に開けられたトンネルを抜けてたどり着いたそこはグオーゴゴーゴゴーグオーという大音響で流れ落ちる大量の水から飛沫と風が巻きあがっており、まるで世界が逆転したような爆音で落下しながらも無音のスローモーション映像の世界に迷い込んでしまったかのように私はしばらく動くことができませんでした。「これだ、これだ。世界はヴェールだ。世界はヴェールでできているんだ。」

Veil (Niagara)

What waxwork and bronze casting work have in common is the image of a rising veil wall. This became clear to me in 1976, when I visited the Niagara Falls and had the opportunity to cross over to the Canadian side of the falls to see the other side of the basin. Passing through an opening within the waterfall, I arrived at a place where a massive force of water cascaded down with a thunderous "goo-go-go-go-go-o" sound, sending up splashes and howling winds. It was as if I was lost in a world of silent, slow-motion imagery as it fell with an explosive sound as if the world turned upside down. I was unable to move for a while. "This is it, this is it. The world is a veil. The world is created by veils."

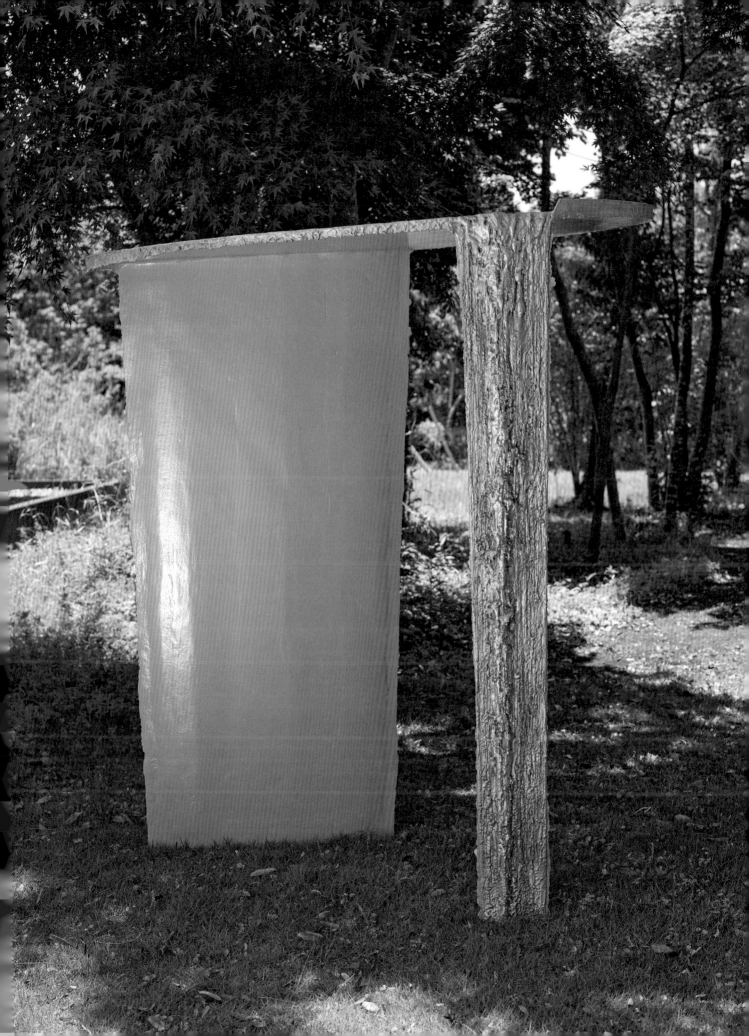

ナイアガラの滝、カナダ側にて、1976年
Niagara Falls, Canadian side, 1976

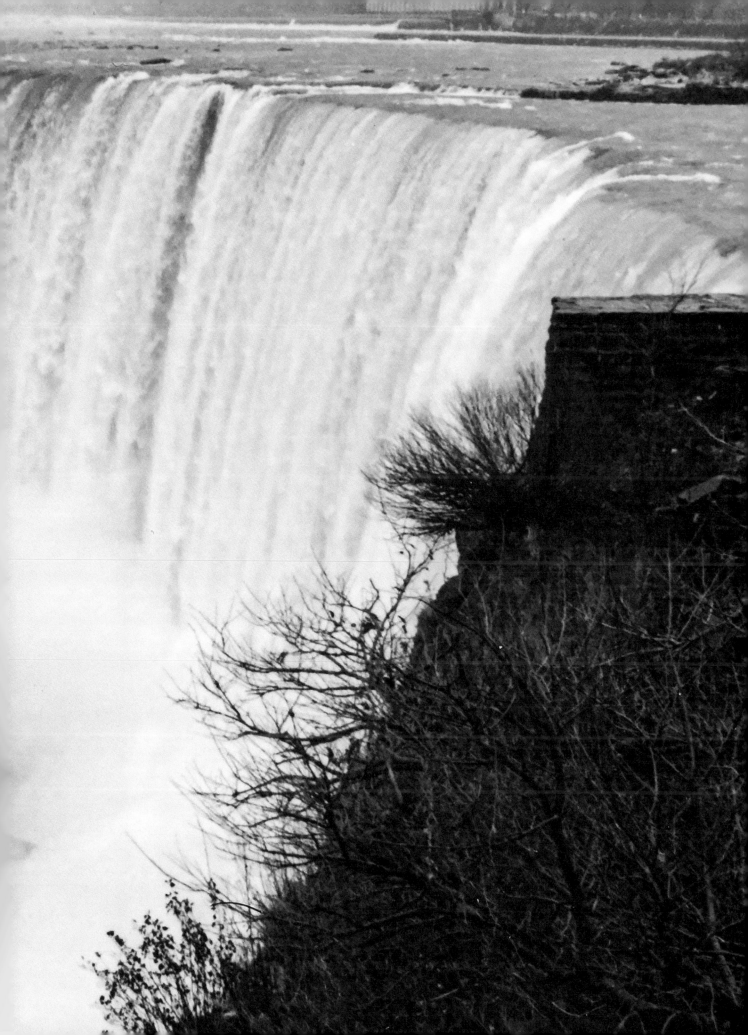

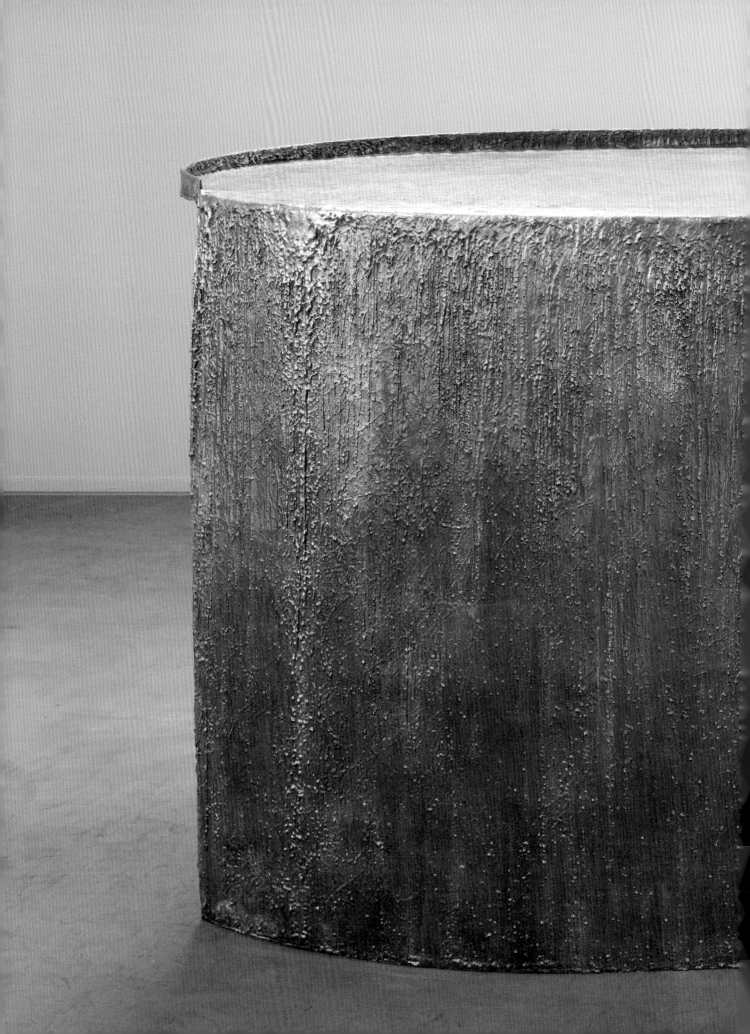

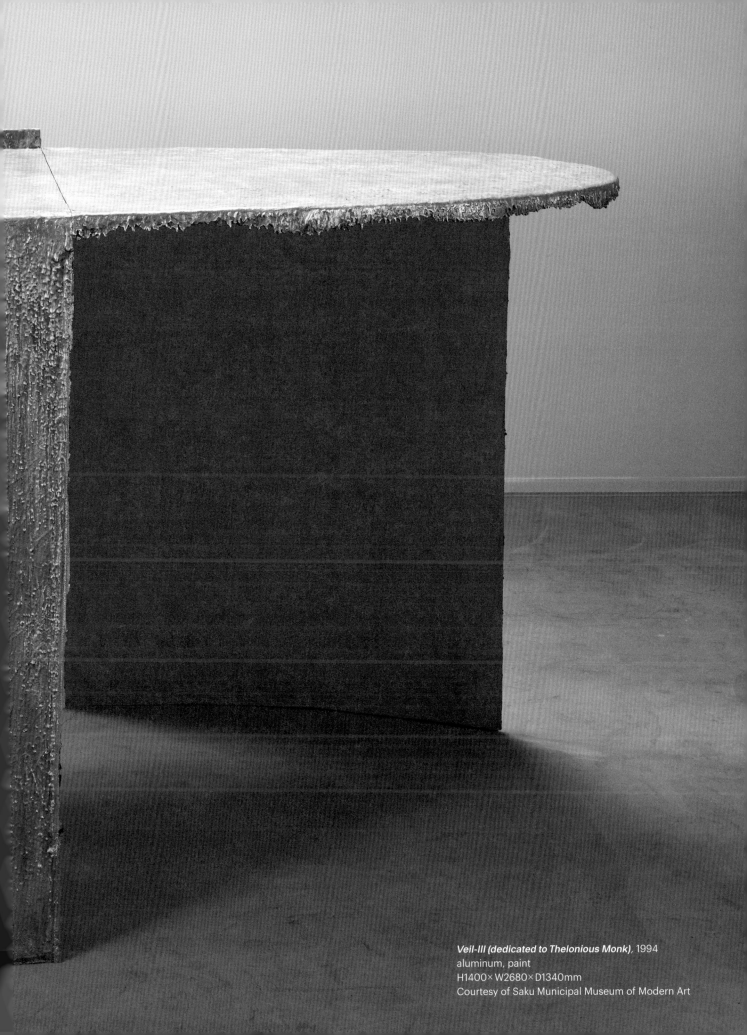

Veil-III (dedicated to Thelonious Monk), 1994
aluminum, paint
H1400× W2680×D1340mm
Courtesy of Saku Municipal Museum of Modern Art

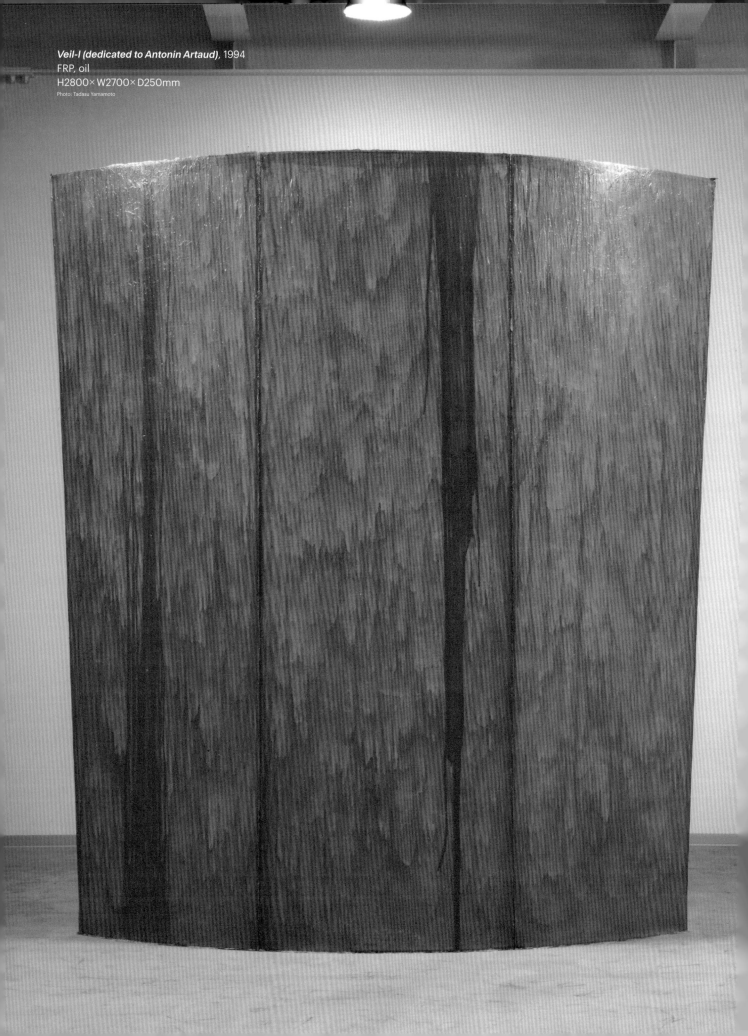

Veil-I (dedicated to Antonin Artaud), 1994
FRP, oil
H2800× W2700× D250mm
Photo: Tadasu Yamamoto

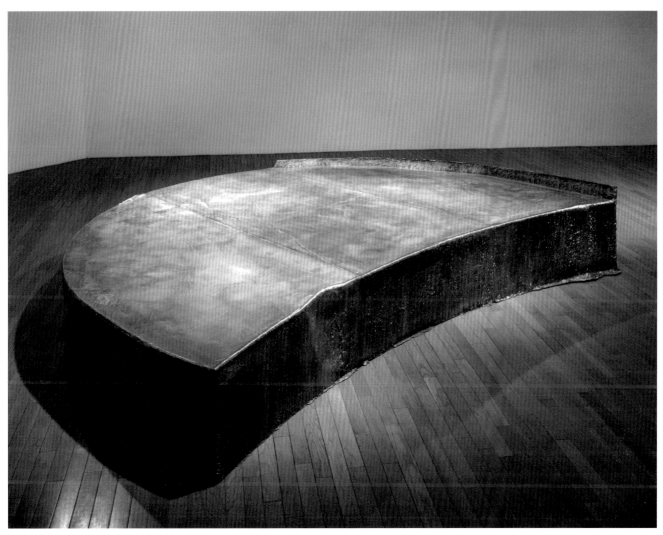

Veil-II (dedicated to Carl Theo Dreyer), 1994
aluminum, paint
H490× W3000× D2200mm
Photo: Tadasu Yamamoto

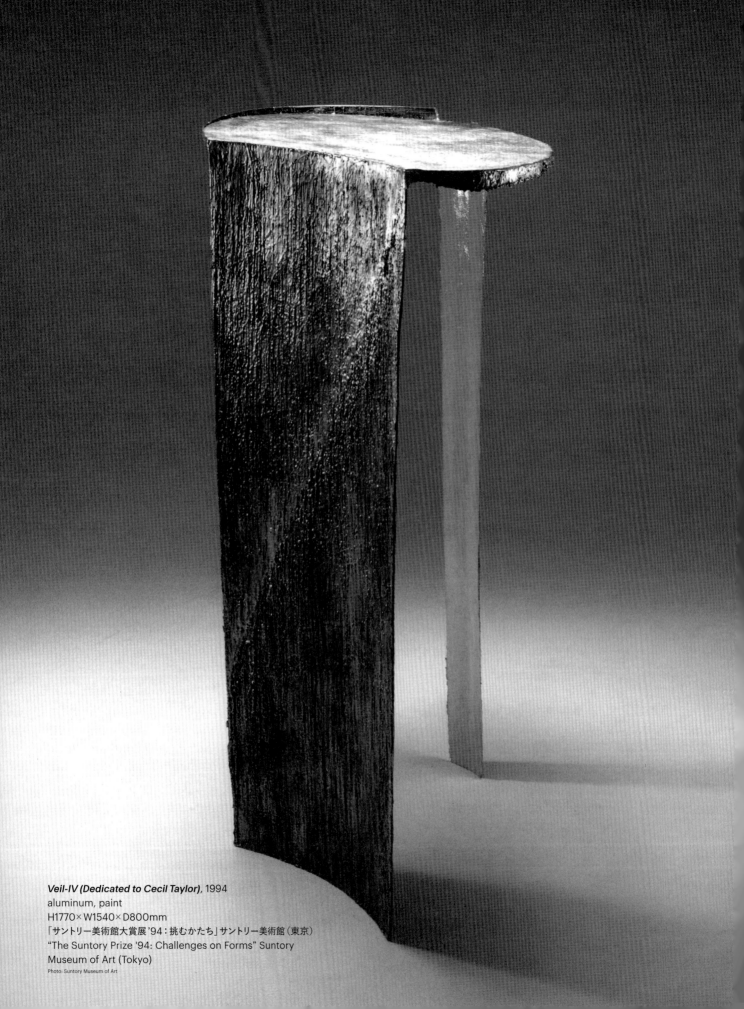

Veil-IV (Dedicated to Cecil Taylor), 1994
aluminum, paint
H1770×W1540×D800mm
「サントリー美術館大賞展'94：挑むかたち」サントリー美術館（東京）
"The Suntory Prize '94: Challenges on Forms" Suntory
Museum of Art (Tokyo)
Photo: Suntory Museum of Art

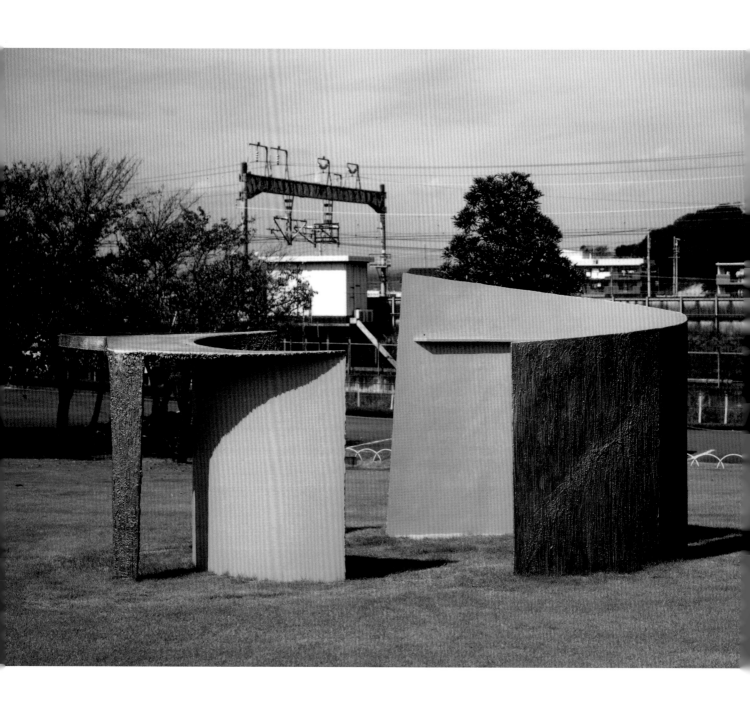

《終わりなきヴェール》
Veil-endless, 1999
aluminum, paint
H2300× W5000× D2000mm
Courtesy of Shiseido Art House
Photo: Tadasu Yamamoto

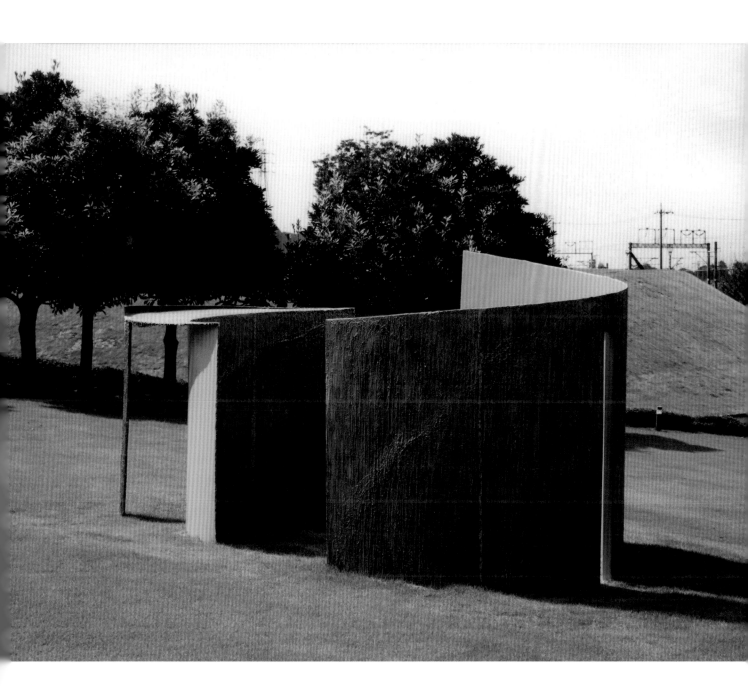

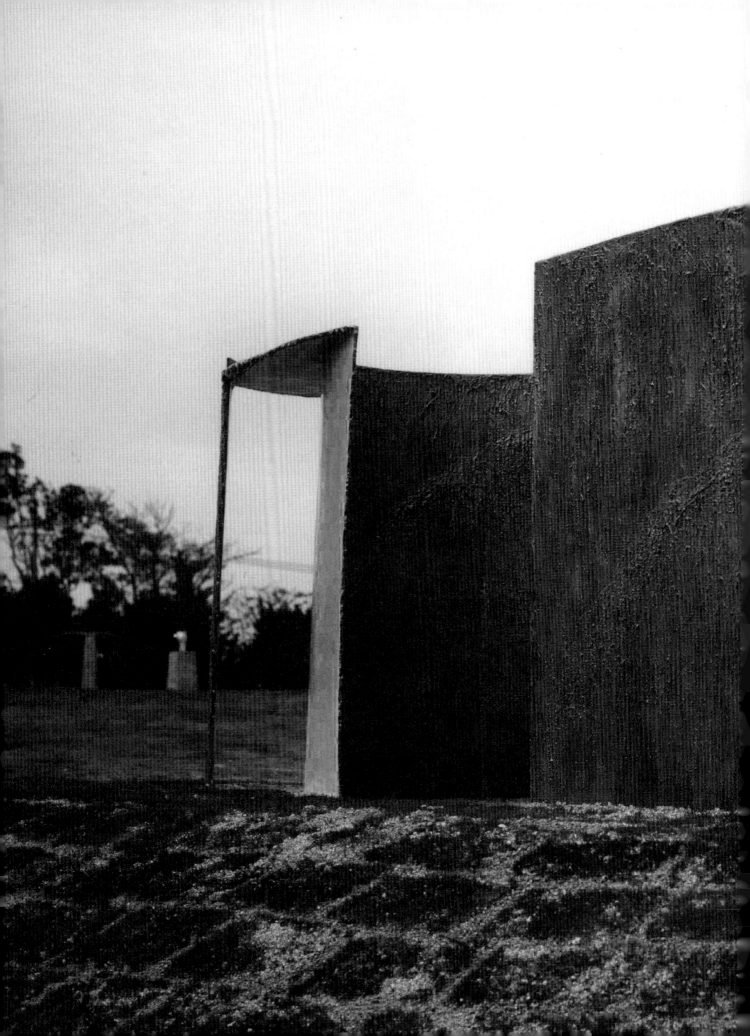

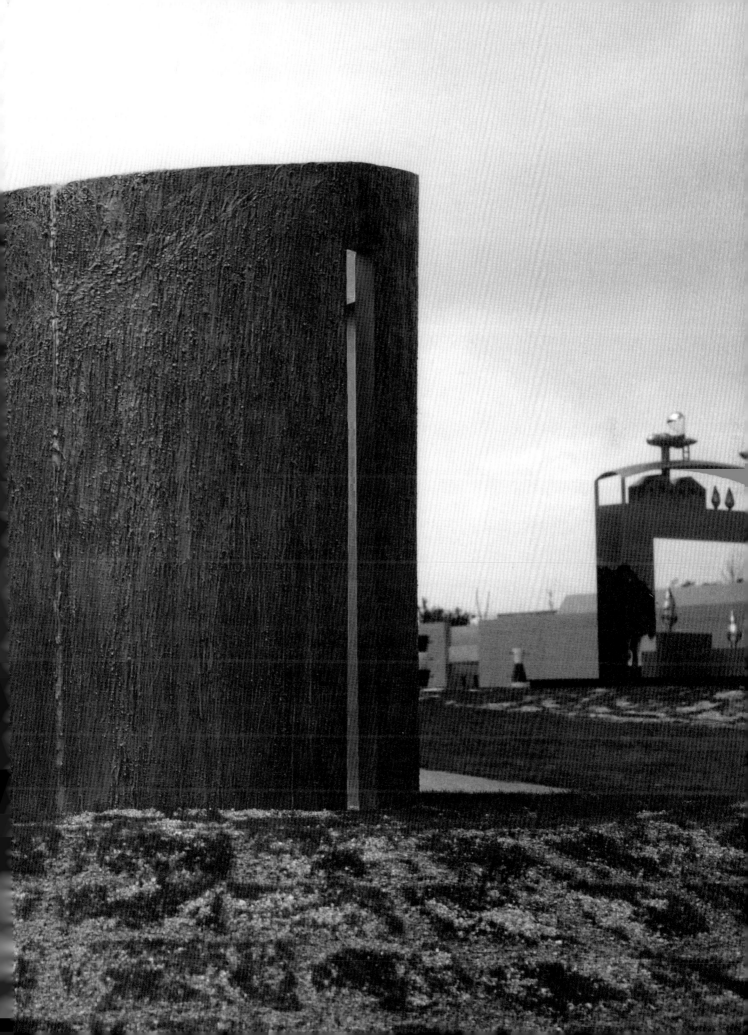

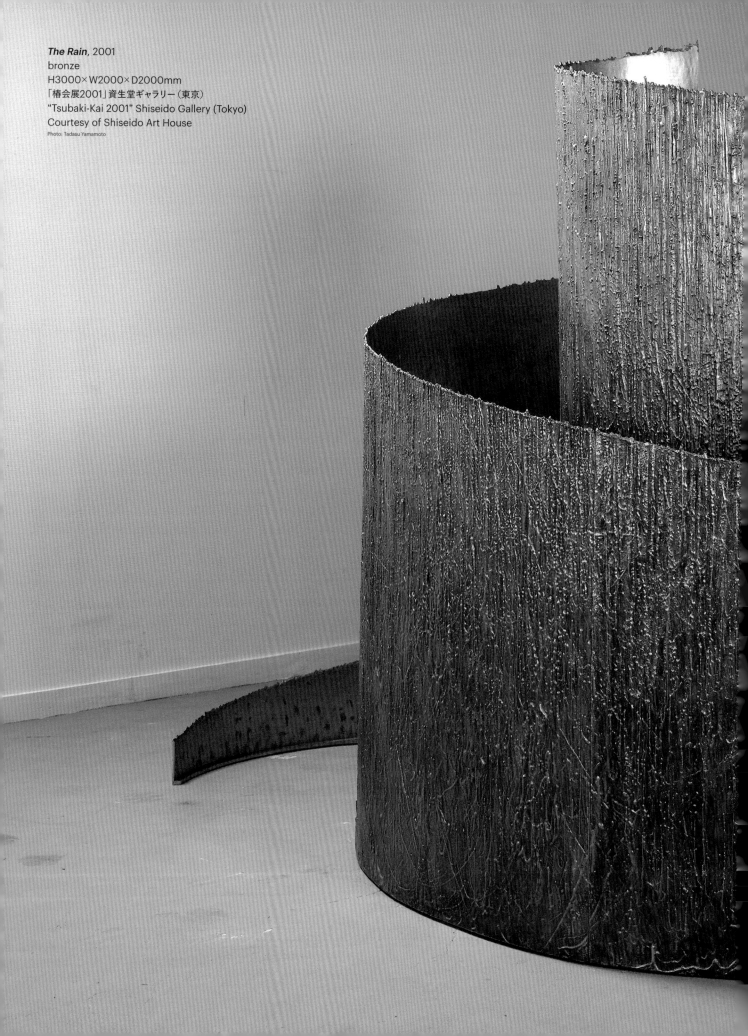

The Rain, 2001
bronze
H3000×W2000×D2000mm
「椿会展2001」資生堂ギャラリー（東京）
"Tsubaki-Kai 2001" Shiseido Gallery (Tokyo)
Courtesy of Shiseido Art House
Photo: Tadasu Yamamoto

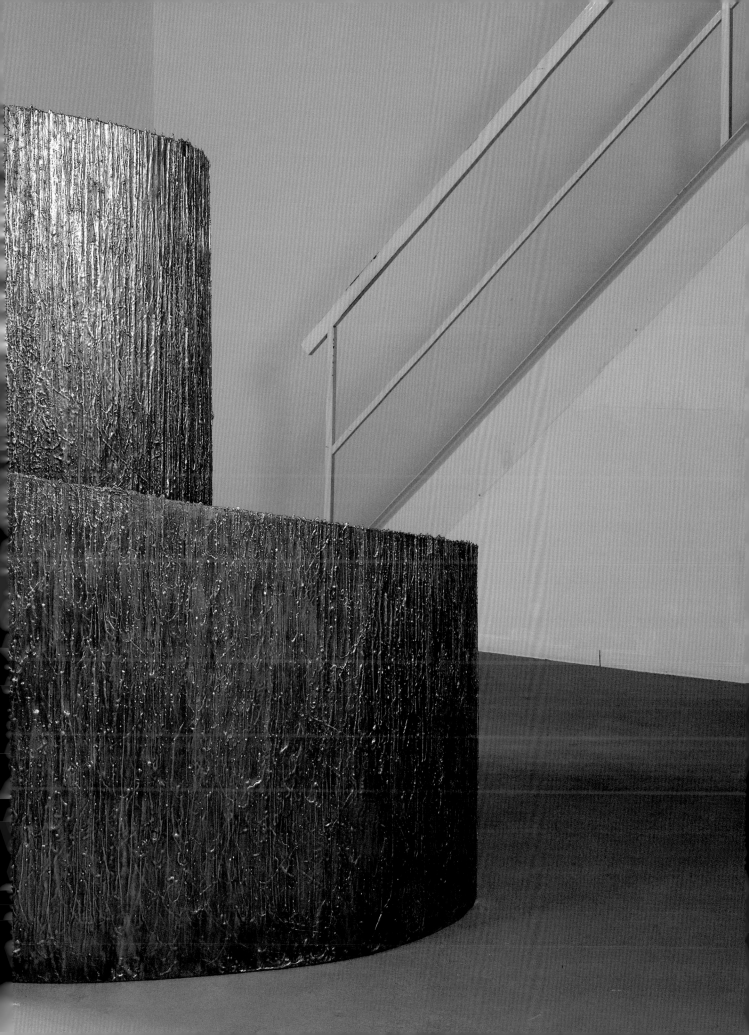

もうひとつのヴェール

松浦寿夫

さまざまな眼86―鷲見和紀郎展「アラベスク」カタログより(1997)

あれはいつの頃だったか、鷲見和紀郎が、デヴィッド・スミスの「キュービ」連作に見られる表面の処理に関して、それが溶接部分の痕跡を消し、かつ、これらの作品の表層にこういってよければ、オール・オーヴァな視覚的に均等性を与えるための手続きであると指摘したことを筆者はきわめて鮮明に記憶している。それは、スミスの彫刻に関してかつて書かれたさまざまな命題のなかでも、その明晰さにおいてとりわけ際立った命題でありえたからであり――この命題の絶対的な明証性のゆえに、それは発話された直後からあたりまえの指摘のような様相をとらざるをえなくなるのだが――、また、それ以上に、いまの時点でふり返ってみれば、このテクストで、鷲見和紀郎は自分の彫刻的な実践に対してもまた、きわめて明晰な意志の提示を行っていたことが理解される。ここで、ポロックが絵画を制作するように彫刻を作るという、彼の言明を想起しておくべきだろうか。

ともあれ、鷲見和紀郎の彫刻の展開を概観してみれば、一連の試みがたえず何らかの二重性に引き裂かれている事態に否応なく直面せざるをえないだろう。より正確にいえば、これらの二重性による分裂こそが、作品を産出させずにおかぬ苦痛にみちた源泉であるばかりか、彼の作品群にある種の感動的な質を与えているという事実を確認せざるをえないということだ。そして、この二重性の一例を、垂直性／水平性、視覚的な表層／触覚的な表層、充実したもの／空虚なもの、包囲するもの／包囲されるもの、幾何学的な表層の平坦性／触覚的な表層の起伏性、モノクロミー／ポリクロミー、量塊性／非量塊性等々、たやすく指摘することができるだろうし、また、このリストをたとえば素材的な次元を考慮に入れるなどして、さらに拡大していくことはきわめて容易であるといってもよい。

だが、改めて指摘するまでもないことだが、鷲見和紀郎はこの二重化にともなう非整合性を、単にあるがまま

に、いわば敗北主義的に露呈させることに満足しているわけではない。彼の作品にある特殊な強度を与えているのは、まさにこのふたつの背反する領域の間にいくつもの力線を産出しているという事実に他ならない。この力線に対して、彼は、橋という暗喩を与えているが、ここで、彼にもなじみ深い、――というのも、それは、彼の「ヴェール III 」(1994年)が敬意とともに捧げられるセロニアス・モンクの実践を深く特徴づけた概念なのだから――、もうひとつ別の暗喩を導き出すこともできる。それは、いうまでもなく、ブルー・ノートという概念である。実際、ブルー・ノートとは、ふたつの対立するブロックの間を駆けぬける半音階であり、どちらのブロックにも帰属することなく、いわば純粋に力学的な線として組織されるものである。それは、リーグル的な意味での視触覚性という概念に対応するものでもあるはずである。そして、「モダン・ジャズ」という語を構成するモダンという形容詞をほとんど唯一保証しえたピアニスト、モンクを、モダニストとして、また、真の意味での形式主義者として位置づけることを可能にしたものが、このブルー・ノートであるはずだ。だが、それにしても、モダニスト、セロニアス・モンクではなく、たとえ瞠目すべきフレーズが多々あるとはいえ、ジョン・コルトレーンらの音響的な強度をもっぱら受け入れ、それをモンクが達成した真に形式的な強度と混同しがちなこの日本と呼ばれる環境において、美術作品もまたジャズと同じような受容の様態を受け入れなければならないとすれば、それはごく端的に思考の貧困さの徴としかいいようがないだろう。

それでは、真の意味での形式主義とは何であろうか。それは、通常考えられているように、ある特定のブロックの内在的な構造の形式的な組織化の論理ではなく、鷲見和紀郎がきわめて意識的に実践しているように、いくつもの離散的なブロックのあいだに可変的な接合の力線を走らせ、いわば分離＝接合(dis-jonction)の形式を組織する実践に他ならない。そのとき、この力線は

どのブロックにも帰属しないがゆえに、非物質的な、その意味で純粋な形式たりえているはずだ。

いずれにせよ、鷲見和紀郎はここでいう形式に、きわめて美しい暗喩を与えている。それが、いうまでもなく、「ヴェール」という概念である。もちろん、近代絵画史はたちどころに、この語をモーリス・ルイスのいくつかの作品群に送り返すことになるかもしれないし、事実、視覚的なフィールドの現前を仕組み鷲見和紀郎のワックスによる作品群のいくつかは、ルイスの作品を想起させることもある。とりわけ、作品の下辺より上辺が長い場合に、この参照の度合いが高まるような印象をたしかに与えるだろう。それでは、彼はルイスの作品群から単にヴェールの形状、つまり描かれた部分の形状を抽出したにすぎないのだろうか。かりにそのような指摘がありえるとすれば、それは最悪の形式主義に依拠した記述でしかないはずだ。というのも、ヴェールとはルイスの作品においても、単に層状に置かれた絵具の拡がりの輪郭線をともなった領域の形態などではなく、いくつもの層の間の、また、絵具の置かれた領域と置かれていない領域のあいだの、いわば無数の間隔のなかに拡がる非限定的な拡がりであったように、彼がルイスに見出し、自らの糧へと変形していったものも、そして、あえて、ヴェールと呼んだものも、この非限定的な拡がりであったはずだ。つまり、鷲見和紀郎がヴェールという暗喩とともに提示しようと試みるのは、フィールドの非限定性、すなわち、無限性以外の何ものでもないということだ。そして、この非限定性、無限性とは、その本性からして、作品のサイズとも、また、その物質的な次元とも無縁なものである。バーネット・ニューマンの好みの語彙を用いて書き換えれば、この無限性とは、サイズの問題ではなく、あくまでもスケールの問題なのである。

それゆえ、鷲見和紀郎展「アラベスク」（かわさきIBM市民ギャラリー、1997年）の出品作品群が、従来の彼の作品群にくらべてはるかに小型のものであることに驚く必要はまったくないはずだ。なぜならば、それは単にサイズの問題であって、何らスケールの問題ではないからだ。むしろ、驚くべきことは、こういってよければ、作品のサイズを無に極限的に近づけることによって、より大きなスケール、つまり無限のスケールを獲得しようという試みがきわめて明晰に提示されているという事実である。

ここでもまたルイスを援用することが許されるとすれば、たとえば、「ベータ・カッパ」（1961年）のような作品に顕著なように、絵具の置かれていない広い無地の領域が、何本かの垂直の絵具のために、余白としての単一の層としてではなく、多層な領域、つまり、複数のヴェールを産出したように、鷲見和紀郎の最近作は、そのあるかなしかのブロンズによって、複数の、そして無限性に開かれたヴェールを美しく押し拡げている。

松浦寿夫：画家・批評家。1954年東京都生まれ。画家・批評家。東京大学大学院博士課程満期退学。多摩美術大学絵画科油画専攻客員教授。近年の展覧会として、2019-2020「メテオール」（鷲見和紀郎、白井美穂との3連続個展）ギャラリー21yo-j（東京）、2021「岡崎乾二郎・松浦寿夫展」ガレリア・フィナルテ（名古屋）。

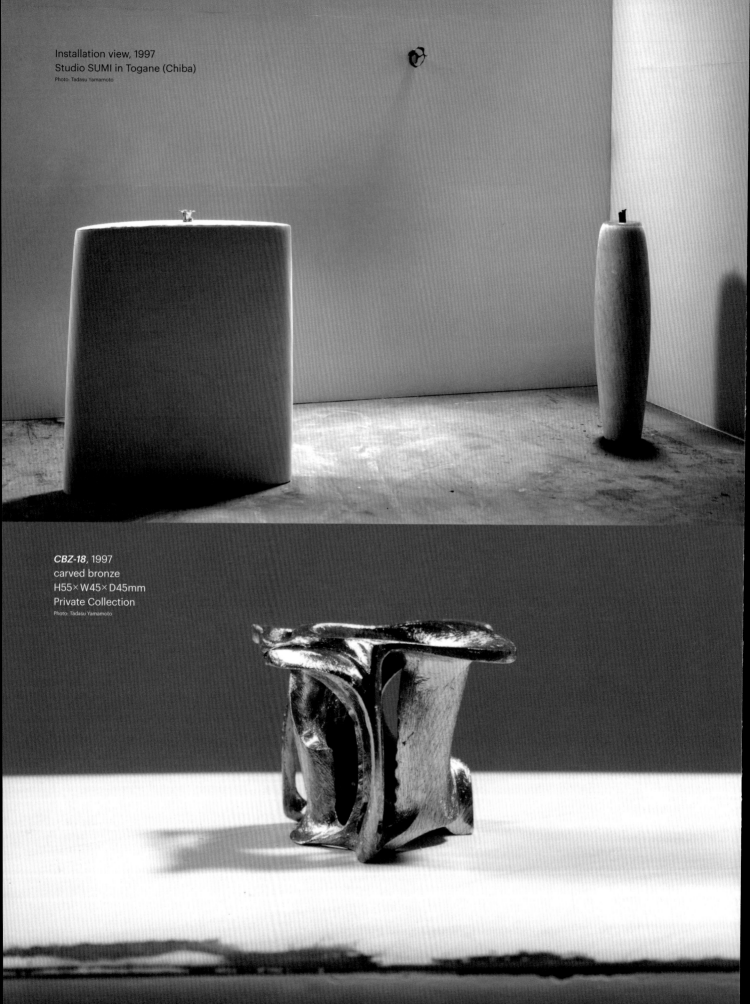

Installation view, 1997
Studio SUMI in Togane (Chiba)
Photo: Tadasu Yamamoto

CBZ-18, 1997
carved bronze
H55×W45×D45mm
Private Collection
Photo: Tadasu Yamamoto

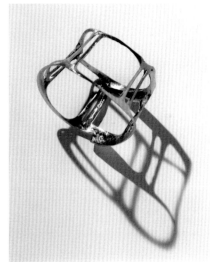

CBS-01, 1996-97
carved bronze
H85×W65×D50mm
Haruki Collection

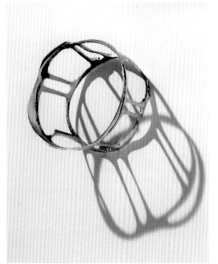

CBS-02, 1996-97
carved brass
H100×W95×D50mm
Haruki Collection

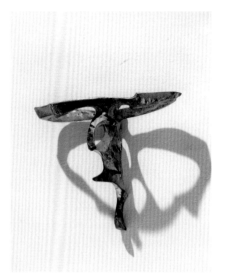

CBZ-10, 1996-97
carved bronze
H95×W72×D45mm

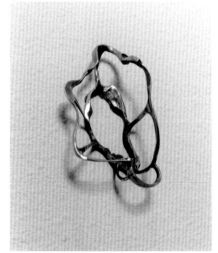

kemuri-1, 2001-2003
carved bronze
H120×W70×D60mm

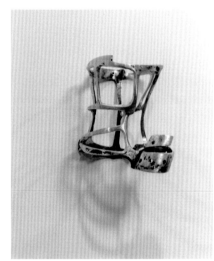

kage-1, 2001-2003
carved bronze
H100×W80×D100mm

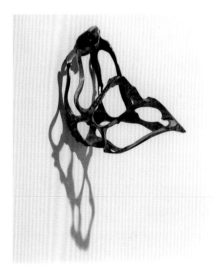

CBZ-06, 1995-96
carved bronze
H60×W105×D120mm

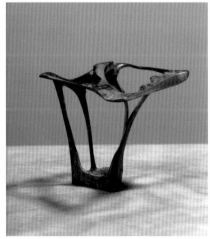

CBZ-01, 1995
carved bronze
H110×W90×D85mm
Haruki Collection

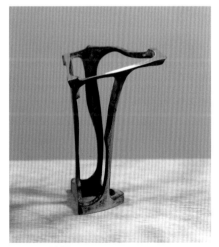

CBZ-02, 1995
carved bronze
H100×W95×D50mm
Haruki Collection

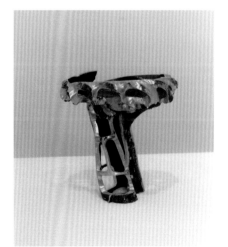

Honoo, 2003
carved bronze, enamel
H135×W120×D130mm

Another Veil

Hisao Matsuura

Various Eyes 86: From Wakiro Sumi's exhibition catalog "Arabesque" (1997)

I remember quite vividly when Wakiro Sumi pointed out that David Smith's surface treatment in his "Cubi" series was a procedure to eliminate welding traces and give these works an all-over visual uniformity. Among the various arguments written about Smith's sculpture, this one stands out in particular for its clarity. Because of its absolute evidentiality, one cannot help but take it as an unequivocal statement from its utterance. Furthermore, in retrospect, it is clear from this text that Sumi also had an evident intention regarding his sculptural practice. Should we recall Sumi's declaration that he sculpts in the same way Pollock paints?

An overview of Sumi's sculptural development will inevitably bring up situations in which some kind of duality continually tears his efforts. To be more precise, the divisions caused by these dualities not only are an essential source of pain for the production of his works but also provide a certain inspiring quality. Then we could cite these dualities as verticality/horizontality, visual surface/tactile surface, fullness/emptyness, encircling/encircled, geometric surface flatness/tactile surface undulation, monochromy/polychromy, massiveness/non-massiveness, among others, and the list could conceivably expand to include other material dimensions.

It is needless to reiterate, however, that Wakiro Sumi is not satisfied with merely exposing the dissonance that accompanies these dualities with defeatist overtones. On the contrary, what gives his work intensity is the fact of formulating lines of force between these opposing fields. Sumi invokes metaphorical 'bridges' for these lines of force as a concept familiar to him, profoundly characterizing the praxis of Thelonious Monk, for whom Sumi's *Veil III* (1994) is dedicated with reverence, another metaphor derivative: that of the blue note. A blue note, in fact, is a chromatic scale that runs across two opposing blocks, organized as a purely dynamic line, without attribution to either side. This thought would also correspond to the Rieglian concept of haptics. And it is this blue note that has positioned Monk as the modernist, arguably the only pianist who could have defined modern jazz, as a formalist in the truest sense of the word.

Nonetheless, rather than the modernist, Thelonious Monk, we tend to embrace the sonic intensity of John Coltrane and others even if their music is full of dazzling phrases, and confuse it with the truly formal intensity achieved by Monk, in this environment of Japan. If works of art were subject to a similar reception as jazz, this could indicate an impoverished mindset.

What, then, is the true meaning of formalism? As Wakiro Sumi so consciously practices, it is not simply the logic of formally organizing the inherent structure of a particular block, as is typically thought, but rather the practice of running variable lines of force of junctions between multiple discrete blocks. Thus, this organizes a form of "separation=joining" (dis-junction). These lines of force will then not belong to any block and are therefore immaterial; in that sense, they must be considered a pure form.

In any case, Wakiro Sumi provides an exquisitely beautiful metaphor for these forms. It goes without saying that this is the concept of "veil." Indeed, the history of modern painting may easily redirect this term back to some of the works of Morris Louis, and in fact, some of Sumi's wax works, structured around the presence of a visual field, may allude to the works of Louis. In particular, when the upper dimension is longer than the lower dimension of the work, it would certainly give the appearance that this measure of reference has intensified. Is it then possible that he merely extracted the shape of the veil, or the

Installation view, 1997
「アラベスク」かわさきIBM市民ギャラリー（神奈川）
"Arabesque" IBM-Kawasaki City Gallery (Kanagawa)

shape of the painted portion, from Louis' works? If such a suggestion were possible, it would be a description based on the worst kind of formalism. The veil is not simply an outlined area of paint in Louis' work but rather an unlimited expansion between layers, between regions with and without paint, and in the countless intervening spaces. What he found in Louis, what he transformed into his sustenance, and what he deliberately called a veil must have been this limitless expansion.

What Wakiro Sumi strives to present with the metaphor of a veil is nothing but the unconstrained nature of the field, in other words, nothing other than infinity. And this illimitability or infinity is, by nature, independent of the work's scale nor its material dimension. Rewritten using Barnett Newman's preferred idiom, this infinity is not a matter of size but only of scale.

Therefore, there is absolutely no surprise that the works in the exhibition "Arabesque" (Kawasaki IBM Civic Gallery, 1997) are much more compact than his previous works. This is simply a matter of size, not scale. Instead, what is surprising is that, if I may put it this way, there is a highly articulated attempt to reach a larger scale, or infinite scale, by bringing the size of the works extremely close to nothingness.

Again, if we are allowed to draw on Louis, as is evident in "Beta Kappa" (1961), a vast empty area of the canvas can be transformed, not into a single layer as a margin, but into multilayered areas, or multiple veils, due to several vertical strands of paint. Just as in Sumi's recent works, with so little bronze, the numerous and mirific veils expand into infinity.

Hisao Matsuura: artist, art critic. Born in 1954 in Tokyo. Withdrew from the doctorial course of Tokyo University in 1988. His recent work has exhibited at gallery 21yo-j in Tokyo as part of three consecutive solo exhibitions "Meteor" with Wakiro Sumi and Mio Shirai in 2019 - 2020, also at two persons exhibition "Kenjiro Okazaki and Hisao Matsuura" held by Galleria Finarte in Nagoya in 2021. He is visiting professor at Tama Art University.

PLANE
WORKS

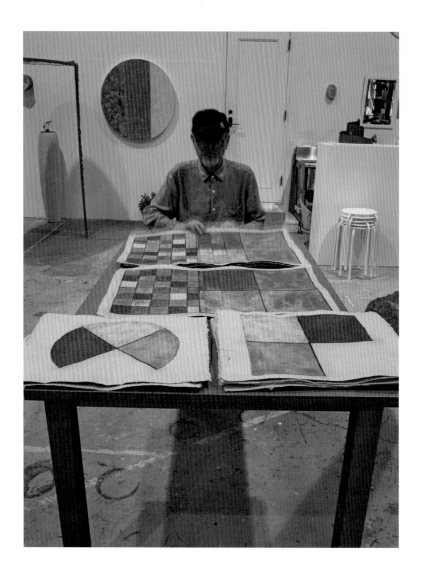

Plane Work

「彫刻は表面、絵画は奥行」が私の制作の基本姿勢です。それれの橋渡しをするのがプランニングドローイングやマケット制作です。

ラージサイズの彫刻作品をつくりながら、かたわらのテーブルの上でドローイングワークを同時に進めます。それらの場所を行ったり来たりしてときが経ち、あるとき気づくと同時に両方が完成しているというのが私の理想です。

Plane Work

"Sculpture is surface, painting is depth" is the fundamental approach in my practice. Building plans, drawings, and maquettes help bridge the sculpture-painting gap. I work simultaneously on large-scale objects and drawings on an adjacent table. My ideal procedure is to move back and forth between the two projects and to realize one day that both have been completed.

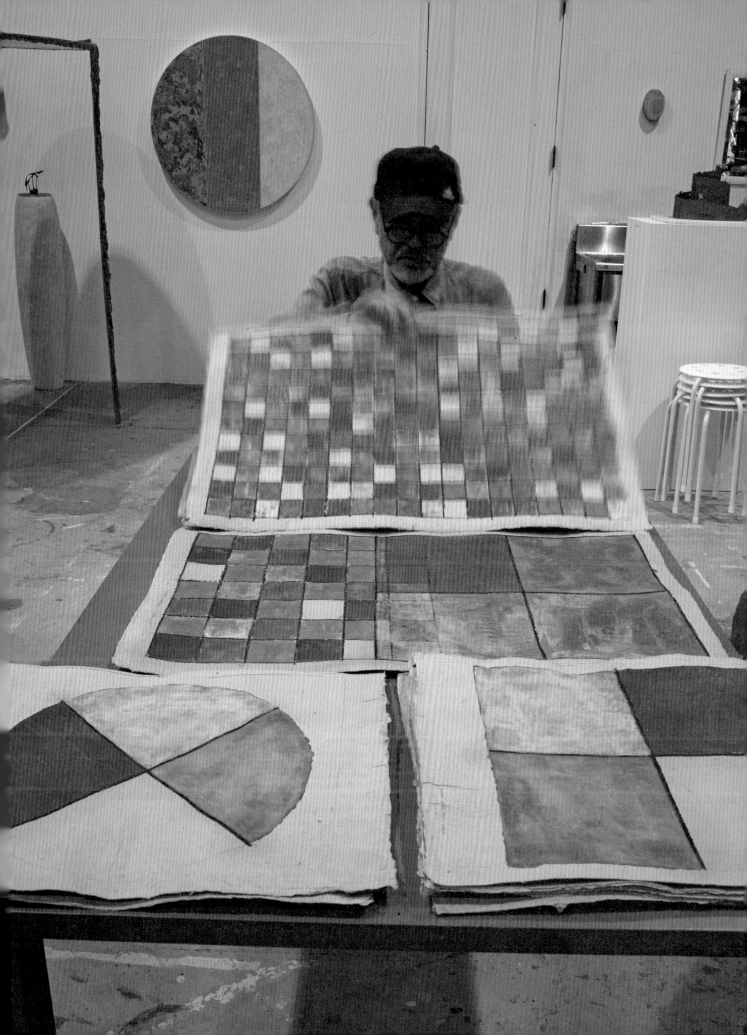

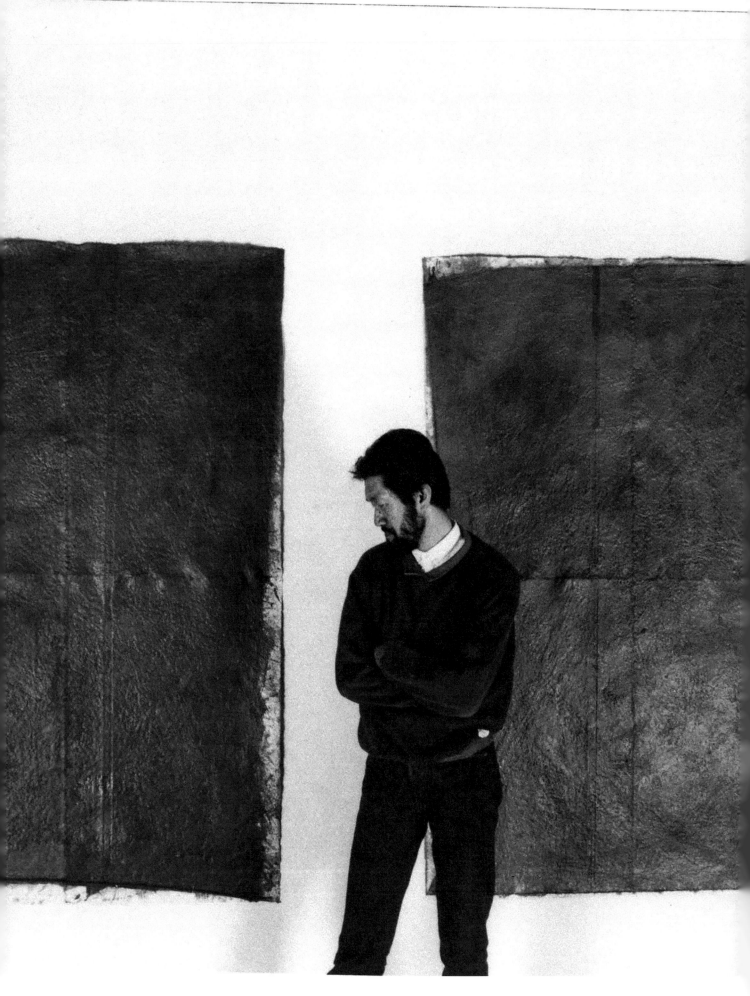

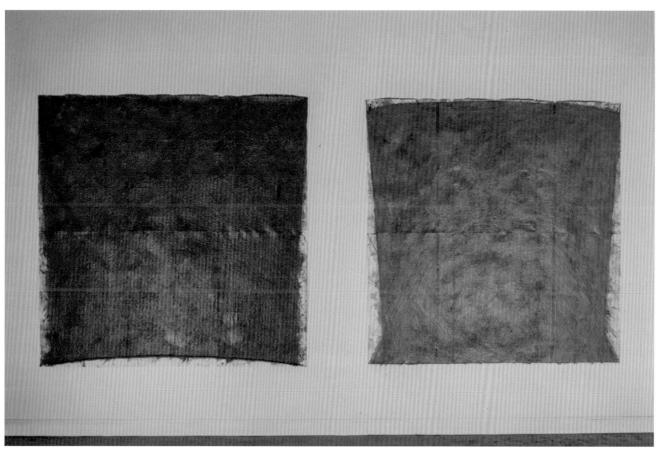

Paratita II, III, 1984
Oil, wax, brass powder on paper
1840×1840mm

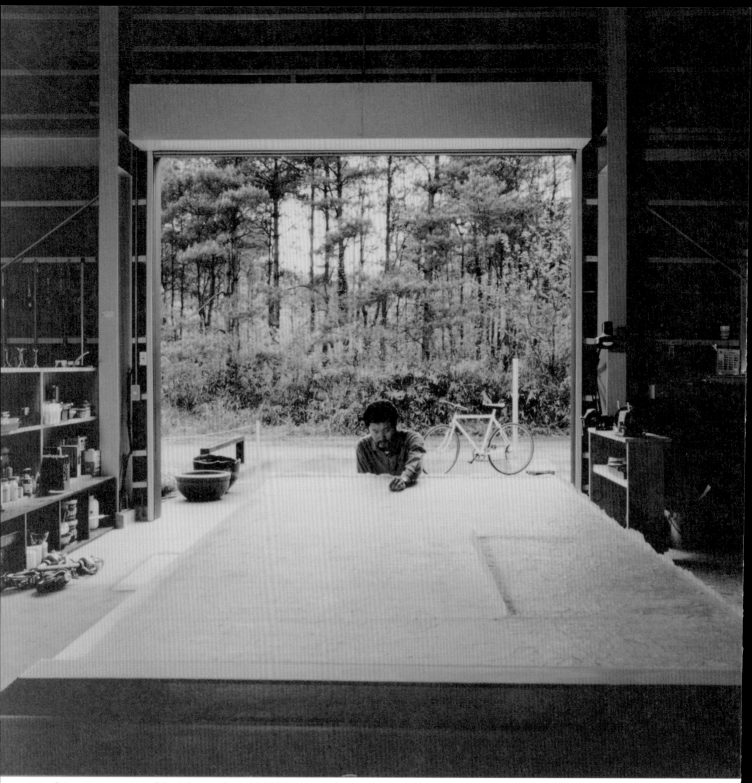

《Many Rivers to Cross》と、東金の Studio SUMI（千葉）にて、1991年
With "Many Rivers to Cross", 1991, Studio SUMI in Togane (Chiba)

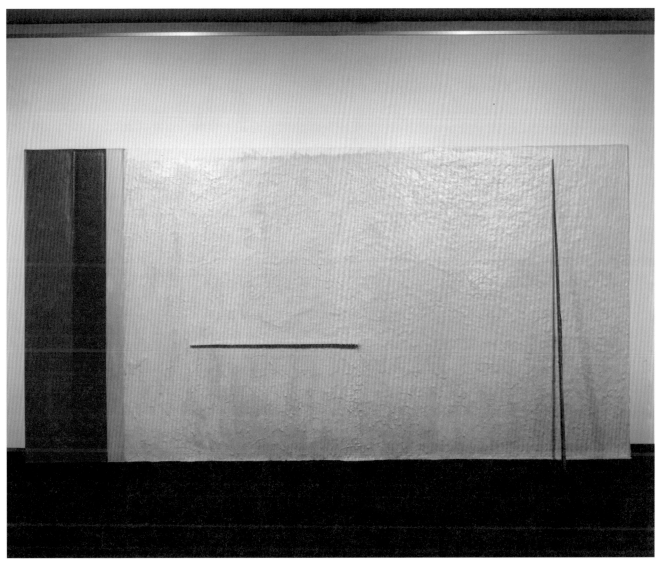

Many Rivers to Cross, 1991
paraffin, wax, oil, bronze, canvas
H1820×W3650×D300mm
Private Collection

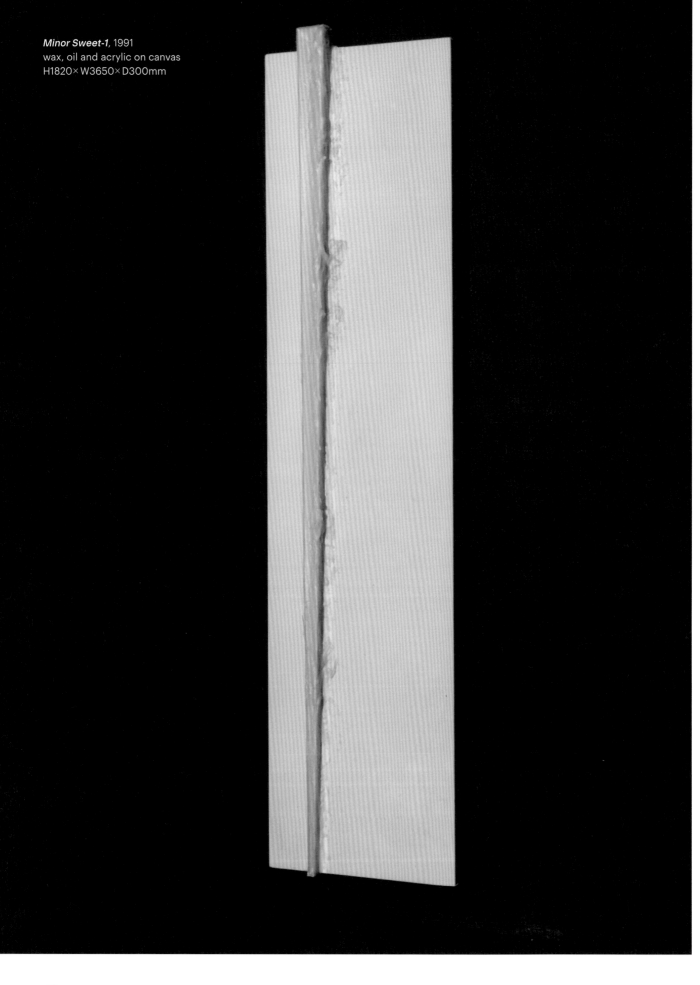

Minor Sweet-1, 1991
wax, oil and acrylic on canvas
H1820×W3650×D300mm

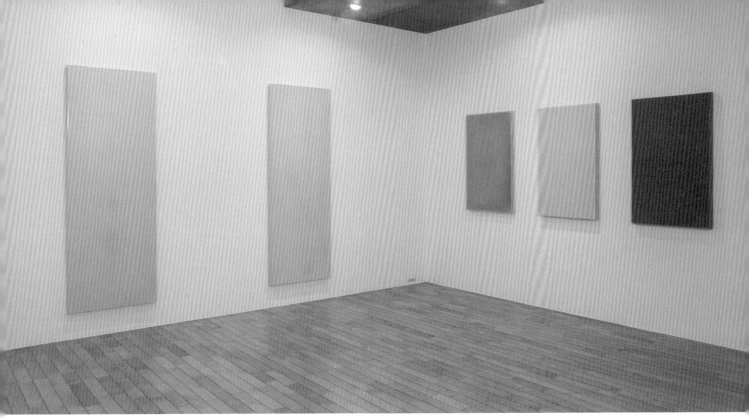

Installation view of "Yukel", 2008
島田画廊（東京）
Shimada Shigeru Gallery (Tokyo)

For Calls & Whispers-red Drawing, 2012
mixed media on paper
1730×1190mm

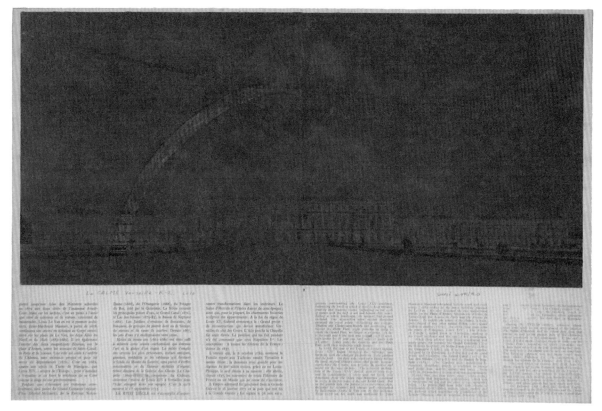

Le Calme Versailles R-1, 2016
pencil and pastel on found printed matter
380×560mm

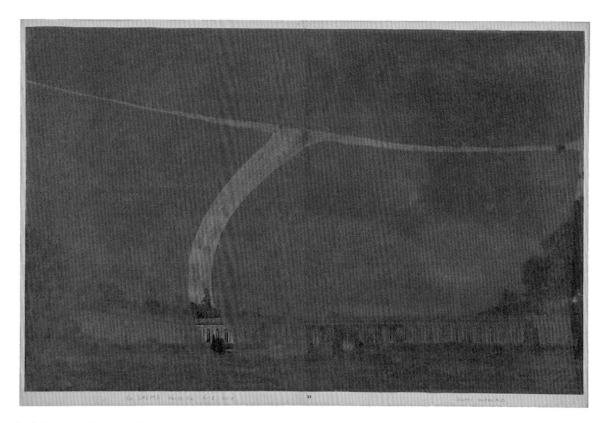

Le Calme Versailles R-2, 2016
pencil and pastel on found printed matter
380×560mm

Hombroich-1, 2018
oilpastel on paper
280×400mm

Hombroich-3, 2018
oilpastel on paper
280×400mm

Circle Drawing 1-16, 2018
charcoal and pencil on paper
(400×400mm each)×16

Grid Work-5, 2022
conté (crayon), wax and oil on recycled paper
490×760mm

Grid Work-2, 2022
conté (crayon), wax and oil on recycled paper
490×760mm

Grid Work-3, 2022
conté (crayon), wax and oil on recycled paper
490×760mm

Grid Work-4, 2022
conté (crayon), wax and oil on recycled paper
490×760mm

Grid Work-6, 2022
conté (crayon), wax and oil on recycled paper
380×490mm

Grid Work-1, 2022
conté (crayon), wax and oil on recycled paper
490×760mm

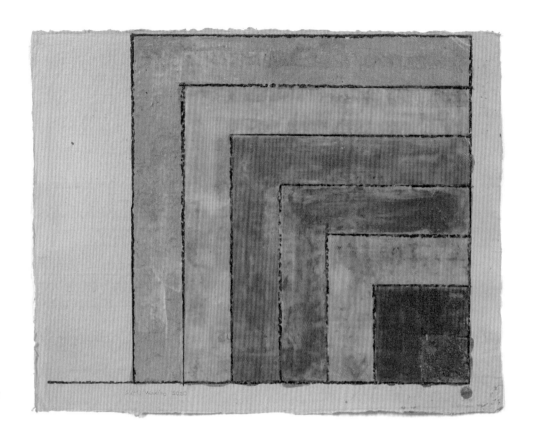

Grid Work-7, 2022
conté (crayon),
wax and oil on recycled paper
490×380mm

Grid Work-8, 2022
conté (crayon), wax and oil on recycled paper
380×490mm

Grid Work-9, 2022
conté (crayon), wax and oil on recycled paper
380×490mm

SHAVED PAINTING - SURFACE WORKS

Shaved painting - surface works

2000年頃からの平面作品シリーズにShaved paintingがあります。自動車などの修理の下地処理に使われるポリエステル樹脂とオイルカラーを混ぜたものをキャンバスや木・金属などの支持体にヘラで塗り込み、固まったら削りだし又塗り込んで削り出すという作業を何回も繰り返し納得のいく色面と表面が生まれるのを待つというものです。

いわゆるpaintingは足して足してゆく表面作業ですが、私のpaintingは削り取り研ぎ出すといったcarvingに近い行為の先に目と指先の感覚で、ここだといった表面が現れたときに完成する ─ といったプロセスがこのシリーズの特徴です。亡くなられたZEIT-FOTO SALONの石原悦郎氏は私の一連の平面作品をsurface worksと名づけてくれました。

Shaved painting - surface works

Shaved painting is a series of two-dimensional works that began in 2000. It involves repeating the process of applying a mixture of polyester resin and oil, a primer for automobile repairs, to canvas, wood, metal, or other substrates with a spatula, scraping it off as it hardens, applying and scraping again, repeating the process until a satisfactory color-varied layer and finished surface is achieved. While painting is an act of adding layer after layer of surface work, my approach to painting is closer to that of carving, in which the surface is scraped and sharpened, and is completed when the right surface appears as sensed by my eyes and fingertips. . The late Etsuro Ishihara of ZEIT-FOTO SALON named my series of two-dimensional pieces "surface works."

Canned Heat No.1, 2000. 220φ×80mm, iron, enamel resin, oil
Canned Heat No.2, 2000. 220φ×80mm, iron, enamel resin, oil
Canned Heat No.3, 2000. 220φ×80mm, iron, enamel resin, oil Private Collection

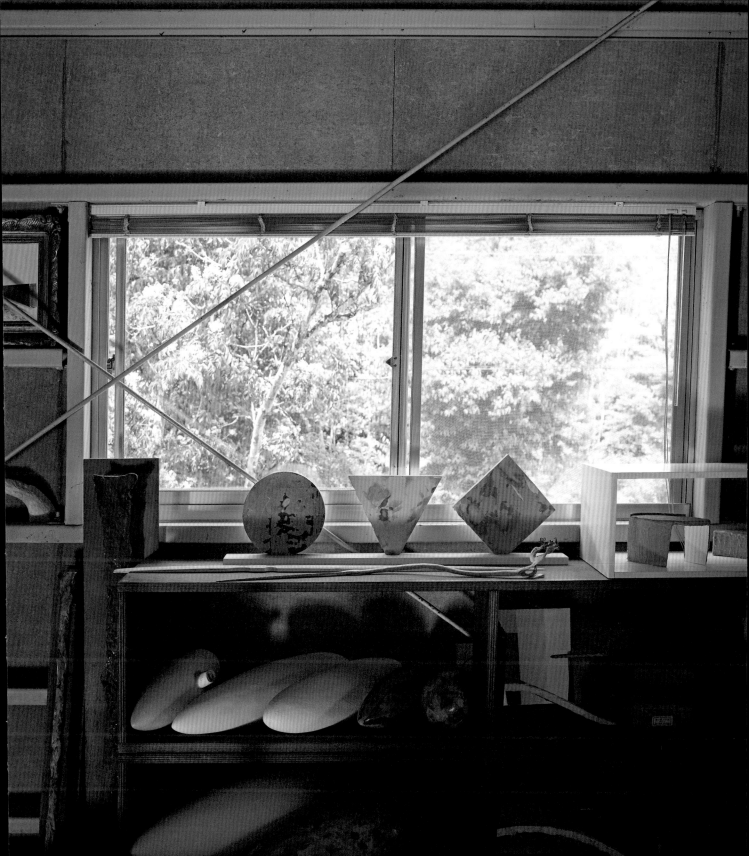

Fusulina 2-C, 2001
plaster, enamel resin, oil, aluminum
H440× W930× D55mm

Fusulina 3-A, 2004
plaster, enamel resin, oil color
H1800×W580×D50mm

Fusulina 3-B, 2004
plaster, graphite, aluminum frame
H1800×W540×D50mm

Riverge-3, 2008
enamel resin and oil on canvas
H410×W305×D27mm

Riverge-1, 2008
enamel resin and oil on canvas
H410×W305×D27mm
Private Collection

Riverge-4, 2008
enamel resin and oil on canvas
H410×W305×D27mm
Private Collection

Riverge-2, 2008
enamel resin and oil on canvas
H410×W305×D27mm
Private Collection

Convex2014-2, 2014
enamel resin and oil on canvas
235×175mm

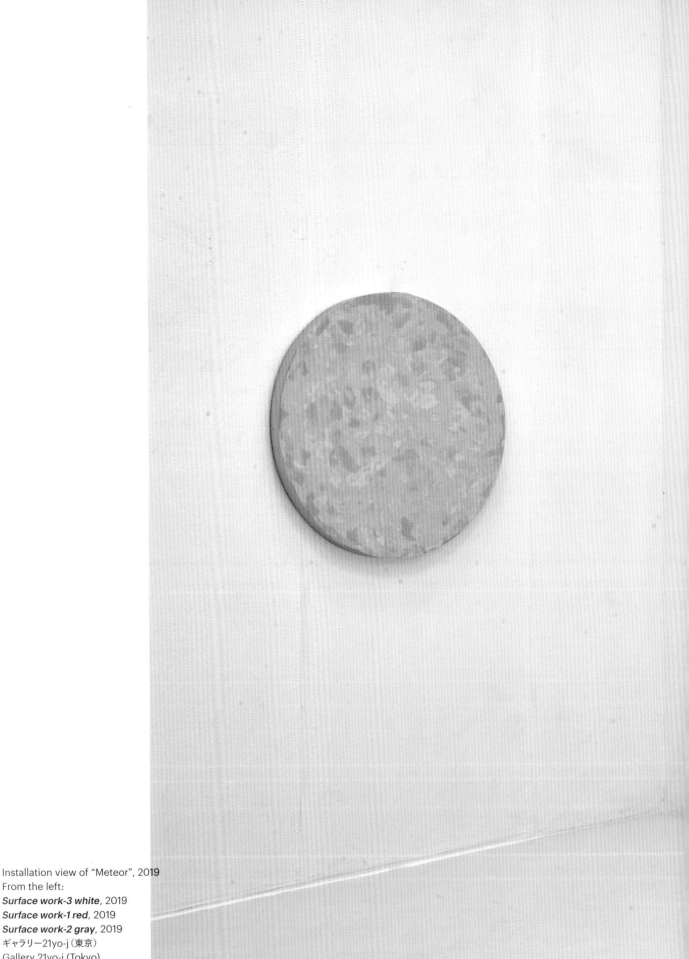

Installation view of "Meteor", 2019
From the left:
Surface work-3 white, 2019
Surface work-1 red, 2019
Surface work-2 gray, 2019
ギャラリー21yo-j（東京）
Gallery 21yo-j (Tokyo)

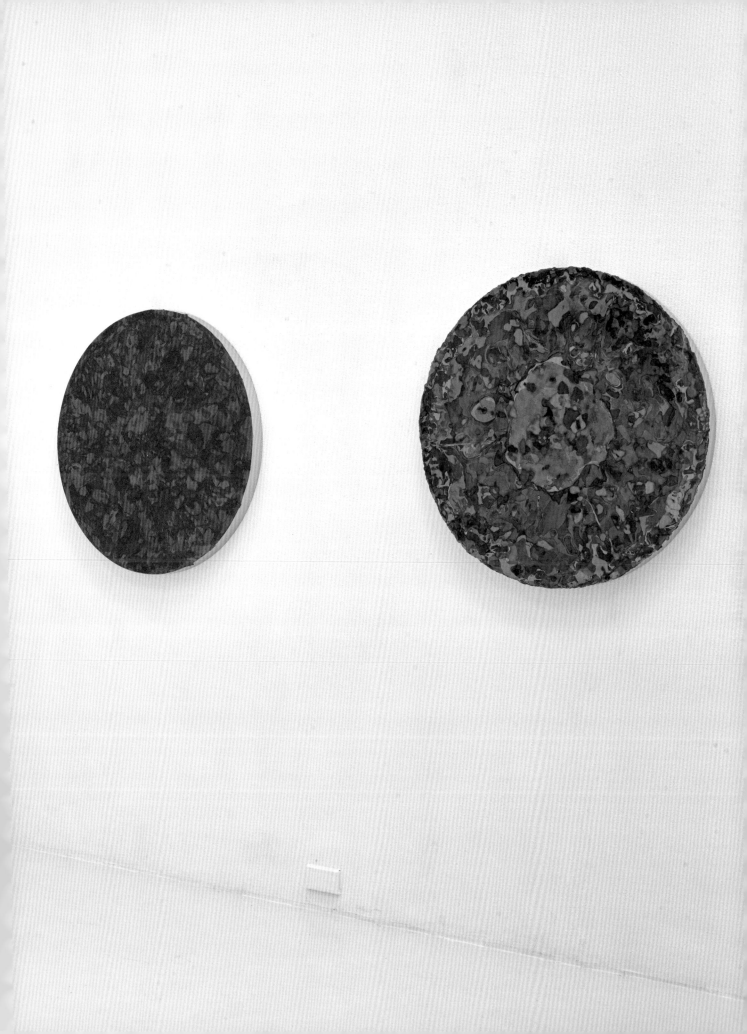

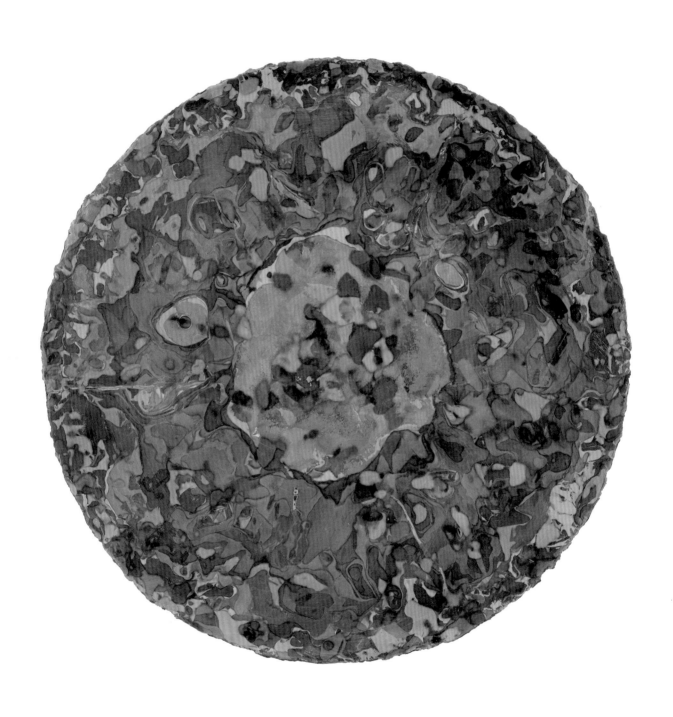

Surface work-2 gray, 2018
resin and oil in aluminum frame
880×880mm

Borg, 2018-2019
resin and oil on cloth
210×185mm
Private Collection

PLASTER WORKS

プラスター ワーク

プラスター（石膏）は粘土等の作業の型取り材としてや、鋳物にする前の原型として馴染んだ素材です。水に溶いてすぐならポーリングやドリッピングができ、固まるまでは直づけをしてモデリングの素材となります。そしてノミ、ヘラ、アラカンで容易にカービングができ、サンドペーパーをかければ綺麗な面を生み出すこともできます。
弱点は強度に欠ける点ですが、それすらもプラスターの持つ白さの魅力が勝る気がしますしワックスとの相性もとても良い。タイトルによく使われている「フズリナ」は古生代の原生動物で紡錘虫の化石の名前ですが、私にとっては幼少期から馴染んだ形でもあります。

Plaster Work

Plaster is a familiar material used for clay molding or as a prototype before casting. When dissolved in water, it is ready to be poured and dripped and until hardened, it could be used as a modeling medium by direct mounting. The material can be easily carved with a chisel, spatula, or arakan (rasp plane) or sanded down to a finely polished surface.
Its shortcoming is in its lack of durability, although, in my opinion, the attractive brightness of the plaster's natural luster can outweigh any weakness, and it is highly suitable to be used with wax. Fusulina, often used as a title, is the name of a fossilized Paleozoic protozoan spindle worm, a form that I have been familiar with since childhood.

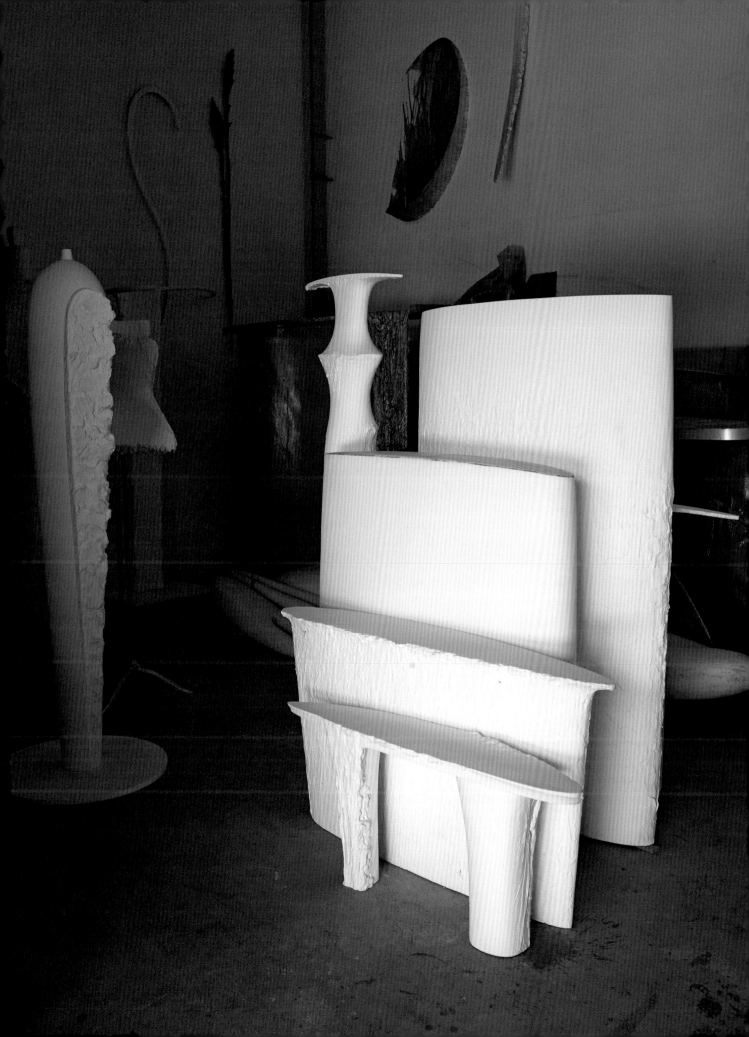

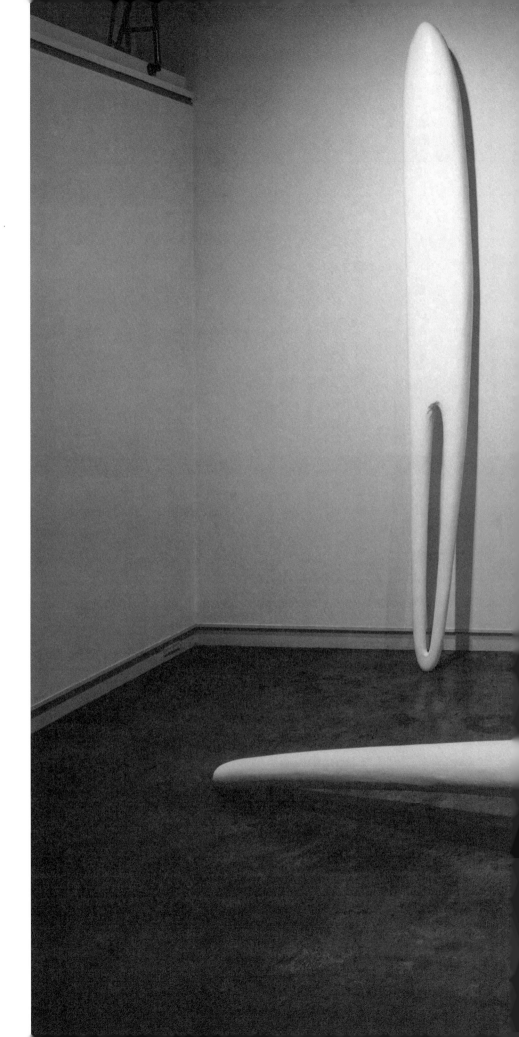

《重力・7月・遠い谺（こだま）》
Gravity – July - Distant Echo, 1991
《重力・8月・通り雨》
Gravity – August - Shower Rain, 1991
島田画廊（東京）
Shimada Shigeru Gallery (Tokyo)
Photo: Tadasu Yamamoto

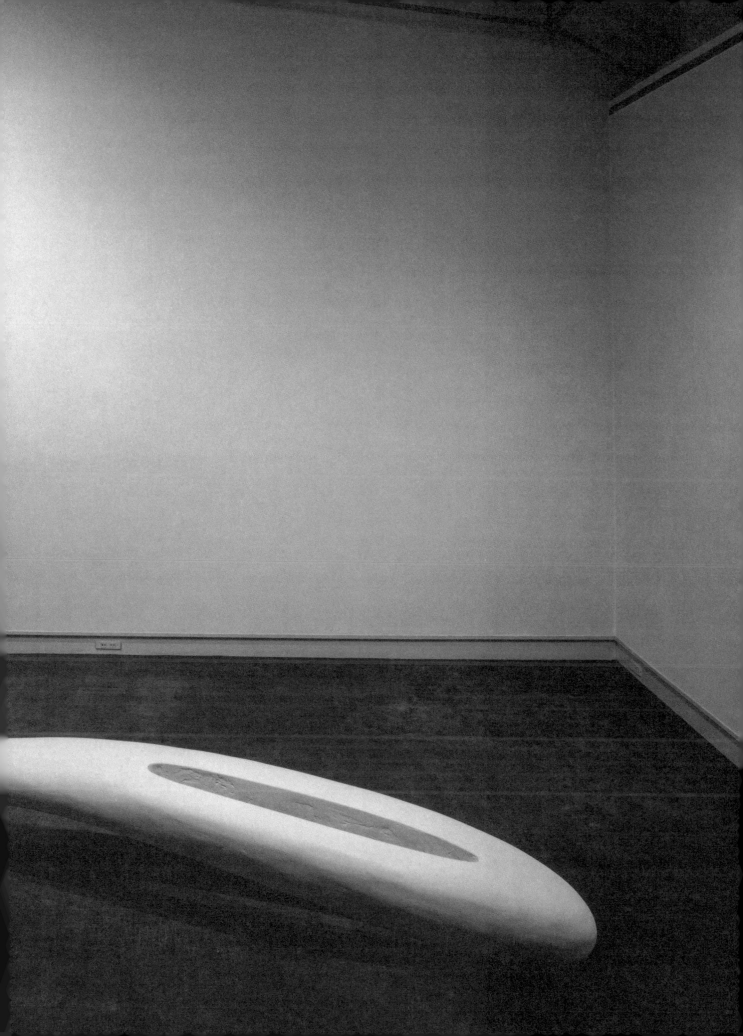

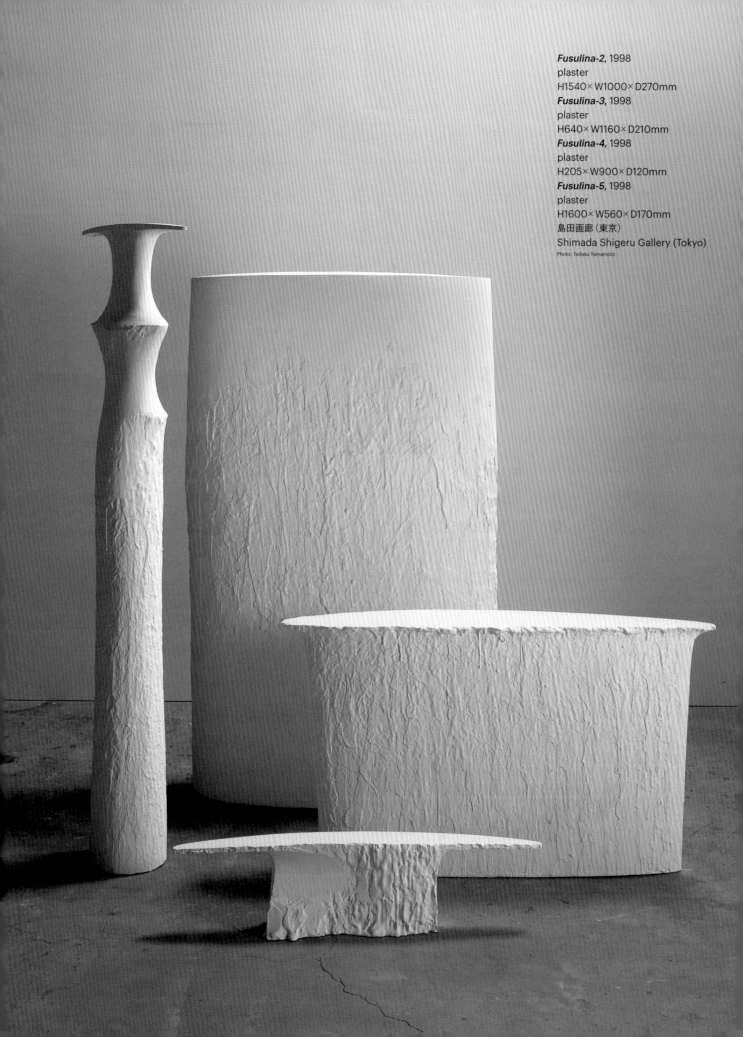

Fusulina-2, 1998
plaster
H1540×W1000×D270mm
Fusulina-3, 1998
plaster
H640×W1160×D210mm
Fusulina-4, 1998
plaster
H205×W900×D120mm
Fusulina-5, 1998
plaster
H1600×W560×D170mm
島田画廊（東京）
Shimada Shigeru Gallery (Tokyo)
Photo: Tadasu Yamamoto

Fusulina-6, 1999
plaster
H1500×W400×D250mm
Photo: Tadasu Yamamoto

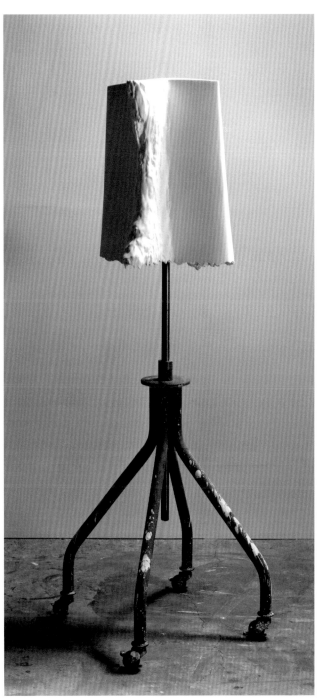

Fusulina-7, 1999
plaster
H1600×W480×D470mm
Photo: Tadasu Yamamoto

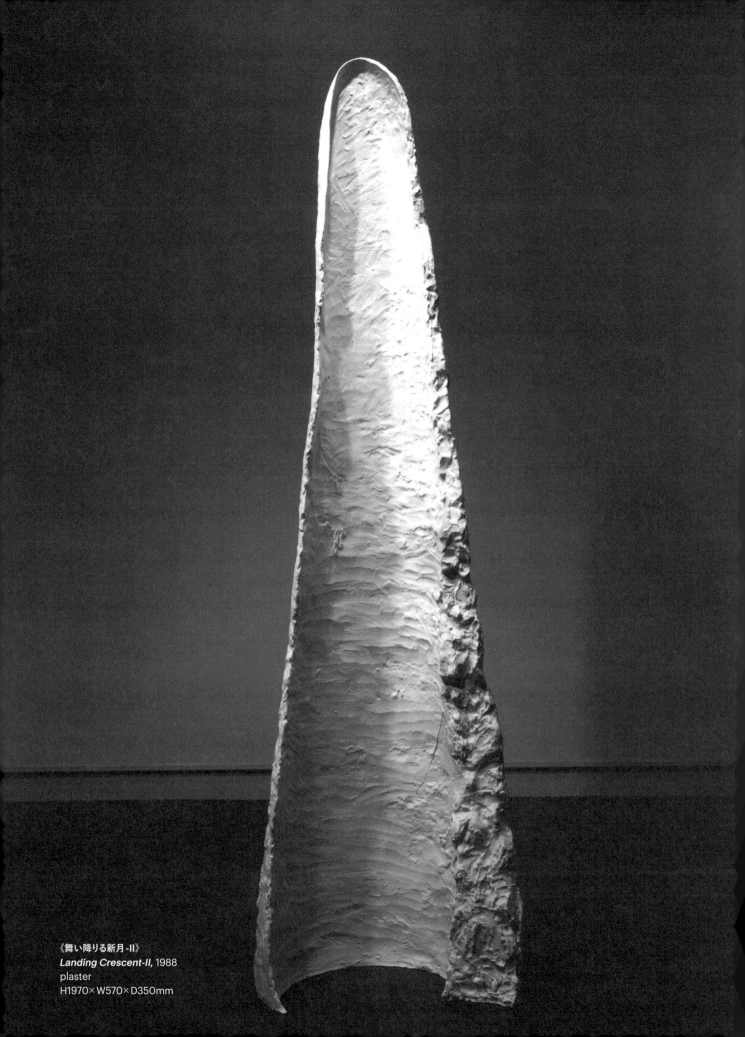

《舞い降りる新月-II》
Landing Crescent-II, 1988
plaster
H1970× W570× D350mm

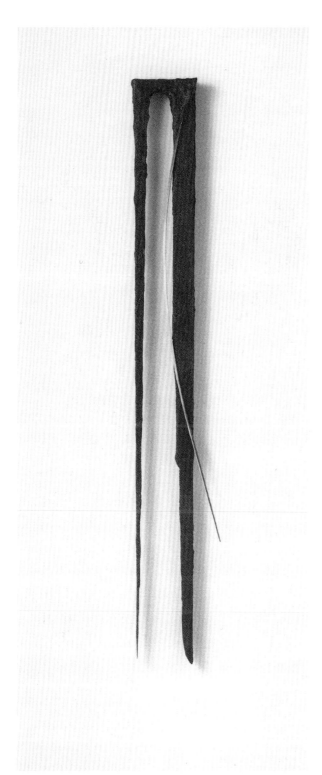

《無際橋》
Musaibashi, 1987
wood, plaster, beeswax, paint
H1180× W180× D50mm
Private Collection

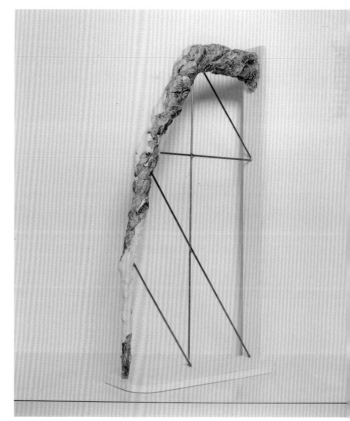

《アマリリスべエラドンナ》
Amaryllis belladonna, 1988
wood, plaster
H1180× W180× D50mm
Private Collection

《熱の谺の為に》
For the Thermal Echo, 1988
wood, plaster, brass
Private Collection

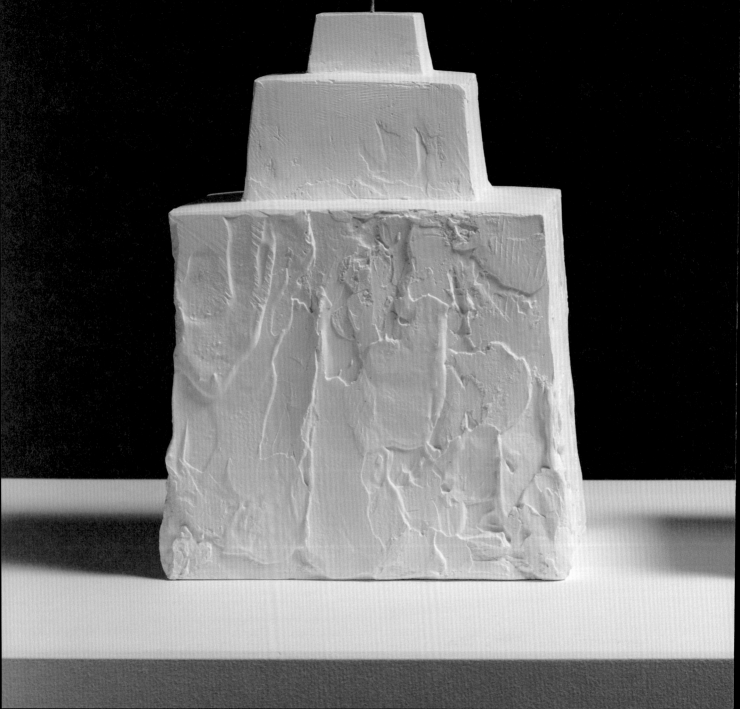

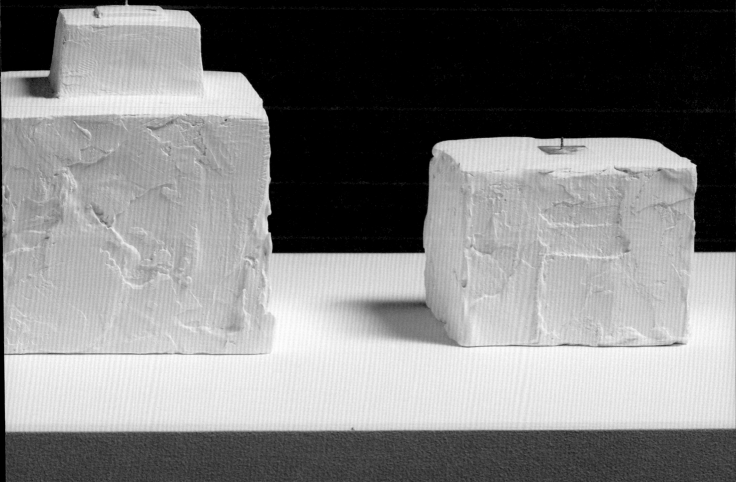

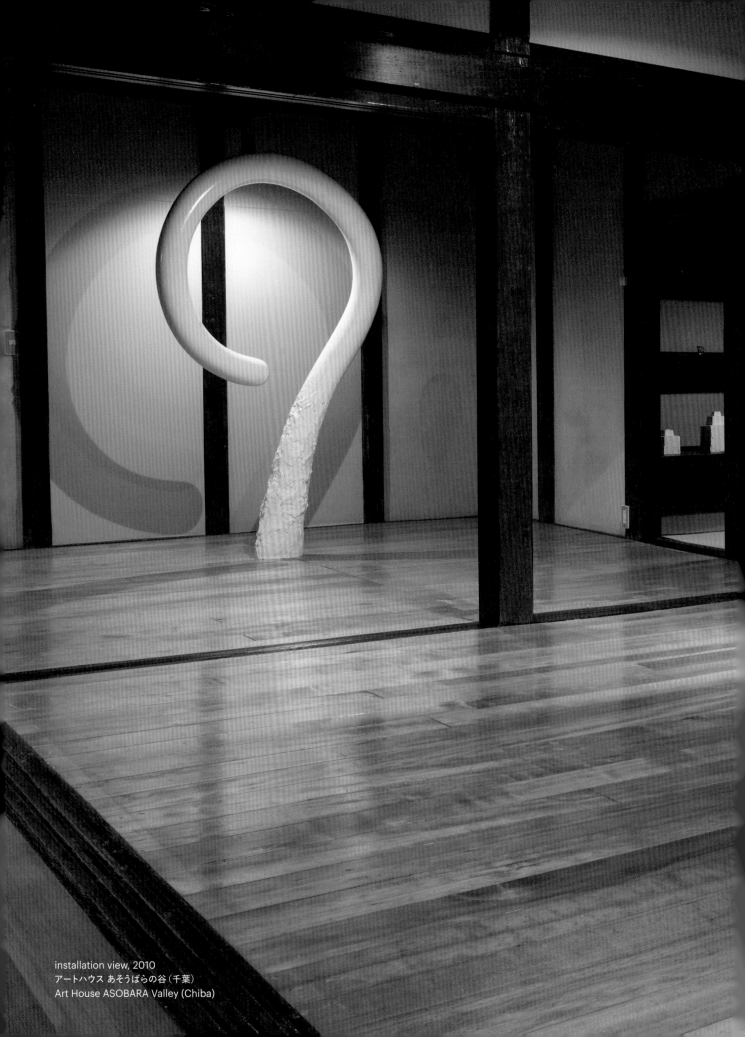

installation view, 2010
アートハウス あそうばらの谷（千葉）
Art House ASOBARA Valley (Chiba)

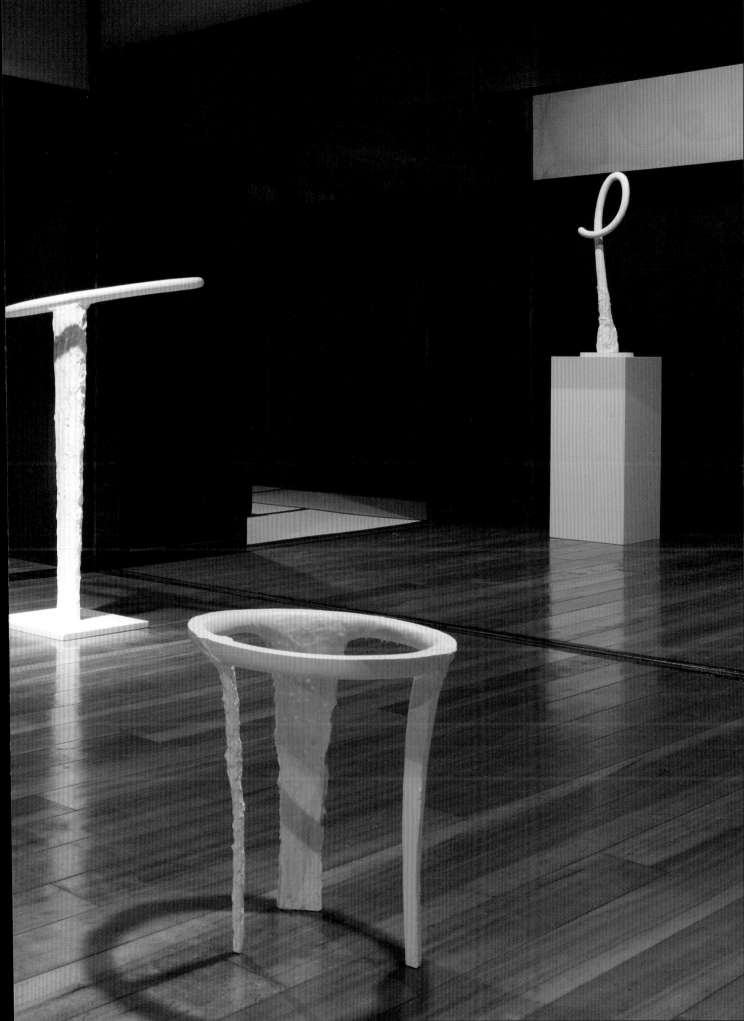

DANCE SERIES

ダンス（セロニアス・モンク）

私のダンスシリーズの始まりは1960年代のセロニアス・モンクの演奏ビデオを見たことからでした。彼はカルテットで演奏をひとしきり続けると、急にピアノから離れて奇妙なダンスを始めるのです。グルグルグルグル廻ったり急にステップを入れたりして完全に曲の世界に入り込んで御機嫌です。しばらく踊り続けていたかと思うとさっとピアノに戻りタンタ、タンとリズムを打ち込むと摩訶不思議なフレーズを指輪だらけの太い指で叩きだして曲は動き始めるのでした。JAZZのブリッジ（インサイド）に入ったときの彼のダンスは滑稽なほどオリジナルで印象的でした。

ですから私のダンスシリーズは人が立つこと、回転することといった初期衝動のようなものを切り取ることで彫刻にならないかというイメージから始まったのでした。

Dance (Thelonious Monk)

My "Dance" series started by watching a video of Thelonious Monk performing in the 1960s. As the quartet kept playing, he left the piano suddenly to begin a bizarre dance. First, he would spin around and around and abruptly leap forward, completely immersed in the music and in a fantastic mood. Then, after dancing for a while, he would quickly return to the piano, tap out a mysterious phrase with his thick, ringed fingers, and set the music in motion. His dance during the bridge of the jazz tune was ridiculously original and impressive. So my "Dance" series began with the idea of cutting out something that resembles a person's initial impulse to stand up and spin and transform them into sculptures.

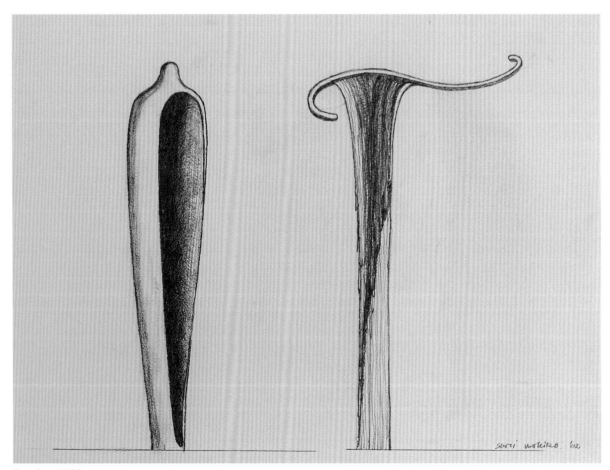

Drawing, 2002
charcoal and pencil on pepar

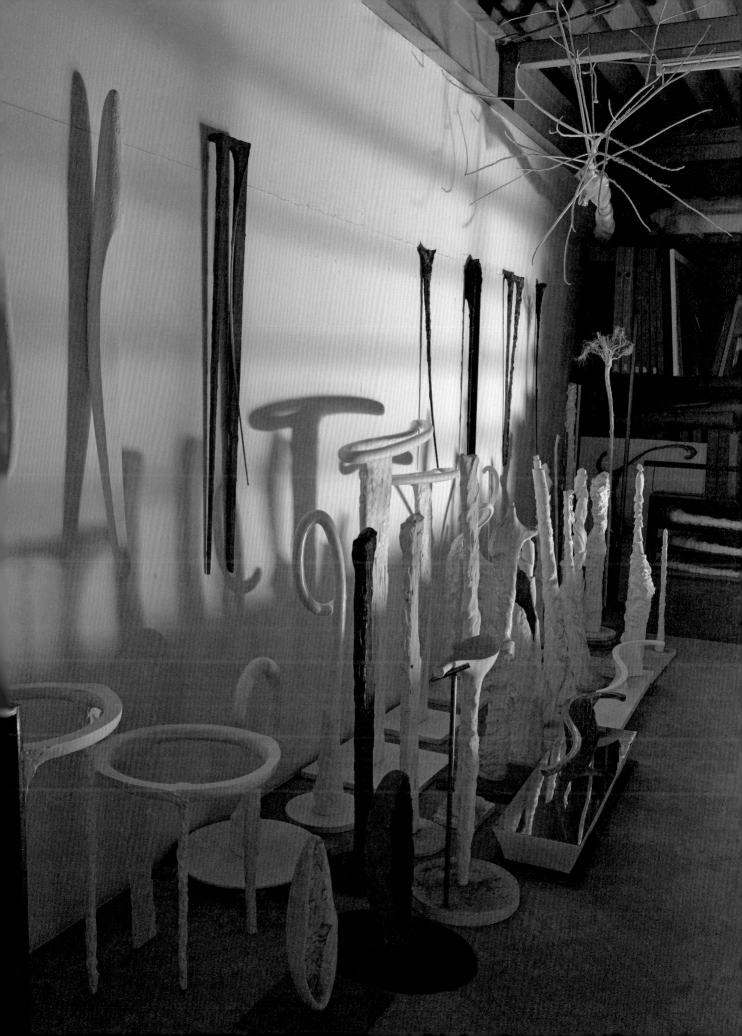

Dance-1, 2001
plaster
H630×W440×D300mm

Dance-2, 2001
plaster
H880×W580×D300mm

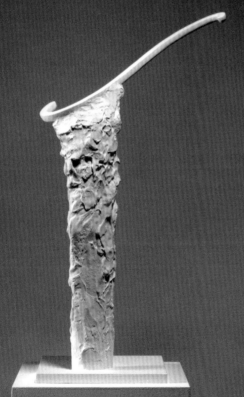

Dance-3, 2001
plaster
H940×W300×D300mm

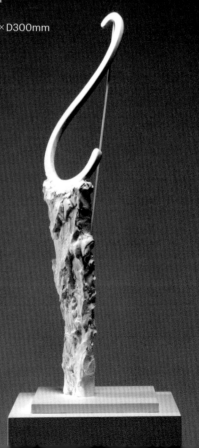

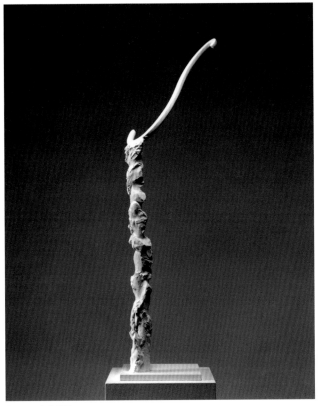

Dance-4, 2001
plaster
H1310×W420×D300mm
Courtesy of National Museum of Modern Art, Tokyo

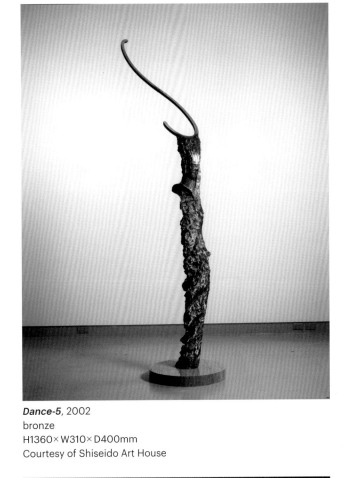

Dance-5, 2002
bronze
H1360×W310×D400mm
Courtesy of Shiseido Art House

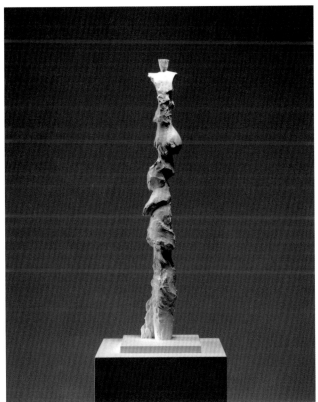

Dance-6, 2002
plaster
H880×W300×D300mm
Courtesy of National Museum of Modern Art, Tokyo

Dance-7, 2002
plaster
H920×W290×D290mm

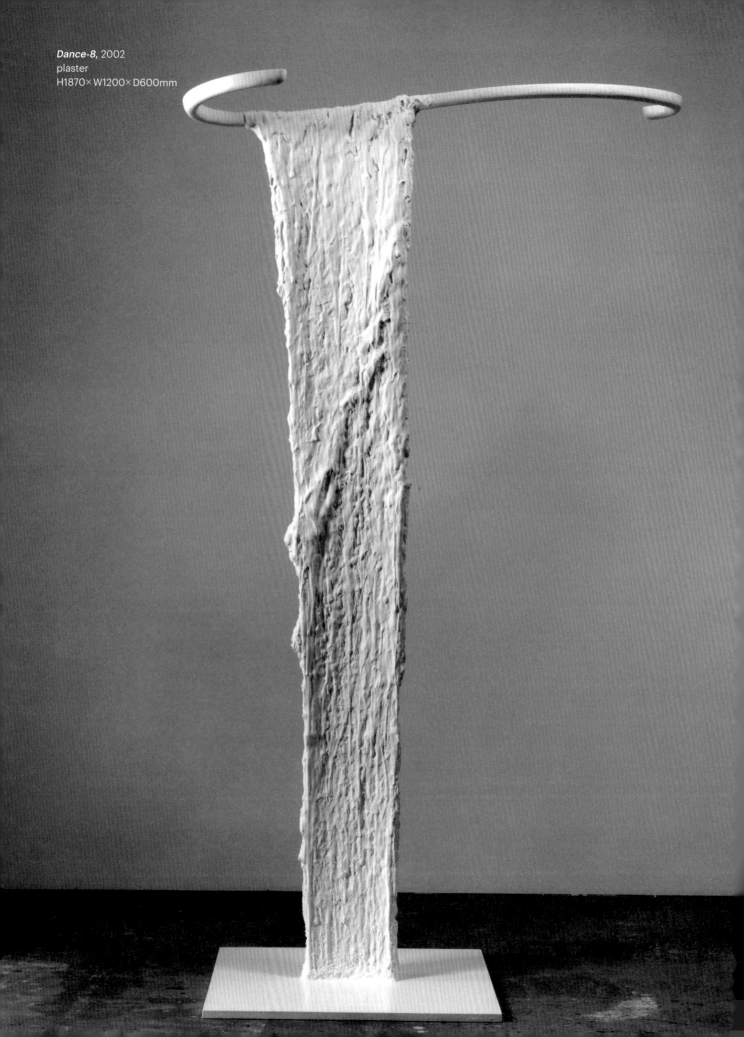

Dance-8, 2002
plaster
H1870×W1200×D600mm

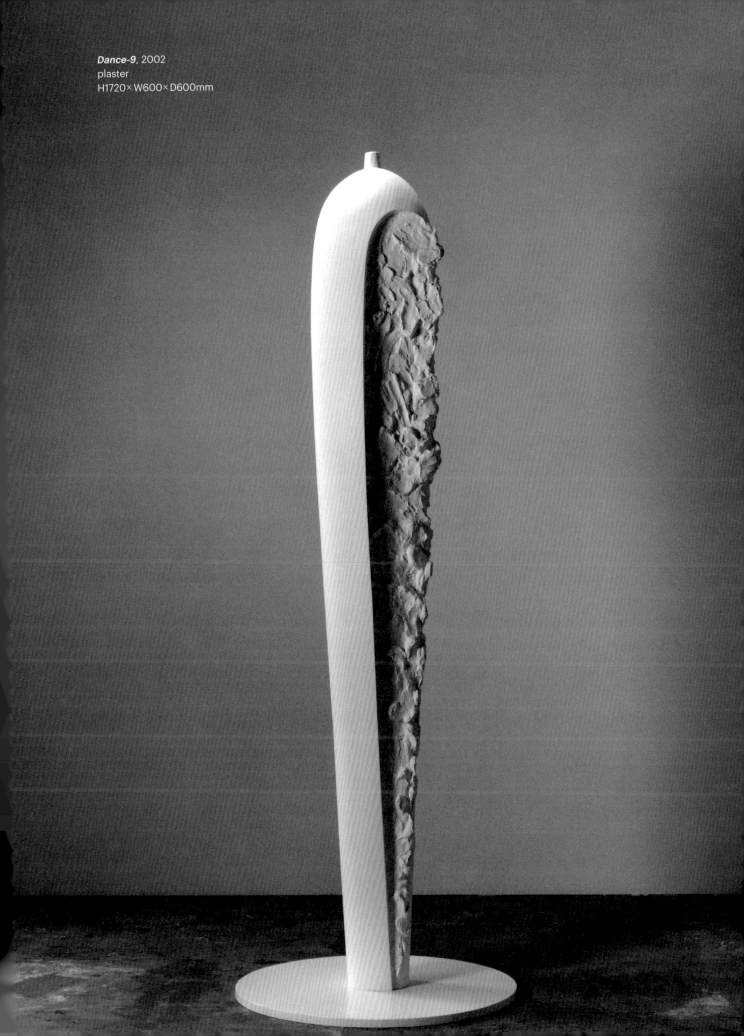

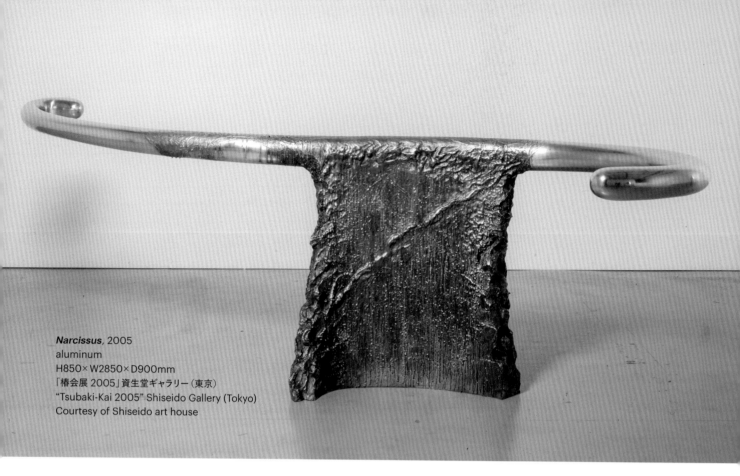

Narcissus, 2005
aluminum
H850×W2850×D900mm
「椿会展 2005」資生堂ギャラリー（東京）
"Tsubaki-Kai 2005" Shiseido Gallery (Tokyo)
Courtesy of Shiseido art house

Drawing, 2001
colored pencil on pepar

Narcissus-3, 2005
Iron, plaster, wax, ink
H120×W230×D80mm

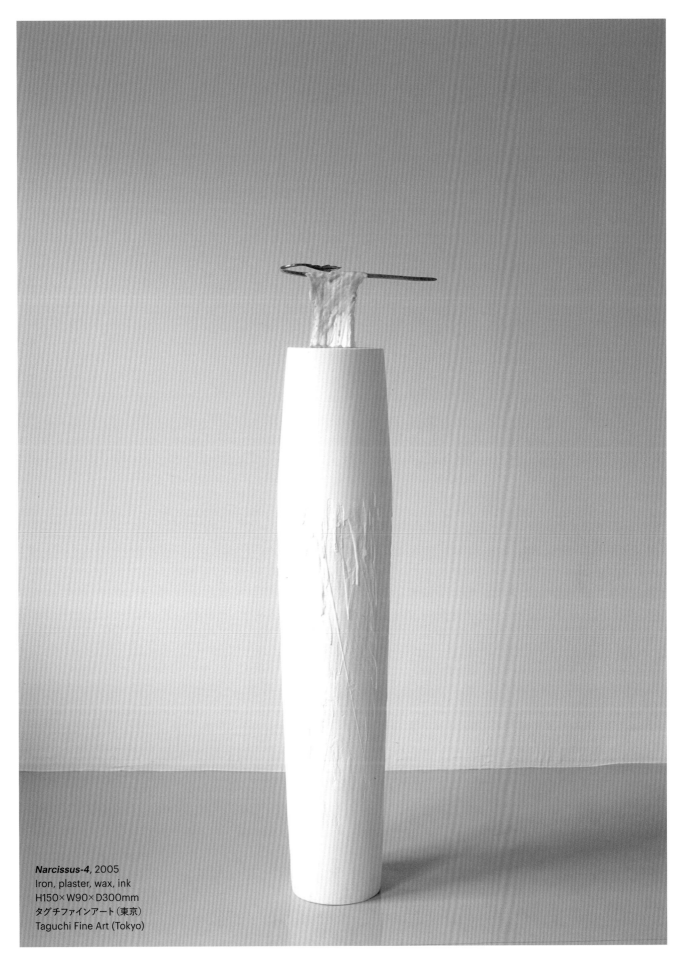

Narcissus-4, 2005
Iron, plaster, wax, ink
H150×W90×D300mm
タグチファインアート（東京）
Taguchi Fine Art (Tokyo)

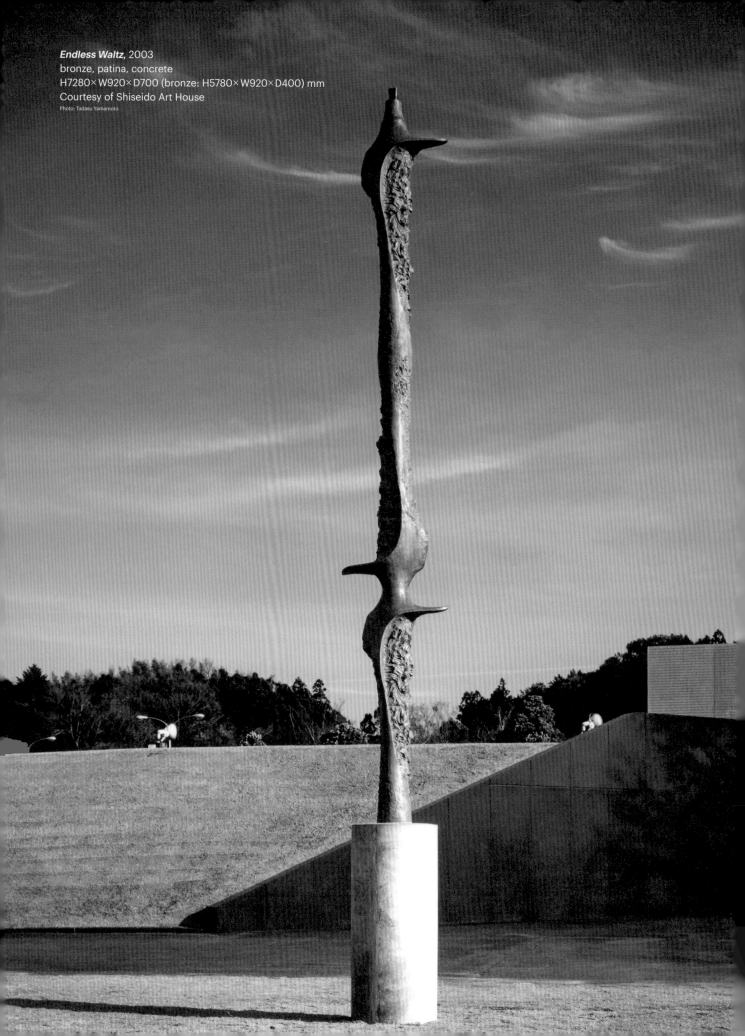

Endless Waltz, 2003
bronze, patina, concrete
H7280×W920×D700 (bronze: H5780×W920×D400) mm
Courtesy of Shiseido Art House
Photo: Tadasu Yamamoto

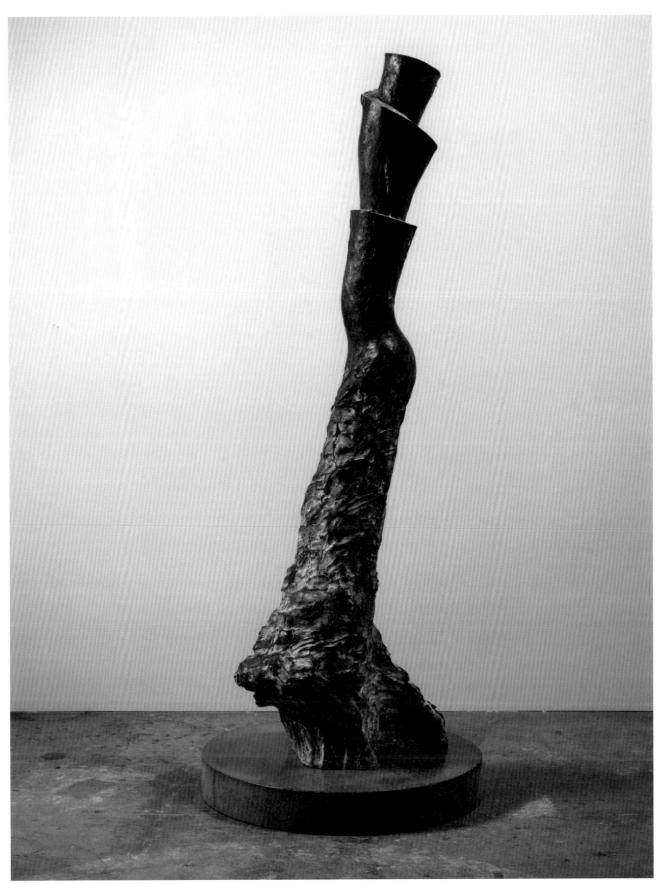

Cassandra, 2004
bronze
H2100×W600×D710mm
Courtesy of Shiseido Art House
Photo: Tadasu Yamamoto

RECENT WORKS

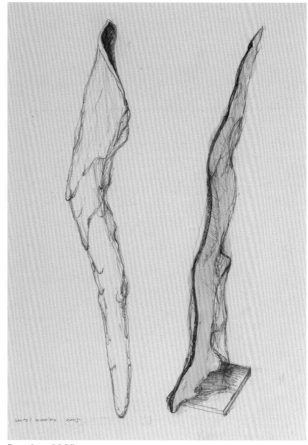

Drawing, 2005
charcoal, pencil and acrylic on pepar

As it is

世界は在るがままに在るのだろうか。

「在るがまま」難しい言葉だ。

ある人にとっての「在るがまま」は他者にとって「無意味な世界」や「異常な現象」と映るかもしれない。

例えば仙厓の○△□、

桑山忠明のメタリックカラーペインティング

使い込んで紙のように薄くなった鉄べら

ジャクソン・ポロックの「ホワイトライト」

風に震える蜘蛛の巣の水滴

たしかにそこに在るのだけれど、なにかの象徴としてとか意味を表現しているわけではない。

無くても構わないモノだと解るようにして、そこに在る。

つまり人工物の極致として自然にそこに在る。

美しいとか醜いは人の歴史がつくった幻影であるが、気づくとそこに在り無視できない記憶のようなモノが美術なのでしょう。

As it is

Does the world exist as it is?

"As it is" is a difficult term to grasp.

The "as it is" for one person may be deemed as "a meaningless world" or "an abnormal phenomenon" for another person.

For example, Sengai's ○△□

Tadaaki Kuwayama's metallic color paintings

A used iron spatula thinned down like paper

Jackson Pollock's "White Light"

Water droplets on a spider's web fluttering in the wind

It is certainly there, but it neither symbolizes nor means anything.

It is there with the understanding that it wouldn't matter if it weren't there.

Thus, they are there naturally as the finest of artifacts.

The beautiful and the ugly are illusions fabricated through the history of humanity, but when noticed, they are there, and art is like a memory that cannot be ignored.

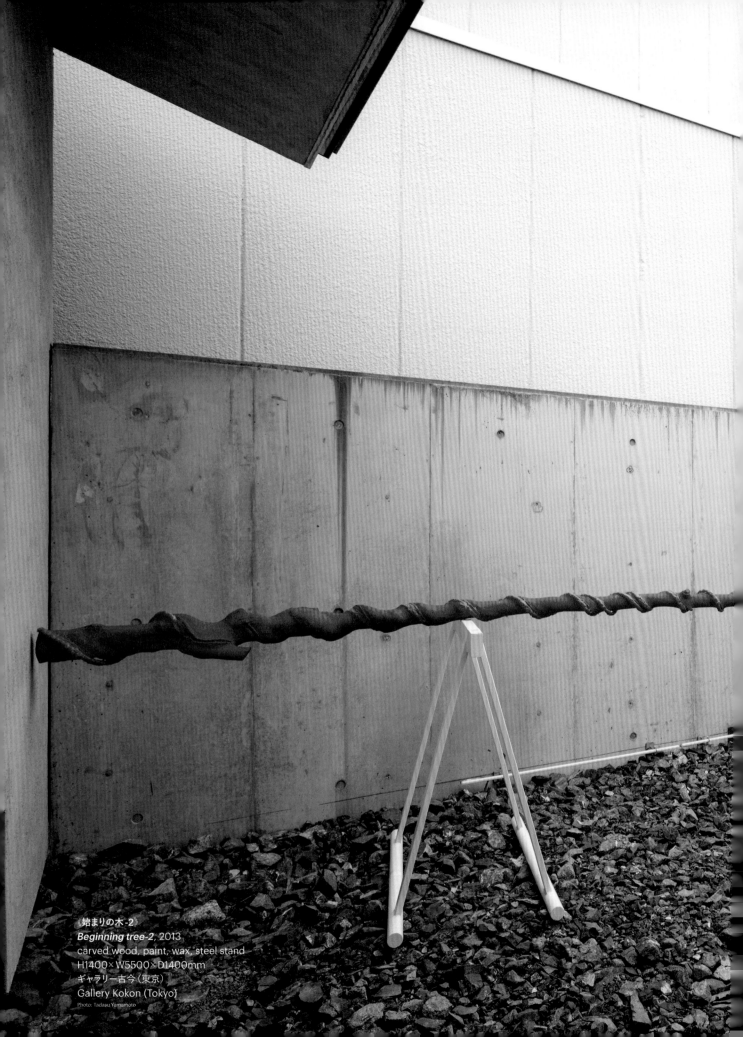

《始まりの木 -2》
Beginning tree-2, 2013
carved wood, paint, wax, steel stand
H1400×W5500×D1400mm
ギャラリー古今（東京）
Gallery Kokon (Tokyo)
Photo: Tadasu Yamamoto

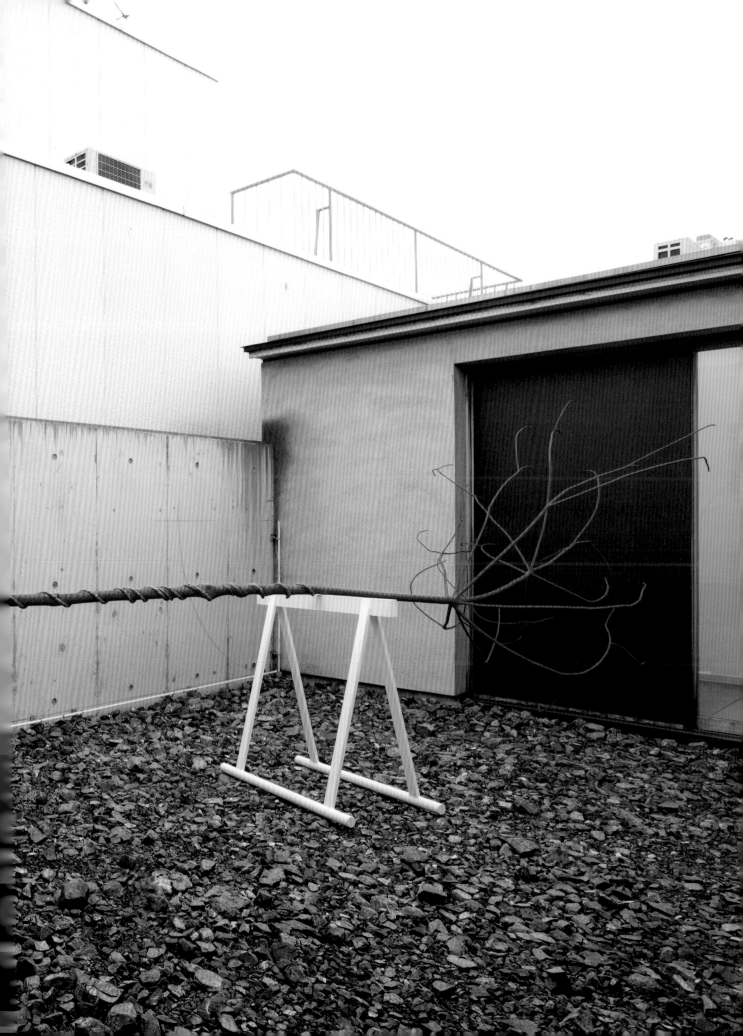

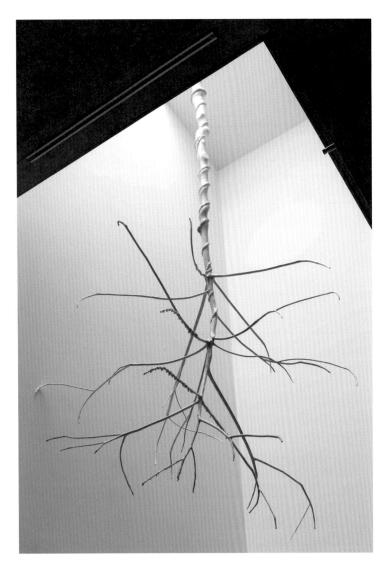

《始まりの木ー1》
Beginning tree-1, 2012
carved wood, paint, wax
H1200×W3300×D1100mm
ギャラリー古今（東京）
Gallery Kokon (Tokyo)

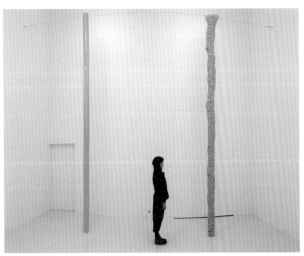

installation view of "Calls & Whispers," 2013 Gallery21yo-j (Tokyo)

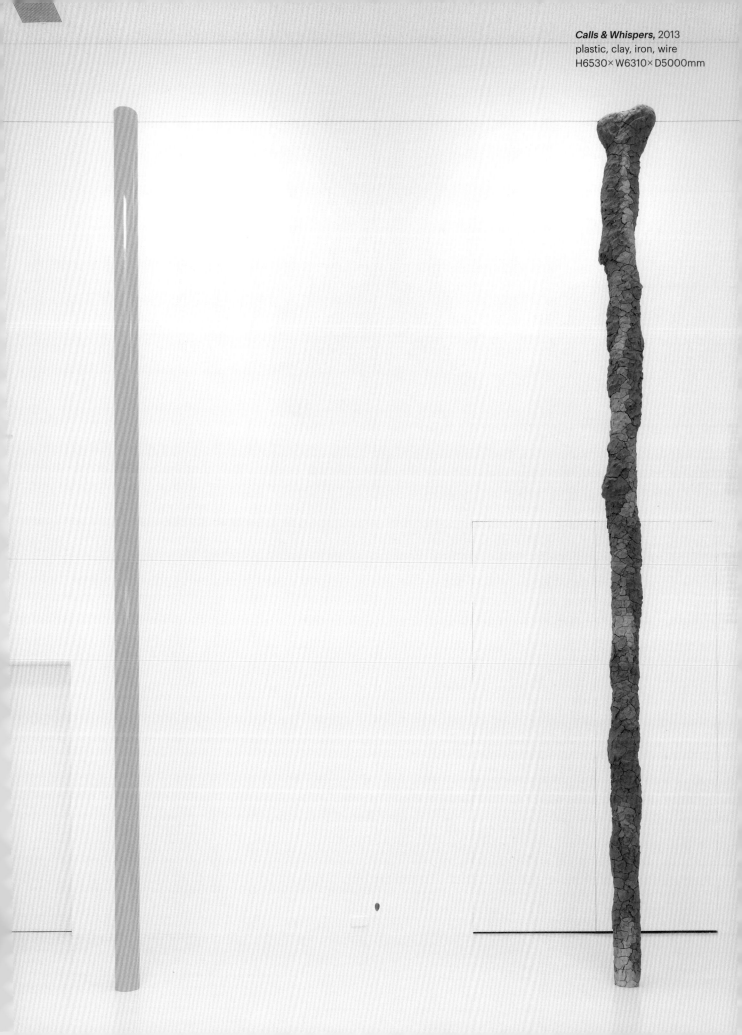

Calls & Whispers, 2013
plastic, clay, iron, wire
H6530× W6310× D5000mm

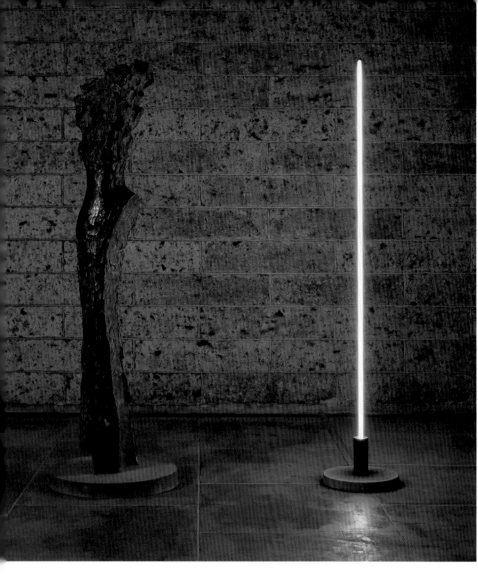

Evidence, 2006
bronze, fluorescent tube, concrete, brass
H1950×W2000×D680mm
Courtesy of The Museum of Modern Art,
Kamakura & Hayama
Photo Tadasu Yamamoto

Two Palls, 2018
iron, suger cube, wood
H140×W160×D355mm

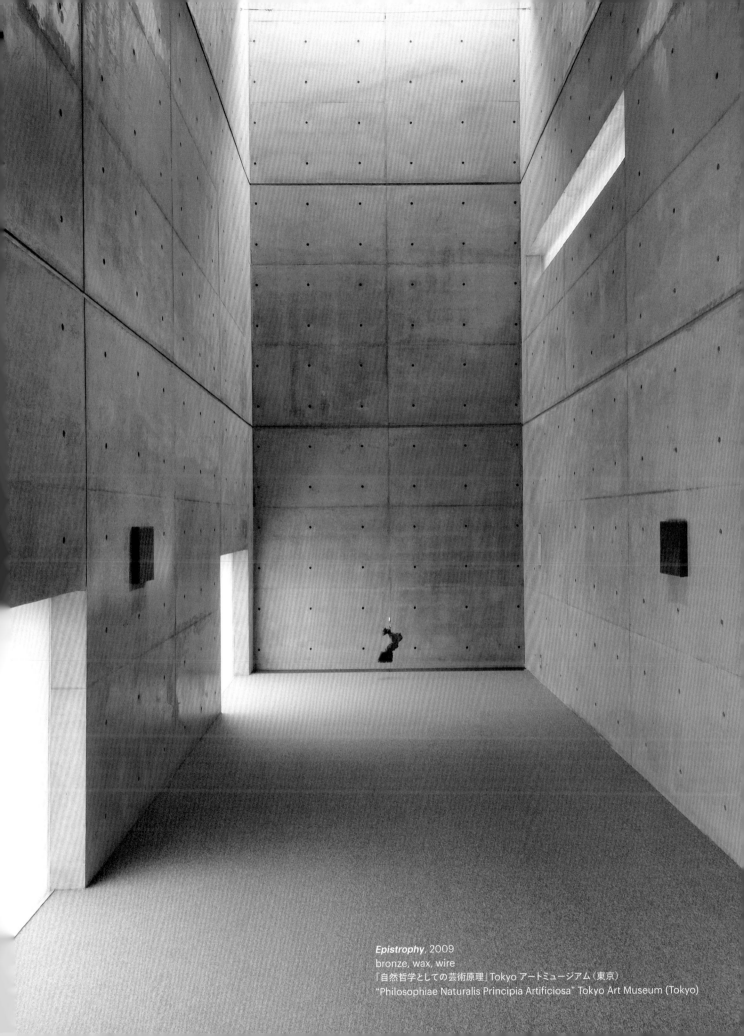

Epistrophy, 2009
bronze, wax, wire
「自然哲学としての芸術原理」Tokyo アートミュージアム（東京）
"Philosophiae Naturalis Principia Artificiosa" Tokyo Art Museum (Tokyo)

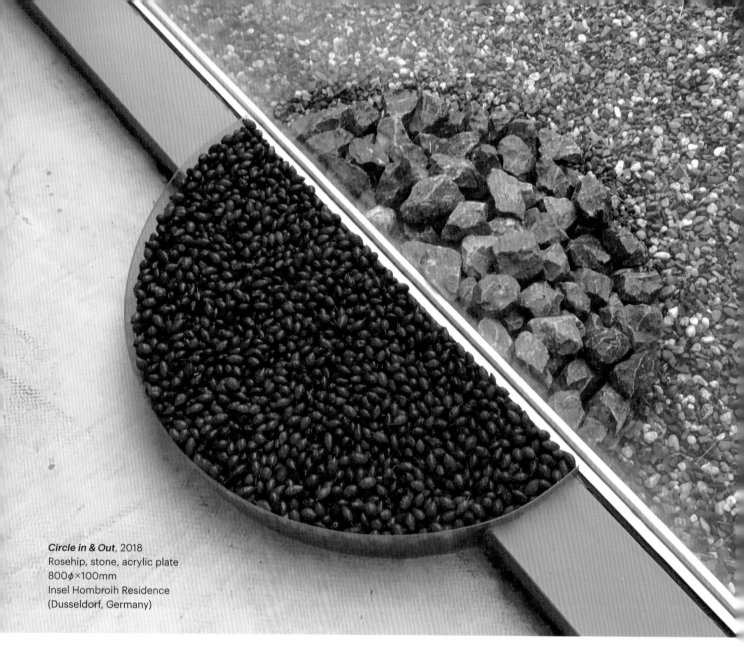

Circle in & Out, 2018
Rosehip, stone, acrylic plate
800φ×100mm
Insel Hombroih Residence
(Dusseldorf, Germany)

Insel Hombroich

2018年に滞在制作したドイツのインゼル・ホンブロイヒは広大な自然が残る土地に彫刻家エヴィン・ヘーリッヒが設計したレンガとガラスのミニマルな建築が点在するというある意味理想郷のような美術館と施設でした。
そこでの滞在制作は与えられたスタジオにあるもので制作するということもあり、ミニマルな空間とは相反する不定形な線や形をした長い時間を経た家具素材を使用したり、周辺で採集した植物を使ったりして素材の選択肢が広がったと感じました。

Insel Hombroich

In 2018, I had a residency at the Museum Insel Hombroich in Germany, which is kind of a utopia of minimalist brick and glass buildings designed by sculptor Erwin Heerich interspersed in an expansive natural setting.
During the residency, we worked with whatever was available in the given studio, and I appreciated the expanded choice of materials, including the use of time-worn furniture made of irregular lines and shapes that were incongruous with the minimalist space, as well as plants collected in the surrounding area.

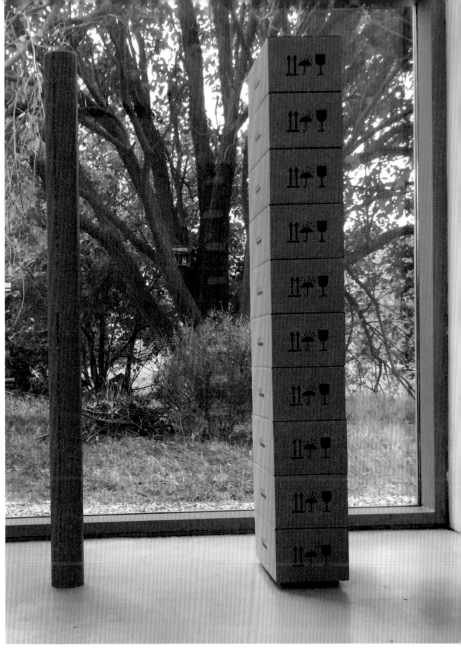

Two Palls, 2018
plastic, pipe, card board box
Insel Hombroih Residence
(Dusseldorf, Germany)

Installation view, 2019
Line-1,2,3 (from right), 2018. wood
Cross Point- 1,2 (from back), 2018. wood
Thinking Moon-1, 2019. plaster , H1700×W400×D230mm
Tthinking Moon-2, 2019. plaster, H2160×W300×D400mm
「考える月」gallery21yo-j（東京）
"Thinking Moon" gallery21yo-j (Tokyo)
Photo: Tadasu Yamamoto

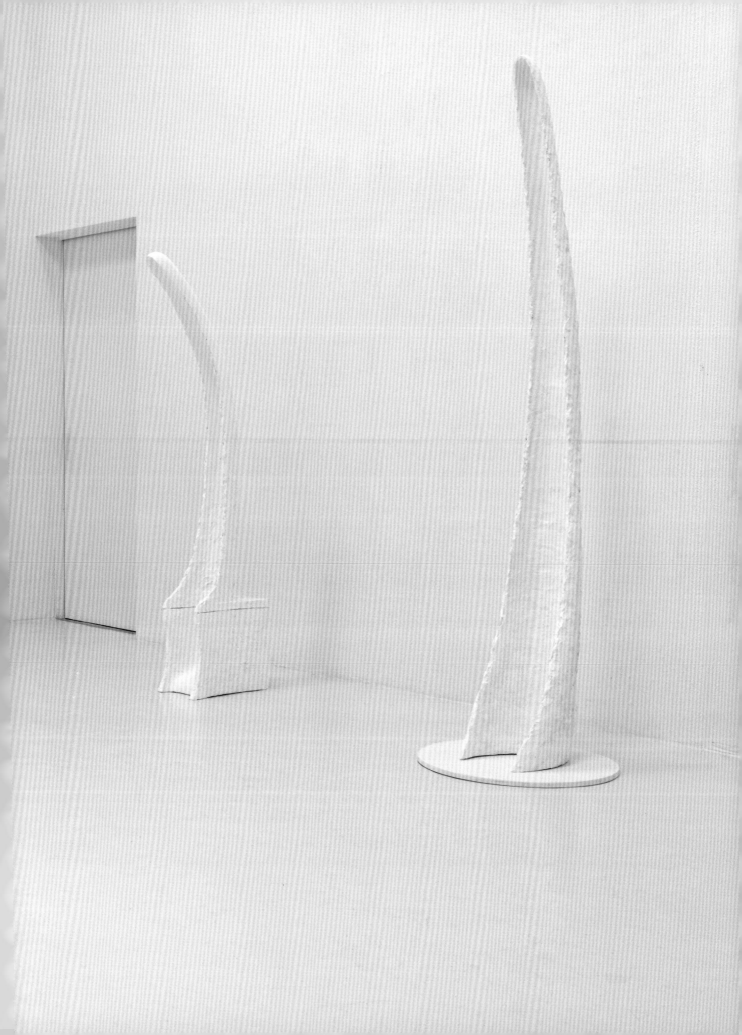

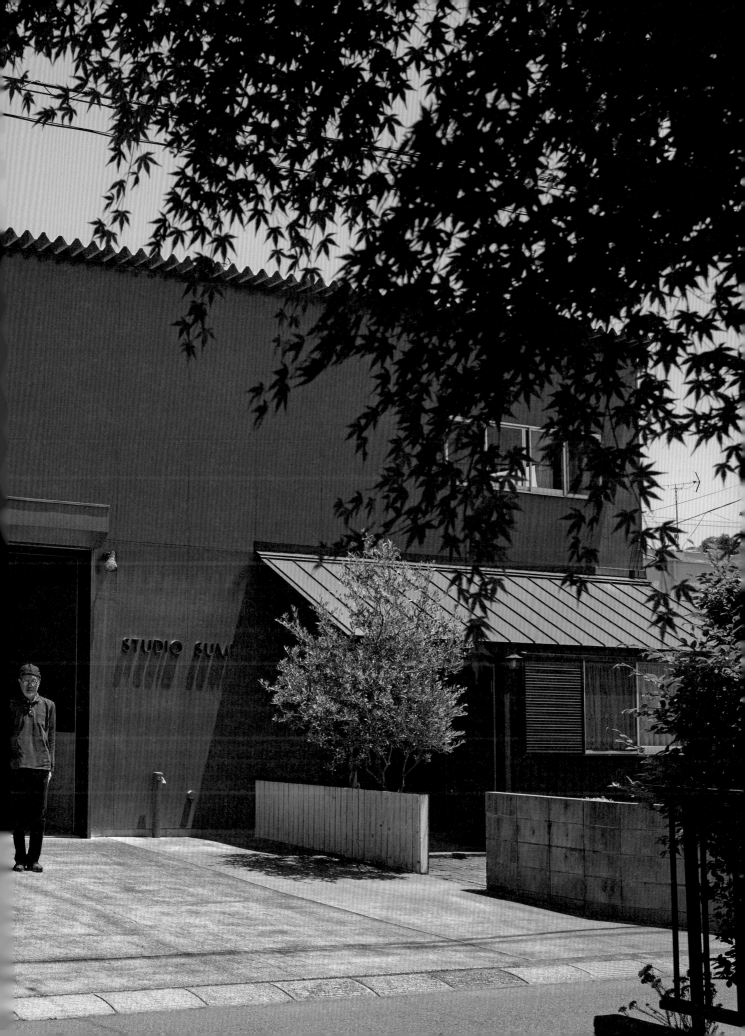

INTERVIEW

鷲見和紀郎 インタビュー
聞き手：蔵屋美香
2022年6月5日
千葉県東金市の鷲見和紀郎スタジオにて

Bゼミ前後

蔵屋：よろしくお願いします。

今日は主に2つのことをうかがいたいと思います。

ひとつは歴史に関することです。鷲見さんがしばしば口にされる、日本の美術の流れのなかで、1980年代が名前を与えられないまま不可視化されている、という問題についてです。そこを再考するためにも、まずは鷲見さんが1970年代から80年代にかけて経験されたことをきちんとうかがいたいと思います。

もうひとつは、もちろん鷲見さんの作品についてです。50年に及ぶ制作のなかで、どのようなきっかけで、いつ、なんのシリーズが生まれ、形や素材の扱いはどう選択されたのか、そこで鷲見さんがやろうとしたことはなんなのか、という、きわめて基本的な話です。

まずは歴史の話から年代順にうかがいましょう。鷲見さんは、1968年、岐阜の県立加納高校美術科を卒業されたんですよね。いろいろな作家さんを輩出している学科です。

鷲見：そうです。そこから名古屋芸術大学の彫刻科に入

学して、しかし71年に辞めました。1年も通わなかったと思います。

蔵屋：そもそも美大を目指す高校生は、特に理由がなければまず絵画科を目指すことが多いかと思います。なぜ彫刻科だったのでしょう。

鷲見：高校の教師の影響ですね。先輩や知りあいが京都市立芸術大学や金沢美術工芸大学の彫刻科に行っていたので、その影響もありました。

蔵屋：大学入学時にイメージしていた彫刻とは、どんなものでしたか。 これから話題にする非常に重要な横浜の私塾、「Bゼミ」に出会う前の、鷲見さんの頭にあった彫刻とは。

鷲見：ヘンリー・ムーアとかアルベルト・ジャコメッティとか、そのぐらいですね。デヴィッド・スミスにはまだ出会っていなかったですし。オーギュスト・ロダンのおもしろさなんかに気づくのは、さらにもっとずっと後のことです。

蔵屋：まずは50〜60年代の戦後彫刻あたりの知識を持って入学されたんですね。しかし大学の教育は期待とは異なっていたということですか。

鷲見：ええ、大学でつくられる人体にうんざりしてしまって、これではだめだと思いました。

当時『美術手帖』が愛読書だったんですが、あるとき、世界の新しい美術教育の特集がありました。そこにカリフォルニア・インスティテュート・オブ・アーツ（Cal Arts）と一緒に紹介されていたのがBゼミでした。どちらかに行きたいなと思い、自分の財布と環境を考えて、まあ横浜にしようかと。

そこで何人かと一緒に大学を辞めて、東京に出て、Bゼミを運営していた小林昭夫先生の面接を受けました。僕はこんなに不幸なんだ、と一生懸命話したら、ニコニコと、まあいらっしゃいよと言われました。1971年に入学して翌72年に修了しましたが、関係はその後もずっと続

fig.1 Bゼミ田中信太郎ゼミより、一番左が鷲見、一番右が田中、1971年
From the Shintaro Tanaka seminar in B-semi, 1971
Sumi (far left), Tanaka (far right)

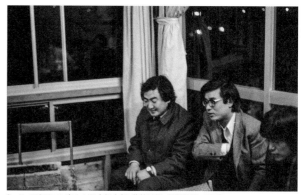

fig.2 Bゼミにて、左から田中信太郎、藤枝晃雄、須賀昭初、1971年
In B-semi, from the left, Shintaro Tanaka, Teruo Fujieda, Suga Shohatsu, 1971

きました。

蔵屋：Bゼミというのは大学を辞めて入るところだったんですね。

鷲見：当時は、大学を卒業するのは恰好が悪い、中退しないと一流になれない、そういう雰囲気がありましたからね。だから僕のスタートはBゼミですね。Bゼミで出会った先生たちや、そこで見聞きしたことが、僕の真のスタートです。Bゼミは本当に楽しかったです。

蔵屋：そのころいらした先生は、田中信太郎さん[fig.1]…

鷲見：関根伸夫さん、李禹煥さん、原口典之さん、藤枝晃雄さん[fig.2]、そういった方たちですね。

蔵屋：すごいメンバーですよね。当時はどんな議論があっ

たのでしょうか。

メディウム・スペシフィシティを重視し、フォーマリズムを日本に根づかせようとした藤枝さんと、すでにそういうこととは異なる地点から制作がスタートしているような関根さんや李さん、原口さんでは、拠って立つところがだいぶ異なるように思えますが。

鷲見：藤枝さんで一番覚えているのは、やはりアメリカ抽象表現主義をきっちりと紹介してくれたことですね。僕たちがまったく知らない世界でした。これと、当時一番新しい潮流だったミニマル・アート、コンセプチュアル・アートの関係などを、藤枝さんを通して知りました。

たとえば、コンセプチュアル・アートのジョゼフ・コースがどういった美術の動きをバックグラウンドにして出てきたのか。スタートに抽象表現主義があって、それに続くネオダダを含めたポップアートがあって、その上でコースのような作家が登場して…そうした流れみたいなものを教わったと思います。

蔵屋：50年代、60年代、70年代の美術動向を、ひとつながりの流れとして教えてくださったということですね。

鷲見：現在進行形のものと、ちょっと前の時代のものとのつながりですね。

Bゼミが終わった後も、藤枝さんの助言で「バーネット・ニューマン研究会」というのを継続して行いました。メンバーは、僕と、須賀昭初、中上清、中村功などでした。トーマス・B・ヘスのバーネット・ニューマン論（Thomas B. Hess, *Barnett Newman*, The Museum of Modern Art, 1971）を教科書として、それを翻訳してみんなで持ち寄って、ということをしばらく続けました。

蔵屋：ニューマンは、追って話題にしたいと思いますが、ちょうど後の鷲見さんのように絵画と彫刻を架橋する試みを行っていますね。この研究会のとき、すでに鷲見さんには問題意識の萌芽があったのでしょうか。

fig.3　ニューヨーク、ソーホーにて、1976年
In SOHO (New York, NY), 1976

fig.4　桑山忠明と、ニューヨークの桑山スタジオにて、1976年
With Tadaaki Kuwayama at KUWAYAMA Studio (New York, NY), 1976

鷲見：いえ、それは本当に後からですね。藤枝さんの授業でも、結局、作品はスライドや本でしか見たことがありませんでした。藤枝さんの言ったことにピンときたな、こういうことだったんだなと思えたのは、後にニューヨークに行って、ニューヨーク近代美術館（MoMA）に頻繁に通ってみてからでした。

蔵屋：話が少し先に飛びますが、鷲見さんが初めてニューヨークに行かれたのは1976年のことですね[fig.3]。

鷲見：ええ。実際の作品の大きさを感じて、絵に包まれるというか、絵と対峙するというかな。そういうことを、やはりMoMAで知りましたね。

ニューヨークでは、僕は篠原有司男さんのロフトに居候していました。桑山忠明[fig.4]さんも新しいスタジオをつくっていて、それをちょっと手伝ったりしました。ギュウちゃんと忠明さん、まったく異なる2人に出会ったわけですね。あとは、杉本博司さんとか、井津建郎さんとか。根岸芳郎さんはまだ学生みたいでした。それが76年のニューヨークでしたね。

蔵屋：時間を巻き戻して、ふたたびBゼミ時代です。

鷲見：そうでしたね。藤枝さんの講義もさることながら、一番楽しかったのは、李さんや田中信太郎さんたちの仕事場に行って、作品制作のアシスタントをすることでした。彼らの授業は授業としてあったんですが、その他に、今度ちょっと展覧会があるから誰か手伝ってくれないか、と声がかかる。現場に行って、実際にはこうやって作品をつくるんだな、ということを知る。あるいは、みんなこんなに貧乏なんだ！ということを目の当たりに見る。

蔵屋：（笑）

鷲見：それが一番リアルな授業でしたね。信太郎さんも、本当に建設会社の飯場みたいなところで作品をつくっていたし、李さんみたいに、パリ青年ビエンナーレに出すぞ、という作家だって、大家さんのガレージで時間を気にしながらつくっているわけですよ。

蔵屋：田中信太郎さんは、手でつくる、ということをとても重視されていましたが、そういうところで影響を受けられましたか。

鷲見：受けましたね。たとえば、FRPや金属を磨くとき、彼はほとんど手でやるんです。荒い部分は機械を使いますが、最後のエッジの仕上げとか、溶接の跡をどこまで見えなくするかという部分は、手なんですよ。

「鷲見くん、ここ消して」って言われて、溶接跡を削りますよね。サンドペーパーの120番、240番、400番あたりから、順番通りにたどってどんどん目を細かくして、最後は1200番ぐらいまでいきます。水研ぎといって、水をつけて磨くんです。たとえばくしゃみなんかをしてちょっとでも手がすべると、均質にしてあった目がだめになってしまうので、「はい、最初からやり直ーし」となる。なにを言っているんだ、と、どう違うのかわからなかったんですが、反射がだめだって言うんです。表面の照り返しが違ってしまうんですね。田中さんはそれぐらい厳しいんです。

そういう経験を経て、手で仕上げないとできない表面というものがあるんだな、ということを、信太郎さんを通して知りましたね。

蔵屋：田中さんにはコンセプトの部分ももちろんおありだったと思いますが、そのなかで手作業というものの比重はとても高かったんですね。

鷲見：そうですね。彼も結局そういったことは、町工場で覚えたと思うんです。たとえば、町工場の職人に立方体をつくらせますよね。溶接すると当然溶接した跡が残るので、「これじゃ駄目だよ」って職人に言う。すると、「先生、あとは手作業ですよ。手で仕上げるしかないんですよ」って言われる。そこから彼は、おそらく自分で覚えたんだと思うんですよ。

fig.5　Bゼミ李禹煥ゼミより、左から2番目が鷲見、一番右が李、1972年
From the Lee Ufan seminar in B-semi, 1972
Sumi (second from left), Lee (far right)

fig.6　Bゼミ原口典之ゼミより、1971年
From the Noriyuki Haraguchi seminar in B-semi, 1971

蔵屋：では、鷲見さんのBゼミでの学びは、藤枝さんのような美術史や理論の部分と、田中さんたち作家を通して知ったつくる技術の部分の、2つで成り立っているんですね。

鷲見：そう。技術というか、つくる実際ですね。表現というものに長い道のりがあるとすると、恰好いいのは一番最後だけ。それまではもう、本当に埃と泥にまみれて、手が傷だらけになって、情けないことのくり返し。最後にちょっと仕上げでいいところを見せる、というのが制作なんだな、ということですね。

たとえば、李さん[fig.5]のように単純に見える表現でもそうなんです。当時、絵画とは別に彼が取り組んでいたのは、ものを使うことでした。木の面をノミで彫る〈刻みより〉とか、あるいは石を、はっ、と、こう・・・。これらについて李さんは、もの派的な、最小限の手わざということを言っていましたが、実際には最小限ではないんですよ。

たとえば〈刻みより〉だって、既製品の木を持ってきてただくっつければいいわけではないんです。自然なものなんて実際にはないわけですから、見た目に自然に見せるために、自然に見えるように、まずつくらなきゃいけないんです。それから手を加えて、あたかも自然にちょっと手を加えただけですよ、と見せるための努力というのが、やっぱりいるんです。李さんは絶対にこんなことは言わないと思うし、言っちゃだめだ、って言うかもしれないですが。

蔵屋：2000年代以降かと思いますが、李さんの絵画制作中の映像を見たことがあります。ひと筆でばっと描くのかと思っていたひとつのタッチを、実に入念に、ゆっくりとつくっているのが印象的でした。もの派当時の立体にも同じような側面があったということですね。

鷲見：まあとにかく、Bゼミがこんな風におもしろかった

のは、小林昭夫さんという類いまれなプロデューサーがいたことが大きかったのは確かです。評論家でも作家でも、そのときどきの旬な人を呼ぶ手腕に非常に長けていました。たとえば『美術手帖』に論文や評論を書いた人が、発売の週にはもう学校に来ている、という感じでした。そんな同時代性があったからこそ、美術史とか美術論とか、理論的な面でも自分なりのものを確立する、ということを考えられたと思います。

ただ、くり返しになりますが、僕がBゼミでもっとも学んだのは、やはりそれぞれの作家がどうやって作品をつくり出しているのかという、その現場性みたいなものでした。これがBゼミという学校で、僕にとって一番リアルなことでしたね。

蔵屋：鷲見さんがBゼミで教えを受けた作家さんたちは、関根さんや李さん、原口さん[fig.6]など、現在もの派と呼ばれる人たちです。理論担当の藤枝さんから、「現在進行形のものとちょっと前の時代のものとのつながり」を学んだ鷲見さんは、では、これら上の世代の作家たちと、次の世代の自分との関係を、どんなふうに考えていましたか。

鷲見：まあ若かったですから、もの派と一緒のことをやっちゃだめだな、と思っていました。

彼らの一番の特徴は、今話してきたように、言葉通りではないにせよ、石なり鉄なりの素材になるべく手を加えないで表現する、ということでした。ようするに、造形はしないということです。

しかし、今この時代でもできる造形というものはあるんじゃないか。もっと即物的な言い方をすると、たとえば石や鉄を使うとき、彼らは自然のもの、または既製品を使います。どちらもまさに自分が「手を加えないもの」です。それなら僕は人工的なもの、つまり、人の手を通したものを使って作品をつくろうと思ったんです。簡単に言うと、

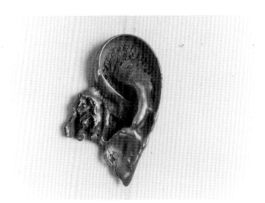

工業製品の鉄板を使わないで、鉄板自体をつくろう、という考え方ですね。

蔵屋：なるほど。

鷲見：初期のころは、僕も既製品の鉄板を使ったり鉄骨を使ったりしていました。しかし、それだとどこまでいっても表面は工業製品の表面なんです。このままつくっていても、もの派的な表現、あるいはミニマル・アートの表現から抜け出せないと感じました。そこで自分で鉄板をつくろうと考え、そこから鋳造という方法を探し当てていったんです。

また、鉄板をつくろう、ということと併せて、もうひとつ、素材も自分にしか使えないものに出会いたいと考えていましたね。

蔵屋：先生たちの世代と同じことはやらない、という意識は、早くからはっきりされていたんですね。

鷲見：先生というのは反面教師だと思っていましたから。人として尊敬はするけれど、同じことをしてはいけない、と。その点で、もうひとつBゼミでありがたかったのは、田中さんや関根さんが三木富雄[fig.7]のような異質な作家を紹介してくれたことでした。

蔵屋：当時のBゼミからすると、三木さんは異質な人という感じなんですね。

鷲見：三木さんはまったく違っていました。そもそも彼は、Bゼミだけではなく、時代ともあっていなかった。ようするに、三木富雄という個人の世界のなかの人でした。まわりも彼を天才だと言っていましたが、本当にワン・アンド・オリーでした。

もちろん、彼の作品はいろんな解釈ができますよ。たとえばポップアート。ひと目で耳ってわかるものをつくるわけですから。あるいは、アンディ・ウォーホルがキャンベルスープの缶を複数つくったように、三木は耳を複数つくるわけですから。

しかしね、ウォーホルは機械的な大量生産という時代の特性を際立たせるために、スープの缶をシルクスクリーンを用いて表しました。対して、三木は耳を1個1個つくっていたんです。もちろん、自分の耳を型取りしてマルチプルにした作品はありますよ。でも、それだって1個1個、手で仕上げています。だから、やはり正しい意味でのポップアートではなかったですよね。

また、耳というおどろおどろしい人体の器官を扱っているということで、シュルレアリスム的なオブジェだという見方もできるかもしれません。実際彼のまわりにはシュルレアリストが多かったし、瀧口修造さんが彼の作品を認めたりしていました。でも、やはりシュルレアリスムの世界とも違っていた。彼はレオナルド・ダ・ヴィンチを尊敬していましたからね。まったくかけ離れた世界を見ていた。ようするに、異常なポジションだったんですよ、彼は。そして幸か不幸か、41歳で亡くなってしまった（1978年没）。

すみません、少し三木の話を続けますが・・・。彼を手伝ったのは、南画廊で個展をするときでした。たくさん作品をつくらなきゃいけないということで、そのアシスタントだったんですが、僕が思うに、彼はもう耳をつくることにうんざりしていたのではないか。

蔵屋：どういう意味でしょう。

鷲見：三木は耳の作家だ、ああまた耳か、って言われることがわかっていてつくっていたんですよ。だから、自分が耳を止めたとしたら、じゃあなにをつくるのか、という迷いがあったと思います。その答えが出せないまま、彼は死んでしまいました。ある意味幸福だったかもしれないですね。ずっとあのまま生きて、70歳になっても耳をつくり続けたのか、あるいはまったく違うところにいけたのか、それはわからないことです。

蔵屋：鷲見さんの作品に三木さんの影響を見出すことは、

一見むずかしいように思えますが、そのさまを近くでみ
ていらしたというのは、やはり大きかったんですね。

鷲見：ええ。もうひとつびっくりしたのは、その耳のつく
り方です。細長い机の上に粘土の塊をドーン、ドーン、
ドーン、ドーンと4ヶ所か5ヶ所置くんです。そして、や
おら手で耳をつくりだすんです。1個ずつつくるのではな
く、4個ぐらい並べて、あっちへ行ったりこっちへ行った
りしながら同時につくり始めるんですよ。だから先ほど
言ったように、できたものは1個1個違うんです。

こうして、「鷲見くん、いいよ」って言われたときには、全
部が完成しています。僕はいつも「はいっ」と言って、そ
れらを石膏で型取りし、アルミの鋳物工場に持って行き
ます。だから鋳物も4、5個一気にできちゃうんです。そ
れを今度は持ち帰って、削って磨いて、完成です。僕
が耳を磨いている間に、彼はまた横で4個、5個、粘土
で耳をつくっている。そうやって、その南画廊の個展の
ために50個ぐらいつくったかな。

蔵屋：じゃあ、このときの耳は、粘土までを三木さんがやっ
て、そこから先はほぼ鷲見さんなんですね。

鷲見：そうですね。石膏取りが僕で、仕上げもほとんど
僕。最後に三木がちょちょっと触って、完成です。だか
ら三木が亡くなった後、美術館に入れるときには、僕が
仕上げをやりましたね。

まあ、異常なときを過ごしましたよ。まわりがミニマル・
アートだ、コンセプチュアル・アートだと言っているとき
に、毎日耳をつくる男の側にいるという体験をしながら、
20歳ごろの青春を過ごしたわけですから。ちょっといび
つな人生になりましたよね。

蔵屋：一方、そのおかげで、ミニマル・アートの時代な
んだからそれにあわせなければ、といった固定観念か
ら自由でいられた、ということはありますか。

鷲見：ええ。それは三木もそうだし、田中信太郎さんみ

たいにミニマル・アートだと思っていた人が、手を傷だ
らけにしながら削っている。「ああミニマル・アートって
職人仕事なんだな」と知ったことも、結局はそうです。
つくっているところを見ると、やはりいろいろ見えてくる
ことがあります。

たとえばドナルド・ジャッドとかカール・アンドレとか、
欧米のミニマルの作家たちは、そこまで手仕事はしてい
ないと思いますよ。デヴィッド・スミスぐらいまでじゃな
いですか、最後まで自分でつくっていたのは。

蔵屋：欧米のミニマル・アートには、個人の手わざを回
避する、意識的に既製品や工場発注を選ぶ、という考
え方があるかと思います。もの派に通じますね。これと、
日本の作家がつくるミニマルな形態を持つ作品とは、見
かけは似ていても、つくられ方や背景にある思想がかな
り異なるということなんですね。

鷲見：そうですね。今日ミニマル・アートの先駆者とい
われる桑山忠明さんだって、初期はすべて自分でつくっ
ていました。画面を結合するクロームストリップなども、
自分でつくっていたんです。もちろん、お金がないので
自分でつくるほかない、ということもありましたが。

ただ、桑山さんの場合はある時期から発注になりました
ね。クロームフレームの初期のころは、エアコンプレッサー
を使って画面も自分でつくっていましたが、ホウロウの
後かな。職人に色見本をわたして、表面の仕上がりま
で指示を出すようになりました。非常に大きな空間のなか
に同じ単位をレイアウトするようになってからです。そ
れは、数や規模のコンセプトを実現するために発注が
必要になってきたからだと思いますけれどね。

蔵屋：今さらですが、鷲見さんご自身は、完全発注を考
えたことはなかったのでしょうか。

鷲見：鋳物屋は職人仕事ですから、もちろんそれは発注
です。僕はいい鋳物屋に行っていました。でもお金が

fig.8 *Untitled*, 1972

fig.9 *Work B-1*, 1981

fig.10「鷲見和紀郎：ZONE」展示風景
"Wakiro Sumi: *ZONE*"

払えない。ということで、気がつけば結局はそこで働いてしまっていました。

蔵屋：ご自分が発注される職人さんの側にいってしまったんですね（笑）。

こうしたなかから、鷲見さんの、もの派でもミニマルでもないものづくりが始まっていくわけです。

1980年代からの展開

蔵屋：72年にBゼミを修了してから、ミニマルな立体の表面に漆を塗るといった手作業を加えた作品が続きます（《Untitled》1972年他[fig.8]）。

鷲見：Bゼミ時代から引き続きのミニマル・コンストラクションでしたが、表面に漆の塗料を塗って、それを田中信太郎さんのアシスタントのときのように、1200番の水研ぎで仕上げていました。大きなものだと7mを超えるサイズだから大変です。

でも、このころは、自分の手を通してつくっている充実感が、ある意味免罪符になっていたかもしれないですね。自己満足というか、職人仕事をしていることで、なにかつくった気になっていた。それと芸術は関係ないということはわかりながら、これがアーティストの仕事なんだ、と言いわけしていたような気がします。

蔵屋：むずかしいところですね。自己目的化した手作業を避けようとすると、もの派や欧米のミニマル・アートのように、最小限の手わざにする、あるいは発注をする、ということを考えます。しかし鷲見さんは、そうはしないわけです。

鷲見：そうですね。こういう表面にしたい、ということのためには、やはり手作業をせざるを得ないんです。

これはさっき話したことのくり返しになりますが、工業製品でもなく自然物でもない、人間の手を通して生まれる人工物の極致。芸術はこの人工物の極致でなければいけないという、自分のなかの縛りがあったんです。もの派を見すぎたということもあるのでしょうが。

蔵屋：こういう表面にしたい、というのは揺るがずにあるんですね。

鷲見：それは確実にあります。

蔵屋：これらのミニマルな形態を持つ作品は、しかし1980年代に入って、《Work A-1》[P.068]、《Work B-1》[fig.9]（いずれも1981年）あたりから急速に変化します。

鷲見：「鷲見和紀郎：ZONE」（ギャラリー手、1982年）[fig.10]で展示した作品ぐらいからですよね。

それまでは、表面にいろいろするものの、やはりどこか幾何学的で構成的な抽象というところから抜け出せていませんでした。しかし、このあたりから自分でテクスチャーをつくった板や棒に変わってきます。

そこに、ワックスワークが出てきます[fig.11]。

ワックスという素材を発見したのは、やはり鋳物工場というものづくりの現場でした。鋳造をするときに、ロストワックスという技法があります。ロダンもジャコメッティもこの技法を用いています。

まず、作家が粘土の原型をつくります。これを受け取った鋳物工場の職人は、その原型をワックスに置き換えます。このワックスのまわりを石膏などで包み、窯で熱してワックスの原型を溶かし出します。これでなかが空洞の型ができます。この型に溶かした金属を流し込んで鋳造をするんです。

僕も当初は、ワックスでつくったものを金属に変えることが目的でワックスワークを始めました。一方で、そのころ僕は、どんどん大きなものをつくりたくなっていました。康画廊というところで個展をする際、「3m×3mのブロンズで作品をつくりたい」と、オーナーに相談しました。しかし、「鷲見くん、それは300万以上かかる。やらせ

fig.11 *Work E-9*, 1981

られないよ」と言われ、だったらワックスのままでどうだろう、と思いつきました。ブロンズにできない。だったらワックスのままでいいや、と。後から考えたら、そもそも3m×3mのブロンズはギャラリーに搬入できなかったんですけどね。

ワックスだけで作品をつくるというアイデアは、こうしてすごく直接的な理由で始まりました。

蔵屋：理論的な筋道というより、やはりつくる現場での発見だったんですね。

鷲見：ええ。おまけにもうひとつ、溶かしたワックスは刷毛塗りをすることが可能なんです。それなら、たとえばジャクソン・ポロックが絵を描く時に塗料がしたたり落ちる、あの「ポーリング」のようにワックスをつかうことができるんじゃないか、と思いつきました。

こうして、僕が「ペインティング・スカルプチャー」と呼ぶ、ワックスを使った面的な彫刻の制作が始まりました。木や石膏でつくった土台の上に、溶かした蝋を刷毛に含ませて塗っていきます。何回塗り重ねるかによって、表面のでこぼこ具合は変わってきます。ポロックの絵画制作と同じく、即興的な作業です。つくりながら、こういったペインティング的な彫刻というものは、ひょっとしたら発明なんじゃないか、と感じました。

ただ、ひとつ問題がありました。ワックスワークだと、展示が終わったときに撤去してしまうので作品が残らないんです。

そこで、ひとつには、どうせ残らないんだったらもっと大きくしてやろう、ということで、作品を外でつくって会場に運び込むのではなく、現場で制作するという考え方が出てきました。

もうひとつには、しかし残るものもつくりたい、ということで、84年ごろから、ワックスワークをブロンズでキャスティングする作品をつくるようになりました。

片方でワックスという永続的ではない素材を使った新しい表現をする。そしてもう片方で、やはり彫刻家として金属彫刻を模索する。2つを並行して成り立たせることは、今も変わっていません。

こうして、気がつくと、誰もつくったことのない表面を持つ、平べったい、絵画の要素を持ちながら、しかし彫刻的なものという、未知の世界が見えてきました。

蔵屋：自己目的化した手作業からいかに抜け出すかという問題、大きさの問題、そして、彫刻と絵画のあわいという問題。こうしたことが、80年代に入った瞬間にワックスという素材の発見によって一気にわっと噛みあったんですね。ビッグバンとでも言いたくなるような事態が、この時期に起こったように見えます。

この80年というタイミングには、なにか理由があるのでしょうか。

鷲見：うーん、80年になにがあったんだろう。まず、76年には先ほど言ったようにニューヨークに行きましたから、その後ですよね。

それから、78年には三木さんが亡くなっているな。三木さんは1回しか僕の個展に来ていないんです。僕の最初の個展で、ギン画廊（1972年）のときだったかな。帰るときに、「鷲見くん、ちゃんと作品をつくったら見にくるよ」って言ったんです。それはもうトラウマですよ、今でも。

蔵屋：続いて、84年ごろから、先ほど話に出たように、《Work M-2 Stolichnaya》（1984年）[P.072] など、ワックスをブロンズに鋳造する作品が登場しますね。ブロンズにしてみていかがでしたか。

たとえば鋳造によって、原型にあるワックスの即興的な滴りが、本当の滴りではなく、形はそっくりだけれど型取りされた別のものになりますよね。そこに疑問は生じないのでしょうか。

鷲見：疑問というか、逆に発見がありましたね。

fig.12 *Work O-1. Horizontal Edge*, 1986

彫刻というものはね、結局表面なんですよ。たとえば、ロダンの《考える人》(1882-83年(原型))も、コンスタンティン・ブランクーシの作品も、鋳造の性質上、厚さ8mmぐらいの金属でできていて、なかは空洞なんです。だから、形の表面をなぞっただけのものを、ふつうわたしたちは作品として見ているんですよね。

ということは、ワックスの面を鋳造した、水の表面のような彫刻があってもいいんじゃないか、それも彫刻と言っていいんじゃないか、と考えるに至りました。

ただしこのとき、面のエッジの部分には本当に注意しなければなりません。ここに繊細さがないと、表現として鈍いものになってしまいますからね。

蔵屋:たとえば、溶けた鉛をまき散らす、リチャード・セラの《Splashing》(1968年)という作品があります。鷲見さんも、溶けた蝋をまき散らすというように、パフォーマンスベース、プロセスベースの方向へと向かうこともできたわけです。しかしそうはせず、ワックスが可能にした薄い膜のような形を、今度はわざわざブロンズで鋳造する。そして、そもそも鋳造という技術に支えられている以上、彫刻とは表面に過ぎないのだ、と、彫刻というメディウムの固有性を再認識する。もちろんセラのベースにも彫刻という概念があったと思いますが、このように、メディウムの考え方を拡張しつつ、その原理に忠実に立ち返るという往復運動が生じるところが、とても鷲見さんらしいと感じます。

鷲見:そうでしょうかね。

ちなみに、後で振り返ってびっくりしたんですが、僕が最初に地元、岐阜でつくった作品が、やはり表面を扱っていたんですよ(《Contemplation》1972年 [P.034])。僕の地元、長良川の河原で、石の上に美濃和紙をかぶせて、水をかけて、乾いたところを外すと、石の跡が型取られて出てくるというものです。もう残っていないんで

すが。

蔵屋:これは、行為が主体の作品だったんですか。それとも、石から外した後の形を作品として成立させるものなんですか。

鷲見:当時はアクションが主体でした。しかし後から、これをもうちょっと肉厚にして重ねれば作品になったなあと思いました。

蔵屋:なるほど、まさに表面としてのキャスティングなんですね。後に偶然に発見したように思える技法も、実は早くから潜在する関心があるから、発見に対してぱっと反応ができるのでしょうか。

話をワックスを鋳造した作品に戻しましょう。

もうひとつ、ブロンズにしたことで、ワックスで克服した大きさの問題が再び出てくるのではないかと思います。この点についてはどうお考えでしたか。

鷲見:そうですね。おっしゃるとおり、そもそもワックスワークが始まった動機は大きさを得ることでした。この点、ブロンズの場合はサイズに限界があります。

しかし、だったら巨大ななにかを連想させるようなものをつくればいいのではないか、と考えました。たとえば、壁の向こうに巨大なものがあるんだけれど、その末端が今ここに見えている、というようなつくり方をする。《Work O-1. Horizontal Edge》(1986年) [fig.12] に始まる壁付けの作品などがそうですね。

あるいは、少し後ですが、構造のなかに入っていけるような、隙間がある形をつくるということも試みました。そうすれば、サイズは小さくても大きな空間を想像させられるのではないか、と。

それともうひとつ、鋳造にともなって、形に空間構造の要素が加わってきました。皮膜のような形にプラスして、渡るとか、つなぐといった要素が出てきたんです。

蔵屋:「鷲見和紀郎展：STOLICHNAYA」(ギャラリー手、

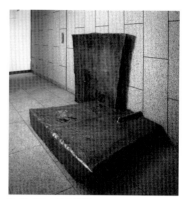

fig.13《Work M-5 対岸》
Work M-5 Opposite bank, 1986

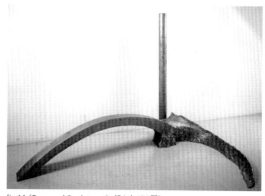

fig.14《Prepared Sculpture-3. 起き上がる闇》
Prepared Sculpture-3. Wakening Darkness, 1987

1984年）に出品した《Work M-2 Stolichnaya》のような作品が、この渡るとかつなぐという点をよく示していますね。垂直に立つ要素と、床置きの塊の要素、そして弧を描いて伸びる細長い要素の3つがそれぞれ関係づけられています。こうした複数の要素の関係性を見せるという発想は、どこから生まれてきたのでしょうか。

鷲見：そうですね。僕はもともと子どものころから橋が好きなんです。巨大な鉄の長良橋がかかる長良川の下流で育ちましたしね。海外でも、パリとかリヨンとか、都市の川にさまざまな橋があることが一番興味深かったんです。

橋というものには3つのディメンションがあると思うんです。まず遠くから見る橋ですね。これは虹のようなもので、なにかとなにかをつなぐ形です。それから実際に渡る橋ですね。ここには運動と視点の変化があります。そして、川の水面から見る橋、仰ぎ見る橋ですね。こんな風に考えると、橋ってまさしく彫刻的な空間なんですよ。

蔵屋：続く《Work M-3 Stolovaya》（1985年）[P.076]、《Work M-5 対岸》（1986年）[fig.13] などの作品についてはいかがですか。2つとも、明確に橋状の形を持つ《Work M-2 Stolichnaya》と見た目は異なりますが、やはり複数の形の関係を扱っています。また、片方のタイトルには「STOLOVAYA（食卓の）」と、「STOLICHNAYA（都市の）」と同じくロシアのウォッカの名前がつけられていますし、「対岸」も橋を連想させる言葉ですね。

鷲見：そうですね。まず、《Work M-3 Stolovaya》はは水平を問題としています。テーブル状の彫刻ですね。視線が水平に移動するようにつくられていて、途中の段差によってわずかに彫刻的空間が意識されます。たとえばポロックは、床にキャンバスを水平に置いて、その上に乗って絵を描きますね。僕も、この平面のなかに入ってワックスでペインティングをして、それをキャスティ

ングしています。つくり方としては共通していますが、僕とポロックとの違いは、ポロックは後に色が残り、僕は表面だけが残る、というところでしょうか。

また、《Work M-5 対岸》は東京国立近代美術館が持っている作品です。これはキャスティングのしくみを利用して、ひとつの原型で、垂直に立っているものと水平に寝ているものの2つをつくっています。穴が開いている部分と突出している部分だけを変えてね。ふたたびポロックで比較すると、ポロックの絵画は水平の状態から壁に掛けるしかない。しかし僕のは垂直にして立てることができます。

蔵屋：なるほど。表面だけで成立すること、水平と垂直の関係性など、複数のパーツの関係と共に、やはり彫刻と絵画の問題を扱っているんですね。この「彫刻は自立する」という点は、また後ほど立ち戻ることになると思います。

話を戻すと、先ほどスタジオで見せていただいた《Prepared Sculpture-3. 起き上がる闇》（1987年）[fig.14] もこの時期の作品ですね。これは《Work M-2 Stolichnaya》に似て、垂直、塊、曲線の3つの要素の組みあわせでできています。ただし垂直の棒には既製品を使っていますね。

鷲見：これは、手の感触の残る粘土原型のブロンズと、これとは異質な既製品の金属のパイプを、垂直に立つ、床に横たわる、そして橋渡しする、という3つのディメンションによって合体させた作品です。手触りのあるものとないものとの違いを強調するために、あえて円柱の部分には既製品を使ったんです。

蔵屋：既製品の使用は、手の仕事にこだわってきた鷲見さんとしては例外的なことではないんですか。

鷲見：それはそうでもないんですよ。この後、折に触れて扱っています。たとえば、だいぶ後ですが、2会場

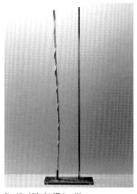

fig.15 《叫びと囁き—II》
Calls & Whispers-II, 2013

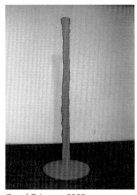

Canal Crimson, 2005

で開催した「叫びと囁き／calls & whispers」（2013年）という個展の例があります。ギャラリー古今にはねじれた自然木と真鍮のパイプを使った作品 [fig.15] を、gallery 21yo-jには既製品の塩ビパイプを使った作品を、それぞれ展示しました。

21yo-jの方は、同じ高さの塩ビパイプが2本あります。1本には黄色の塗装がなされ、もう1本には現場で手で表面に水粘土をモデリングしています [PP.216-217]。粘土の食いつきをよくするため、下に荒縄を巻いてからね。時間がたつと、粘土が乾いてクラックが入ります。

蔵屋：なるほど。クラックが入ると、既製品の上に表面だけの手作業がなされていることがはっきりとわかるわけですね。

鷲見：そうです。あと、写真だと見えづらいんですが、2本のパイプのちょうど真んなかに、天井から無垢の鉄製の卵が吊り下げてあるんですよ。だから既製品の使用というだけでなく、この作品は《Work M-2 Stolichnaya》や《Prepared Sculpture-3. 起き上がる闇》と同じく、実は3つの要素のあいだの関係をつくる作品なんです。

蔵屋：なるほど。要素の関係性をつくる場合、鷲見さんには3つという例が比較的多いのでしょうか。

鷲見：うーん、たとえば、3つではなく2つというのはきついんですよね。これがちょっと僕の弱点かな。一番いいのはひとつなんです。これは本当に「ワンメント」（「唯一無二の瞬間」という意味のバーネット・ニューマンの作品のシリーズ名）だから、究極の世界ですよね。対して、3つは決まりやすいんです。座りよく安定しますし、要素もバランスよく出てきます。「点・線・面」「○△□」みたいにね。

2つというのは、とてもコンセプチュアルなものだと思います。たとえば、ジャスパー・ジョーンズの2個のビール缶《彩色されたブロンズ（エールの缶、バランタイン）》1960年）とか、ブランクーシの《キス》（1907 - 08年）とかね。コンセプチュアルな作家にはよく対の作品がありますが、右か左かという世界です。

しかし、要素は3つながら、「叫びと囁き」にはニューマンへのオマージュみたいなところもありますね。

蔵屋：Bゼミ時代に藤枝晃雄さんの助言で読書会をされていたということで、最初の方にニューマンの名前が出ましたが、ここで再登場ですね。

ニューマンは、「ジップ」と呼ばれる絵画面上の線を棒状の立体に置き換えた彫刻を作っていますよね。ジップが画面上につくり出す空間のイリュージョンを、棒の太さや棒同士が立つ位置関係によって、3次元で検証するような作品です。鷲見さんが抱えてきた彫刻と絵画の往還というテーマに、絵画を起点に迫っている感じがあります。

鷲見：そうですね。

蔵屋：すみません、ワックスをキャスティングする80年代の話から2013年と、また一気に30年ほど話が飛んでしまいました。しかし、つい話がそこにいくということは、おそらく、時代は離れていても鷲見さんの頭のなかで課題意識がつながっているということだと思います。ですから、こうした話の飛び方自体、鷲見さんの考えをたどる上で重要ですよね。

さて、90年代に入ると、いよいよ〈ヴェール〉のシリーズが登場します。

鷲見：ええ。1994年にギャルリー・ところで「鷲見和紀郎：THE VEIL」という個展をしました。このときのキーワードが「ヴェール」です。ヴェールというのは布だから、平面的なものです。しかし、それが彫刻作品として成立するんじゃないか、と考えたんです。ワックスが垂れ下がる、垂れ落ちるさまを表面に持ちつつ、立体的構造もあるという風に。

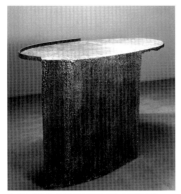

fig.16 《Veil -Ⅲ（セロニアス・モンクに捧ぐ）》
Veil-Ⅲ (dedicated to Thelonious Monk), 1994

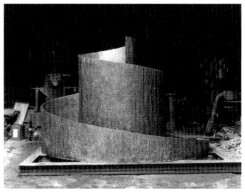

fig.17 *The Rain*, 2001

蔵屋：ここで展示されたのが、《Veil -Ⅰ（アントナン・アルトーに捧ぐ）》[P.148]、《Veil -Ⅱ（カール・テオドール・ドライヤーに捧ぐ）》[P.149]、《Veil -Ⅲ（セロニアス・モンクに捧ぐ）》[fig.16]の3点ですね。《Veil -Ⅳ（セシル・テイラーに捧ぐ）》[P.150]も加えて、1994年には4点が作られています。

《Veil -Ⅰ》のみ繊維強化プラスティックに油絵具、他の3点はアルミニウムに裏面だけ油性塗料で彩色されています。

鷲見：はい。このときに重要だったのは、平面でありつつ、単体として成り立つということ。もうひとつは、先ほどブロンズのサイズの限界をいかに超えるか、というところで触れましたが、人を巻き込める、内側に入り込めるということですね。

この個展と同じ年に広島市現代美術館でつくった《Lunar Passage》（1994年）[PP.128-129]なども、全体がカーブを描いていて、完全に通り抜けできる作品です。少し後の2001年につくった、渦巻き型の《The Rain》（2001年）[fig.17]もそうですね。

蔵屋：ちなみに鷲見さんは、作品をみる人の動きを、いわゆる現象学的に意識されますか。

鷲見：入口はどこにあるか、通り抜けられるか、上からのぞけるか、のぞけないか。空間に置く作品の場合は、やはり360度の視点をふつうに意識しますね。

蔵屋：しかし、先ほど話に出た東京国立近代美術館所蔵の《Work M-5 対岸》のような、平面的な形が床と壁に沿って置かれている作品は、回って見ることはできず、比較的正面性が強いように思います。

鷲見：たしかに、初期のものは限定的でしたね。

蔵屋：これが自立して、360度回り込めるようになり、内側にも入れるようになった重要な要素に、らせん形があるのではないかと感じます。渦巻き型の《The Rain》が一番明快ですが、平らなものをらせん状に巻くことで、

自立もするし、人が入れるようにもなります。

鷲見：それは後から気付いたかもしれませんね。

うまく言えば、ワックスのインスタレーションをやる。その平面的な形を今度は金属でやる。そこで自立するものにたどり着く。そのためにはらせんの構造が適している…。ああ、自分ではあまり深く考えていませんでしたが、やっぱりそうなのかなあ。

蔵屋：らせん形は、目で見るだけでも360度の動きをいざなわれます。そして、実際に入り込むと、形があるところとないところが次々と出てきます。いわば、実の空間と虚の空間が入れ子になっている。形がない部分も、単にないということではなく、虚の空間として実の空間を支えていて、両方がなければ成立しないつくりです。

鷲見：まさにそのとおりです。ヴューポイントがいたるところにある。人が壁のなかに隠れてしまったり、壁から現れたり、スリットから外をのぞいたり、スリットのなかをのぞき見したり…。

蔵屋：らせんの形はまた、人体が強くねじれてらせん運動を示すロダンの作品にも通じますね。

鷲見：そうですね。たとえば少し後につくった《Candide》（2005年）[fig.18]、これはロダンの《バルザック》（1892年）[fig.19]を意識しているんです。

蔵屋：先ほどスタジオで拝見して思わず連想しましたが、やはりそうだったですね。

先ほど鷲見さんが指摘されたように、ロダンの場合、鋳造すると原型が消えて、厚さ8mmの表面が残ります。特に《バルザック》の場合、中身の身体がなく、ぐるぐると巻きつけられたマントだけが立っているようなつくりです。まるで鷲見さんのいう「彫刻は表面である」という問題を、らせんを描くマントという布によって、ことさらに強調して見せるようです。

ちなみに、冒頭に、ロダンのおもしろさに気づくのはずっ

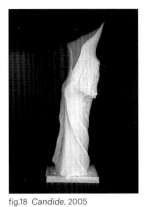
fig.18 *Candide*, 2005

fig.19 Auguste Rodin, *Balzac*, 1892

© Ad Meskens / Wikimedia Commons

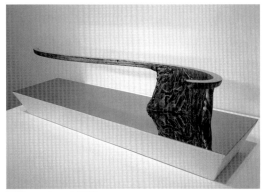
fig.20 *Narcissus-2*, 2005

と後のことだ、というお話があったかと思います。この《Candide》に示されるように、長くやっているうちに彫刻の歴史的な原理の問題を再発見されるということは、やはりあるのでしょうか。

鷲見：先人の作品はこういうことだったのか、と自分でようやくわかるというようなことは、やはりありますね。

思うに、ロダンって相当アバンギャルドな人ですよね。たとえば、生涯を捧げた《地獄の門》（1840-1917年）は、完全なアッサンブラージュでしょう。あちこちでつくった作品を取ったり付けたり、パーツだけ入れ替えたり、大きさを変えてみたり。異常なことですよ。こうしたロダンの先進性は、若いころにはわかりませんでした。

蔵屋：ロダンは100年以上前に、同じものを複数つくれるという鋳造の性質をすでにそういう形で活かしているんですよね。

さて、次に登場するのが、2001年の《ダンス-1》[P.204] に始まる〈ダンス〉のシリーズです。

振り返ってみると、70年代にBゼミと構成的な作品、80年代にワックスワーク、90年代に〈ヴェール〉、2000年代に〈ダンス〉と、わりときれいに10年ごとに節目があるんですね。

鷲見：10年周期の男ということでしょうか（笑）。〈ダンス〉は、自立する人体彫刻的な構造に回りまわってたどり着いた、というのかな。台座もここで出てきましたね。

蔵屋：360度の動きを誘われるらせんの運動があり、自立の問題があり、〈ヴェール〉から展開が自然につながっているように見えます。

鷲見：人体はそもそもらせんですからね。違いと言えば、〈ヴェール〉はワックスでつくりましたが、〈ダンス〉はもう1回粘土のモデリングに戻ろうとしたものだ、という点でしょうか。石膏でつくり始めて、石膏に親しい粘土へとたどり着いた。

だからこのシリーズには、石膏直づけでつくったものもありますし、粘土で原型をつくってブロンズに鋳造したものもあります。

蔵屋：先ほど、このシリーズで台座が登場したと言われました。彫刻における台座の問題は、言うまでもなく、彫刻を周囲の空間に結びつけるか、切り離して自律させるか、という意味で、近代において非常に大きなものです。そもそも〈ダンス〉以前、鷲見さんは台座のことをどのように考えていたのでしょうか。

鷲見：〈ダンス〉以前は、台座は必要ないものだと思っていました。だから床に直置きだったわけです。でも、〈ダンス〉の前の〈フズリナ〉のシリーズ（1998年-）[P.194] では、すでに台座と彫刻が合体していますね。台座彫刻と言っていいのかな。この下の部分がもっと細くなると立たなくなる。だったら、必要悪ではなく、もう台座もちゃんとつくろうということになってきました。だから〈ダンス〉では、作品にあわせて、四角くなったり、円形になったり、鏡面になったり。

蔵屋：《Narcissus-2》（2005年）[fig.20] の台座にあたる部分、これは鏡面なんですね。だから水鏡に映った自分の姿に見ほれる美少年、ギリシャ神話のナルキッソスなんですね。

では、今は台座は必要悪ということではなく、造形の1要素として成り立っているということでしょうか。

鷲見：少なくとも、台座が無意味だ、必要悪だという考え方はなくなりました。〈フズリナ〉までは、台座を非常に意識していました。しかし〈ダンス〉になってからは、立てばいい、という感じになってきましたね。立たせる道具というか、必要なパーツというかね。

でも、2010年に「SUMI WAKIRO 谺 -kodama-」（アートハウス あそうばらの谷）で展示したときは、床の底からビスを打って直に立てたりもしています [PP.201-202]。だ

fig.21 セロニアス・モンク（ライブ映像より）
Thelonious Monk (live footage)

fig.22 「現代美術への視点：形象のはざまに」模型
"A Perspective on Contemporary Art : Among the Figures," exhibition model

から、台座があるものもあるし、直に立てるものもあるんです。

蔵屋：あえて今1度お聞きしますが、ダンスの一番重要な要素はなんでしょうか。 自立することですか。 それともらせんの回転運動でしょうか。

鷲見：上についているこの部分がぐるっと回る、その形態ですね。ようするに、水平に回転する動きが立ち上がる、というところです。

ちなみに「ダンス」という言葉なんですが、社交ダンスとか、そういうふつうのダンスとはちょっと違う意味で使っているんですよ。

僕はセロニアス・モンクというジャズ・ピアニストが大好きなんですが、モンクは演奏中に立ち上がって踊り出すんです。グルグルと回転していると思うと、急にタタンって変な動きをするんです [fig.21]。おもしろいなあ、と思って、これが〈ダンス〉シリーズの始まりなんです。不意な動きっていうのかな。

蔵屋：水平垂直がバランスを崩す瞬間ということですか？

鷲見：いえ、崩れないんですよ。こう、テンポでいうと変拍子みたいな、タタンっていう感じなんです。

2010年代以降、最近作まで

蔵屋：続いて2010年代以降、最近までのお話をうかがいましょう。

鷲見：それじゃあ、いいタイミングなので、ここに積んである箱を開けてお見せしちゃおうかな。

ワックスの作品は、展覧会が終わった後、記録のためにこうしてすべて会場の模型をつくっているんですよ。現場制作の空間は会期が終われば消えてしまいますからね。記録映像を収めたCDもちゃんと一緒に入れられるようになっています。

これはちょっと昔ですが、1992 - 93年、東京国立近代美術館のグループ展「現代美術への視点：形象のはざまに」に参加したときの展示のようすです [fig.22]。

蔵屋：これはすごいですね。わたしは残念ながらこの展覧会、拝見していないんですが、改装前の近代美術館の空間の、どこに、なにを、どんな風に展示したのかがとてもよくわかります。

鷲見：このときは、ワックスを溶かして作業するためにプロパンガスを持ち込んだんですよ。

蔵屋：文化財を保管・展示する施設ですから、今だったら絶対にダメと言われそうです。

鷲見：黙って持ち込みましたからね。誰もそんなことをするとは思っていなかったんじゃないかな（笑）。

2010年代に話を進めると、ワックス・インスタレーションの最近のものはこれですね。2016年に神田のギャラリー・メスタージャでやった個展「LE CALME －凪―」に展示した、《Le Calme》（2016年）[PP.140-141] です。これは今回、BankART KAIKOの個展でつくろうと思っているものとちょっと似ています。壁のコーナーに設置され、手前が低くて奥が高くなっています。途中にスリットがあって、人がなかに入れるようになっています [fig.23]。

しかし、このスリットはせいぜい幅50cmぐらいしかないので、なかに入ってワックスペインティングをするのは本当に大変でした [fig.24]。 蝋を溶いているときは暑いですしね。

このときの作業や展示のようすを含めて、最近の作品はホームページで見ていただけます。

（https://sumiwakiroart.wixsite.com/sumi）。

蔵屋：2018年にはドイツのインゼル・ホンブロイヒで滞在制作をされていますね。

鷲見：ええ。ものすごくミニマルな空間でした。そんな空間にいると、へそ曲がりなので、フニャフニャな作品

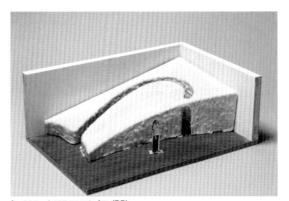

fig.23 BankART KAIKOプラン模型
Plan for BankART KAIKO exhibition model

fig.24「LE CALME－凪－」制作風景
"LE CALME," work in progress

がつくりたくなってしまいました。

《Cross Point-1》、《Cross Point-2》、《Cross Point-3》（いずれも2018年）[PP.222-223]は、作業場にあった曲木の古い椅子の脚を分解して、ジョイントしたものです。

《Circle in & out》（2018年）[P.220]は、室内に現地で集めた深紅のローズヒップを半円形に敷き詰め、透明なガラス壁をはさんで外側には石を半円形に敷き詰めた作品です。2つの部分をあわせると円形になります。

《Line-1》、《Line-2》、《Line-3》（いずれも2018年）[PP.222-223]は、壁と床を結ぶ、棒状のものを立てる、というずっとやってきたテーマのフニャフニャ版ですね。これも、古い家具の脚をジョイントしてできた真っすぐではない木の棒を壁に立てかけています。

蔵屋：その後にコロナ禍の2年半が続きます。今現在はどんなお仕事をされていますか。

鷲見：今はね、メインは平面作品です。削るという意味で、自分では「シェイプド・ペインティング」と呼んでいます。ポリエステル樹脂と油絵具をよく混ぜたものを、ヘラを使って平面上に積層させていきます。自分の気に入った表面になるまで、つけては削り、削ってはつけをくり返して、最後はツルツルの面にします。いろいろな色彩が積層されているから、フィニッシュするまでどんな色彩になるか、どんな形態が出てくるかはわからないし、どこでやめるかも誰にもわかりません。

絵画というものは、基本的に絵具をプラスしていくものですよね。シェイプド・ペインティングは削っていく、いや、単純に削るというより、削りながら足していくものです。最終的に表面は磨き出されてツルツルになり、その意味では初期のころにやっていた1200番の水研ぎに近く、しかし絵画である、というものが生まれます。

蔵屋：キャンバスにあたる支持体の多くが円形なのはなぜでしょう。

鷲見：それは、上下左右がないからです。まず四方からつくっていって、最後、壁に掛けるときに、どこが上か決めればいいんです。

蔵屋：やはり鷲見さんが長く考えられてきた彫刻と絵画のあわいの問題なんですね。しかし、なぜ特に今、平面という形式を選んでその問題を考えるのでしょう。

鷲見：ひとつには体力の問題かな。もうひとつには、今はちょっと彫刻から離れていたかった、ということがあるかもしれないですね。もう1回フラットなものをつくるところに戻ってみたかった。また彫刻に向かう時期もくるとは思いますけれどね。

蔵屋：それはなぜなんでしょう。これまでお話をうかがってきて、鷲見さんは、割と論理的に次の動きが出てくるように思えます。こういう問題を考えたい、これをやったらこれができた、次はこの素材でこうすればここができるぞ、というように、課題を追って連鎖的に次のシリーズが登場するように聞こえました。今彫刻を離れて、フラットなものをつくるということにも、なにかそこにつながる理由があるのでしょうか。

鷲見：それは、後から振り返ると結果的につながっていた、というだけだと思いますけれどね。僕はまったくコンセプチュアルな作家ではないので、自分の手癖っていうのかな、それに忠実に従ってつくっていると、それに呼ばれて次が出てくる、ということなんじゃないかと思います。それと、三木さんではないけれど、1点だけに集中してつくっているわけではないんですよ。実際には、ここで粘土を触って、こっちでは絵を描いて、あそこで小品をつくって、こちらで巨大なものをつくって、という感じなんです。すると、いつもそうなんですが、あるときに一気に辻褄があってきます。1点は完成しているけれどこちらは未完成、ということではなく、小品も大きな作品も絵画も彫刻も、みんなぴたっと辻褄があうときがあるん

fig.25 神田の立ち飲み屋にて、1980年頃
At a standing bar in Kanda, Tokyo, circa 1980

です。その瞬間、「ああ、完成した」と感じます。

歴史のなかで

蔵屋：だいぶ時間も経ったので、そろそろインタビューを締めくくろうと思います。
ここまで鷲見さんの約50年の制作の流れをうかがってきました。その重要な転換点となった80年代に、美術史上の名前がない、という冒頭の問いに戻りましょう。あらためて、鷲見さんご自身は、80年代をどんな時代だったと思われますか。ご自分の制作という意味でも、時代一般という意味でもいいのですが。

鷲見：僕が知っている80年代の東京の美術界は、非常に活気のあるところでした。銀座から神田にかけて貸画廊がいくつもあって、昨日まで学生だったような人も、お金さえ出せば1週間空間が借りられて、好き勝手なことができました。画廊主も、鉄骨を運び込もうが裸で踊ろうが、容認してくれました。
若い作家はもちろん学生も含めて多くの人が界隈にいましたが、当時でいうと大先生の堀内正和さんなんかもみえていました。美術評論家も、新聞記者も、編集者も、みんなギャラリー巡りのルーティンがあって、最後は大体、田村画廊やときわ画廊（いずれも日本橋にあった画廊）に集まって、お酒を飲んでいました。そこからまた新宿などに流れるということが日常で、そこに身を置いていると、ひとつのコミュニティというか、なにか美術界というもののなかに自分がいるような気がしていました [fig.25]。
それが、気がつくとそういった貸画廊がなくなって、時代が90年代、2000年代と進んでいくうちに、時代のはざまで、僕たちはなんの名称もつけられないまま忘れ去られてしまった。もの派でもなく、ニューウェーブでもなく、自分たちでグループを結成して名前をつけたわけ

でもない。飛び抜けたスターが出てきたわけでもない。あれだけ盛んだった銀座や日本橋のギャラリー街も勢いを失ってしまった。

蔵屋：ああ、それは…言葉を失いますね。

鷲見：50年も経つと、亡くなっていく同世代も結構いるんです。ペインターの辰野登恵子さんは僕と同い年でしたが、早くに亡くなってしまった（2014年没）。同じときに「椿会展2001」に参加して、お互い一緒になにかやろうと話していましたが、そうはならなかった。
今では知る人も少ないと思いますが、八田淳という奇人変人がいてね。軽音楽というものがあるでしょ。だから軽美術というものがあってもいいんだ、自分の表現は軽美術だと言っていました。こんな風に作家が亡くなったり忘れ去られたりしていくということがね。脇で見ていると、もう本当にさびしいんですよ。
そこには、それを語るべき評論家の不在ということもあると思います。同年代の批評家には、高島直之さん、北澤憲昭さんなどがいるんですけれどね。

蔵屋：時代背景としては、70年代から経済成長が続き、80年代のバブル経済へと入っていく、社会全体に勢いがあるころですね。

鷲見：美術の動きとしては、インスタレーションというものが容認され始めたころでしたね。なにか見繕って持ってきさえすれは作品になる、というおかしな風習も生まれてきていました。

蔵屋：今日ではごくふつうの表現形式となったインスタレーションが日本に登場したのは、おっしゃる通り、この時期ですね。たとえば、彫刻というメディウムを正面から考えていた方たちは、これをどのように受け止めていたのでしょうか。

鷲見：どうなんだろうな。インスタレーション云々以前に、そもそも彫刻ということを前面に押し出した作家も、日

本にはそんなにいなかったように思いますけれどもね。

蔵屋:鷲見さんご自身はどうなんでしょう。彫刻の概念を拡張しつつ、その拡張の土台に、19世紀末から20世紀の欧米で提起された彫刻の問題系を一貫して置く、という意識をお持ちだったように思いますが。

鷲見:うーん、僕はね、美術史を愛しているんですよ。愛しているという言い方も変ですけれど、美術史あっての美術だと思っているんです。だから、自分もそこに立っていたいんですよ。

蔵屋:鷲見さんがワックスワークをブロンズにしたり、模型にしたりと、作品を残すということに自覚的なのも、この歴史への意識によるものなのではないかと感じます。そうした美術史への意識の強さは、歴史と実技をつなげる教育を行ったBゼミが生み出した鷲見さんの世代の特徴として、きちんと捉えるべきではないかと、今日お話をうかがってあらためて思いました。

鷲見:やはりBゼミの功績はね、僕は相当あると思いますよ。今回個展の会場となるBankARTを設立した池田修さん（2022年没）への影響も含めてね。

蔵屋:池田さんは、田中信太郎さん、岡崎乾二郎さんなど、ご自分がBゼミで教わった方たちの個展を開いて、そこを歴史化しようとしていた形跡がありますね。こうしたBゼミの功績になんらかの名づけの手がかりを見つけられたら…。

もちろん、同じ時代を生きていても、個々人の制作はさまざまなので、単純にひとつの名称でくくればいいというわけではありません。しかし、なにか名前がなければ、美術の歴史のなかで見えなくなりやすいということも事実です。

鷲見:そうですよね。だから、No Nameのままではさびしいな。

蔵屋:今仮に鷲見さんご自身が名前をつけるとしたら、なんとつけますか？

鷲見:それはね、僕の仕事じゃないな。

文責：蔵屋美香

蔵屋美香：横浜美術館館長。千葉県生まれ。千葉大学大学院修了。東京国立近代美術館を経て、2020年より横浜美術館館長。主な展覧会に、2011～12「ぬぐ絵画―日本のヌード 1880-1945」（第24回倫雅美術奨励賞、東京国立近代美術館）、2014～15「高松次郎ミステリーズ」（同、共同キュレーション）、2017～18「没後40年 熊谷守一：生きるよろこび」（同）、2019～2020「窓展：窓をめぐるアートと建築の旅」（同、共同キュレーション）など。2013第55回ヴェネチア・ビエンナーレ国際美術展日本館の田中功起個展「abstract speaking: sharing uncertainty and other collective acts」で特別表彰。主な著作に、2019『もっと知りたい 岸田劉生』（東京美術）、2017『現代アート10講』（共著、武蔵野美術大学出版局）ほか。

インタビューを終えて

「作品を解説するなんて野暮なことは止めな」と八田淳なら言うだろう。

蔵屋さんとの対談をしてみて自分の作品でも、何年も経ってから見直すといろいろとわかってくることがあることに気づかされました。

私の作品は絵画と彫刻、重さと軽さ、垂直と垂平、饒舌と寡黙といった複数の要素の間を吊されたランプのように行ったり来たり揺れてきました。そして支点が曖昧なために不規則な楕円を描いたり、上昇と下降も加わったりして取り留めがありません。だからこそ明確な時代との結びつきや名称を与えられることもないままで50年間つくり続けることができたのでしょう。

「解るなんて言うことは二流の作家の証しだよ」とまた誰かに言われそうですが、不規則な規則と相反する要素のらせん構造が生む矛盾の溜まり場が私のブリリアントコーナーズなのでしょう。

鷲見和紀郎 Jun. 2022.

Wakiro Sumi Interview

Interviewer: Mika Kuraya
At the Wakiro Sumi studio in Tōgane, Chiba Prefecture,
June 5, 2022.

Before and after B-semi

MIKA KURAYA (MK): Thank you very much for your time. I would like to ask you about two main topics today. The first is about history. You often mention that the 1980s remain nameless and invisible in the history of Japanese art. To rethink this issue, we would first like a clear understanding of what you experienced from the 1970s to the 1980s.

The second question is, of course, about your work: how, when, and what kind of series birthed over 50 years of production, how did you choose the forms and materials, and what was it that you were trying to achieve?

Let's start with the history in chronological order. Sumi, you graduated from the art department of Kano High School in Gifu Prefecture in 1968, right? This department has been prolific in producing a variety of artists.

WAKIRO SUMI (WS): That's right. From there, I enrolled in the sculpture department at Nagoya University of Arts but left in 1971. I don't think I attended there for even a whole year.

MK: First, most high school students who enter an art college set their goals in the painting department unless they have a specific reason to do otherwise. So why did you choose the sculpture department?

WS: My high school teacher influenced me. In addition, seniors and other acquaintances had gone to Kyoto City University of Arts or Kanazawa College of Art for sculpture, which also influenced my decision.

MK: What did you envision sculpture to be when you enrolled at the university? How did you perceive sculpture before you stumbled upon the critically influential private school in Yokohama, "B-semi," which we will be discussing later.

WS: Henry Moore and Alberto Giacometti, and they were pretty much it. I had not yet discovered David Smith. It was much, much later that I realized how interesting Auguste Rodin was.

MK: So you entered the university with some knowledge of postwar sculpture from the 1950s and 1960s. Was your education at the university different from what you expected?

WS: Yes, I was fed up with being forced to build the human figure and thought this was no longer good enough.

At the time, *Bijutsu Techo* was my favorite publication, and there was a special feature on new art education worldwide. It included the California Institute of the Arts (Cal Arts) and the B-semi. I wanted to attend one or the other, and considering my budget and circumstance into consideration, I thought, well, let's choose Yokohama.

So I resigned from the university with some others, went to Tokyo, and had an interview with Akio Kobayashi, who was running the B-semi. I tried my best to tell him how unhappy I was, and he smiled and said, "Well, come on in." So I was admitted in 1971 and completed the course in 1972. My ties with Kobayashi continued for many years.

MK: So, the B-semi was the significant place for you to quit a university and join?

WS: At that time, there was an attitude that it was not cool to complete a university degree, and only by dropping out did you have a chance to acquire a first-class position.

That is why I started at the B-semi, and the teachers I met and the things I saw and heard there were my true beginnings. I truly enjoyed the B-semi.

MK: The teacher who was there at that time was Shintaro Tanaka[fig.1]...

WS: Nobuo Sekine, Lee Ufan, Noriyuki Haraguchi, Teruo Fujieda, and others[fig.2].

MK: That's an extraordinary lineup of members, isn't it? What kind of discussions did you have at that time? Fujieda, who emphasized Medium-Specificity and tried to root Formalism in Japan, and Sekine, Lee, and Haraguchi, who started their work from a different point of view from Fujieda's, seem to have taken very different positions.

WS: I remember most about Fujieda's thorough introduction to American Abstract Expressionism. We were completely unfamiliar with this movement. Through him, we learned about the relationship connecting this and the newest movements of the time, such as Minimal Art and Conceptual Art.

For instance, which art movement was Joseph Kosuth's background before he emerged as a conceptual artist? Starting with Abstract Expressionism, followed by Pop Art, including Neo-Dada, and then the emergence of artists like Kosuth... I think that is the kind of flow that I

learned from him.

MK: So he taught you about the art trends of the '50s, '60s, and '70s in a continuous flow?

WS: It is a connection between what is going on now and what was happening in the previous era. After the B-semi had finished, we continued with the "Barnett Newman Study Group" on Fujieda's advice. The members were me, Shōhatsu Suga, Kiyoshi Nakagami, Isao Nakamura, and others. For a while, we used Thomas B. Hess's *Barnett Newman* (The Museum of Modern Art, 1971) as the textbook, translating it and sharing it with everyone.

MK: I would like to bring up Newman's topic later, but I have noticed Newman experimenting with bridging painting and sculpture just like you did later in your career. Did you already have a budding awareness of this theme at the time of this study group?

WS: No, that came later. Even in Fujieda's class, in the end, I had only seen his works in slides or in books. It was only later, when I went to New York and visited the Museum of Modern Art (MoMA) in New York regularly, that I could grasp what Fujieda was talking about and that this was indeed what he had meant.

MK: Let me jump ahead here, but your first visit to New York was in 1976, wasn't it? [fig.3]

WS: Yes, I did. I felt the magnitude of the actual artworks and was enwrapped by the paintings, or rather, confronted by them. That was something I learned at MoMA.

In New York, I stayed at Ushio Shinohara's (Gyu-chan) loft. Tadaaki Kuwayama[fig.4] was also building a new studio, and I helped out with that. I met Gyu-chan and Tadaaki-san, who were two very different people. Then there were Hiroshi Sugimoto and Kenro Izu. Yoshiro Negishi still looked like a student. That was New York in 1976.

MK: Turning back the clock, we are back again in the B-semi period.

WS: Indeed. In addition to Fujieda's lectures, the most enjoyable experience was going to Lee's and Shintaro Tanaka's studios and working as a production assistant. Of course, they had their classes, but they would also ask if anyone could help them prepare for an upcoming exhibition. So I would visit the site and learn how work was produced. Or seeing firsthand how impoverished they all are!

MK: (Laughing)

WS: That was about the most practical lesson I had ever received. Shintaro-san was making his works in what looked like a construction company's bunkhouse, and even an artist like Lee Ufan, who said he would participate in The Paris Youth Biennale, was making work in the landlord's garage while minding the time.

MK: So were you influenced by Shintaro Tanaka's emphasis on making things by hand?

WS: Yes, indeed. For example, Tanaka polishes FRP and metal mostly by hand. He used a machine to handle the rough parts but always used his hands to finish the final edges and determine how to hide the weld marks. When he says, "Sumi, erase this part," I shave off the weld marks. Then, starting with sandpaper No. 120, No. 240, and No. 400, we follow the procedure properly in gradually using a more refined grain until we reach No. 1200. Water polishing is a process in which water is applied to the sandpaper for polishing. For instance, a slight slip of the hand caused by a sneeze would ruin the uniformity of the grain, resulting in *"Let's start all over again."* I didn't understand what he was talking about and couldn't figure out any difference, but he told me that the reflection was no good. The surface reflections would be completely wrong. Tanaka was that strict.

Through this experience, I learned about the surface quality that can only be achieved by manual labor through Shintaro.

MK: It's evident that Tanaka had a concept for the project, but the manual work was a significant part of it, wasn't it?

WS: Absolutely. I think he also learned such things at a local factory. For instance, he would have the craftsmen at a local factory make a cube. Naturally, welding leaves a residue, so he tells the craftsman, *"This is not acceptable."* The craftsman would respond, *"Sir, the rest of the work must be done by hand. We can*

only finish it by hand." From then on, he probably learned to do it by himself.

MK: So, Sumi, your studies at the B-semi comprised of two parts: Fujieda's art history and theory segment, and the technical part you learned through Tanaka and the other artists, right?

WS: Yes. It's not so much the technique but the actual production. If an artistic expression can be described as a long road, only the last stretch of that road is the best part. Until then, you are covered in dust and mud, your hands are covered in scars, and you are repeating the same miserable process over and over. The last step is to show the best part of the work with some final touches.

That is true, even with such simple-looking expressions as Lee's. [fig.5] At the time, besides painting, he worked on using objects. For example, in "Cut Up", he used a chisel to carve a wooden surface, or he used a stone, and then he would do this (demonstrating)…. Lee referred to these techniques as Mono-ha style, minimal handwork, but in fact, they were not minimal at all.

For example, for "Cut Up", a ready-made piece of wood cannot just attached to another piece of wood. Since nothing is natural, you have to first make it look natural in order to make it look natural. After that, you have to make an effort to make it look like a natural product that has just been slightly modified. Of course, Lee would never say such a thing, and he might even insist that I shouldn't mention this.

MK: I once watched a video of Lee working on a painting, probably in the 2000s or later. I was impressed by how he elaborately and gradually created a single brushstroke, which I had expected him to achieve with a quick brushstroke. It's a similar aspect in his three-dimensional work during the Mono-ha period.w

WS: Well, B-semi was inevitably fascinating primarily because of the presence of an exceptional producer named Akio Kobayashi. He was exceptionally skilled at calling up who was cutting edge at the time, whether a critic or an artist. For instance, an editor writing an article or critique for *Bijutsu Techo* would already be at the school the week the issue was released. Because of this contemporaneousness, I formulated my own ideas about art history and art theory.

To reiterate, what I learned most from the B-semi was the on-site experience of how each artist produced their work. This was the most realistic aspect of the B-semi for me.

MK: The artists you learned from in the B-semi were Sekine, Lee, Haraguchi [fig.6], and others, known today as Mono-ha artists. Fujieda, the theory instructor, taught you about "the ties between contemporary matters and those from the previous generation," so

how did you imagine this relationship between the older generation of artists and yourself, the next generation?

WS: Well, being young, I figured I shouldn't do the same thing as the Mono-ha artists.

As I have mentioned, their primary characteristic was to use materials like stone and steel without modifying them at all, even if that is not exactly what they said. In other words, they do not sculpt.

But there must be some type of sculptural art that can be made even at this time and age. To phrase it more practically, whenever they use stone or iron, they will either use natural materials or ready-made products. In either case, there are things you "don't manipulate." That being the case, I decided to use artificial things, in other words, materials that have undergone manual intervention to make my work. Or, to put it simply, the idea is to create the steel plate itself instead of using an existing commercial steel plate.

MK: I see.

WS: I also used ready-made steel plates and steel frames early in my career. However, the surfaces remained industrial products no matter how much work I put into it. I felt I would never break away from the Mono-ha style of expression or Minimal Art if I continued working this way. Therefore, I decided to make my custom steel plates, and from there, I found the casting method.

And in addition to making steel plates, I also wanted to find materials that only I could use.

MK: You were clear early on about your intention not to repeat the practices of your teachers' generation, weren't you?

WS: I thought of teachers as bad role models. I respected them as people but knew not to repeat what had been done.

In that regard, another gratifying moment during the B-semi was when Tanaka and Sekine introduced me to such eccentric artists as Tomio Miki [fig.7].

MK: Given the B-semi at that time, Miki-san must have

seemed quite the anomaly.

WS: Miki was utterly different. In fact, he did not fit with the times, let alone with B-semi. In short, he existed within Tomio Miki's world. Everyone praised him as a genius, but he really was a one-and-only artist.

Of course, his works can be interpreted in many ways. Take Pop Art, for example. He created objects that are instantly recognizable as ears. Or, just like Andy Warhol making multiple Campbell's Soup cans, Miki made multiples of ears.

However, Warhol used the silkscreen method to produce soup cans to emphasize the age of mechanical mass-production. On the contrary, Miki crafted each ear piece by piece. Sure, there are works in which he molded his own ears into multiples, but even those were individually made. So it was not Pop Art in the true sense of the term, after all.

Since he is dealing with the ear, a dreadful organ of the human body, it may also be seen as a surrealist object. In fact, there were many Surrealists around him. Even Shuzo Takiguchi acknowledged his work. However, it was at the same time very different from Surrealism. He revered Leonardo da Vinci, you see. He was overlooking a radically different world. In short, he was in an extraordinary position. And fortunately or unfortunately, he passed away at the age of 41 (1978). Forgive me, but let me continue about Miki a little more.... I helped him when he had a solo exhibition at Minami Gallery. He had to generate a large body of work, and I was his assistant, but my guess is that he was already fed up with making ears.

MK: What do you mean?

WS: Knowing that people would say, *"Miki is an ear artist, oh, it's the ears again,"* he kept on producing his art. For this reason, I think he wondered what he would make if he stopped being an ear artist. Unfortunately, he died without being able to answer that question. In a sense, he may have been blessed. It's impossible to know whether he would have continued to make ears at the age of 70 or whether he might have found a completely different path.

MK: At first glance, it is challenging to find Miki's influence in your work, but it must have been significant for you to have observed it closely.

WS: Yes, it was. Another thing that surprised me was the ear-making process. On a long, narrow desk, Miki would throw lumps of clay in four to five spots, and then he would gradually shape the ears by hand. Then, instead of making them one at a time, he would put about four in a row and begin to make them simultaneously while shuffling from one to the other. So, as I mentioned earlier, the finished pieces are all very different from one another.

Thus, when he said, *"Sumi, it's all good,"* all the pieces were finished. And I always said, *"Yes,"* and then proceeded to make plaster molds of them and take them to the aluminum foundry. That is why four or five castings were made at once. Then I would bring them back to the studio, shave and polish them to complete the process. While I polished the ears, Miki continued to make four or five more clay ears beside me. That is how we produced about 50 pieces for the exhibition at the Minami Gallery.

MK: Okay, so for the ears at this time, Miki did the clay work, and you did the rest of the work after, right?

WS: Yes, that's right. I did the plaster molding and most of the finishing work. Miki touched it up a bit at the end, and then the piece was complete. So when Miki passed away, I did the finishing touches for the inclusion in the museum.

Ah, well, that was a very unusual time for me. As a 20-year-old, my youth was spent in the company of a man who made ears every day while everyone around me was talking about Minimal Art and Conceptual Art. So it was a bit of a distorted life, I suppose.

MK: On the other hand, did this free you from the stereotypes that you had to conform to Minimal Art trends?

WS: Sure. That was true of Miki and people like Shintaro Tanaka, who I regarded as a Minimal Art artist who was scraping away with his hands covered in scars. I learned after all that "Minimal Art is artisanal work," too. Watching the process at work, you can understand a lot of things.

I don't think Western Minimalists like Donald Judd and Carl Andre have done that much handwork. Wasn't David Smith the last generation who made all his work by himself?

MK: I think there is an idea in Western Minimalist art of intentionally steering clear of individual handwork and consciously choosing ready-mades or factory-ordered products. This is in line with the Mono-ha movement. The Minimalist works created by Japanese artists may look similar, but the processes and philosophies underpinning the works are quite distinct.

WS : I agree. Even Tadaaki Kuwayama, today considered a Minimal Art pioneer, made everything himself in his early days. He even fabricated the chrome strips that joined the screens together by himself. But unfortunately, he had no choice but to make them himself because of a lack of funds. However, from a certain point, Kuwayama began to outsource his work. During the early chrome frame period, he used an air compressor to make the screens, perhaps after he started using 'hōrō' (enamel). He provided color samples for the fabricators with instructions on finishing the surface. This was after laying out the same units in a larger space. At that point, I think it became necessary for him to commission work to achieve the concepts in

volume and size.

MK: Now that you mention it, did you ever consider outsourcing your work?

WS: Certainly, since foundries are the artisans' trade, that would be outsourcing. But, on the other hand, I used to go to a good foundry but couldn't afford to pay them. So I found myself working there after all.

MK: So you ended up on the side of the artisans who receive work orders (laughs).

This was the beginning of your non-Mono-ha and non-Minimalist style of creating art.

Developments since the 1980s

MK: After completing B-semi in 1972, you continued by adding lacquer to the surface of minimalist objects by hand (*Untitled*, 1972, and other works) [fig.8].

WS: Continuing with the Minimalist Constructions from the B-semi period, I applied lacquer paint to the surfaces. Finally, I finished it with a 1200-grit wet sander, just as I had done when I was Shintaro Tanaka's assistant. It's incredibly strenuous work since the larger objects are over 7 meters in size.

At that time, the sense of fulfillment of creating something with my own hands was, in a sense, an indulgence. It was a feeling of self-complacency as if I had created a work worthy of an artisan. I knew art had nothing to do with it, but I was making excuses that this was an artist's work.

MK: This is a tough call. If self-objectified handwork is deemed unacceptable, you may resort to minimal handwork and outsourcing, just as the Mono-ha and Western minimalist artists have done. But you chose not to do that.

WS: That is right. I had no choice but to do it by hand to get the surface I wanted.

This is a reiteration of what I said earlier, but this is neither an industrial product nor a natural object, but the fruition of handmade artifacts created by a person's hands. Nevertheless, I held myself accountable to the belief that art must be the supreme form of this artifact. I guess I could have seen too much of the Mono-ha school.

MK: So you have an unwavering determination to create this kind of surface?

WS: That is definitely true.

MK: These works with Minimalist forms, however, rapidly changed in the 1980s from the time around *Work A-1* [P.068] and *Work B-1* [fig.9] (both in 1981).

WS: It all started with the work I exhibited at *Wakiro Sumi: ZONE* (Gallery Te, in 1982)[fig.10]. Until then, I had not been able to break free from geometric and compositional abstraction, although I did various things on the surface. However, from then on, I shifted towards making my own textured boards and rods.

This was when the waxwork started emerging[fig.11]. It was also at the foundry, obviously a manufacturing site, that I discovered wax as a material. When casting, there is a technique called lost-wax. Both Rodin and Giacometti used this technique.

First, the artist makes a clay prototype. Next, the craftsman at the foundry substitutes the prototype with wax. The wax is encased in plaster and then heated in a kiln until the wax prototype is melted. This results in a hollow mold. Finally, the molten metal is poured into this mold for casting.

At first, I started waxwork with the purpose of converting wax products into metal. On the other hand, I wanted to create some larger-scale works at that time. When I held a solo exhibition at a place called Ko Gallery, I asked the owner if I could produce a 3m x 3m bronze work. However, he said, "*Sumi, that would cost more than 3 million yen. I can't allow you to do that.*" So I thought, "*How about leaving it as wax? Bronze is not doable. Well, then, I thought, I'll just leave the wax as it is.*" In hindsight, I realized that I couldn't have brought the 3m x 3m bronze piece into the gallery in the first place.

The idea of creating work only with wax began in this very practical manner.

MK: It was really a discovery made at the production site rather than theoretical reasoning.

WS: Yes, in fact, there is one more thing. The dissolved wax can also be brushed on surfaces. So then I thought I could use wax in the same way as Jackson Pollock did when he painted, using his "pouring" technique.

Thus began the creation of what I have called "Painting Sculptures," planar sculptures made of wax. I would dip melted wax into a brush on a wooden or plaster substrate and then paint over the surface. The lumpy surface texture varies depending on the number of coats applied. Like Pollock's paintings, this is an improvisational process. As I worked on these pieces, I realized that this painterly sculpture might actually be an invention.

However, there was one problem. With waxwork, nothing remains of the work after deintalling and removing work when the exhibition closes.

With this in mind, I considered the idea of creating larger-scale works on site rather than making them outside and transporting them to the exhibition site. Secondly, I also wanted the work to be permanent, so around 1984, I began casting waxwork in bronze.

On the one hand, I could express myself in a new way using wax, a non-permanent material. And on the other, I was still exploring metal objects as a sculptor. As a result, I can still make both works in tandem.

In this way, I found myself in an unknown world of flat, painted, sculptural objects with surfaces that no one

had ever made.

MK: The problem of breaking free from self-objectified handwork, the problem of scale, and the problem of the boundary between sculpture and painting. All of these issues coalesced with the discovery of wax as a material at the turn of the 80s. It seems to me that something like a "big bang" occurred during this period.

Is there any particular reason for this timely coincidence in 1980?

WS: Hmmm, I wonder what happened in 1980. First, as I mentioned earlier, I went to New York in 1976, so it was after that, wasn't it?

Then, in 1978, Miki passed away, right? Miki has been to only one of my solo exhibitions. I suppose it was my first solo exhibition at Gin Gallery (1972). When he left, he said, *"Sumi, I will come back to see your work when you have made it properly."* I am still traumatized by that even now.

MK: Then, from around 1984, as you mentioned earlier, you began casting wax into bronze, such as *Work M-2 Stolichnaya* (1984)[P.072]. How did it feel turning them into bronze?

For example, by casting, the improvised wax drips from the prototype do not resemble the original dribbles but rather are molded into something else that looks exactly like the original but is molded into a different form, right? Doesn't that raise a question?

WS: Rather than doubt, I had a discovery.

Sculpture, after all, is all about the surface. For example, Rodin's *The Thinker* (1882-83 (prototype)) and Constantin Brancusi's works are made of metal about 8 mm thick and hollow inside due to the nature of casting. Therefore, we generally perceive works of art as mere tracings of surfaces in the form of shapes.

So I concluded that there ought to be sculptures made by cast wax surfaces, like that of water, and that these could be considered sculptures in their own right. However, attention must be paid to the edges of these surfaces. Without refinement along these edges, the work would appear obtuse.

MK: Take, for example, Richard Serra's *Splashing* (1968), in which molten lead is splattered about. You could have gone in the direction of performance-based or process-based. Instead, you went to the trouble of casting the thin film-like form made possible by wax, only this time in bronze. You then reaffirm the inherent nature of the medium of sculpture, saying that sculpture is only a surface since it is supported by the technique of casting in the first place. Of course, Serra also had the concept of sculpture at the foundation of his practice. Still, I feel that this back-and-forth movement of expanding the idea of the medium while faithfully returning to its principles is very typical of you.

WS: Is that right?

As a matter of fact, I was surprised when I looked back on my first work in my hometown of Gifu (*Contemplation*, 1972)[P.034], which was also created treating a surface.

It was a work in which Mino Washi covered over stones on the banks of the Nagara River in my hometown, with water poured over them. And when I removed the dried parts, the traces of the stones appeared as molds. But this work no longer exists.

MK: Was this work primarily about the act? Or is it a work in which the form was shaped after the stone was removed?

WS: At that time, the action was the main focus. Later, however, I thought of how it could become a work of art by thickening and layering it.

MK: I see, so it is really about casting them as surfaces. I might say, that a technique seemingly discovered later by accident is a result of an earlier dormant interest, enabling you to react quickly to the discovery?

Let's return to the wax casting work.

On another note, I wonder if the issue of scale, which you overcame with the wax, will come up again by making the piece in bronze. What were your thoughts about this.

WS: That's right. As you noted, the motivation for starting waxwork in the first place was to obtain magnitude. In this regard, there is a size limitation with

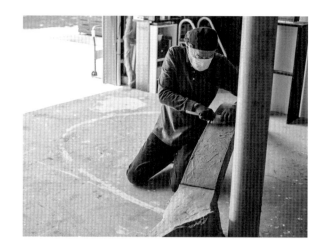

bronze.

However, I thought, "Why not make something that reminds the viewer of something massive? For example, I could create something that suggests the presence of a huge object on the other side of a wall, of which only its end can be viewed from the here and now. Works such as the wall-mounted installation that began with *Work O-1. Horizontal Edge* (1986)[fig.12] are examples of this.

Or, a little later, I tried to create a structure with gaps that would allow the viewer to enter the work. By doing so, however, limited in size, it could give the viewer an illusion of a larger space.

Another thing that came up with the casting process was adding a spatial structural element to the form. In addition to the film-like form, there were other functions such as crossing and connecting.

MK: Works such as *Work M-2 Stolchnaya*, which you exhibited for *Wakiro Sumi: STOLICHNAYA* (Gallery Te, 1984), demonstrate this point of crossing or connecting quite well, doesn't it? There are three components in relation to each other: a vertical component, a massive component placed on the floor, and an elongated component stretching out in an arc. Where did the idea of showing these connections between multiple elements come from?

WS: Sure. I have always loved bridges since I was a child. I grew up downstream from the Nagara River, where a massive steel bridge, the Nagara Bridge, is located. I was most interested in the various types of bridges that existed over the rivers in other countries such as Paris and Lyon.

I think there are three dimensions to bridges. First, there are bridges seen from afar, like a rainbow, connecting one thing to another. Then there is the bridge that you can cross over. Then, there is movement and a shift in the point of view. And then, there is the bridge viewed from the surface of the river, the bridge that you look up at. When you think about it this way, a bridge is truly a sculptural space.

MK: What do you think about the subsequent works, *Work M-3 Stolovaya* (1985)[P.076] and *Work M-5 Opposite Shore* (1986)?[fig.13] They both differ in appearance from *Work M-2 Stolichnaya*, which has a bridge-like form, but they still deal with the relationship between multiple forms. One title is *Stolovaya (of a table)*, like *Stolichnaya (of a city)*, named after a Russian vodka, and *The Opposite Bank*, which is also a title that alludes to bridges.

WS: Right. First, *Work M-3 Stolovaya* addresses the issue of horizontality. It is a table-shaped sculpture. It is made in such a way that the viewer's eye moves horizontally, and the unevenness along the way makes the viewer slightly conscious of the sculptural space. For example, Pollock placed his canvases horizontally on the floor and stood on them while he painted, right? I, too, enter the work space, paint with wax, and then cast the painting. We share the same creation method, but the difference between Pollock and myself is that with Pollock, the color will remain in the work, while with me, only the surface will remain.

Also, *Work M-5 The Opposite Bank* is a work owned by the National Museum of Modern Art, Tokyo. This is a single prototype using the casting mechanism to create two pieces, one standing vertically and the other lying horizontally. The only changes are the holes and the protruding parts. Again, compared with Pollock, Pollock's paintings can only be hung on the wall after lifting them from the horizontal position. But my work can stand upright.

MK: I see. You are addressing the issues of sculpture and painting, the relationship among its multiple parts, the formation of surfaces, and the horizontal and vertical relationships. We will revisit this idea of "freestanding sculpture" later on.

Returning to where we left off, the work you just showed us in your studio, *Prepared Sculpture-3. Wakening Darkness* (1987)[fig.14], is another work from this period.

This is similar to *Work M-2 Stolichnaya* and is made of a combination of three elements: vertical, mass, and an arc. However, you used a ready-made vertical rod.

WS: This work combines a clay prototype bronze, retaining a tactile quality, and a ready-made metal pipe, unrelated to this one, in three distinct dimensions: one standing vertically, one laying on the floor, and the third bridging them. To emphasize the difference between the tactile and non-tactile parts, I deliberately used a ready-made part for the cylindrical pipe.

MK: Wasn't the use of ready-made products exceptional for you, as you have always insisted on making them by hand?

WS: That's not really so. I have considered it from time to time since then. For instance, although much later,

there is a solo exhibition, *calls & whispers* (2013), held at two venues. At Gallery Kokon, I exhibited works made of twisted natural wood and brass pipes[fig.15], and at Gallery 21yo-j, I exhibited works made of ready-made PVC pipes.

The one at Gallery 21yo-j had two PVC pipes of the same height, one painted yellow and the other modeled on-site by hand with water clay modeled directly over the surface. I wrapped the pipes with a rough rope underneath to make the clay stick better. Over time, the clay will dry and crack.

MK: I see. So when the cracks appear, it clearly shows that only the surface has been worked by hand over the ready-made product.

WS: That's right. Also, the photo makes it hard to see, but a solid steel egg hangs from the ceiling between the two pipes. So, this work is not only limited to the use of ready-made products, but like *Work M-2 Stolichnaya* and *Prepared Sculpture-3. Wakening Darkness*, this work establishes a relationship between the three elements.

MK: I see. When creating elemental relationships, do you have relatively have more instances of 'elements of three' rather than another numeric configuration?

WS: Well, it is tough to make two work out instead of three. I suppose this is my shortcoming.

The best is when it is only one. This is an "onement" (the series title of Barnett Newman's work, meaning "the one and only moment"), so it truly is the ultimate world.

In contrast, three is easy to regulate. It sits nicely, it's stable, and the elements are well balanced. Like "point, line, plane," and "○△□."

I think two is very conceptual. For example, Jasper Johns' two beer cans, *Painted Bronze (Ale Cans, Ballantine),* (1960) or Brancusi's *The Kiss* (1907-08). Conceptual artists often have pairs in their works, which is a right-or-left world.

But while there are three elements, there is a kind of homage to Newman in this work.

MK: You mentioned Newman's name at the beginning of this interview, as you had a reading group with advice from Teruo Fujieda when you were in the B-semi, and here he is again.

Newman created sculptures, substituting lines on the picture plane which he called "zips," right? The works are like examining the illusion of space created by the zips on the picture plane in three dimensions, depending on the thickness of the sticks and the positional relationship of where the sticks stand to each other. He seems to be tackling the crossroads between sculpture and painting, a theme you have embraced, with painting as the point of departure.

WS: Yes, I think so.

MK: Pardon me for jumping from the wax casting

subject in the '80s to 2013, about 30 years in a single leap. However, the fact that our discussion jumped to 2013 probably means that these issues are interconnected in your mind, even if they are far apart in time. Therefore, the divergent nature of the conversation itself is crucial in tracing back to your thoughts, isn't it?

And now, as we move into the 1990s, the "Veil" series finally makes its appearance.

WS: I had a solo exhibition titled *Wakiro Sumi: THE VEIL* at Galerie Tokoro in 1994. The keyword at that time was "veil." A veil is a cloth and, therefore, a flat object. However, I thought that it could work as a sculptural work. For example, the wax hanging down, dripping over the surface and yet having a three-dimensional structure.

MK: The three pieces exhibited here were *Veil-I (dedicated to Antonin Artaud)*[P.148], *Veil-II (dedicated to Carl Theo Dreier)*[P.149], and *Veil-III (dedicated to Thelonious Monk)*[fig.16]. With the addition of *Veil-IV (dedicated to Cecil Taylor)*[P.150], four pieces were made in 1994.

Only *Veil-I* is made of FRP (fiber-reinforced plastic) and painted in oil, while the other three are made of aluminum and painted only on the reverse side with oil.

WS: Yes, it needed to be flat while also capable of being a freestanding piece. The other thing I mentioned earlier on how to transcend the scale boundaries of bronze was the ability to bring people in, allowing them to enter within the work.

In the same year as this solo exhibition, I made *Lunar Passage* (1994)[pp.128-129] at the Hiroshima City Museum of Contemporary Art, which is entirely made of curved surfaces allowing the viewer to walk through the work completely. The same is true of the spiral-shaped *The Rain* (2001) [fig.17]. I made a little later, in 2001.

MK: By the way, do you consider audience movement in your works phenomenological?

WS: Where should the entrance be located? Can it be passed through? And can it be seen from above or not? When work is set in a space, I am usually conscious of the 360-degree perception of the work.

MK: However, a work such as *Work M-5 The Opposite Bank* from the collection of the National Museum of Modern Art, Tokyo, mentioned earlier, consists of flat forms placed along the floor and wall, which cannot be turned and viewed, and seems to have a relatively frontal solid characteristic.

WS: True, the early works were quite limited.

MK: I find the spiral shape a critical element in making it freestanding, able to move around a full 360 degrees and allowing people to reach into the interior. The spiral-shaped *THE RAIN* is the best example, where a flat object can be spiraled to stand on its own

and enable people to enter it.

WS: I may have realized that later.

In the best way to put it…First, I would do an installation in wax. Then, I would make that two-dimensional form in metal. And then, I would be able to achieve something that could stand on its own. For that, the spiral structure was suitable… Ah, I didn't overthink about it myself, but I guess it is so.

MK: The spiral shape compels you to make a 360-degree movement with just your eyes. And when you enter the space, you will find a series of places where the forms are and are not present. In other words, the real and imaginary spaces are nested together. The formless part is not simply an absence, but an imaginary space that supports the actual space, a structure that would not be possible without both.

WS: That is exactly right. There are viewpoints everywhere. People can hide inside the walls, emerge from the walls, look out through the slits, and peek inside the slits…

MK: The spiral shape also correlates with Rodin's work, where the human figure twists with great force, revealing a spiral motion.

WS: That's right. Take, for example, *Candide* (2005) [fig.18], which I made a little later, with Rodin's *Balzac* (1892)[fig.19] in mind.

MK: I saw the piece in your studio earlier and unintentionally made the association, so I guess I was right.

As you pointed out earlier, in Rodin's case, the original form disappears in the casting process, leaving behind an 8mm-thick surface. In the case of *Balzac*, the body is hollow, and the mantle wrapping around it is the only thing left standing. It is as if the fabric of the spiraling mantle is used to emphasize precisely what you said, *"Sculpture is a surface."*

Incidentally, you mentioned at the beginning of this interview that you would not realize how interesting Rodin's work was until much later. As shown in *Candide*, do you find yourself rediscovering historical sculpture concepts after working for an extended period?

WS: There are times when I finally realize that this is what my predecessors' works were about.

I think that Rodin was quite an avant-garde artist. For example, *The Gates of Hell* (1840-1917), to which he devoted his life, is a complete assemblage. He took pieces he had made elsewhere and rearranged them, replacing only the parts, changing the size, and so on. It was extraordinary. I did not understand this radicalism in Rodin's work when I was young.

MK: Rodin had already taken full advantage of the casting nature of creating multiples out of the same object more than 100 years ago.

Moving on, your next series of works is the "Dance"

series, which began with *Dance-1* [P.204] in 2001. Looking back, there are milestones occurring rather neatly every ten years, such as B-semi and compositional works in the 70s, waxwork in the 80s, "Veil" in the 90s, and "Dance" in the 2000s.

WS: I guess you could say I am a man on a 10-year cycle (laughs).

I would say that "Dance" made its way around and arrived at a freestanding, sculptural form of the human body. The pedestals also started to show up around here.

MK: The spiral movement entices a 360-degree motion, there is the issue of independence, and the development seems to lead naturally from the "Veil."

WS: The human body is a spiral in the first place. If there is a difference, I would say that "Veil" was made with wax, while "Dance" was an attempt to revisit clay modeling. Starting with plaster, I arrived at clay, a material intimately related to plaster.

Some works from this series were made directly with plaster, while others were prototyped in clay and cast in bronze.

MK: You mentioned earlier that the pedestal had made its debut with this series. The pedestal issues pertaining to sculptural work are of great significance in modern times in terms of whether to link the sculpture to its surroundings or to detach it and make it autonomous.

Before "Dance," what was your thought regarding pedestals?

WS: Before "Dance," I thought pedestals were unnecessary. Therefore, I placed the sculptures directly on the floor. But before "Dance," in the "Fusulina" series (1998-)[P.194], the pedestal and sculpture were combined already. I guess you could call it a pedestal sculpture. If the bottom part of this piece were narrower, it would not have stood up. That being the case, I decided to make proper pedestals rather than considering it a necessary evil. So in "Dance," the pedestal can be square, circular, or

mirrored, depending on the work.

MK: I understand that the base of *Narcissus 2*(2005) [fig.20] is a mirrored surface. Thus, this is the Narcissus from Greek mythology, a beautiful boy admiring his reflection in the water.

So the pedestal is not a necessary evil now, but rather an integral part of the work?

WS: At least I no longer think of pedestals as meaningless or a necessary evil. Until "Fusulina," I was very self-conscious about the pedestal. But since "Dance," I have shifted my mind to think it is fine as long as it stands up. It is more like a tool or an essential component to making it stand up.

However, when I exhibited at *SUMI WAKIRO: Echoes -kodama-* (Art House Asobara-no-Tani) in 2010, I drove in screws from the bottom to erect the work directly onto the floor. So some have pedestals, while others stand directly on the floor[PP.201-202].

MK: Once again, let me ask, what is the most critical aspect of "Dance"? Is it independence? Or is it the spiral movement?

WS: It is the shape on top that spins around. In other words, it is a horizontally rotating movement that rises. By the way, I use the word "dance" slightly differently than ballroom dancing or other types of traditional dancing.

I absolutely adore jazz pianist Thelonious Monk, who would stand up and dance while he performed. But then, just when I thought he was spinning around, he would suddenly move mysteriously, tapping his feet[fig.21]. I found this fascinating, and that's how the "Dance" series took shape. It's like an unexpected movement.

MK: Do you mean the moment when the horizontal and vertical fall out of balance?

WS: No, it does not collapse. Instead, it's more like an irregular tempo, like a tap-tap.

From the 2010s until the most recent work

MK: Moving on, let's talk about the 2010s and up to more recent developments.

WS: Well then, since this is the right time, let me open the boxes piled up here so I can show you.

The wax works are all made into a model of the exhibition site after the exhibition ends, as a record of the exhibition. These spaces created on-site will disappear after the show is over. CDs containing video footage are also included with the models.

This is a while back, but here is a view of the group exhibition I participated in at the National Museum of Modern Art, Tokyo, in 1992-93, entitled "A Perspective on Contemporary Art: Among the Figures." [fig.22]

MK: This is amazing. Unfortunately, I did not see this exhibition, but this helped me understand where,

what, and how the works were displayed in the Museum of Modern Art space before its renovation.

WS: For this occasion, I brought propane gas into the building to work on melting wax.

MK: As a facility for storing and exhibiting cultural artifacts, it would be prohibited to use fire today.

WS: We brought it in without mentioning it. I doubt that anyone thought I would do such a thing. (laughing) Moving on to the 2010s, the most recent wax installation is this: *Le Calme* (2016), which I exhibited in my solo exhibition *LE CALME - Nagi -* at Gallery Mestalla in Kanda, Tokyo, in 2016. This is somewhat similar to what I am planning to create for my solo exhibition at BankART KAIKO this time. It is installed in the corner of the wall, low in the front and high in the back. There is a slit along the way, allowing people to enter[fig.23].

But since this slit is only about 50 cm wide, it was tough to get in and work on the wax painting[fig.24]. It was also very hot working with the melting wax.

You can see my recent works on my website, including the work from this period and the exhibition. (https://sumiwakiroart.wixsite.com/sumi)

MK: In 2018, you did a residency at Insel Hombroich in Germany.

WS: Yes, it was a very Minimalist space. However, being in such a space made me want to create something feeble because of my curmudgeonly nature.

Cross Point-1, *Cross Point-2*, and *Cross Point-3* (all 2018)[PP.222-223] were made by joining the disassembled legs of old bentwood chairs found in the workshop.

In *Circle in & Out* (2018)[PP.220], an indoor space was covered with crimson rose hips collected locally and shaped into a semicircular form. A transparent glass wall divides this area from an adjacent outdoor space of stones placed in a similar semicircular shape. These two sections form a circle when they meet at the glass wall.

Line-1, *Line-2*, and *Line-3* (all 2018)[PP.222-223] are feeble versions of a theme that I have been working on for a long time: connecting walls to floors by propping up stick-like objects. For this one, I have also repurposed the legs of old furniture and joined them together to form a somewhat crooked wooden stick, which is then propped up against the wall.

MK: This was followed by two and a half years of the COVID-19 pandemic. What are you working on now?

WS: Right now, my main focus is on two-dimensional works. I call them "Shaped Paintings" in the sense that I am "scraping" them.

After mixing polyester resin and oil paint thoroughly, I use a spatula to layer the mixture on a flat surface. I repeat the process of applying and scraping until I have achieved the desired surface and finally polish it

to a smooth surface. Since so many different colors are layered over each other, no one knows what color or form will emerge until it is finished, and no one knows where it will end up.

Painting is basically an additive process, isn't it? Shaped Painting is about scraping or adding while scraping, rather than simply scraping.

The final surface is polished to a smooth finish, in a sense, similar to the 1200-grit wet sanding work of my earlier years, except now I'm working on a painting.

MK: Why are most of the substrates circular in shape?

WS: Because there is no top, bottom, left, or right. I can start from every side and decide which end is up when I finally hang it on the wall.

MK: I suppose this is the interstice between sculpture and painting that you have been thinking about for a long time, isn't it? But why have you chosen the two-dimensional form in particular now to consider this issue?

WS: For one thing, it is a matter of physical endurance. Another reason might be that I wanted to step away from sculpture for a while. I wanted to go back to making flat things once more. I am sure there will come a time when I will return to sculpture again.

MK: Why is that? I have learned that you come up with your next move rather logically. It seems to me that you always follow through with a theme, bringing about the next series of works in succession. As you say, *"I want to work on this problem," "I got this done by doing it this way,"* and *"If I use this material in this way next time, I can get this done here."* Is there a connecting reason for leaving sculpture now and creating something flat?

WS: Looking back on that, I think it all ended up being connected. I am not a conceptual type of artist at all, and I can only follow my habits, or whatever they may be, faithfully, and in that way, the following work will turn up.

And, unlike Miki, I don't exclusively concentrate on a single subject. Here I touch clay, here I draw, there I make a small piece, and here I make a larger-scale work. Then, as is always the case, it all falls into place at once. It's not that one piece is finished and the other is incomplete, but suddenly at some point, all of the pieces, whether small or large, paintings or sculptures, are in complete alignment. In that moment, I feel, *"Ah, it's done."*

Through History

MK: We have been talking quite a bit now, and I would like to begin wrapping up this interview.

Up to this point, we have talked about the progression of your artistic practice over the past 50 years. Let us return to the question we asked at the beginning of this interview: why are the 80s, which marked a significant turning point in your career, missing names from art history? Again, what do you think of the 80's yourself? This could be in the context of your production or in the context of the era in general.

WS: The Tokyo art world I knew in the 1980s was a lively place. There were many rental galleries from Ginza to Kanda, and even former art students could rent a space for a week and do whatever they wanted as long as they paid for it. The owners of the galleries would allow us to bring in steel frames or dance naked. Many young artists and students frequented the area, and someone like Masakazu Horiuchi, a great teacher at the time, was also there. In addition, art critics, newspaper reporters, and editors all had a routine of touring galleries. At the end of their tour, they usually gather at Tamura Gallery or Tokiwa Gallery (both located in Nihonbashi near Ginza) to have a drink. From there, we would drift to Shinjuku and other places daily, and it felt like we were part of some community or belonged to the art world[fig.25].

Then, as times passed, we noticed that such rental galleries had disappeared, and as we moved into the 90s and 2000s, we became forgotten and unnamed in the margins of that time. We weren't a Mono-ha group, we weren't New Wave, and we didn't form our group to give it a name. No prominent art stars have emerged either. And the gallery districts of Ginza and Nihonbashi, which had been so prosperous, lost their momentum.

MK: Oooh, that is... I'm at a loss for words.

WS: After 50 years, quite a few from my generation have passed away. For example, the painter Toeko Tatsuno was the same age as me but passed away early (she died in 2014). We both participated in the *Tsubakikai Exhibition 2001* at the same time and talked about doing something together, but it never happened.

I don't think many people know about him now, but there was an eccentric and oddball named Jun Hatta. There is such a thing as *keiongaku* (lightweight music), isn't there? He said it was okay to have *keibijutsu* (lightweight art) and that his expression was *keibijutsu*. Artists pass away or are forgotten in this way. Watching from the sidelines really makes me sad.

I think there is also an absence of critics who should address these issues. Naoyuki Takashima and Noriaki Kitazawa are among the critics of this generation.

MK: As to the historical background, economic growth continued from the 70s and entered the bubble economy of the 80s, when society gained momentum.

WS: In terms of art movements, this was around the time when installations were gaining acceptance. As a result, a strange practice emerged: as long as you brought something to a gallery, it could be considered

a work of art.

MK: As you mentioned, installation art so familiar today, made its first appearance in Japan during this period. For instance, how did artists working in the sculptural medium respond to this?

WS: I wonder. I don't think many artists in Japan pushed the idea of sculpture to the forefront, even before the concept of installation art.

MK: What about yourself, Sumi? It seemed to me that you were consistently aware of the complex system of sculpture raised in the West from the end of the 19th century to the 20th century as the foundation upon which you expanded the concept of sculpture.

WS: Hmmm, you know, I love art history. It is strange to say that I love it, and I believe art exists because of art history. That is why I want to be standing there.

MK: I feel that this awareness of history makes you consider preserving works of art, such as turning waxwork into bronzes or models.

I realized again after today's discussion that such a strong awareness of art history is a characteristic of your generation, cultivated by the B-semi, offering an education that integrated history and practical skills.

WS:

I think that the B-semi has done an excellent service. That includes the influence of Osamu Ikeda (who died in 2022), who founded BankART, the venue for my current solo exhibition.

MK: There are indications that Ikeda had been making efforts to historicize the B-semi by exhibiting the works of Shintaro Tanaka, Kenjiro Okazaki, and others who taught at the seminar.

If we could identify such achievements of the B-semi, we might be able to dedicate a name to them...

Of course, we cannot simply put them under a single name because every artist's work is diverse, even if they belonged to the same period. However, it is easy to vanish from art history without a moniker.

WS: Indeed. It's so sad that it remains as NO NAME.

MK: If you were to name it yourself, what would you call it?

WS: Well, that's not my job.

Interview edited by Mika Kuraya

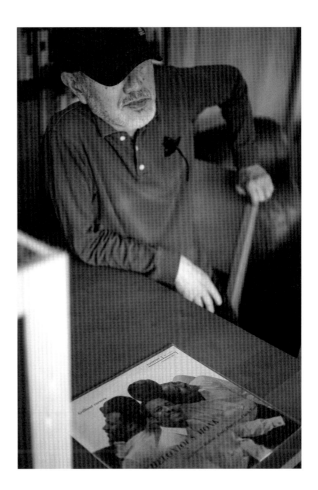

Mika Kuraya: Director of Yokohama Art Museum. She was Born in Chiba prefecture and graduated from Chiba University. She had been working as chief curator of The National Museum of Modern Art, Tokyo (MOMAT), and assumed director of Yokohama Art Museum in 2020. Her main curatorial projects include: "Undressing Paintings: Japanese Nudes 1880-1945" (2011-2012, MOMAT, the 24th Ringa Art prize), "Jiro Takamatsu Mysteries" (2014-2015, MOMAT, co-curation) , "Kumagai Morikazu: A Joy of Living" (2017-2018, MOMAT), and "Windows: Journey through Art and Architecture" (2019-2020, MOMAT, co-curation). She had received Special Mention for the 55th Venice Biennale of International Art Exhibition with Koki Tanaka's solo show "abstract speaking: sharing uncertainty and other collective acts" in 2013.

After the interview

Jun Hatta would probably say, "Don't be ridiculous in trying to explain your work."

After my interview with Mika Kuraya, I realized many things about my work that became clear to me as I reexamined them many years later.

My work is like a hanging lamp, swinging back and forth between painting and sculpture, weight and lightness, vertical and horizontal, eloquence and reticence. Because of the arbitrary fulcrum, the ellipses are drawn irregularly, with ascents and descents thrown in to add to the unrestrained chaos.

This circumstance is perhaps why I have been able to continue creating for 50 years without being given a title or a tangible connection to the times.

Someone else may say, "It is a sign of a second-rate artist to claim that you understand," but I may say that my Brilliant Corners is a hangout of contradictions created by a spiral structure of irregular rules and conflicting elements.

Wakiro Sumi, Jun. 2022

SUMI SEMI

B-Semi 1982~2000

Bゼミ School/Schooling System 鷲見和紀郎ゼミ
B-semi School/Schooling System Wakiro Sumi seminar

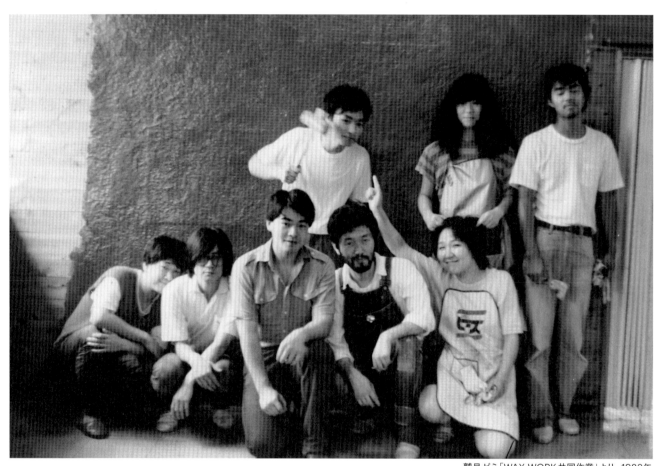

B-semi Schooling System

1982年に講師の田中信太郎氏から受け継ぐ形で始まった
鷲見ゼミは授業の形は取っていたものの、いまだに試行錯
誤中の自分が制作のなかで未解決な事象や疑問に思って
いることを生徒と一緒に話しあったり制作したりしながら解
決の糸口を探す旅のようなものでした。

ポイントとなったのは素材の問題と、空間の捉え方の問題で、
自己と他者の価値観を比較したり合成したりして既成概念
に囚われない制作方法を探る実験場でした。もうひとつの
ポイントはヴィジュアルアーチストとして、あえて形をつくる
ことや手仕事へのこだわりを強調したことと映画や音楽との
通底した感覚を共有したことでしたが、私自身がゼミを通し
て制作の確認と問題の整理にいちばん時間を使わせてもらっ
たようで狡い講師だったと思います。

B-semi Schooling System

The Sumi Seminar, which began in 1982, succeeding
Shintaro Tanaka's seminar, started as a class course
but transitioned into a quest to find solutions to
unresolved issues and questions that I was still trying
to solve in my work by discussing and creating works
with my students.

The key points were the problems concerning
materials and how to perceive space. It was a place to
compare and synthesize values of the self and others
and to experiment with unconventional production
methods. Another point was that as a visual artist, I
dared to emphasize my commitment to create forms
and handwork and share a common ground with film
and music. Still, it seemed that I used most of the
seminar time to identify my production and sort out
the problems. I think I was a tricky teacher.

1982

1982年度 鷲見ゼミ（田中信太郎ゼミ代行）
「ワックスとパラフィン」（火曜日／昼）全7回
■11月30日「スライドで自己紹介」
■12月7日・14日・1月18日・25日・2月2日・8日
「ワックスとパラフィンを使って実習」

1982 Sumi Semi (acting for Shintaro Tanaka Seminar) "Wax and Paraffin" (Tuesdays/Lunchtime) Total 7 sessions
■ November 30 "Slide Self-Introduction."
■ December 7, 14, January 18, 25, February 2, 8 "Hands-on practice with wax and paraffin

1983

1983年度 鷲見ゼミ「彫刻の素材」
（金曜日／昼）全14回
■5月6日 マテリアルワークを中心に作家としての態度、方法のトレーニング、手の延長としての知性、物質の知性の探求。
■5月17日「単体で成立する作品」紙粘土1〜2コ使って、単体で成立する作品を制作する。制作する過程で行き詰まったら、さまざまな粘土のもつ表情を探りながら、出てきたものを客観的に発見する。その繰り返しから、自分のやりたいものを手探りしていく。
■5月20日「複合体として成立する作品」紙粘土1〜2コ使って、複合体として成立する作品を制作する。複合体＝関係の構造、つまり空間の問題。ものともの、空間とものの、空間と空間。鑑賞する人たちは作家が持っている概念が、すぐにわかるものを面白がってはくれない。単純なコンセプトのみを見せる作品ではなく、それを超えたところに出てくるものを目指して欲しい。壁と橋という構造の空間、関係性についてディスカッション。
■5月27日「ミクスト・メディア」紙粘土1〜2コ＋αを使って、ミクスト・メディアを制作する。複数の要素があわさってまったく別の見え方に変化させる。これまで扱ってきた単体、複合体を踏まえて、紙粘土のイメージから脱却しつつ、新たな素材の持つイメージに負けないように、それぞれの素材の可能性を模索する。
資料：ロバート・ラウシェンバーグ、ジャン・ティンゲリー、李禹煥、映画「アギーレ／神の怒り」（ヴェルナー・ヘルツォーク）
■6月3日「ひろう芸術」1時間、Bゼミ付近を散歩して、目についたものをひろい集め、作品にする。ひろうこと＝美術の基本：見る（意識・無意識）→選ぶ（もの・イメージ・行為）→（ヴィジョン・テクニック）→作品。
■6月10日「プランニング」前回ひろったものでインプロビゼーションに近い表現を試みたが、そこで気がついたことを掘り下げる。
■6月17日「WAX WORK I」パラフィン、ワックスを実際に触り、融かし、固め、着色して素材の特性を掴み、粘土との違いを知る。粘土は固体のまま、削る、くっつけることで整形するが、パラフィン、ワックスは

液体から固体になる。
■6月24日「WAX WORK II」マテリアルの実験。型をつくって流す（融ける）。ものに塗りつけ離型する（喰いつく、染みる、型取る）。着色する。固まる（半透明、独特な質感）。
いかに自分が素材の特性を掴み取り、自己のイメージに引き寄せることができるか？
■7月1日「WAX WORK III」より強い素材「パルヴァックス」を使う。
■7月8日「WAX WORK IV」各自の作品を展示。
■7月15日「WAX WORK 共同作業」大きな作品をつくる（3m×4m, redwax）。壁に取りつけて記念写真。作品を壊す。彫刻の不在性、単体では成立しない作品、ものに、空間に、状況に頼った、自立できないインスタレーションについて。
■9月16日「遠藤利克の作品と象徴性について」ゲスト：遠藤利克（美術家）、司会：高島直之（美術評論家）
■9月30日「金属について」金属の実物（鉄、銅、真鍮、アルミニウム、ステンレスなど）を見てそれぞれ感じる。金属の物性の比較（比重、融点、引張強度など）。金属の工業規格。鋳造の種類（蝋型、焼型、ガス型、電鋳など）。粘土で型をつくり、鉛を使った簡単な鋳造を行う。
■10月10日「川口鋳造所見学」12:30 JR川口駅集合。川口産業会館、池田美術鋳造所見学。ガス型鋳造法の実際。川口鋳物屋を巡る。上野国立博物館東洋館を見学。18時解散。

1983 Sumi Seminar " Sculpture Materials" (Friday/Lunchtime) Total 14 sessions
■ May 6: An artist's attitude with a focus on ■ May 6: An artist's attitude with a focus on material work, methodology training, exploration of the intellect as an extension of the hand, and the intelligence of matter.
■ May 17 "A work that stands on its own": The students will create a work of art that can stand alone, using one or two pieces of paper clay. If they get stuck in the process, they will explore the various characteristics of the clay and observe the results. From repetition through these processes, students will find their way toward their objective.
■ May 20, "A work realized as a composite": The artist will create a work that can be formed as a composite using one or two pieces of paper clay. Composite = structure of relationship, in other words, a matter of space. Things + things, space + things, and space + space. Viewers are not interested in an artist's concept that is obvious. I would like the artist to strive for something beyond that, rather than a work presenting a simplistic concept. Discussion about the space and relationship between the structures of walls and bridges.
■ May 27 "Mixed Media" - Mixed media will be created using 1 or 2 pieces of paper clay + α. Multiple elements are combined and transformed for an entirely different visual representation. Based on the single and composite elements we have dealt with so far, we will break away from the representations associated with paper clay. At the same time, we will explore the possibilities of each new material without succumbing to the existing representations it possesses.
Sources: Robert Rauschenberg, Jean Tinguely, Lee Ufan, and the film *Aguirre: Wrath of God* by Werner Herzog
■ June 3 "The Art of Collecting" For one hour, students will walk around the B-semi site, collect things that catches their eyes, and create a work of art. The principle of art is to look (conscious/unconscious) → select (object/image/action) → (vision/technique) → work of art.

■ June 10 "Planning" In the previous session, we tried to improvise with the material we found. We will elaborate on what we have noticed using found objects.
■ June 17 The students will actually touch, melt, harden, and color paraffin and wax to grasp the characteristics of the material and learn how it differs from clay. Clay is shaped by scraping and sticking while it remains solid, while paraffin and wax changes from a liquid to a solid.
■ June 24 "WAX WORK II" Experimentation of materials. Molds are made and poured (melting). Applying wax to objects and releasing the mold (adhering, staining, and mold taking). Coloring. Hardening (translucent, unique texture).
How to grasp the characteristics of a material and pull it into one's image?
■ July 1: "WAX WORK III" will use a more robust material, "Palvax."
■ July 8, "WAX WORK IV" will be an exhibition of each artist's work.
■ July 15 "WAX WORK Collaboration" – Students will create a large-scale work (3m x 4m, redwax). Install it on the wall and take a commemorative photo. Break down the work. The absence of sculpture, works that cannot stand alone. And, installations that cannot stand on their own, dependent on objects, space, and circumstances.
■ September 16 "On Toshikatsu Endo's Works and Symbolism" Guest: Toshikatsu Endo (artist), Moderator: Naoyuki Takashima (art critic)
■ September 30 "Concerning Metals," looking at actual metals (iron, copper, brass, aluminum, stainless steel, etc.) and getting a sense from each material. Comparison of physical properties of metals (specific gravity, melting point, tensile strength, etc.). Industrial standards for metals. Types of casting (wax molds, fired molds, gas molds, electroforming, etc.). Making molds out of clay and simple casting with lead.
■ October 10 "Kawaguchi Foundry Tour" 12:30pm - Meet at JR Kawaguchi Station. Visit Kawaguchi Industrial Hall and Ikeda Art Foundry. Actual gas casting method. Tour of Kawaguchi foundry. Visit the Toyokan (Asian Gallery) of the Ueno National Museum. 6:00pm - Dismissal.

1984

1984年度 鷲見ゼミ「彫刻の空間」
（金曜日／夜）全7回
■6月15日「彫刻の現在」ブランクーシ以降の彫刻、ジャッド以降の彫刻を比較しながら、彫刻が抱えている空間、対峙するときに生まれる視覚的な空間について。また悪しき自然主義としてのアース・ワークや、安易な具象と抽象の狭間にある表現などへの危惧について。
■6月22日「開いた空間」持参した半円筒型の機械の鋳型を例に、壁や床に対して、視覚的に閉じたり開いたり、あるいは両方を行ったり来たりする空間

を示す。粘土で「開いた空間」を持った作品をつくる。
■7月6日・13日「橋の空間Ⅰ、Ⅱ」橋はＡ地点とＢ地点をつなぎ、あちらの空間とこちらの空間を渡すものでもあり、そして真ん中が浮いている。橋の空間を使って作品をつくる。材質は自由。構造などを説明できる状態にすること。
■9月14日「スライドで自作品の紹介」
■9月21日・28日「1/10スケールの個展Ⅰ、Ⅱ」各自、自分が展覧会をしたいと思う場所を想定して模型をつくり、展覧会プランをつくる。資料：自身の個展「ZONE」ギャラリー手（東京・1982）と「彫刻とドローイング1978-83」画廊匠屋（岐阜・1983）の模型

1984 Sumi Semi " Sculptural Space" (Fridays/evenings) Total 7 sessions

■ June 15 "Sculpture Today" Comparing post-Brancusi and post-Judd sculptures, this lecture will discuss the space that sculpture holds and the visual space it creates when confronted with it. In addition, there will be a discussion of the concerns about earthwork as a form of misguided naturalism and representation that lies somewhere between simple figuration and abstraction.
■ June 22, "Open Space" Using the semi-cylindrical machine mold you brought as a sample, show a space that visually closes or opens against a wall or a floor, or show a space that moves back and forth between the two. Create a piece that has an "open space" using clay.
■ July 6 and 13 "Bridge Space I, II" A bridge connects point A to point B. It also passes between *that space* and *this* space, and the middle part floats. Students will create artworks using the space of a bridge. The material can be any material. The work should be in a condition to explain its structure, etc.
■ September 14: "Slide presentation of student work."
■ September 21 and 28: "1/10 Scale Solo Exhibition I, II" Each student will make a model of a venue where they would like to hold an exhibition and create a plan for it. Source: Sumi's solo exhibition *ZONE* at Gallery Te (Tokyo, 1982) and *Sculpture and Drawing 1978-83* at Gallery Takumiya (Gifu, 1983).

1989

1989年度 鷲見ゼミ「語りかける形」（木曜日／昼）全12回

■6月15日「形の逆襲」紙粘土（フォルモ）1～2kgをつかって、作品の前夜という段階から始める。粘土を机の上に置いて、1分間目をつむって、宇宙人になって、初めて見たものだと思ってひとつだけ行為をする。次に、なにかひとつの行為を繰り返しやる。空間という概念が、多くのものに適応されすぎて、ひとつひとつの形態に目がいかない。目の前のものをよく見ながら、行為の履歴を振り返り、細かく分析すること。

■6月22日「人体」紙粘土（フォルモ）1～2kgをつかって「人体」をつくる。「人体」という言葉に思い浮かべることは多いが、「人体」の元となる身体自体が組織や器官の集合体であり、「人体」とは美術の変遷のなかで生まれた形態である。
■6月29日「家具」人体のような有機的な形に対して、机のような用途がある形、椅子のように身体の器としてある形などをつくる。
■11月30日「スライドで自作品の紹介」
■12月7日「自然の引用」1時間かけて、植物を観察、採集、植物を通して自分が持っている波長を探して作品をつくる。資料：バーナード・ルドフスキー「驚異の工匠」
■12月14日「形のないものを採集」形がないものを見つけて作品をつくる。採集は気づきと言い換えても良い。
■1月18日・25日・2月1日・8日・15日「プランニング・粘土・石膏取り・鉛の鋳造」
■2月22日「三木の耳」三木富雄の《EAR—1972》を壁に設置してディスカッション。

1989 Sumi Semi "Narrative Forms" (Thursday/Lunchtime) Total 12 sessions

■ June 15, "The Form Strikes Back" Using 1 to 2 kg of paper clay (formo), we begin with the phase referred to as the "*eve of the work*". Put the clay on the table, close your eyes for a minute, pretend you are from outer space and do one act as if you were seeing it for the first time. Next, repeat a single act. The concept of space adapts to so many things that we can't keep our eyes on one form at a time. While looking closely at what is in front of you, review the history of the act and analyze it in detail.
■ June 22, "The Human Body": Create a "human body" using 1 to 2 kg of paper clay (formo). Although the word "human body" brings to mind many things, the body itself, the source of the "human body," is a collection of tissues and organs, and the "human body" is a form that has emerged throughout artistic transitions.
■ June 29: "Furniture": In contrast to organic forms such as the human body, we create forms that have a purpose, such as a desk and forms that serve as vessels for the body, such as a chair.
■ November 30: "Slide presentation of student work."
■ December 7," Quoting Nature," an hour-long class to observe and collect plants and to create works based on each student's personal wavelength. Source: Bernard Rudofsky, "The Prodigious Builders."
■ December 14 "Collecting the Formless" Finding something that has no form and creating a work of art out of it. Collecting can be described as noticing.
■January 18, 25, February 1, 8, 15 "Planning, Clay, Plaster Removal, Lead Casting."
■ February 22, "Miki's Ear" Tomio Miki's "EAR-1972" will be installed on the wall for discussion.

1990

1990年度 鷲見ゼミ「形の生まれるとき」（火曜日／夜）全9回

■5月8日「好きなもの／嫌いなもの」好きなものと嫌いなもの各29項目のアンケートに匿名で記入。ランダムに配り直される。手元にあるアンケートと、自分との違いを考える。その後、ひとりで判断して決定することと、第三者が関わることで、決定が変化すること、その人数や関係が変化するとどうなるかを、紙、ことば、行為を組みあわせて実験する。
■5月15日「粘土のプリント」粘土をなにかに押しつけて、ものの形を写し取る。
■5月22日「立ち上がる」立ち上がるという言葉から想起されるものを机の上でつくる。
■5月29日「壁と床を結ぶもの」現実の教室のなかに作品をセッティング。条件は、床（水平）と壁（垂直）という2つの要素を結ぶもの。
■6月5日「ツイン（対の構造）」同じものを2つつくることによって表現する。※5月29日と6月5日は「現代美術演習Ⅳ」（現代企画室）収録。
■6月12日「立体的なものに色を塗る」
■6月26日「やわらかいもの」
■7月7日（土）渋谷東急プラザ16時集合。ユーロスペースで映画「風の物語」（ヨリス・イヴェンス）を鑑賞。
■7月14日（土）京成佐倉駅13:15集合。

1990 Sumi Semi "When a Form is Born" (Tuesdays/evenings) Total 9 sessions

■ May 8, "Likes / Dislikes" Anonymously fill out a questionnaire with 29 items for things you like and don't like. These will be randomly re-distributed. Contemplate the differences between the survey at hand and yourself. Then, experiment with a combination of paper, words, and actions to see what happens when a single person makes a decision and when a third person is involved, and what happens when the number of people and the relationships between them change.
■ May 15 "Clay Printing": Pressing clay against something and replicating the object's shape.
■ May 22 "Stand up": Students will make something on a desk that reminds them of the word "stand up."
■ May 29 "Connecting the Wall and the Floor" The work will be set up in an actual classroom. The condition is something that connects two elements: floor (horizontal) and wall (vertical).
■ June 5 "Twin (pair structure) "Representation by making two identical objects.
*May 29 and June 5 sessions will be video recorded at "Contemporary Art Exercise IV" (Gendai Kikakushitsu).
■ June 12, "Color application to a sculpture."
■ June 26: "Soft Things."
■ July 7 (Sat): Meet at Shibuya Tokyu Plaza at 4:00pm. We will watch The *Tale of the Wind* by Joris Ivens at Eurospace.
■ July 14 (Sat) Meet at Keisei Sakura Station at 1:15pm.

1992

1992年度 鷲見ゼミ「WAX & CLAY」
（水曜日／昼）全5回
■11月11日・18日・25日「WAX WORK I, II, III」
資料：鷲見和紀郎作品（パラフィンでつくったくさび形の作品、継ぎ目のない平面作品）、ブライス・マーデン（蝋を混ぜた油絵具のコテっとした表面）
■12月2日「CLAY WORK I」可塑性の強い粘土が持つ力と作家の手によって、色々な表情が生まれる。8cmの立方体をつくり、ひとつだけ行為を加え交換、それを3回繰り返す。崩れた形をまた立方体に戻す。円環状に机を並べ、全員参加で、行為を加えて交換、を繰り返す、変わり果てた姿が返ってくる。
■12月16日「CLAY WORK II」粘土で人体をつくる。人間の手のなかで粘土がおさまって両手の間から生まれる形態、人間の記憶がつきまとう形。机の上で完結するのではなく、最終的にどんなサイズにしたいかを考えながらつくること。

1992 Sumi Semi "WAX & CLAY" (Wednesday/Lunchtime) Total 5 sessions
■ November 11, 18, 25 "WAX WORK I, II, III" materials: Wakiro Sumi's works (wedge-shaped works made of paraffin, seamless two-dimensional works), Bryce Marden's (oil paints mixed with wax on a dense surface).
■ December 2 "CLAY WORK I" A variety of forms can be created by the artist's hand combined with the strong plasticity of the clay. An 8cm cube is made, a single action is added to the cube and exchanged, and this process is repeated three times. The collapsed form is then reconstructed back into a cube. The tables are arranged in a circle, and everyone participates, adding an action, exchanging, and repeating until an altered form is returned.
■ December 16 "CLAY WORK II" Create a human figure with clay. The clay is held in the hands of a human being, and a form is created between the two hands—a form persisting in human memory. This work is not completed on a desk but constructed as the final size of the work is determined.

1993

1993年度 鷲見ゼミ「戦略としてのイノセント」
（火曜日／昼）全6回
■11月9日「紙の環」1枚の紙に1ヶ所点をつける。もう1ヶ所点をつける。2つの点を線で結ぶ。紙を裏返して、中心に点をつける。そこを中心に利き腕を使って正円を描く。次はコンパスを使って正円を描く。自由がきかない方法も最大限表現には生かすこと。同じことをひとつの工程ごとに6人で順番に繰り返す。グループごとに差異が生まれる。既視感から解かれて「ゼロの視点」で、素材との出会い方を考える。資料：フィリップ・ソレルス「例外の理論」。
■11月16日「粘土の環」粘土で球体をつくる。できたら目の前に置く。なぜ完璧な球体がつくれないのだろう？ その球体になにか作業を加える。右回りに隣の人にその球体を渡していく。どんどん回していって、自分のところに戻ってきたらどう変わったか？ 球体だった粘土を元の直方体に戻す。次は2つの要素で成り立っているものをつくる。最後に3つの要素で成り立つものをつくる。
■11月30日「散歩と採集／人工と自然」（目的地：清水ヶ丘公園）散歩の途中に出会った人工と自然のものを持ち帰る。採集してきたものを目の前に置いて、よくよく観察する。
■12月7日・14日「WAX WORK I, II」
■12月21日「スライドで自作品の紹介」

1993 Sumi Semi "Innocence as a Strategy" (Tuesday/Lunchtime) Total 6 sessions
■ November 9, 2011 "Paper Rings" Mark one dot on a sheet of paper. Make another dot on the same sheet of paper, and connect the two dots with a line. Turn the paper over and put a dot in the center. Draw an equilateral circle with your dominant arm around the point. Next, use the compass to draw an equilateral circle. You must make the best use of the method that does not allow flexibility in your effort. The process is repeated by six people, one at a time. Every group will be different from the others. The group will be freed from a sense of deja vu and will consider how to encounter the material from a "zero point of view. Source: Theory of Exceptions by Philippe Sollers.
■ November 16 "Clay Rings" Make a sphere out of clay. When you are done, put it in front of you. Why can't we make a perfect sphere? Do something else to the sphere. Pass the sphere to the person to your right. Continue passing the sphere around. When you receive back your sphere, how did it change? Restore the clay sphere to its original rectangular shape. Next, make something that is composed of two elements. Finally, make something that is composed of three elements.
■ November 30 "Walking and Collecting / Artificial, and Natural" (destination: Shimizugaoka Park) Students will collect artificial and natural objects they find during their walk and bring them back to class. The objects gathered will be placed in front of the student for careful observation.
■ December 7 and 14 "WAX WORK I, II."
■ December 21 "Slide presentation of student work."

伊部 年彦

1994

1994年度 鷲見ゼミ「迂回、あるいは遠回り」
（火曜日／昼）全5回
■11月8日 映画「ストーカー」（アンドレイ・タルコフスキー）に登場する「案内人」がナットを結んだ紐を振り回して行き先を決める様子に触発され、今年はあえて回り道しながらゼミを進める。セロニアス・モンクの「間」をずらす奏法について、広島市現代美術館のグループ展で現場制作を予定している《光と影》のトンネル状の回廊のような作品について。
■11月22日「紙を立体に変身させる」
■11月29日「散歩と芸術」
■12月6日・13日「旗をつくるI, II」旗が持つ機能や構造について考え、作品を制作。資料：ダニエル・ビュレンヌ

1994 Sumi Semi "A Detour or a Roundabout Way" (Tuesday/Lunchtime) Total 5 sessions
■ November 8 Inspired by the "guide" in the movie *Stalker*, by Andrei Tarkovsky, who decides the destination by swinging a string with a nut tied around it, this year's seminar will proceed by taking a diversionary approach. We will discuss Thelonious Monk's technique of playing with shifting "moments" and the tunnel-like corridor of Sumi's *Light and Shadow*, which is scheduled for on-site production for a group exhibition at the Hiroshima City Museum of Contemporary Art.
■ November 22 "Transforming Paper into a Sculpture
■ November 29 "Walking and Art."
■ Dec. 6 and 13 "Flag Making I, II" Students will contemplate the function and structure of a flag and create a work of art. Source: Daniel Buren

1995

1995年度 鷲見ゼミ「形の生まれるとき」
（月曜日／昼）全12回
■11月13日「立体と色彩」絵画における色の位置と立体における色の問題を絡めて、立体造形をする。あみだくじでランダムに結びついた2つの言葉の組み合わせをイメージとして形をつくる。
■11月20日「色彩から立体彫刻」各自の私的な色について。素材の色を利用するようなネガティブな姿勢ではなく、色彩を空間的に意識できる作品をつくる。私（鷲見）の色は、グリーンを含んだカドミウム系の黄色と緋色。黄色はブルー、グリーン、レッドのように強いメッセージがない寄る辺ない色だが、私にとって空間における物質としての色でもある。資料：イブ・クライン、デイビッド・スミス、アンソニー・カロ
■11月27日「形から色彩を考える」各自が関心のある具体的な形について発表。
■12月4日・11日・18日「WAX WORK I, II, III」
■1月22日「鋳造について」発泡スチロールで30cm前後の原型をつくる。資料：ビデオ「Skin of Sculpture」（20min）

■1月29日「鋳造実習」12:00 JR川口駅集合。（有）創芸社で見学と鋳造実習。
■2月5日「鋳造した作品に手を加える」鋳造をして原型となにが変わったのか、物質の変化を最大限観察しながら作品に手を加える（研磨など）。さらに、もういちど発泡スチロールで作品をつくる。資料：ブランクージ《永遠の鳥》シリーズ
■2月19日「人工物と自然物の関係を考える」手を加えて残そうとする一方で、手を加えないで自然を残そうとすることの間に表現が存在する。
■2月26日「残らないものをつくる」まずは「残る」ことについて考え、「残らない」ことについて考える。
■3月4日 対談「ネオダダイズムオーガナイザーズから今日まで」ゲスト：田中信太郎

1995 Sumi Semi "When a Form is Born" (Monday/Lunchtime) Total 12 sessions

■ November 13 "Sculptural Forms and Colors" We will create sculptural forms by integrating the placement of colors in paintings and the matter of colors in sculptural forms. We will form a shape based on an image of a two word combination connected randomly in an amidakuji (ladder lottery).
■ November 20 "Sculpture created from color" A discussion about personal color. Rather than a conservative tendency to use appropriate a material's color, we will create works that stimulate a spatial awareness of color. My (Sumi's) colors are cadmium yellow with a green tinge and scarlet. Yellow is a color that has no strong message like blue, green, or red, but for me, it is a color that is material in space. Sources: Yves Klein, David Smith, Anthony Caro.
■ November 27: "Thinking about Color from Shapes," each student will present a specific shape that interests them.
■December 4, 11, and 18: "WAX WORK I, II, III.
■ January 22: "About Casting": Making a styrofoam prototype of about 30 cm in length. Resource: Video *Skin of Sculpture* (20min.)
■ January 29 "Casting Practice" 12:00pm - Gather at JR Kawaguchi Station. (Visit and practice casting at Sogeisha Ltd.
■ February 5 "Modifying Cast Works": We will thoroughly observe any changes made from the prototype after casting and modifying (polishing, etc.). The work will then be recreated from styrofoam. Source: Brancusi, "Bird in Space" series
■ February 19 "Considering the Relationship between Artificial and Natural Objects" On the one hand, there is an effort to preserve the natural environment by manipulating it, and on the other hand, there is an effort to preserve it by leaving it as is.
■ February 26 "Making Ephemeral Work." We will first reflect on what "remains" and then think about what "does not remain."
■ March 4: In Conversation "From Neo-Dadaism Organizers to Today" Guest: Shintaro Tanaka

1996

1996年度 鷲見ゼミ「身体からはじめる」（月曜日／昼）全6回

■1月20日「眼の知性、手の知性」思考の知性をいったんおいて、眼と手の往復のなかに生まれるものをつかむ。まずは人体を描く。鷲見さんが台に座る（1分）。鷲見さんが床に横になる（1分）。人体以外のものとの関係、自分との関係を踏まえ、もういちど描く。鷲見さんが台に座る（3分）。
■1月27日「人体を使う」ペアになって、それぞれポーズをとって、紙粘土を使って人体をつくる。資料：マチス《蛇のような女》1909
■2月3日「人体の細部」人間のパーツからどこかを抽出する。頭の先から足の先まで無数にある細部、それは身近にあって、実はいちばん遠くにある。資料：三木富雄、合田佐和子、セザール・バルダッチーニ、アンゼルム・キーファー
■2月10日「擬人化する」人間的な要素、非人間的な要素、結びつけると作品のヒントが生まれるかもしれない。資料：関根伸夫《歩く石》
■2月17日「人体を覆うもの」衣服や被服に限らず、帽子、マスク、手袋、靴、眼鏡、ネクタイなど、感覚を変化させる、人体を覆うものについて考える。
■2月24日「人間の顔」映画「Mazeppa（ジェリコー・マゼッパ伝説）」（バルタバス）、最期には狂った人間の顔を描いた、馬の画家について。

1996 Sumi Semi "Starting with the Body" (Mondays at noon) Total of 6 sessions

■ January 20, "The Intelligence of the Eye, the Intelligence of the Hand." Pausing the mind's intellect for a moment, we will grasp what is created in the interchange of the eye and the hand. First, draw a human body. Sumi sits on a platform (1 minute). Sumi lies down on the floor (1 minute). Then, taking into account the relationship with other things besides the human body and yourself, you will draw again. Sumi sits on a platform (3 minutes).
■ January 27 "Using the Human Body" In pairs, each student will pose for the other. while to create a human body using paper mache. Source: *La Serpentine*, Matisse,1909.
■ February 3 "Details of the Human Body" Pick out any part of a human body. From the tip of the head to the tip of the toe, innumerable details are familiar to us but, in fact, most distant from us. Sources: Tomio Miki, Sawako Gōda, César Baldaccini, Anselm Kiefer
■ February 10, "Anthropomorphize" When you connect human and non-human aspects, you may find some hints for your work. Material: *Walking Stone*, Nobuo Sekine.
■ February 17 "Things that cover the human body" Think of things that cover the human body, not only clothes and outfits, but also items that can alter the senses, such as hats, masks, gloves, shoes, glasses, and neckties.
■ February 24 "The Human Face" The movie *Mazeppa* by Bartabas is about a painter of horses, who in his final moments, painted the face of a madman.

1997

1997年度 鷲見ゼミ「お互いことをよく知ろう」（月曜日／昼）全11回

■11月10日「自己紹介」みんなで自己紹介
■11月17日「部屋のなかを散歩」天気が悪いので5分間Bゼミ内を散歩する。意外な拾い物や普段と違う気づきがある。それを踏まえて紙の上で作品をつくる。まずは眼の認識、次は手の認識ということで、紙粘土を使う。目と手と脳のトライアングルで制作。
■12月1日・8日・15日「WAX WORK I、II、III」資料：ビデオ「広島市現代美術館、秋山画廊での現場制作」
■1月19日「散歩して採集」清水ヶ丘公園にみんなで行って、自分の目を覚醒させながら、なにかを拾って持ち帰る。ついついその場になじまないものを拾ってしまう。途中で雨が降ってくる。資料：トニー・クラッグ
■1月26日「端（Edge）を視覚化する」絵画や彫刻を規定するエッジに限らず、たとえば、座るときも、椅子の端を見て、輪郭を頼りに座る。
■2月2日「橋をつくる」日本では掛橋、飛び石、船の上に置かれた板のように、仮設のような自由さがあるが、西洋において、橋はこちらから向こう側へ渡る重要な概念。資料：ゲオルク・ジンメル「橋と扉」
■2月9日 対談「藤堂良浩の仕事」ゲスト：藤堂良浩
■2月16日「塔をつくる」塔は垂直に架けられた橋（梯）。下から上に登るだけでは無機能に近く、シンボルとしての意味が強い。誘導されているのは外から見上げる視点。視点を垂直的に上昇、下降させるのは美術の考え方に近い。資料：ロラン・バルト「エッフェル塔」
■2月23日「グレン・グールドとセロニアス・モンク」2人の共通性。

1997 Sumi Semi" Getting to know each other well" (Monday/Lunchtime) Total 11 sessions

■ November 10 "Self-Introductions" Everyone introduces themselves.
■ November 17 "Walking around the room" Because of poor weather, we take a 5-minute walk around the campus of B-semi. There will be unexpected things to be found and unusual things to take notice. With that in mind, we will create work on paper. First is the awareness of the eyes, followed by an acknowledgment of the hands by using paper mache. We will work in the triangulation of eye, hand, and brain.
■December 1, 8, and 15, "WAX WORK I, II, III" Source: Video "On-site Work at the Akiyama Gallery, Hiroshima City Museum of Contemporary Art.
■ January 19 "Walking and Collecting": Everyone goes to Shimizugaoka Park. While keeping their eyes active, they will pick up something and then bring it back to the studio. We will all end up picking up things that are unfamiliar to the location. It will rain on the way. Source: Tony Cragg.
■ January 26 "Visualizing the Edge" Edges are not limited to those that define a painting

or sculpture; when sitting, we look at the edge of a chair and rely on the outline of the chair to guide us to sit down.
■ February 2, "Creating Bridges" In Japan, there are temporary, freestyle structures, such as a hanging bridge, stepping stones, or a board that is placed on to the deck of a ship, whereas in the West, a bridge is a significant concept of crossing from one side to the other. Source: Georg Simmel, "Bridge and Door."
■ February 9, In Conversation. "The Work of Yoshihiro Tōdō" Guest: Yoshihiro Tōdō
■ February 16 "Building a Tower" A tower is a vertical bridge (ladder). Simply climbing up from the bottom up is nearly dysfunctional; it has a more substantial meaning as a symbol. What guides us is the point of view looking up from the outside. It is similar to the idea of art making the viewpoint ascend and descend vertically. Source: *The Eiffel Tower*, Roland Barthes.
■ February 23 "Glenn Gould and Thelonious Monk" The parallels between the two.

1998

1998年度 鷲見ゼミ「戦略としてのイノセント」（月曜日／昼）全6回
■1月18日「イメージの逆襲」紙を使った演習。
■1月25日「こころよい形を探す」粘土を使った演習。ドイツの写真家、カール・ブロスフェルト（Karl Blossfeldt）は植物の形だけに注目、手を加え、美しい写真に仕上げている。ブロスフェルトの写真を12枚黒板に貼る。各自好きな写真を選び、形に対する好みを知る。植物とは正反対の人工的な形「キューブ」や「スフィア」について。
■2月1日「なんでもないもの」名づけようのないものをつくる。資料：ヴァルター ベンヤミン「図説 写真小史」、ロラン バルト「表徴の帝国」
■2月8日「散歩と採集」
■2月15日・22日「WAX WORK I、II」

1998 Sumi Semi "Innocence as a Strategy" (Monday/Lunch) Total 6 sessions
■ January 18 "The Image Strikes Back" Exercise using paper.
■ January 25: "Searching for Pleasant Shapes," An exercise in clay. German photographer Karl Blossfeldt focuses only on the shapes of plants, modifying them and creating beautiful photographs. Put 12 of Blossfeldt's photographs on the blackboard. Each person chooses a favorite photo to learn about his or her preference for form. Discuss "cubes" and "spheres," artificial shapes that are the opposite of plants.
■ February 1: "Nothing": Create something that cannot be named. Sources: *A Short*

History of Photography, Walter Benjamin, *The Empire of Signs*, Roland Barthes.
■ February 8: "Walking and Collecting."
■February 15 and 22: "WAX WORK I, II."

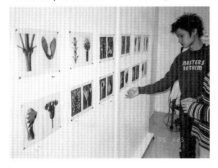

1999

1999年度 鷲見ゼミ「ART GOES ON」（月曜日／昼）全12回
■5月10日（月）美術がなんとなく進んでゆくことについて。
■5月11日（火）〜15日（土）「石膏直づけI、II、III、IV、V、VI」
■5月24日「地図を描く」家からBゼミまでの道のりを自分なりに描く。
■5月31日「散歩と採集」ポラで1枚写真を撮る。散歩してなにかを拾ってインスタレーションする。資料：映画「我輩はカモである」（マルクスブラザーズ）
■6月7日・14日・21日「タイムカプセル・プロジェクト I、II、III」1999年6月現在の"私"を入れ、Bゼミに穴を掘って各自の作品を入れた箱を埋める。資料：ビデオ「三木富雄 耳が私を選んだ」
■6月28日「セミ・プロジェクト—cicada project—」タイムカプセル（気になったもの・作品）を埋める。大きさ：(h600×w1000×d600mm)埋めた場所：Bゼミ入り口、階段下記録：ビデオ（各自のコメント）1年後、開封したとき、その1年で、埋めたものや私たち自身がどう変化したのか再認識する。プロジェクト名の「セミ」は長い幼虫期を土の中で過ごす「蝉」に由来する。
■2000年7月5日「セミ・プロジェクト」タイムカプセルを掘り出し、開封する。
■2000年7月18日（火）〜23日（日）「セミ・プロジェクト」展示（第33回2000年Bゼミ展内、横浜市民ギャラリー）参加者：鷲見和紀郎、池田博喬、石渡誠、小森祥子、近藤愛助、酒井隆一、須貝高博、菅原祐子、藤川直美、蛭田圭一、古谷しのぶ、前田真由美、三芳奈緒子

1999 Sumi Semi "ART GOES ON" (Mondays, Lunchtime) Total 12 sessions
■ May 10 (Mon.) Regarding the gradual progress of art.
■ May 11 (Tue.) - 15 (Sat.) "Direct Plastering I II III IV V VI."
■ May 24 "Map Drawing" Draw the route from your home to B-semi in your style.
■ May 31 "Walking and Collecting" Take a Polaroid photo. Go for a walk, pick up something, and install it. Source: Film *Duck Soup* by The Marx Brothers
■June 7, 14, and 21: "Time Capsule Project I, II, and III": Dig a hole in the B-semi campus space and bury a box containing each student's work, which will contain the "myself" as of June 1999. Video *Tomio Miki: My Ears Chose Me* (in Japanese)
■ June 28, 1999: "Semi project - cicada project -" Bury a time capsule (things of

curiosity and artworks). Size: (h600 x w1000 x d600mm) Burial location: entrance of the B-semi, under the stairs Documentation: video (individual comments) When we open the capsule one year later, we will rediscover how the buried items and ourselves have changed over the past year. The project name "semi" comes from "cicada," which spends its long larval stage in the soil.
■ July 5, 2000: "Semi Project" - digging up and opening the time capsule.
■ July 18 (Tue.) to 23 (Sun.), 2000: *Semi Project* exhibition (in the 33rd 2000 B-semi exhibition, Yokohama Civic Art Gallery) Participants: Wakiro Sumi, Hirotaka Ikeda, Makoto Ishiwata, Shoko Komori, Aisuke Kondo, Ryuichi Sakai, Takahiro Sugai, Yuko Sugawara, Naomi Fujikawa, Keiichi Hiruta, Shinobu Furuya, Mayumi Maeda, Naoko Miyoshi

2000

2000年度 鷲見ゼミ「点・線・面」（昼）全3回
■5月10日（水）〜12日（金）「点・線・面」点・線・面に関する作品をつくる。

2000 Sumi Semi "Point, Line, Surface" (lunchtime) Total 3 sessions
■ May 10 (Wed.)-12 (Fri.) "Point, Line, Surface" Create works related to point, line, and surface.

SUMI SEMI PROJECT 2002~2008

和光大学芸術学科 鷲見和紀郎ゼミ 再制作プロジェクト
Wako University, Department of Art, Wakiro Sumi Seminar, Re-Production Project

SUMI SEMI

2002年から和光大学芸術学科の三上豊教授から誘われて
行った SUMI SEMI PROJECT は美術実習での模写、模
刻の現代アート版でした。なまじアートの歴史など知らない
学生たちが実際の制作の現場に立ちあうことによって生じる
リアルな感情を見てみたいと思ったからです。
年度ごとに設定した作家と作品は、関根伸夫の「位相大地」
ハイレッドセンターの「ドロッピングイヴェント」鷲見の「ツイ
ンタワープラン」榎倉康二の「壁」山中信夫の「ピンホール
ルーム」ジュゼッペ・ペノーネの「木の中の木」三木富雄の
「EAR」です。初めは気乗りのしなかった学生も実際に事物
が時間と手を経て作品へと変化することに興奮し始め、毎
回面白い体験ができたと思います。
毎回共同作業から生まれるコミュニケーションと初めて触れ
る素材との時間が、このプロジェクトの重要ポイントでした。
作品はコンセプトや美学からではなく作業の積み重ねの先
に生まれるのだという事実の実践が、美術史を再制作する
ことによって体感するリアルな経験が、SUMI SEMI での現
代アートの再制作の意味だったと思います。

SUMI SEMI

Professor Yutaka Mikami of the Department of Art at
Wako University invited me to participate in the SUMI
SEMI PROJECT in 2002, a contemporary art version of
replication and re-production work. I wanted to
observe the real feelings generated by students,
relatively unfamiliar with the history of art, as they
engage in the actual production site.
The artists and works selected for each year were
Nobuo Sekine's *Phase—Mother Earth*, Hi-Red Center's
Dropping Event, Sumi's *Twin Tower Plan*, Koji Enokura's
The Wall, Nobuo Yamanaka's *Pinhole Room Revolution*,
Giuseppe Penone's *Tree Within A Tree*, and Tomio
Miki's *EAR*. At first, students were reluctant to
participate. Still, they grew excited to see the
transformation of materials into artworks with the
passage of time and handiwork, making each session
a fun experience.
A key point of these seminar projects was the
communication that emerged from the collaborative
process and the time spent interacting with the
materials for the first time. Implementing the principle
that a work of art is born not from concepts or
aesthetics but the cumulative work process, the
real-life experience of re-producing art history was
the true meaning of contemporary art reproduction at
SUMI SEMI.

SUMI SEMI PROJECT 1
関根伸夫「位相─大地」2003
Nobuo Sekine *Phase - Mother Earth*, 2003

2003年10月4日（土）～12月13日（土）
和光大学キャンパス内

■35年のときを経て、今、私たちの手によって「位相─大地」が再び立ち現れようとしている。これから次々におとずれる困難など予想もせず、写真で見る「位相─大地」（1968）のイメージそのままに、作業は順調にスマートに進んでいくものだと思っていた。完成の形は用意されているのに、「土地」というものはなかなか思いどおりになってくれない。問題が起きるたびにアイデアを出しあって、少しずつ作業を進めていった。泥だらけになりながら、土を掘っては積み上げる。その行為を繰り返すうちに穴は徐々に深くなってゆき、円筒は高さを増していった。この70日間はまさに大地との格闘だった。

■12月13日（土）には最後の工程として、円筒の木枠を外すイベントが催されたが、円筒状に積み上げられた土の柱はすべての荒縄を外したと同時に、あっけなく崩れ落ちた。その現場には関根伸夫氏も同席、神戸須磨離宮公園でオリジナルの「位相─大地」の撮影にあたった村井修氏も記録写真を撮影した。

■制作スタッフ：五十嵐 愛、池田里奈、山内嘉代子、海老原宏樹、萩原貴一、菊地 賢、込山正一郎、斉藤麻里子、鈴木奈津子、平 雅仁、田村早蓉子、地脇りら、秦 典子、帆苅祥太郎、堀切幸子、宮地 幸、柳澤とも子、山岸美恵子、山本 瑞

■資料：「位相─大地」の考古学（1996、西宮市大谷記念美術館）1970年─物質と知覚 もの派の根源を問う作家たち展カタログ（1995、読売新聞社）

■協力：関根伸夫、村井 修、藤川 清（教務課）、山下 健／沢里 実／上田倫裕（管財課）東京画廊、半田滋男、三上 豊

October 4 (Sat) - December 13 (Sat), 2003, on the campus of Wako University

■After 35 years, *Phase - Mother Earth* is now about to rematerialize by our hands. We had no idea of the difficulties that were about to unfold, as we expected the work to proceed smoothly and skillfully, just as we had seen the image of *Phase - Mother Earth* (1968) through photographs. However, while a completed shape model was prepared, the "land" did not conform to our intentions. As problems arose, we developed new ideas and carried on gradually. We dug and piled up the dirt, getting covered in mud. As we repeated these actions, the hole gradually became deeper, and the cylinder grew taller. This 70-day process was truly a struggle with the land.

■On Saturday, December 13, the final step was to remove the wooden frames from the cylinders, but the stacked cylindrical column of soil collapsed as the ropes were removed. Nobuo Sekine was present at the event, and Osamu Murai, who photographed the original *Phase - Mother Earth* at Kobe Suma Detached Palace Park, also was in attendance taking documentary photographs..

■Production Staff: Ai Igarashi, Rina Ikeda, Kayoko Yamauchi, Hiroki Ebihara, kiichi Hagiwara, Takashi Kikuchi, Shoichiro Komiyama, Mariko Saito, Natsuko Suzuki, Masahito Taira, Sayoko Tamura, Rira Chiwaki, Noriko Hata, Shotaro Hokari, Sachiko Horikiri, Sachi Miyachi, Tomoko Yanagisawa, Mieko Yamagishi, Mizu Yamamoto

■Source: *The Archaeology of "Phase-Mother Earth"* (1996, Otani Memorial Art Museum, Nishinomiya City) Matter and Perception 1970: mono-ha and the search for fundamentals (1995, Yomiuri Shimbun, Inc.) In cooperation with Nobuo Sekine, Osamu Murai, Kiyoshi Fujikawa(Academic Affairs Division), Ken Yamashita, Minoru Sawasato, Michihiro Ueda(Finance Division), Tokyo Gallery, Shigeo Handa, Yutaka Mikami

SUMI SEMI PROJECT 2
ハイレッドセンター「ドロッピング・イベント」2004 前期
High Red Center's *Dropping Event*, 2004, 1st semester

2004年6月19日（土）和光大学J棟屋上

■「ハイレッドセンターの軌跡を追う」。1964年、御茶ノ水にある池坊会館の屋上でのイベントから40年。陽光照りつけるなか、静かにとり行われた。

■落とされたもの：トイレットペーパー、目玉焼き、新聞紙、納豆、雑誌切り抜き、大判印刷物、ビニール、傘、紙テープ、ベッドカバー、スニーカー、黒板消し、 vbウィッグ、つなぎ、アボカド、にんにく、豆腐、画集、箱

■畔上咲子、大貫博文、川村 蘭、込山正一郎、斉藤麻里子、鈴木奈津子、鈴木奈穂子、平 雅仁、田村早蓉子、地脇りら、帆苅祥太郎

Saturday, June 19, 2004, Rooftop of Building J, Wako University

■*"Tracking High Red Center's Trajectory."* It has been 40 years since the 1964 rooftop event at the Ikenobo Kaikan in Ochanomizu. It was held quietly in the blazing sunlight.

■Items dropped: Toilet paper, fried egg, newspaper, natto, magazine clippings, large format prints, vinyl umbrella, paper tape, bedspread, sneaker, blackboard eraser, wig, jumpsuit, avocado, garlic, tofu, art bookcase.

■Sakiko Azegami, Hirofumi Onuki, Ran Kawamura, Shoichiro Komiyama, Mariko Saito, Natsuko Suzuki, Naoko Suzuki, Masahito Taira, Sayoko Tamura, Rira Chiwaki, Shotaro Hokari

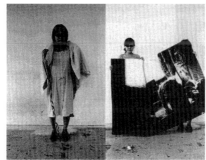

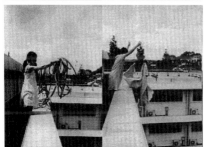

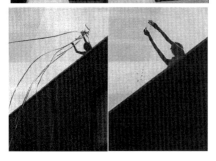

鷲見和紀郎「ツインタワー・プラン」2004 後期
Wakiro Sumi *Twin Tower Plan*, 2004, 2nd semester

2004年11月6日（土）～12月11日（土）

■鷲見和紀郎が1972年初個展でつくった作品を下敷きに、同サイズの楔形2個を型にパラフィンを流し込んでつくり、TWINをキーワードにアトリエの空間を使ってインスタレーションする。寺院や宗教建築では、中心を意識させるために相似形をした対の灯篭や狛犬など数多く見られるが、同型・同サイズの物2個で成立する作品は、アンジュ・レッチア、ジェフ・クーンズのインスタレーヨンやジャスパー・ジョーンズのビール缶などがあるものの現代美術での例は少ない。いずれにしてもTWINという設定は逃れようのない絶対性を生み、ミニマルアート、ポップアートの持つ複数性（匿名性）を許さない。今回の学生のインスタレーションでは、相似形をいかにずらすかに重きが置かれていた。たしかに2つの相似形の存在により見えない中心が生まれるが、それをどのように周りの空間（3つ目の要素）と関係させるかが重要なポイントになる。

■ツインタワー

素材：パラフィン135°　約35kg

サイズ：（180×35×20cm）×2点

型枠：12mm塗装ベニヤ

機材：プロパンガス、コンロ2台、大鍋2個ほか

※1972年のオリジナルよりひとまわり小さなサイズ。またオリジナルではパラフィンにアルミ粉が混ぜられていた。

■2004年12月11日（土）

イベント「インスタレーションと集団演奏」

図と写真

■畔上咲子、斉藤麻里子、鈴木奈穂子、田村早蓉子、 込山正一郎、田中耕作、帆苅祥太郎ほか

November 6 (Sat) - December 11 (Sat), 2004

■Based on a work created by Wakiro Sumi's first solo exhibition in 1972, an installation of two wedge-shaped objects of the same size will be re-created by pouring paraffin into a mold, using the keyword "TWIN" to describe his studio space. In temples and religious architecture, there are many similarly shaped paired objects such as tōrō (lanterns) and komainu (guardian dogs) to emphasize a sense of centrality. There are few examples of contemporary art pieces consisting of paired objects of the same shape and size, such as Ange Leccia, Jeff Koons' installations, and Jasper Johns' beer cans. TWIN, in any case, creates an inevitable absolutism and will not allow the plurality (anonymity) of Minimal Art and Pop Art. In this student's installation, emphasis was placed on how to displace similar forms. While the existence of the two similarities does yield an invisible center, the critical point is determining how to relate this center to the surrounding space (the third element).

■Twin tower

Material: paraffin 135° approx. 35 kg

Size: (180 x 35 x 20 cm) x 2 pieces

Mold: 12mm painted veneer

Equipment: propane gas, 2 stoves, 2 large pans, etc.

*This is a smaller size than the original version made in 1972. In the original, paraffin was mixed with aluminum powder.

■Saturday, December 11, 2004 Event *Installation and Group Performance* Drawings and Photographs

■Sakiko Azegami, Mariko Saito, Nahoko Suzuki, Sayoko Tamura, Shoichiro Komiyama, Shotaro Hokari and others

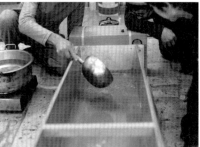
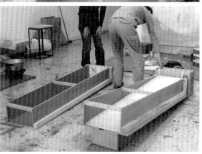

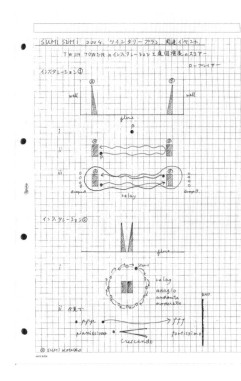
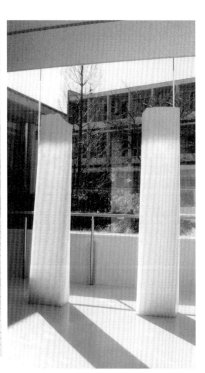

SUMI SEMI PROJECT 4
榎倉康二「壁」Wall to fall 2005
Kōji Enokura *Wall*, Wall to fall 2005

■榎倉康二の壁シリーズは、1971年第10回現代日本美術展の「質」、第7回パリ青年ビエンナーレの「壁」に始まり、モルタル塗りからコンクリートの型枠流し込みへ、壁の自立と他立、野外と室内など環境との関係を変化させながら1995年まで断続的に制作された。今回のゼミでは榎倉の壁の基本的なアイデアは共有しつつ、2005年に和光大学B-303アトリエの空間に新しい「壁」をつくるためにできることを模索し制作された。人の視点より少し高いセメント塗りの壁が部屋のコーナーから立ち現れて、鉢植えのフェニックスの幹にたどり着いて止まる。壁は面によって見え方が違うようだ。
■制作スタッフ：浅田幸栄、大野皓介、小川玲子、込山正一郎、平 雅仁、告野展子、帆苅祥太郎、宮地 幸、吉竹昌子、米山真理子
■資料：榎倉康二展（東京都現代美術館）回顧展カタログ　Space23℃での壁シリーズの資料展

■Koji Enokura's wall series began with *Quality* exhibited at the *10th Japanese Contemporary Art Exhibition* in 1971 and *Wall* at the *7th Biennale des Youth* in Paris. The series continued intermittently until 1995, changing its relationship with the environment, from mortar application to poured concrete molds, from freestanding to attached walls. In this seminar, while sharing the basic idea of Enokura's wall, the students explored the possibilities of creating a new "wall" in the space of the B-303 Atelier at Wako University in 2005. A cement-coated wall, slightly higher than a person's eye level, appears from the corner of the room and ends at the trunk of a potted pygmy date palm. The wall is perceived in different ways depending on its surface.
■Production Staff: Yukie Asada, Kosuke Ohno, Reiko Ogawa, Shoichiro Komiyama, Masahito Taira, Noriko Tsugeno, Shotaro Hokari, Sachi Miyachi, Masako Yoshitake, Mariko Yoneyama
■Reference: Koji Enokura exhibition (Museum of Contemporary Art Tokyo) retrospective exhibition catalog, Wall series archive exhibition at Space23℃.

SUMI SEMI PROJECT 5
山中信夫「ピンホール・ルーム 2006」2006
Nobuo Yamanaka *Pinhole Room 2006*, 2006

2006年4月〜12月15日（金）
撮影：11月10日（金）、11月17日（金）
■山中信夫の「ピンホール・ルーム revolution 1」（1973）に着目、「川に川を撮影したフィルムを投影する」の考察で大学近くの鶴見川の流れを見ることから始め、写真家の渡辺修氏を招きカメラ・オブスキュラを学び、各自ピンホールカメラを制作し撮影した。フィルム現像からプリントまで、ひと通りの手順の体験は学生にとっては驚きと失望の連続だった。更に山中の「ピンホール・ルーム」の実現は困難なもので、彼が使用したリスフィルムの密着焼きのデータがなく、富士フィルム技術部の深野雅彦氏の協力を得て製品を特定しその後何度も失敗を繰り返し、なんとか現像できたのは2ケ月もたってからだった。真っ暗闇のなかでフィルムを扱う単純作業もさることながら、想像を超えていたのはピンホールから差し込む光によって壁に写り込む転倒した外の風景で、それは30年以上も前に真っ暗にした自室のなかでひとり佇んでピンホールの画像を見たであろう山中へとつながるタイムトンネルのような、宙づりにされた時間だった。
■展示：「ピンホール・ルーム 2006」
日程：2006年12月10日（日）〜15日（金）
会場：和光大学Ｂ棟303アトリエ
■展示リスト：《ピンホール・ルーム 2006.11/10》、《ピンホール・ルーム 2006.11/17》、山中信夫〈あるひとつの点 No.3〉1981-1982、山中信夫《マチュピチュ No.26》1980、《学生によるピンホールカメラ》2006、《学生に撮影プリントボード》2006、《カメラオブスクラ体験ルーム》2006、《ピンホール・ルーム撮影データ》2006
■制作スタッフ：秋葉恵美、阿部章裕、石河則子、太田藍生、岸 沙織、長野郁絵、服部健治、帆苅祥太郎、三原智幸、森岡知子、山岡千畝、山本 健、結城七生、雷 和平
協力：高見澤文雄、深野雅彦（富士フィルムグラフィックス株式会社）、渡辺 修、半田滋男、松枝 到、三上 豊

April 2006 - December 15, 2006 (Friday)
Photographed: November 10 and 17, 2006 (Friday)
■Focusing on Nobuo Yamanaka's *Pinhole Room Revolution 1* (1973), the students studied "Projecting a film of a river onto a river" by observing the flow of the Tsurumi River near the university. Photographer Osamu Watanabe was invited to instruct on camera obscura. Each student made a pinhole camera and took pictures and was surprised and/or disappointed by the whole process, from film development to printing. Yamanaka's "pinhole room" was challenging to achieve, as there were no references of print data for the lith film he used. With the help of Masahiko Fukano from the Fuji Film Technical Department, he identified the product and, after repeated failures, developed the film after two months. The simple task of handling the film in total darkness was one thing, but what was beyond our imagination was the overturned scenery on the wall by the light streaming through the pinhole. It was like a time tunnel leading into the mountains where we would have seen the pinhole image more than 30 years ago with Yamanaka standing alone in the pitch-darkness of his room—a time suspended in space.
■Exhibition: *Pinhole Room 2006*
Dates: December 10 (Sun) - 15 (Fri), 2006
Venue: 303 Atelier, Building B, Wako University
■Exhibition List: *Pinhole Room 2006.11/10*, *Pinhole Room 2006.11/17*, Nobuo Yamanaka *Mono Point No.3* 1981-1982, Nobuo Yamanaka *Machu Picchu No.26* 1980, *Pinhole Camera by Students* 2006, *Print Board of Photography by Students* 2006, *Camera Obscura Experience Room* 2006, *Pinhole Room Photography Data* 2006
■Production Staff: Emi Akiba, Akihiro Abe, Noriko Ishiko, Aoi Ota, Saori Kishi, Ikue Nagano, Kenji Hattori, Shotaro Hokari, Tomoyuki Mihara, Tomoko Morioka, Chiune Yamaoka, Ken Yamamoto, Nanao Yuuki, Wahei Rai
Support: Fumio Takamizawa, Masahiko Fukano (FUJIFILM Graphics Co., Ltd.) Osamu Watanabe, Shigeo Handa, Itaru Matsueda, Yutaka Mikami

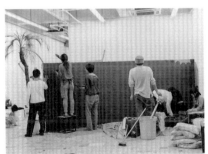

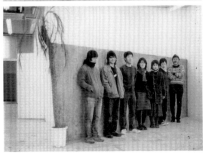

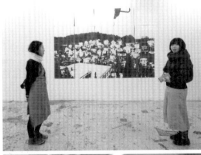

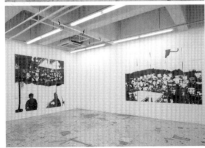

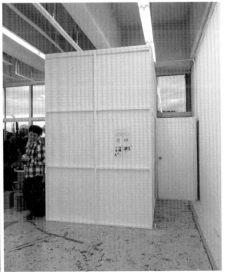

SUMI SEMI PROJECT 6
Giuseppe Penone「木」ペノーネの方へ 2007
Giuseppe Penone *Wood*, Toward G. Penone 2007

■アルテ・ポーヴェラの作家のなかでも、ペノーネに着目したのは、鷲見が実際に会ったことのある作家でもあったから。前期には「私の木」を選んで日常的に対話・観察を行い、6月29日（金）に木と身体を関係させるパフォーマンスを行い、7月6日（金）には豊田市美術館に行き青木正弘館長のご好意により収蔵庫で実作を見学した。研究を進めるうちに、ペノーネがまったく独自の自然観を持っており、アルテ・ポーヴェラやもの派が持つ物質観とは異なる、内省的な自然観や身体感覚がその作品を特徴づけていることが見えてきた。ペノーネの木の作品には、大きく「木材の中心部の選ばれた年輪を枝とともに丸ごと彫り出したもの」と「木材の半分（ある部分を）残して、選ばれた年輪を半分（その他の部分）だけを彫り出したもの」の2つにわけられる。ゼミではこの2つのバージョンにトライしているが、スケールダウンと仕上がりの稚拙さは否めない。
■展示：「ペノーネの方へ 2007」TOWARD G. PENONE
日程：2007年12月1日（土）〜9日（日）
会場：和光大学B棟303アトリエ
展示リスト：《3mの木＝1》2007, 14×14×304cm, 杉、《3mの木＝2》2007, 14×14×304cm, 杉、《3mの木＝3》2007, 18×40×304cm, 掘り出された杉の木屑、《ペノーネの鉛筆》2007, 11×40×127cm, 木、芯を削り出した鉛筆
■制作スタッフ：阿部章裕、石川泰堂、岸 沙織、小島直子、佐藤一仁、白石諒男、鈴木拓也、三原智幸宮崎桜子
協力：青木正弘（豊田市美術館）、河本雅史（造形作家、文化財修復家）、柏木木材、詫摩昭人、半田滋男、三上 豊

■We chose Penone from among the Arte Povera artists since Sumi knew the artist. In the first semester, we selected "*my tree*" for our day-to-day discussions and observations and organized a tree-body relational performance on Friday, June 29. We went to the Toyota Municipal Museum of Art on Friday, July 6, with the goodwill of Director Masahiro Aoki, to examine Penone's actual work in the storage room. During our research, it became clear that Penone held an entirely original perception of nature. His works are characterized by an introspective view of nature and a bodily sensibility that differs from the materialistic view of Arte Povera and the Mono-ha school. Penone's wooden works can be roughly divided into two types: those in which the selected tree rings in the center of the wood are carved out in their entirety along with the branches, and those in which only half (or a portion) of the tree rings are carved out, leaving the other half (or other parts) untouched. Both versions were made in the seminar, but the reduced scale and poor workmanship cannot be denied.
■Exhibition: *Toward Penone 2007*
Dates: Saturday, December 1 - Sunday, December 9, 2007
Venue: 303 Atelier, Building B, Wako University
Exhibition List: *Wood of 3m=1*, 2007, 14×14×304cm, cedar / *Wood of 3m=2*, 2007, 14×14×304cm, cedar / *Wood of 3m=3*, 2007, 18×40×304cm, dug out cedar chips / *Penone's Pencil*, 2007, 11×40×127cm, wood, pencil with sharpened lead
■Production Staff: Akihiro Abe, Taidou Ishikawa, Saori Kishi, Naoko Kojima, Kazuhito Sato, Akio Shiraishi, Takuya Suzuki, Tomoyuki Mihara, Sakurako Miyazaki
Support: Masahiro Aoki(Toyota Municipal Museum of Art), Masafumi Kawamoto (sculptor, conservator of cultural properties), Kashiwagi Mokuzai, Akihito Takuma, Shigeo Handa, Yutaka Mikami

Instant BRANCUSI 2008
at BankART Studio NYK
「インスタント・ブランクーシ 〜君にもできる無限柱〜」
Instant Brancusi – *Infinity Pillars that even you could build*

■ルーマニアが生んだ近代彫刻の巨匠、コンスタンティン・ブランクーシの「無限柱」を模して、共同制作で紙コップやプラスチック、ステンレスボウルなどの身近な素材を繰り返してつなぎポップアート化するというSUMI SEMI以外でのイベント。
「和光大学卒業制作展2008 - PORT OF CALL」関連イベント
日程：2008年2月20日（水）12:00-16:00
会場：BankART Studio NYK

■An external SUMI SEMI event in which, analogous to Romanian-born master of modern sculpture Constantin Brancusi's *Infinity Pillar*, the collaborative work repeatedly connects familiar materials such as paper cups, plastic, and stainless steel bowls and turns them into pop art.
Related Event *Wako University Graduate Thesis Exhibition 2008 - PORT OF CALL*
Date: Wednesday, February 20, 2008 12:00-16:00
Venue: BankART Studio NYK

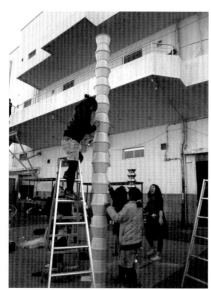

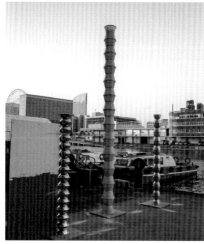

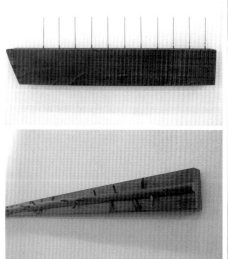

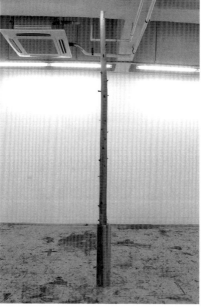

三木富雄「EAR—2008」記憶の耳 2008
Tomio Miki *EAR-2008*, Memories of an Ear 2008

■1967年の美術手帖に自身がつくった耳と添い寝をする三木の写真が載っている。心なしか微笑んで横たわる裸足の三木は幸せそうだ。この自らつくった作品に添い寝するという感覚を体験してほしいというのが今回のプロジェクトの1番の目的。6月6日（金）に東京国立近代美術館で《EAR—1965》をみる。兒嶋画廊で「三十年目の三木富雄」展を観る。実習では、自分の耳の型取りやそれぞれの耳も制作する。2メートル以上の耳を粘土でつくるということは、押したり削ったり撫でたりして身体全体を使い床の上でいわばダンスを踊ることであり、両手で抱きしめることによって生まれるくぼみや膨らみは人体のレプリカをつくることでもあるだろう。まさしく耳に添い寝をする三木のように…。

■展示：「記憶の耳」三木富雄没後30年
日程：2008年12月6日（土）～12日（金）
会場：和光大学B棟303アトリエ
トークイベント：「60年代と三木富雄を語る」ゲスト：田中信太郎

■展示リスト：《EAR—2008》2008, h240×w180×d60cm, プラスター、《EAR—1972》1972, h40×w28×d9.5cm, アルミニウム、《学生たちがつくったそれぞれの耳》

■制作スタッフ：相原亜沙子、秋葉真理、阿部ゆかり、大野皓介、岡本羽衣、桂田あゆみ、菊池尚子、北野由望、小島直子、小山幸子、白石諒男、野呂あかね、三原智幸

■協力：三木敦雄、蔵屋美香、瀬尾典明、兒嶋俊郎（兒嶋画廊）、田中信太郎、篠原有司男、菊池賢、上野良隆、半田滋男、三上豊、高岡悠氣、太田藍生、和光大学彫刻ゼミ

■A 1967 issue of *Bijutsu Techo* shows a photo of Miki snuggled up to the ear he created. The slightly grinning, barefooted Miki looks so happy. This project's purpose is to have the students experience this sensation of snuggling up to a work of art created by themselves. On June 6 (Fri.), we will visit the National Museum of Modern Art, Tokyo, to see *EAR-1965*. From there, we will go to the KOJIMA GALLERY to see the exhibition *Tomio Miki in his 30th year*. In the actual workshop, the students will mold their own ears and also make each other's ears. To sculpt an ear of more than two meters in length out of clay is to push, scrape, and fondle it, using the entire body as a dance on the floor, and the hollows and swellings born from the embrace of both hands may also be the process of replicating the human body. Just like Miki cuddling his ear...

■Exhibition: *Memories of an Ear - 30 years after Tomio Miki's death*
Date: Saturday, December 6 - Friday, December 12, 2008
Venue: 303 Atelier, Building B, Wako University
Talk Event: *A Talk about the Sixties and Tomio Miki* Guest: Shintaro Tanaka
Exhibition List: *EAR-2008*, 2008, h240×w180×d60cm, plaster / *EAR-1972*, 1972, h40×w28×d9.5cm, aluminum / *"Individual ears made by students"*

■Production Staff: Asako Aihara, Mari Akiba, Yukari Abe, Kosuke Ohno, Hagoromo Okamoto, Ayumi Katsurada, Naoko Kikuchi, Yumi Kitano, Naoko Kojima, Sachiko Koyama, Akio Shiraishi, Akane Noro, Tomoyuki Mihara

■Support: Atsuo Miki, Mika Kuraya, Noriaki Seo, Toshio Kojima (Gallery Kojima), Shintaro Tanaka, Ushio Shinohara, Takeshi Kikuchi, Yoshitaka Ueno, Shigeo Handa, Yutaka Mikami, Yuuki Takaoka, Aoi Ota, Wako University Sculpture Seminar

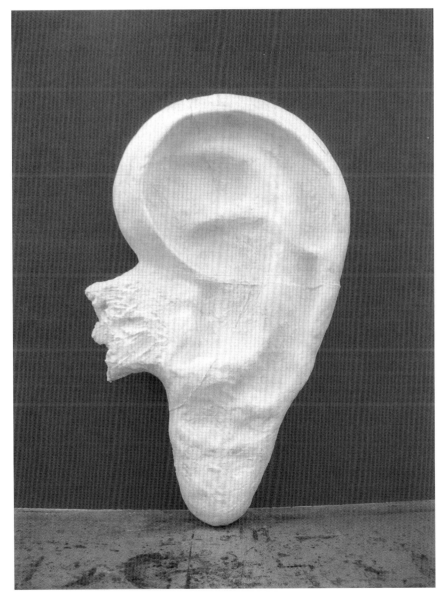

鷲見和紀郎

1950　岐阜県岐阜市に生まれる
1968　岐阜県立加納高校美術科卒業
1971　名古屋芸術大学彫刻科中途退学
1972　横浜・富士見町アトリエBゼミ修了
1976　ニューヨーク（米）に滞在
86~87　フランス文化省の招聘でエクス・アン・プロバンスに滞在。マルセーユ、トロワで制作、展示
99~00　文化庁特別派遣芸術家在外研究員としてリヨン（仏）に滞在
2018　インゼル・ホンブロイヒ美術館（独）にてアーティスト イン レジデンスで滞在、制作、展示
──── 現在、千葉県東金市に在住

[個展]

1972　ギン画廊（東京）
1973　「STAY」田村画廊（東京）
1974　ときわ画廊（東京）
1977　村松画廊（東京）
1979　現代芸術研究室（東京）
1981　「WALLS & BRIDGES」銀座絵画館（東京）
1982　「ZONE」ギャラリー手（東京）/「WALLS & BRIDGES II」ギャラリー・ホワイトアート（東京）
1983　「彫刻とドローイング1978-83」画廊匠屋（岐阜）
1984　「STOLICHNAYA」村松画廊・ギャラリー手（東京）/「彫刻とドローイング」ギャラリーK&M（岐阜）
1985　「Partita」エスエズギャラリー［現島田画廊］（東京）
1986　秋山画廊（東京）
1987　コンセプトスペース（群馬）
1988　秋山画廊（東京）
1989　「CRESCENT」エスエズギャラリー（東京）
1991　「ワックスドローイング・スカルプチュア」ギャラリー砂翁・トモス（東京）
　　　「Wax Works」秋山画廊（東京）「GRAVITY」島田画廊（東京）
1993　島田画廊（東京）
1994　「THE VAIL」ギャルリー・ところ（東京）
1995　「Wax Works」秋山画廊（東京）
1997　〈さまざまな眼〉'86 鷲見和紀郎展 アラベスク」かわさきIBM市民文化ギャラリー（神奈川）
1999　「フズリナ」島田画廊（東京）
2001　「フズリナ2」島田画廊（東京）
2002　「ダンス」タグチファインアート（東京）
2003　「ORDET」島田画廊（東京）/「素描」タグチ・ファインアート（東京）
2004　「鷲見和紀郎 - 重力の為のパヴァーヌ」府中市美術館市民ギャラリー /「Painting Sculpture」公開制作室（東京）
2006　「ナルキッソス」タグチ・ファインアート（東京）
2007　「今日の作家XI 鷲見和紀郎 / 光の回廊」神奈川県立近代美術館・鎌倉
2008　「yukel」島田画廊（東京）
2009　「波打ち際」ギャラリー・メスタージャ（東京）
2010　「SUMI WAKIRO 谺 -kodama-」アートハウス あそうばらの谷（千葉）
2013　「叫びと囁き / calls & whispers」ギャラリー21yo-j（東京）/ ギャラリー古今（東京）
　　　「鷲見和紀郎・常設展示」島田画廊
2015　「平面」ツァイト・フォト・サロン（東京）
2016　「LE CALME 一凪一」ギャラリー・メスタージャ（東京）
2018　「SUMI WAKIRO Practice for Work & Space」インゼル ホンブロイヒ財団レジデンス（ドイツ）
2019　「メテオール-1. 考える月」ギャラリー21yo-j（東京）

[グループ展]

1970　「パラレル展」河原町ギャラリー（京都）
1971　「京都アンデパンダン展」京都市立美術館
1972　「Bゼミ展」横浜市民ギャラリー（同1973, '74, '75年）
1975　「○△□展」須賀昭初 中上清 中村功らと　神奈川県立県民ギャラリー（横浜）
1976　「第12回今日の作家展：今日の空間」横浜市民ギャラリー
1978　「第12回日本国際美術展」東京都美術館
1979　「スペース '79」横浜市民ギャラリー
　　　「現代美術 '79」辰野登恵子 中村功 山田正亮と 現代芸術研究室（東京）
1982　「アートシンポジウム茨城」茨城県民文化センター（水戸）
1985　「'85岐阜現況展─戦後生まれの作家たち─立体部門」岐阜県美術館
　　　「間 - 眞板雅文・古渡章・鷲見和紀郎」秋山画廊（東京）
　　　「秋山画廊 '85」秋山画廊（東京）
　　　「オムニバス '85」エスエズギャラリー（現島田画廊）（東京）
1986　「'86岐阜現況展─戦後生まれの作家たち─平面部門」岐阜県美術館
　　　「7人の作家による小品展」秋山画廊（東京）
1987　「JAPON ART VIVANT 日本の過去と現在」Centre de la Vieille Charité（マルセーユ・フランス）
　　　「JAPON ART VIVANT - 矢野・池ヶ谷・鷲見 - 」Galerie Passage.（トロワ・フランス）
　　　「共相展」彩林画廊（横浜）
　　　「JEUNE SCULPTURE」Port d'Austerlitz .（パリ・フランス）
1988　「MONO SEXUAL Exhibition」ギャラリー・ホワイトアート（東京）
　　　「LIVE」辻耕治、桑山忠明、楠本正明、椎原保らと　佐賀町エキジビットスペース（東京）
　　　「7人の作家による小品展」秋山画廊（東京）
1989　「ART CONTEMPORAIN JAPONAIS」Espace Nouvelle.（カルカソンヌ・フランス）
　　　「暮らしのなかの現代美術展」ギャラリー・ホワイトアート（東京）
1990　「FACADES IMAGINAIRES」Saint-Louis Church.（グルノーブル・フランス）
1992　「HARUKI Collection:SELECTED WORKS FROM HC」SOKO東京画廊（東京）
~93　「現代美術への視点・形象のはざまに」国立近代美術館（東京），国立国際美術館（大阪）
1994　「サントリー美術館大賞展 '94：挑むかたち」サントリー美術館（東京）
~95　「光と影・うつろいの詩学」広島市現代美術館（広島）
1995　「視ることのアレゴリー=1995：絵画・彫刻の現在 =」セゾン美術館（東京）
　　　「ブロンズ」伊藤誠、西雅秋と　島田画廊（東京）
1996　「ARCOS DA LAPA PROJECT」（リオ・デ・ジャネイロ・ブラジル）
1998　「PACAEMBU PROJECT」（サンパウロ・ブラジル）
1999　「蠱惑の赤」伊藤誠、草間弥生、近藤克、李禹煥と　島田画廊（東京）
　　　「第18回現代日本彫刻展：爽（湖とモニュマン）」宇部市野外彫刻美術館（山口）
2000　「PREVIEW・ART TODAY 2000」伊藤誠、川島清と　S.A.Pギャラリー（東京）
　　　「ART TODAY 2000 ─3つの回顧から」セゾン現代美術館（軽井沢）
　　　「LES SEMIOPHORES 2000」Town Hall （リヨン・フランス）
2001　「ホワイトアート2001」トキ・アートスペース（東京）
　　　「椿会展2001」資生堂ギャラリー（東京）
2002　「新収蔵作品展」佐久市立近代美術館（長野）

2002	「椿会展2002」資生堂ギャラリー（東京）
2002	「かたちの所以」土屋公雄.藤堂良浩.中村哲也.丸山富之と 佐倉市立美術館（千葉）
2003	「第5次椿会作品展」資生堂アートハウス（静岡）
	「椿会展2003」資生堂ギャラリー（東京）
	「11人の彫刻」盛岡クリスタル画廊（岩手）
2004	「椿会展2004」資生堂ギャラリー（東京）
	「Répliques / Luminis」Downtown University Tunnel.（アルジェ・アルジェリア）
2005	「椿会展2005」資生堂ギャラリー（東京）
2006	「表現から表現へII田中信太郎＋鷲見和紀郎」ヨコハマ・ポートサイドギャラリー（神奈川）
2007	「宇宙御絵図」豊田市美術館（愛知）
2009	「自然哲学としての芸術原理」東京アートミュージアム（仙川）
2013	「光のある場所・コレクションに見る 近現代美術の現実感」神奈川県立近代美術館 鎌倉
2014	「時代・開館30周年記念所蔵名品展」佐久市立近代美術館
2015	「鎌倉からはじまった。PART-1. 近代美術館のこれから」神奈川県立近代美術館 鎌倉
	「デッサン展」ツアイト・フォト・サロン（東京）
	「現代の美術作家10人展」岐阜現代美術館
	「GIFU・DNA」岐阜県美術館
2017	「彫刻を作る / 語る / 見る / 聞く」東京国立近代美術館ギャラリー4
2020	「ミュージアムとの創造的対話03 何が価値を創造するのか?」鳥取県立博物館
~21	「メイド・イン・フチュウ 公開制作の20年」府中市美術館（東京）
2021	「空間の中のフォルム」神奈川県立近代美術館 葉山

[パブリックコレクション]

東京国立近代美術館	Work M-5 The Opposite Bank 作品 M-5 対岸 1986
	dance-4 2001
	dance-7 2002
資生堂アートハウス	VEIL-ENDLESS 終わりなきヴェール 1999
	endless waltz エンドレスワルツ 2003
佐久市立近代美術館	VEIL-III (Dedicated to Thelonious Monk) ヴェールIII 1994
府中市美術館	Pavane for Gravity 重力の為のパヴァーヌ 1992
豊田市美術館	Work M-6 CANAL 作品 M-6 運河 1986
	Thermal Echo 熱の谺 1987
神奈川県立近代美術館	Crescent クレッセント 1991~2002
	FAR CRY ファー クライ 1995
	EVIDENCE 2006
愛知県美術館	drawing 2003
岐阜市	Cascade 1995

[コミッションワーク]

・ホテルオーレイン静岡（静岡市）エントランスレリーフ「CRESCENT」2019
・ザ・クレセントアームズ三番町（千代田区）エントランス彫刻「CRESCENT」絵画「12Cantos」2018
・豊商事社員寮（埼玉県北越谷）エントランス壁面彫刻「栄冠」2007
・名和長年公記念碑（京都市）2007
・資生堂アートハウス（静岡県掛川市）彫刻「エンドレスワルツ」2003
・長良橋通り（岐阜市）モニュメント「CASCADE」1995
・ユピテルビル（文京区本郷）エントランス彫刻「舞い降りる新月」「クレッセント」1990
・スカッシュハウス（長野県北佐久郡）壁面彫刻「CRESCENT」1990
・豊商事本社（中央区日本橋蛎殻町）エントランス壁面彫刻「飛翔」「永遠」1987
・青山学院大学聖書記念碑（渋谷区）1986
・ペリー来航記念碑レリーフ（神奈川県浦賀）1986

[ドア把手彫刻]
葡萄舎（神田）1986、石光邸（金沢文庫）1990、白川邸（千葉）1991

[執筆文献・コメント]

1982	個展コメント / 美術手帳 5月号 p.144（美術出版社）
1983	現代美術の新世代とニュースタイル / 美術手帳 3月号 p.65
1984	グレートアメリカンスカラプターD.スミス / 美術手帳 2月号 p.126~134
1985	個展コメント / パンフレット（エスェズギャラリー）
	展覧会コメント / 岐阜現況展 - 立体部門 - カタログ p.30（岐阜県美術館）
1986	現代彫刻の発言 / 美術手帳 6月号 p.25
	展覧会コメント / 岐阜現況展 - 平面部門 - カタログ p.22
	作品集コメント / WAKIRO SUMI WORKS 1981-1986（アルゴコーポレーション）
1988	最前線の技法—ブロンズ / アトリエ 2月号 p.58, 63（アトリエ出版社）
1989	作品コメント「舞い降りる新月」/ 日経 Image Climate Forecast 890417 0（日経新聞社）
	制作コメント（談）/ ぴあ 1月20日号 p.241（ぴあ株式会社）
1991	CONTEMPORARY ARTISTS WAKIRO SUMI / C.A.R No.1 p.8-11（スカイドア）
	コメント / SOMETHING ELSE ハルキコレクション（ハルキ）
1992	作品コメント / 現代の眼 10月号 p.3~4（東京国立近代美術館）
1994	スミスの飛躍と定着 / 美術手帳 8月号 p.102~109
	対談［脱領域］をめぐって.市川平＋倉林靖＋高島直之＋鷲見 / 武蔵野美術 No.95 p.14~24
	鷲見和紀郎ゼミより / 現代美術演習IV・Bゼミ Schooling System 編 p.58~70（現代企画室）
1995	作品コメント / 挑むかたち カタログ p.17（サントリー美術館）
	TEXTS & DOCUMENTS / 視ることのアレゴリー展カタログ p.18（セゾン美術館）
1997	コメント /B-Semi HAND BOOK1967-1997 p.27（Bゼミ30周年記念事業実行委員会）
1998	デラシネの帰還・故吉松哲夫初の個展 / 毎日新聞 4月9日夕刊 8面文化 批評と表現
	アート・オルタナティブ / あいだ 35号 p.14~16（美術と美術館のあいだを考える会）
1999	作品コメント / 第18回現代日本彫刻展パンフレット（宇部市野外彫刻美術館）
2000	サルディーニアへの旅 / 読売新聞 3月18日夕刊 9面土曜文化
	作品コメント / ART BOX IN JAPAN vol-1. 現代日本の絵画 p.110-111（ART BOX）
	インタビューの回顧から / PREVIEW ART TODAY 2000パンフレット（SAPギャラリー）
	鷲見和紀郎は語る / ART TODAY 2000カタログ p.13~16（セゾン現代美術館）
	コメント・決定メセナ大賞新トロフィー / メセナ note.08（社団法人企業メセナ協議会）
	インタビュー / かたちの所以展カタログ p.14~25（佐倉市美術館）
2004	「位相―大地」再制作2003始末記 / 国立国際美術館月報 138号
	ブリリアント・コーナーズ / 府中市美術館公開制作23 パンフレット
2005	コメント・ある日 / 椿会展 2005 カタログ（資生堂ギャラリー）
2007	回廊にて / 今日の作家XI 鷲見和紀郎 光の回廊 カタログ

p.14~15（神奈川県立近代美術館）

2006年のアーティストトークから / 現代の眼 562 p.11-12（東京国立近代美術館）

2008 耳を作る男 / たいせつな風景 9号 p.8-9（神奈川県立近代美術館）

追悼文 /HIROKO OKAMOTO Graveur 1957~2007 p.39（岡本裕子 遺作展実行委員会）

2009 作品コメント <carved work> / taguchi fine art個展、リーフレット

2013 無音・或いは写真だけの為に撮られた写真 / 外久保恵子個展パンフレット（Beansseoul Gallery）

2015 田中信太郎インタビュー / 聞き手：林道郎、松浦寿夫と / ART TRACE PRESS 第3号（ART TRACE）

コメント / たいせつな風景 22号、特集：かまくら p.10（神奈川県立近代美術館）

コメント / GIFU・DNA / 玉井正爾と愉快な教え子たち（GIFU・DNA実行委員会）

［関係文献］

1973 「アートクロニクル」/ みづえ7月号 p.96

1982 「展評」/ 美術手帳 5月号 p.140

「展覧会評―金属板の隅々に手の痕跡」

1983 「ART & ARTIST in the 80's」/ 流行通信 3月号 p.102

1984 「展覧会・鷲見和紀郎展」/ 毎日新聞 5月17日夕刊

「展覧会から・鷲見和紀郎、未公認の輝きをもった形へ」/ 美術手帳 7月号 p.78-83

「表紙写真・作品解説」北沢憲昭 / Beruf 6月7日号 p.240

「展覧会評・ブロンズの都市」北沢憲昭 / アトリエ 8月号 p.93~94

「展覧会評・表の本性を裏が明かす」田中幸人 / アトリエ 8月号 p.91~93

1985 「展評」武井邦彦 / 三彩 3月号 p.154

「強烈！アートの凄み・鷲見和紀郎のブロンズ」田中幸人 / 毎日新聞 4月9日夕刊

「感性の祖形―7. 気配に感応する能力」田中幸人 / いけ花龍生 7月号 p.38~39

「展評・ホビーとアート・鷲見和紀郎のブロンズ」田中幸人 / アトリエ 6月号 p.90

1986 「作品集 WAKIRO SUMI WORKS 1981~86 英文テキスト」AKIRA NAKAJIMA

1987 「JAPON ART VIVANT-1」/ フランス文化省 p.16~19

「国越え人間的共感」坂根巌夫 / 朝日新聞 2月25日夕刊

「JAPON ART VIVANT-2」/ フランス文化省 p.42~44

1988 「最前線の技法―ブロンズ」/ アトリエ 2月号 p.63

「変容する表面に挑む」三田晴夫 / 毎日新聞 2月26日夕刊

「ART FORUM-鷲見和紀郎展」高島直之 / モノマガジン 3-16号 p.123

「展評・形態と量のバランス関係」難波英夫 / アトリエ 5月号 p.101

「日仏芸術家交流の軌跡」坂根巌夫 / フランス人作家達の日本展カタログ p.44

「ARTS」JANET KOPLOS / ASAHI EVENING NEWS 7月15日

「1988アートシーンを回顧する」JP ヴァロムブローサ / 月刊ギャラリー 12月号

1989 「表紙写真」/ MUSE Vol .11. JULY サントリーホール

「表紙写真・作品解説」/ JAPAN UPDATE No.13, AUTUMN p.2

1990 「REVIEWS : W.SUMI ESSES GALLERY」JANET KOPLOS / Sculpture, Mar-Apr

「気になる日本のアーティスト」三上豊 / 美術手帳 9月号

p.51~52

「FACADES IMAGINAIRES」/ LABORATOIRE Production

「作品写真―ユピテルビル（白井晟一研究所）」/ 新建築 11月号 p.361

1991 「美術時評6」三上豊 / いけ花龍生 6月号 p.11

「Art Focus :SUMI WAKIRO/Sculptor」Amaury Saint Gilles / 毎日 DAYLY NEWS

「空間の揺らぎざわめき：既成の彫刻枠組みへ挑戦」/ 岐阜新聞 4月19日

「ホルベインカラーコレクション YELLOW-SUMI WAKIRO」/ BT 8月号裏表紙

「展評 TOKYO」藍 龍 / 三彩 12月号 p.121

「美術この1年：四氏が選んだベスト5」本江邦夫 / 読売新聞 12月18日夕刊

「Contemporary Japanese Sculpture」Janet Koplos / Abbeville Press p.145~146

1992 「作品解説」田中淳 / 東京国立近代美術館 形象のはざまに展カタログ p.69~73

「Contemporary Artist in Japan」/ 日本演出 アートプロジェクト p.224~22

「表現手段と空間柔軟にとらえる：形象のはざまに展」/ 読売新聞 9月30日夕刊

「形象のはざまに：展覧会を実見して気づいたこと」島崎吉信 Art & Critique no21 p.14

1993 「最新日本人アーティスト名鑑 」早見堯 / 美術手帳 1月号 p.181

「表紙写真」MUSE Vol.34 MAY サントリーホール

「ASIA UPDATE」Janet KOPLOS / ART in AMERICA July p.66

1994 「現代日本アーティスト名鑑」菅原教夫 / 美術手帳 1月号 p.181

「ヴェールについて」本江邦夫 / ギャルリーところ 個展カタログ

「絵画の性格も持つ彫刻」菅原教夫 / 読売新聞 7月1日夕刊

「表面の意味を視覚化・鷲見和紀郎展」三田晴夫 / 毎日新聞 7月6日夕刊

「実在と非在結ぶヴェール・鷲見和紀郎展」（M）/ 産經新聞 7月6日夕刊

「鷲見和紀郎「関係」と「自立」と」菅原教夫 / 美術手帳 10月号 p.236~239

「Der Schleier-Wakiro Sumi」Marion SETTEKORN / Japan Aktuell Oct-Nov p.34~35

1995 「作家解説」洲浜元子 / 広島市現代美術館 光と影-うつろいの詩学展カタログ

「検証'94現代日本美術の実績」/ 美術手帳 3月号 p.36~37

「戦後50年写真で見る日本の現代美術」/ 美術手帳 5月号

「覚えていない記憶 芸術の核への旅」樋田豊次郎 / いけ花龍生 6月号 p.22~23

「視ることのアレゴリー展カタログ」/ セゾン美術館

「現代美術の位相」赤坂英人・北島敬三 / アサヒグラフ 7月15日号 p.6-7

「日本の現代美術・24作家の（持続する現在）」菅原教夫 / 丸善ブックス p.189~194

1996 「作品写真 CASCADE」/ 岐阜県パブリックアートガイドブック p.44

「ARCOS DA LAPA , Rio de Janeiro Project」/ LABORATOIRE PRODUCTION

1997 「もうひとつのヴェール」松浦寿夫 / かわさきIBM市民文化ギャラリー カタログ1999

1999 「鷲見和紀郎の端麗ホワイト」/ 芸術新潮 5月号 p.99

「創造の現場から-11 鷲見和紀郎ヴェールの向こう側」/ 美術手帳 6月号

「PACAEMBU , Sao Paulo Project」/ LABORATOIRE

PRODUCTION
「三次元性について」二木直巳 / 記憶の中のコレクション
p.16~17

2000　「表紙写真」Coral Cascade 2000」セゾンアートプログラム News Letter №15
「作品写真」ART TODAY 2000」/ SAP JOURNAL №4　p.5,15
「現代日本の絵画 vol.1 / 作品写真・コメント」株式会社 ARTBOX インターナショナル p.110~111
「作品記録写真 / ANZAI 1970-1999」国立国際美術館 p.170

2001　「色彩うごめく雄弁な表面」三田晴夫 / 毎日新聞 4月17日夕刊
「椿会展2001」カタログ / 資生堂ギャラリー
「空洞化した色彩 - 鷲見和紀郎『フズリナ -2』」天野一夫 / てんぴょう009 p.43,60,61
「鷲見和紀郎『FUSULINA Deux』」藤井匡 / ART & CRAFT Forum 22号 p.14~15

2002　「Report from Tokyo. The art weed flourishes」Janet Koplos / Art in America Feb
「強まる立体性 彫刻の原点想起：鷲見和紀郎ダンス展」菅原 / 読売新聞 4月4日夕刊
「椿会展2002」カタログ / 資生堂ギャラリー
「かたちの所以」展カタログ 黒川公二, 高島直之 / 佐倉市立美術館

2003　「鷲見和紀郎の白い踊り子たち（形の所以）展より」/ 芸術新潮 2月号 p.109
「作品に生命力いっぱい資生堂アートハウス2作目野外設置」/ 中日新聞 3月30日
「興味深い展開促す企画・椿会'03小品考」三田晴夫 / 毎日新聞 5月6日夕刊
「椿会'03ギャラリートーク辰野登恵子×鷲見和紀郎」Shiseido Web Magazine
「鷲見和紀郎 彫りのこされた輪郭」芸術新潮 7月号 p.117
「鷲見和紀郎の秋色ダンス」芸術新潮 11月号 p.118

2004　「血は立ったまま眠っている」山村仁志 / 府中市美術館公開制作23 パンフレット

2005　「興味そそる表現の新展開。椿会展2005」三田晴夫 / 毎日新聞 5月9日夕刊 6面
「Older talent flowers in Ginza gallery」EDAN CORKILL / Herald Tribune Apr.22
「鷲見和紀郎 静かなフォルティッシモ 椿会展2005より」/ 芸術新潮 6月号 p.119

2006　「割に合わぬ領域を守る魂、田中・鷲見展」田中三蔵 / 朝日新聞 2月2日夕刊
「対談 ジャコメッティ私だけの愉しみ方」保坂健二朗と / 芸術新潮 7月号 p.64~66
「現代のアート①　/ 作品写真・作家紹介」朝日アーティスト出版 p.105
「a-chroniques-12 非展望性について（その3）」松浦寿夫 / 水声通信 10月号 p.13
「表現から表現へ II / 田中信太郎・鷲見和紀郎展」Yokohama Portside Gallery Exhibitions 04-06

2007　「親不孝な彫刻 - 新作をめぐって」山梨俊夫 / 鷲見和紀郎・光の回廊展カタログ
「展評」今日の作家XI 鷲見和紀郎・畠山直哉 / 中島水緒 / Web complex
「Confusing the categories Wakiro Sumi's works invite quiet contemplation」/ The Japan Times
「作家解説 鷲見和紀郎」安言子 / 宇宙御絵図展カタログ p.103 / 豊田市美術館

2009　「皮膜、あるいは実体の不在」外久保恵子 / ギャラリーメスタージャ個展パンフレット

2010　「SUMI WAKIRO / 谺 - kodama- 」アートハウスあそうばらの谷オープン企画展リーフレット
「古民家と白い芸術とのコラボレーション」シティーライフ vol.1041 11月6日号

2011　「SUMI WAKIRO 谺 –kodama-」アートハウスあそうばらの谷展示作品パンフレット

2012　「表紙作品写真」純粋言語論　瀬尾育生 / 五柳書院

2013　「異素材で「空間」が見えて来る」中村英樹 / 東京新聞 3月15日夕刊
「鷲見和紀郎展 覚醒された彫刻の始原」三田晴夫 / ギャラリー2013 vol.4 - 評論の眼 p.66,67
「鷲見和紀郎 阿吽の直立」/ 芸術新潮 5月号 p.128
「佐久市立近代美術館開館30周年記念所蔵名品展［時代］」佐久市立近代美術館

2014　「神奈川県立近代美術館コレクション選・彫刻」神奈川県立美術館 鎌倉 葉山 p.59
「鷲見和紀郎 鋳造から導かれる表面」現代彫刻の方法　藤井匡著 / 美学出版 p.46-52

2015　「作品写真 / 美術科50周年記念誌」岐阜県立加納高校美術科同窓会

2016　「鎌倉からはじまった / 神奈川県立近代美術館 鎌倉 の65年」建築資料研究社 p.198

2017　「彫刻を作る / 語る / 見る / 聞く」東京国立近代美術館 / コレクションを中心とした小企画展パンフレット

2021　「作品展示写真　古 & 今　I」ギャラリー古今 p.32,33.46
「メイド・イン・フチュウ 公開制作の20年」府中市美術館 / 記録集+展覧会記録集

［映像資料］
「鷲見和紀郎、ワックスワーク制作風景」DVD　Oct.2006.　神奈川県立近代美術館
「第8回アーティスト・トーク」DVD　Nov.2006.　東京国立近代美術館
「SUMI SEMI PROJECT 2003-2007」DVD 2007 和光大学芸術学科
「自然哲学としての芸術原理、展覧会記録」東京アートミュージアム CD-ROM　Dec.2009.　Pnpa展実行委員会
「Le CALME　製作記録」DVD　2016.　ギャラリーメスタージャ

SUMI WAKIRO

1950 Born in Gifu City, Japan
1968 Graduates from Gifu Prefectural Kano High School
(major:art)
1971 Leaves Nagoya University of Arts (Major:sculpture)
1972 Complete B-Semi School (presently B-Semi Schooling
System), Yokohama
1976 Lives and works in New York
86-87 Invited by French Ministry of Culture to work and exhibit
in Marseille and Troyes
99-00 Lives and works in Lyon, Agency for Cultural Affair's
Special Study-Abroad Pro-gram
02-08 Lecturer in Wako University Art Department
2018 Artist in residence at Stiftung Insel Hombroich. Germany
Currently Lives in Togane, Chiba Prefecture

SOLO EXHIBITION

1972 Gin Gallery. Tokyo
1973 Tamura Gallery. "STAY" Tokyo
1974 Tokiwa Gallery. Tokyo
1977 Muramatsu Gallery. Tokyo
1979 Institute of Contemporary Art. Tokyo
1981 Ginza Kaigakan Gallery. "WALLS & BRIDGES" Tokyo
1982 Gallery Te. "ZONE" Gallery White Art. "WALLS &
BRIDGES-2" Tokyo
1983 Gallery Takumiya. "SCULPTURE & DRAWINGS 1978 – 83"
Gifu
1984 Gallery Te, Muramatsu Gallery. "RECENT SCULPTURE &
DRAWINGS"
K&M Gallery. "RECENT WORKS" Gifu
1985 Esses Gallery (presently Shimada Shigeru Gallery).
"PARTITA" Tokyo
1986 Akiyama Gallery. Tokyo
1987 Concept Space. Shibukawa
1988 Akiyama Gallery
1989 Esses Gallery. "CRESCENT"
1991 Akiyama Gallery, Gallery Saoh, Gallery Tomos. "WAX
WORKS" Tokyo
Shimada Shigeru Gallery. "GRAVITY" Tokyo
1993 Shimada Shigeru Gallery
1994 Galerie Tokoro. "THE VEIL" Tokyo
1995 Akiyama Gallery
1997 IBM-Kawasaki City Gallery. "ARABESQUE" Kawasaki
1999 Shimada Shigeru Gallery. "FUSULINA"
2001 Shimada Shigeru Gallery. "FUSULINA DEUX"
2002 Taguchi Fine Art. "dance" Tokyo
2003 Shimada Shigeru Gallery. "ORDET" / Taguchi Fine Art.
"drawings"
2004 Fuchu Art Museum Gallery. "PAVANE for GRAVITY" Tokyo
Fuchu Art Museum Open Studio Room.
"PAINTINGSCULPTURE"
2006 Taguchi Fine Art. "narcissus"
2007 The Museum of Modern Art,Kamakura. Artist Today XI.
"Corridor of Light"
2008 Shimada Shigeru Gallery. "yukel"
2009 Gallery Mestalla. "NAMIUCHIGIWA" / Taguchi Fine Art.
"carved work" Tokyo
2011 Asobara valley Art House ."kodama" Ichihara, Chiba
2013 Gallery 21yo-j. / Gallery Cocon. "Calls & Whispers" Tokyo
2015 ZEIT-FOTO SALON. "surface works" Tokyo
2016 Gallery Mestsalla. "LE CALME" Tokyo
2018 Raketenstation Hombroich "Practice for Work & Space"
Insel Hombroich Neuss Germany
2019 Gallery 21yo-j. "Thinking Moon" Meteore-1

GROUP EXHIBITIONS

1970 PARALLEL. Kawaramachi Gallery, Kyoto
1971 KYOTO INDEPENDENT EXHIBITION. Kyoto Municipal
Museum of Art
1972 EXHIBITION B-SEMI. Yokohama Citizen's Gallery (also in
'73.'74.'75)
1975 ○△□. Kanagawa Prefectural Gallery. Yokohama
1976 ARTIST TODAY '76 : SPACE. Yokohama Citizen's Gallery
1978 12th INTERNATIONAL ART EXHIBITION JAPAN. Tokyo
Metropolitan Art Mu-seum
1979 SPACE '79. Yokohama Citizen's Gallery
CONTEMPORARY ART '79. Institute of Contemporary Art.
Tokyo
1982 ART SYMPOSIUM IBARAKI. Ibaraki Prefectural Culture
Center Gallery. Mito
1985 CURRENT STATE of GIFU '85. Artists Born in Postwar Years.
The Museum of Fine Arts Gifu
HAZAMA. Akiyama Gallery. Tokyo
1986 CURRENT STATE of GIFU '86 : PAINTINGS. The Museum of
Fine Arts Gifu
1987 JAPON ART VIVANT. Centre de la Vieille Charité. Marseille,
France
YANO/IKEGAYA/SUMI. Gallerie Passages-Centre d'Art
Contemporain.Troyes, France
JEUNE SCULPTURE 1987. Port d'Austerlitz. Paris, France
SĀMĀNYALAKANA, Sairin Gallery.Yokohama
1988 LIVE. Sagacho Exhibit Space. Tokyo
1989 ART CONTEMPORAIN JAPONAIS. Espace Noubel.
Carcassonne, France
1990 FAÇADES IMAGINAIRES. Saint-Louis Church. Grenoble,
France
1992 Selected Collection from HARUKI COLLECTION. Soko
Tokyo Gallery
AMONG THE FIGURES. The National Museum of Modern
Art Tokyo. Osaka
1994 LIGHT&SHADOW:The sense of ephemerality. Hiroshima
City Museum of Con-temporary Art
THE SUNTORY PRISE '94 : Challenges on Forms. Suntory
Museum Of Art. Tokyo
1995 ALLEGORY OF SEEING-1995 : Painting & Sculpture in
Contemporary Japan. Sezon Museum of Art 1996
ARCOS DE LAPA PROJECT. Rio de Janeiro, Brazil
1998 PACAEMBÚ PROJECT. Sao Pãulo, Brazil
1999 18th Exhibition of CONTEMPORARY JAPANESE
SCULPTURE '99. UbeCityOpenAirSculp-ture Museum
2000 ART TODAY 2000 PREVIEW. Sezon Art Progrum Gallery.
Tokyo
ART TODAY 2000:THREE RETROSPECTIVES. Sezon
Museum of Modern Art. Karuizawa
LES SEMIOPHORES 2000. Town Hall. Lyon, France
2001 TSUBAKI-KAI 2001. Shiseido Gallery. Tokyo (also in
2002,2003,2004,2005)
2002 New Museum Collections :AGES. The Museum of Modern
Art Saku-city
RETRACING THE PATHS. Sakura City Museum of Art. Chiba
2003 Masterpieces from The 5th Exhibition of TSUBAKI-KAI
GROUP. ShiseidoArt-House,Kakegawa
SCULPTURES BY 11. Crystal Gallery. Morioka
2004 REPLIQUES/LUMINIS. Downtown University Tunnel Algiers.
Algeria
2006 FROM EXPRESSION TO EXPRESSION-II. Yokohama Port
side Gallery
2007 Artist Today XI. SUMI·HATAKEYAMA . Museum of Modern
Art Kanagawa. Kama-kura
UCHU MIE ZU. Toyota Municipal Museum of Art. Toyota
2009 PHILOSOPHIAE NATURALIS PRINCIPIA ARTIFICIOSA.
Tokyo Art Museum

2013	SCULPTURE Selected collection. The Museum of Modern Art. Kamakura
2014	30th Anniversary Museum Collection JIDAI. The Museum of Modern Art Saku-city
2015	All Begun in Kamakura PART 1 :The Present and Future. The Museum of Modern Art. Kamakura
	CONTEMPORARY ARTISTS -10 persons. Gifu Collection of Modern Arts. Gifu
	GIFU·DNA. The Museum of fine Arts Gifu
2017	Producing/Discussing/Looking at/Hearing, Sculptures. The National Museum of Mod-ern Att.Tokyo
0~21	MADE IN FUCHU. Twenty Years of Open Studio Programs. Fuchu Art Museum

PUBLIC COLLECTIONS

The National Museum of Modern Art Tokyo.
Museum of Modern Art Kanagawa.
Aichi Prefectural Museum of Art
Toyota Municipal Museum of Art.
Fuchu Art Museum.
The Museum of Modern Art Saku-city.
Shiseido Art House.
Gifu City. and more

奥さま 真弓さんと、2022年
With his partner, Mayumi , 2022

あとがき

この鷲見和紀郎個展は、2022年3月に急逝したBankARTのディレクターだった池田修が、最期に手掛けた企画のひとつです。カタログの冒頭には企画書に池田さんが書いた文章をそのまま載せました。本来なら、池田さんがカタログの編集もするはずのところ、急遽、現BankART代表の細淵太麻紀からの依頼があり、助っ人という形で、このカタログの編集をすることになりました。なぜ私なのかといえば、池田さんと鷲見さんとの共通の接点であるBゼミが、私の父が創設者であり、私自身も最後の所長であることから、2人ともつきあいが長く、池田さんの企画意図を汲み取りつつ、鷲見さんの作家性にも沿うことができるということだと理解して、お引き受けしました。

鷲見さんはBゼミ出身のアーティストであると同時に、長年Bゼミで講師として若いアーティストの育成にも携わった人です。企画者の池田さんがBゼミ生だったころに、鷲見ゼミがちょうど始まり、私にとっても1984年に父の助手として最初に任された仕事が鷲見ゼミの記録でした。実はこのカタログのデザイナー北風総貴さんもBゼミ出身なのですが、偶然にも、彼が最初に受けた授業も鷲見ゼミだったそうです。なにか巡りあわせというのか、散々受けた恩をお返しする、めったにない機会を池田さんからもらったような気持ちにもなりました。

この展覧会は、当初、池田さんと鷲見さんの間では、鷲見和紀郎がもの派と80年代に出てきたニューウェイブの狭間の名前のない、あるは歴史化されていない世代の作家であることに注目して、「No Name Age」という仮題で進んでいた企画です。池田さんが指摘したのは、批評的には埋もれた世代の作家という意味だったのでしょうか?

私としては、「No Name」という言葉を聴いて、鷲見ゼミが、いつも学生たちに課していた「自分の知らない自分を見つける」というミッションと重なりました。それは自分たちが知らずに持っている価値観を疑い、目の前にあるものを初めて見たものとして接することで、自分ですら気がつかない、最初から持っているはずの性質や嗜好性を掘り起こしていく作業でした。そしてそれは、あくまでもつくることを通して思考することを自身に課した作家自身の姿勢でもあったと思います。

BankARTで開催する大規模な個展で、カタログを制作するときに、池田さんが持っていた共通のイメージは、大判の図版がいっぱい入った写真絵本のような、パラパラとめくっていくと、いっきにその作家の全貌が頭のなかに流れ込んでくるというもの。そして池田さんがもうひとつ遺してくれたのは、インタビューを蔵屋美香さんにお願いするということでした。客観的な視点を持ちながら、アーティストの目線にも寄って、なおかつ読み手を置き去りにしないような蔵屋さんに、聴き手としてお願いしたかったということだと思います。

鷲見さんからのたっての希望もあり、巻頭と扉の写真には、鈴木理策さんに撮り下ろしていただきましたが、理策さんも、鷲見さんや池田さん(PHスタジオ)と同じ時期にBゼミでゼミを運営していました。これまでもっとも丁寧に鷲見作品を見てきた松浦寿夫さんに再録をお願いし、現代美術の文脈で彫刻を再考している森啓輔さんには新しくエッセイを書いていただきました。またカタログ全体に鷲見和紀郎自身による言葉「note」が散りばめられています。すべての英訳を担当してくださったのは、横浜とロサンゼルスを拠点に活動するアーティストでキュレーターのキオ・グリフィスさんです。

池田さんの遺志を継ぎつつ、最大限、立体的に鷲見作品を浮かび上がらせたいと考えて編集にあたりました。

この場を借りて、ご協力をいただいたみなさまに感謝を申し上げます。
ありがとうございます。

2022年8月1日
小林晴夫

Afterword

Wakiro Sumi's solo exhibition was one of the last projects undertaken by Osamu Ikeda, the former director of BankART, who passed away suddenly in March 2022. Included at the beginning of this catalog, is the introductory text written by Ikeda for this proposal. Normally, Ikeda would have edited the catalog, but instead, I received an urgent request from Tamaki Hosobuchi, the current director of BankART, to assist her in the editing of this catalog. As for why I was chosen, is that Ikeda and Sumi share a common ground in the B-semi, of which my father was the founder and myself the last director. We had all known each other for a long time and, therefore, could comprehend Ikeda's intentions for this project while also adhering to Sumi's artistic sensibilities; thus, I accepted the task.

While being a former B-semi artist, Sumi also served as an instructor at the B-semi for many years and was involved in training young artists. The Sumi Semi started when Ikeda, the organizer of this exhibition, was a B-semi student. For myself, the first appointment as my father's assistant in 1984 was to record the work of the Sumi Semi. It so happens that the catalog designer, Sohki Kitakaze, was also a graduate of the B-semi, and his first class was also the Sumi Semi. I think Ikeda granted me a rare opportunity to reciprocate the favor he had bestowed upon me.

This exhibition was first planned under the tentative title "No Name Age" by Ikeda and Sumi, focusing on how Wakiro Sumi was an artist from a nameless or unhistoricized generation caught between the Mono-ha school and the New Wave movement which emerged in the 80s. Did Ikeda intend to point out that he was referring to a critically buried generation of artists?

When I heard the phrase "No Name," it overlapped with the mission that the Sumi Semi has consistently assigned to its students: to discover the unknown self. It was a process of questioning the values they unknowingly hold and approaching what they see in front of them as if they were seeing it for the first time to discover qualities and preferences that even the students were unaware of and should have possessed from the beginning. I suppose this was also the artist's commitment to think through the creative process.

When creating a catalog for a large-scale solo exhibition to be held at BankART, Ikeda had a consistent theme: a photo-picture book filled with large-format reproductions which, as you flip through it, brings the whole scope of the artist's work into the mind of the viewer in an instant. Another thing Ikeda bequeathed to us was to have Mika Kuraya conduct the interview. I think he chose Kuraya for her objective point of view, her ability to see from the artist's point of view, and her dedication of not abandoning her readers.

At the request of Sumi, we commissioned Risaku Suzuki to take the photographs for the opening pages and chapter title pages of the book. Risaku also ran a seminar at B-semi concurrently with Sumi and Ikeda (PH Studio). We requested Hisao Matsuura, who has been the most conscientious observer of Sumi, to re-record his work, and Keisuke Mori, who has been rethinking sculpture in the context of contemporary art, to write a new essay. In addition, the entire catalog is interspersed with "notes" written by Wakiro Sumi himself. All English translations were done by Kio Griffith, an artist, and curator based in Yokohama and Los Angeles.

In keeping with Ikeda's legacy, my goal was to bring to life Sumi's work in its fullest, most three-dimensional form.

We would like to take this opportunity to thank all of you for your cooperation.
Thank you very much.

August 1, 2022
Haruo Kobayashi

Photograph Credits

鈴木理策 / Risaku Suzuki
pp.5-20, 24-25, 32-33, 64-65, 101, 143, 164-165, 179, 191, 203, 213, 224-225, 226-228, 245, 246, 249, 250, 252, 255, 273, 表紙/cover,

山本 糾 / Tadasu Yamamoto
pp.63, 66-72, 74-79, 83-85, 92-96, 102-105, 110-111, 116-123, 130-131, 135-139, 148, 150, 152-153, 156-157, 160, 192-195, 210-211, 214-215, 218, 222-223

安齊重男 / Shigeo Anza
pp.40-45, 48-49, 52, 110

北島敬三 / Keizo Kitajima
p.73

SUMI WAKIRO
鷲見和紀郎
brilliant corners

2022年8月26日 初版第1刷発行

First published 26 August, 2022

編集	小林晴夫	Edited	Haruo Kobayashi
インタビュー	蔵屋美香	Interviewer	Mika Kuraya
執筆	松浦寿夫	Text	Hisao Matsuura
	森 啓輔		Keisuke Mori
翻訳	キオ・グリフィス	Translation	Kio Griffith
デザイン	北風総貴	Design	Nobutaka Kitakaze
企画	池田 修	Produced by	Osamu Ikeda
発行者	細淵太麻紀	Publisher	Tamaki Hosobuchi
発行所	BankART1929	Published by	BankART1929

〒220-0012 横浜市西区みなとみらい5-1
新高島駅B1F
TEL 045-663-2812

B1F, Shin-Takashima Station, 5-1 Minatomirai,
Nishi-ku, Yokohama, Kanagawa, 220-0012
Tel: +81-(0)45-663-2812

印刷・製本　株式会社シナノ

Printed by　Shinano Co, Ltd in Japan